STORYTELLING IN YELLOWSTONE

§

Storytelling in Yellowstone

Horse and Buggy Tour Guides

❦

Lee H. Whittlesey

University of New Mexico Press
Albuquerque

Library of Congress Cataloging-in-Publication Data

Whittlesey, Lee H., 1950–
Storytelling in Yellowstone : horse and buggy tour guides /
Lee H. Whittlesey. — 1st ed.
p. cm.
Includes bibliographical references and index.
ISBN-13: 978-0-8263-4117-4 (cloth : alk. paper)
1. Yellowstone National Park—History.
2. Yellowstone National Park—Historiography.
3. Historiography—Yellowstone National Park—History.
4. National parks and reserves—Interpretive programs—
United States—Case studies.
5. Storytelling—Yellowstone National Park—History.
6. Storytellers—Yellowstone National Park—Biography.
7. Tour guides (Persons)—Yellowstone National Park—Biography.
8. Tourism—Yellowstone National Park—History.
9. Yellowstone National Park—Biography. I. Title.
F722.W589 2007
978.7'52—dc22

2006031014

Book and cover design and typesetting by Kathleen Sparkes
This book was typeset using Minion 10.5/13.5, 26P.
Display type is Mona Lisa Recut and Poetica.

To the interpreters and tour guides of Yellowstone—
whether past, present, or future,
whether government, concessioner, or private.

❧

The proper presentation of the park is a fine art.
Many will visit it but once in a lifetime. It is expensive
to make the visit once. How important then that
there should be men capable of so presenting it
as to make it the one great event of a life.

—G. L. Henderson, Norristown (Pa.) *Weekly Herald*,
January 21, 1889

❧

Telling stories, after all, is what we do in Yellowstone.

—Theodore Roosevelt IV, at the 100th Anniversary of
the Roosevelt Arch, August 25, 2003

❧

CONTENTS

§

LIST OF ILLUSTRATIONS

§

ACKNOWLEDGMENTS

§

I must acknowledge the help of Yellowstone's historian emeritus Aubrey L. Haines. Until he passed away in September of 2000, he remained the great master of the vast history of Yellowstone.

Paul Schullery, senior technical writer in the Yellowstone Center for Resources, continues to shape my thinking simply by his presence, and I am grateful for our long lunches, our always-stimulating discussions, and his patient readings of my work. Al Runte remains my friend and advisor from afar and at symposia, and it is to him that I owe the title of this book. My heartfelt thanks to Betsy Watry of Gardiner, Montana, for her valuable contributions from her own research, her generosity of time to read my manuscript, and her enthusiastic and unfailing support.

The Yellowstone staff of Susan Kraft, Vanessa Christopher, Jon Dahlheim, Beth Raz, Sean Cahill, and Kirk Dietz always seemed to find what I needed in the park's magnificent historical photo collection. Laura Joss was the stabilizing force I needed on more than one occasion, and her successor, Sue Consolo-Murphy, was similarly supportive. Alissa Cherry, Kathryn Lancaster, Barb Zafft, and Harold Housley have been and are librarians and archivists that every repository can envy.

Other institutions have helped me as well. Kim Allen Scott, archivist at Montana State University, has seemed always willing to help out a fellow researcher. Dave Walter at the Montana Historical Society has often filled holes in my knowledge with his amazing Montana cerebrum. The late Dean Larsen of Brigham Young University and Tamsen Hert of the University of Wyoming have constantly appeased my hunger for new tidbits from the vast Yellowstone bibliography.

The huge network of Yellowstone aficionados, hobbyists, and collectors is fortunately always present to expand our knowledge and keep us historians honest. Jack and Susan Davis of Bozeman, Montana; M. A. Bellingham of

Livingston, Montana; Rocco Paperiello of Yellowstone; Leslie and Ruth Quinn of Yellowstone; Mike Keller of Yellowstone; Randy Ingersoll of Gardiner-Mammoth; and B.J. Earle of Buffalo, Wyoming, continue to slip me obscure bits of "Yellowstonia" that generally add to my thinking and get cited in my books and articles.

Some of the nation's best stereo-photo experts are showcased in this book. Dr. Jim Brust of San Pedro, California, is a frontier-photography historian who has significantly added to my and our knowledge of early Yellowstone photographers. Steve Jackson of Bozeman's Museum of the Rockies has made important contributions to what is known about the life of Joshua Crissman. Without William Hallam Webber of Gaithersburg, Maryland, we would know substantially less about the lives of W. I. Marshall, Henry Bird Calfee, and William Henry Jackson. Bob Berry of Cody, Wyoming; the late Ed Knight of Jackson, Wyoming; William Eloe, of Rockville, Maryland; Paul Rubinstein of Charlottesville, Virginia; and Michael Francis of Billings, Montana, are five of the nation's leading stereo-photograph collectors, and their Yellowstone collections have added exponentially to our knowledge not only of these early photographers but also of the 1870s landscape of Yellowstone. I am grateful to all for their continuing help.

Professors in the Montana State University history department have been inspirational to me through their speeches, and very helpful to me through books they recommended and their readings of my manuscripts: Billy Smith, Thomas Wessel, Rob Campbell, Mary Murphy, and Tim LeCain. Rob, Mary, and Tim suggested material changes in the manuscript that made it better.

Finally, my daughter Tess and my wife, Tami, continue to give me perspective about what is truly important whenever I get too immersed in obscure corners of history.

I have been an employee of the National Park Service for the past sixteen years, but it must be made clear that in this book I do not represent the National Park Service, nor does the National Park Service necessarily endorse this book in any way. All conclusions are my own, and my research utilized no information that was not available to any other writer. My sources are shown in the endnotes and bibliography. While I wrote this book partially on government time in accordance with an early assignment by my supervisors in 1993, I greatly

expanded it later on my own time and used it to fulfill the requirements of a master's program in history accomplished with my own time and money. Because of the book's original government connection, all proceeds from this book are donated to the National Park Service.

Map of the Yellowstone National Park
based on a map drawn in 1895 by Hiram Chittenden

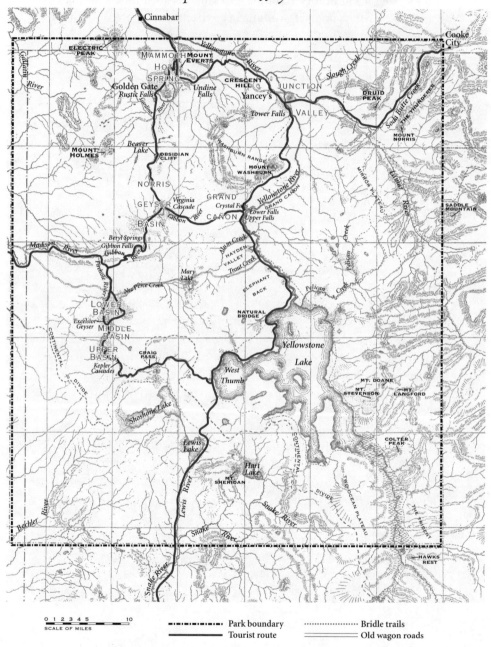

0 1 2 3 4 5 10
SCALE OF MILES

▪▪▪▪▪▪▪ Park boundary ·············· Bridle trails
━━━━━ Tourist route ═════ Old wagon roads

Introduction

National Park Interpretation and
Its Roots in Early Yellowstone National Park

*T*his is a book about the history of storytelling, later called interpretation, in Yellowstone National Park prior to 1920. Interpretation in the national parks is the art of telling people about the wonders and attractions of a geographical area, that is, giving them information and provocation about a place so that they can more fully enjoy it. Later persons would call it "giving tours" or "interpreting" a place, and it is routinely done today by anyone anywhere who is serving as a tour guide. Tourism generally produces tour guiding, which in turn produces storytelling about places visited. One of the phenomena that occurred in early Yellowstone is that virtually everyone who had been there suddenly became a tour guide on their very next visit when they were faced with escorting new people. This included those who had been there only once, even though most of those people had other functions as well—such as hunting, prospecting, exploring, surveying, or picture-taking.

Yellowstone was not only the first place in the interior American West to become the center of such prolific storytelling activities, it was arguably the place with the most natural wonders for these storytellers to describe. Because Yellowstone was first as a national park, nearly everything that happened there—in storytelling, tourism, tour guiding, and park interpretation—represented a first for the nation. And, too, Yellowstone's large size meant that it took longer than most places to see. In a locale with so many wonders to interpret, how did this storytelling get started? Who were those early park guides? What kinds of stories did they tell to park visitors about Yellowstone's wonders? What influences affected them in the telling of their tales? What did park visitors think of their stories? The answers to these questions are addressed here.

The "story of storytelling" is one that has not been told. Previous attempts at relating this history—works by Denise Vick, William Sanborn, and C. Frank Brockman—began the tale with the National Park Service (NPS) in the 1920s and did not attempt to chronicle the long, pre-1920 story. This book attempts to correct that. Although his magnificent work *The Yellowstone Story* has covered Yellowstone's history thoroughly, historian Aubrey Haines would be the first to admit that there are numerous subjects he did not cover, such as storytelling. "You have every right to exclaim with the Queen Sheba," Haines has admitted about the untold stories of Yellowstone history, "of the half [that] was not told me!"[1]

Storytelling in Yellowstone is part of the larger story of American tourism.[2] While mineral spring resorts developed as early as the 1820s and became the first destinations for the nation's early tourist economy, tourism in the West developed much more slowly.[3] Perhaps the "earliest example of Anglo tourism in the northern West" occurred when residents of Portland, Oregon, made steamboat excursions in the 1850s on the Columbia River to Astoria and the Cascade Mountains. In the 1860s Henry Corbett's Overland Mail (Stagecoach) Route to California advertised, almost as an afterthought, scenery in the Oregon country, but most travelers still saw stagecoach travel as a terror rather than a pleasure. The completion of the transcontinental railroad, however, suggested to railroad promoters that western tourism might be a possibility, but the time and effort required to visit the West dissuaded most tourists from making the trip. Thus, tourism in the interior West did not really boom until the early 1880s, when the Northern Pacific Railroad (NPRR), the nation's second transcontinental railroad, completed its line from St. Paul through Montana to the West Coast. By that time Yellowstone National Park was already eleven years old and carrying a reputation of some fame.[4]

Established in 1872 and difficult of access, Yellowstone nevertheless quickly became the first incentive for tourist travel to the interior of the American West following the Civil War and a nationally famous place from nearly day one. As historian Paul Schullery has explained, "[I]f Yellowstone had not been an authentic global wonder, it would have settled into a regional recreational role, more on the scale of the New York Catskills or the Wisconsin Dells." Instead, Yellowstone became legendary almost immediately as the first of many permanent reserves established in the American West by Congress. Its mythic status developed quickly, precisely because of its world-class attractions. Says Schullery, "Right from the start, we called it

Wonderland."[5] No place outside of Alice's rabbit hole could claim that kind of instant eminence.

As early as 1873, the *New York Times* proclaimed that "it is only necessary to render the Park easily accessible to make it the most popular Summer resort in the country." By the end of the 1870s, due in large measure to Yellowstone's emerging legend, the selling of the West as a tourist destination had begun, even though a railroad to Yellowstone remained four years in the future. Entrepreneurs were developing, packaging, and promoting railroad tours in the West, and this proved to be a crucial means of raising eastern awareness of western destinations. "It was a remarkable example," concludes Lynne Withey, "of how scenic beauty, popular attitudes, transportation improvements, and clever promotion came together to transform a sparsely settled frontier into a Mecca for tourists." Insists John Sears, "No place came to embody the vast, strange, exotic, wild, and even grotesquely comic qualities of the West better than Yellowstone."[6]

Arrival at Yellowstone of the Northern Pacific Railroad in 1883 marked the first time in the history of the American West that a railroad built tracks specifically to a tourist destination.[7] Predicated on world-class features like natural hot water fountains called *geysers* that spouted hundreds of feet into the air, Yellowstone's "Grand Tour" for travelers was quickly established. Later, Americans traveling through Europe would declare that "the [European] grand tour was a lesson in time and antiquity."[8] But in the American West the "Grand Tour" unveiled for tourists, at least initially, lessons in nature, not culture, and Yellowstone was its centerpiece.

Yellowstone, because it appeared so early as a major western tourist destination, must have influenced the way storytelling, tour guiding, and tourism were developing in other, younger places—in resort areas around the West, in emerging city and state parks, and eventually in other national parks. Surely Yellowstone's early park visitors and employees talked about the way such activities were developing in Yellowstone, although no study of such developments exists. The Grand Old Park must have influenced the development of similar travel entities all over the West, and perhaps even in the East, after 1872, but, again, no information has been found in many years of searching to enlighten us about these questions, probably because park interpretation itself, especially its history, has been little studied nationwide.

Yosemite Park witnessed its share of storytellers during the period 1855–1889, while it was a California state park. Although Yosemite had no walking guides, at least in the numbers Yellowstone did, it did have stagecoach

operations and its stage drivers "became renowned for their stories," says Yosemite historian Jim Snyder. John Muir probably served as a walking guide in Yosemite as early as 1871, but he had none of the state permits required to run businesses in that park, so his interpretive activities were informal, general, and limited. James Hutchings gave tours of the area on horseback during the period 1855 to 1874, after which the first roads entered Yosemite and several stagecoach companies operated. Yosemite's hotels were limited, however—until 1886, it had only three. Yellowstone had eight by that time with many more hotels, lodges, and tent camps as the era wore on, and these became places from which walking guides could work. Yellowstone also had five in-park stagecoach companies, at least two out-of-park companies, and dozens of independent stage lines, all providing drivers who told stories. And, too, Yellowstone's wonders took longer to see than Yosemite's—five days as opposed to one—so Yellowstone needed more walking tour guides and talking stagecoach drivers than did Yosemite, and at more widely dispersed geographical locations. For all these reasons Yellowstone developed a much larger concern with storytelling than did Yosemite, even though tourists visited Yosemite as a "resort" earlier than Yellowstone.[9]

In her study of American tourism, *See America First*, Marguerite Shaffer venerated Yellowstone, calling it "a premiere American resort" and a "national symbol" that moved beyond anything in Europe. As Shaffer noted, by the 1870s "a mythic ideal of the West became the basis for a new national consciousness" in America.[10] Yellowstone, because it was so different and developed so early, quickly became a key part of this "mythic" ideal. For example, an 1882 visitor wrote, "I confess I was skeptical; I read the most exaggerated (as I then thought) accounts of the Park and its wonders, and was as heretical as could be; [but] the half was not told." [11] The legendary Yellowstone inspired many Americans to spend time and money traveling across the country to visit it and less celebrated wonders in the American West.[12] With that in mind, railroad agents and other tourist advocates began producing, with Yellowstone as its centerpiece, a flood of information and images such as the popular *Wonderland* series of guidebooks (1883–1906) that capitalized on and added to this popular ideal of the mythic West.[13] Of course, long before Yellowstone became part of the mythic West, it had its storytellers. The history of Yellowstone storytelling starts with Indians and then progresses through the era of fur trappers, prospectors, and early explorers into the establishment of Yellowstone National Park itself in 1872. The story continues with photographers who sold stereo views of the "New Wonderland,"

commercial lecturers of the 1870s American West who made speeches about it, park personnel who erected signs and "guideboards" to proclaim the route through it, and the writers of early Yellowstone guidebooks who gave advice on what to see there and how to see it. Later the story becomes biographical, as tale telling by three of Yellowstone's most important storytellers is discussed: W. I. Marshall, P. W. Norris, and G. L. Henderson.

These three men played crucial roles in the history of storytelling in the park. It may be argued that the first Euro-American storyteller in Yellowstone was either Marshall, a private individual who brought commercial tours to the park, or Norris, a U.S. government employee. But it may also be argued that the first truly significant Yellowstone interpreter was G. L. Henderson, a park concessioner employee. The patterns these men represent relate to today's national park interpretation when one realizes that all three of these types of individuals—private, government, and concessioner storytellers— have continued to interpret Yellowstone from the 1870s to the present.

Finally, stagecoach drivers who chauffeured the public over Yellowstone's dirt roads and engaged their passengers with tales of the great Geyserland form the story's climax. Their saga ends with the new National Park Service, green in both its uniformed appearance and its experience in parks, preparing to take over the duties of these "horse and buggy tour guides." The new rangers would soon learn that storytelling by park concessioners and private tour guides was not going to end just because the men in green and gray had arrived.

Regardless of whether their stories were simple or more provocatively complicated or whether told by Indians or fur trappers or the much later park rangers, these early Yellowstone interpreters generally told their stories to enlighten new people about the strange wonders of Yellowstone. If hundreds of diaries and journals are any indication, both storytellers and listeners found the practice to be enlightening, socially stimulating, time-killing on long stretches of park roads, and generally fun.

The story of National Park Service interpretation (1920–2004) is a companion volume to this one yet to be written, but some authors have claimed that the National Park Service started interpretation in national parks. That is not true. Interpretation in and of Yellowstone National Park and education of its visitors by park employees and residents predated the NPS's Education Division, established in the 1920s. Instead it had its origins in the preceding fifty years with the now little-remembered informal storytellers—the horse and buggy tour guides of concessioner employers—and in

the related "tour guide" activities of early photographers and lecturers, along with the writers and makers of guidebooks and signs.

In particular, the history involving Yellowstone concessioners is long, complicated, and important in the evolution of U.S. national park interpretation. As one of the masters of National Park interpretation, Freeman Tilden would probably have been fascinated to walk or ride with some of those early Yellowstone storytellers and tour guides. Moreover, because Yellowstone is the world's first national park, its early storytellers are doubly important. They technically represent the origins of interpretation for all national parks worldwide.

Originally, this Yellowstone interpretation was the verbal dispensing of information followed by simple storytelling. Not until 1919, when the National Park Service became interested in distributing park information, did interpretation become something more serious. From that time through 1954, National Park Service terminology went from "information" to "education" to "naturalist" to "interpretation" and the name of its relevant division went from "Education Department" to "Naturalist Department" to "Research and Information" to "Branch of Natural History" to "Research and Interpretation" to "Division of Interpretation."[14]

The NPS chose the term *interpretation* because it focused on firsthand experience. National Park Service master interpreter Freeman Tilden called interpretation "a voyage of discovery in the field of human emotions and intellectual growth." He defined it as "an educational activity which aims to reveal meanings and relationships through the use of original objects, by firsthand experience, and by illustrative media, rather than simply to communicate factual information."[15]

While park interpretation was in essence education, the 1930s NPS wished to disassociate itself from the idea of educating the public. "Those involved in the educational work," writes one historian, "did not want the park visitor to think he was going to school when he came to a national park." Associating park activities with education would, according to one Yellowstone naturalist, "put the kiss of death . . . on what we were trying to do." Neither did the NPS like the term *information*. While interpretation included information, it went much further. "Interpretation is revelation based upon information," wrote Tilden. The NPS believed that there was a depth to interpretation that went beyond the mere imparting of information.[16]

Therefore the true interpreter, said Tilden, "[b]esides being ready in his information and studious in his use of research . . . goes beyond the apparent

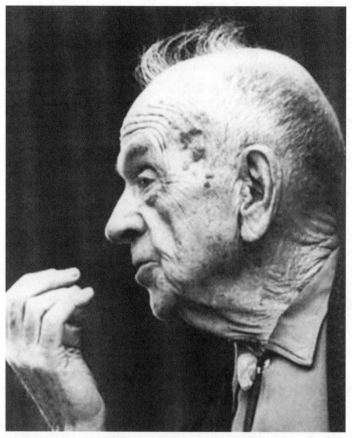

1. *Freeman Tilden, Dean of National Park Service Interpreters, who authored* Interpreting Our Heritage *(1957). National Park Service.*

to the real, beyond a part to a whole, beyond a truth to a more important truth." The true interpreter, believed Tilden, becomes "the primary means by which the National Park Service [can] generate an understanding of the visible and invisible values of the national parks." "Through information [comes] interpretation," says the NPS motto, "through interpretation, appreciation; [and] through appreciation, protection." Thus the NPS wants the public to see the important "truths" of appreciating the intangible values of nature and culture in national parks and of helping to protect them through that appreciation.[17]

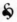

To the casual reader of this book, questions about park storytelling do occur. How did interpretation in Yellowstone compare with that of other places such as Niagara Falls? The present study does not attempt to compare interpretation in other places with that of Yellowstone; instead, it chronicles the history of how such activities developed in the first such interpretive place. How did travelers integrate these stories into their personal beliefs about the park? That question is difficult to answer. After reading hundreds of early accounts, I believe that it is impossible to know. Probably that activity was an individual task, generally not written about. How were the stories arrived at? The literature does not tell us specifically, but it implies that most stories were spontaneously made up from the immediate experiences of early travelers in their encounters with Yellowstone natural wonders and then passed along to others. When stagecoach drivers and walking guides arrived in the park, they used the stories others had told them or they added to the lore independently in the form of random inventions of stories that later people heard and adopted for their own. Were the stories consumer driven or imposed by concessioners or government officials? Again, a vast literature does not tell us, but neither of those propositions seems likely, as government oversight in early Yellowstone was extremely limited and concessioners were too busy running their hotels and stagecoaches to make such directives about simple stories and their storytellers.

Messages the Early Interpreters Considered Important and How They Got Them Across

Any attempt to study storytellers, park interpreters, educators, or tour guides in early Yellowstone must ask what messages they considered important, how they got them across to early visitors, and perhaps how those things are different from today.

Because so few written examples of their actual speeches exist, it is harder to determine what messages these early storytellers considered important and how they got them across to visitors. The fact that Yellowstone was strange and unusual was the initial subject seized upon by the early storytellers and their visitors. The beauty, grandeur, vastness, and sublimity of the country followed as a subject. Nineteenth-century writers penned so many descriptions of the park in these veins that one can hardly doubt that early storytellers used them as subject matter for speeches.

Another topic of storytelling used by early park guides was Yellowstone's relationship to religion, although this area has been little studied. The resemblance of the park's thermal areas to hell was often noted by the religious-minded, whether guides, lecturers, or authors. For instance, an 1884 stage driver loaded his speeches with "expletive [*sic*] and illustrative allusions to the realm of Pluto."[18]

Another message put forth by early Yellowstone storytellers was one calling for park promotion. Parlor lecturers in particular propagated this message. Yellowstone was initially a product to be sold, and the Northern Pacific Railroad saw that potential as early as 1870.[19] Additionally, it could not have failed to occur to stagecoach drivers, hotel porters, and other early tour guides that their livelihood depended to some degree on visitors coming to the park; hence, they must have promoted the place with that idea in mind.

Preservation messages as topics for Yellowstone storytelling seem not to have come along until much later (post-1920). There was, after all, a lot of undeveloped land in the American West. Wild animals and unspoiled country seemed to be limitless resources that would last forever. These riches, bountifully supplied in a country wherein God was "surely on our side," were to be conquered, used, and fully exploited for the good of mankind per Genesis 1:28. (Fundamentalist religion, it seems, has not always been a good friend to preservation of the environment and its wildlife, although some recent religious writers have been trying to change that perception.)[20] While a few eastern minds worried about preservation, many westerners did not, and this was reflected in Yellowstone in the dearth of conservation messages from early storytellers. But an outstanding exception to this rule was manifested in early attempts to prevent park geysers from being vandalized. Even in an era of "boundless" resources, early park employees and visitors could see the need to protect Yellowstone's exquisite hot spring formations from souvenir hunters; if lakes, mountains, and canyons did not need protecting, the unique geysers did.[21] Another exception was park interpreter G. L. Henderson's continuous message that Yellowstone "ought to be vigorously protected and generously endowed."[22]

Strictly informational messages, often coupled with humor, were probably the most common type of early Yellowstone interpretation, but occasionally park guides broadened their message. Superintendent P. W. Norris, for example, gave speeches to tourist parties on wormy trout in Yellowstone Lake and on canyon geology. Mrs. L. D. Wickes mentioned that Norris gave her party "much valuable information." G. L. Henderson used a lot of straight

information in his tours of the park, but he occasionally used material that was interpretively provocative, that is, intended to cause his visitors to tune in to the natural world around them and to make them integrate the messages into their own lives.

Finally, although we have no definite information on it, early storytelling in Yellowstone must have dealt occasionally with controversy, as park interpreters regularly do today. For example, from 1883 until the mid-1890s, cries to build a railroad through the park to Cooke City, Montana, were loud and continual. A look at the lengthy literature on this conflict indicates that great disagreements were ever a part of its scene, and park guides must have discussed it with visitors and with each other to the accompaniment of arguments and probably even occasional anger.

As for how these early storytellers got their messages across to Yellowstone visitors, that question is hard to answer in light of the lack of records on the exact speeches of early guides. In general, the more skillful early interpreters, like those of today, were probably better verbal communicators than their peers and thus likely utilized some of the same advanced communicative skills—comparisons, contrasts, metaphors, allegory, rhapsody, poetry, and provocation—that are used today.

Certainly there were good talkers in early Yellowstone. P. W. Norris has been described as "a most entertaining talker," W. I. Marshall as having "a pleasant voice, a very clear enunciation, and a fluent delivery," and G. L. Henderson as a person of "great eloquence and marvelous loquacity." One visitor gushed enthusiastically about Henderson, proclaiming that "to hear Professor Henderson in one of his impassioned descriptions where fun, philosophy and science are in turn touched with a master hand, leads one to regard him as an embodiment of Wonderland itself."[23]

May you enjoy the tales these storytellers told and the stories about those men as well, while you consider the possibility that storytelling is the essence of the Yellowstone, and the national park, experience.

CHAPTER ONE

Native Americans

The Earliest Yellowstone Storytellers

*The thermal wonders of the Park did not frighten the
native peoples of the region. Euro-Americans originated
this idea and it must be dispelled before we can
understand the true nature of Yellowstone's human past.*

—Joseph Weixelman in "The Power to Evoke Wonder"

*N*ative Americans probably had many more tales, legends, and myths—
simple forms of interpretation based in storytelling—about the
Yellowstone country than the few currently known, but thanks to Peter
Nabokov and Larry Loendorf's *American Indians and Yellowstone National
Park: A Documentary Overview*, we have a better sense of the stories the vari-
ous tribes told about the region.[1] Prior to publication of Nabokov and
Loendorf's book, historians trusted only one Indian legend relating to Yellow-
stone; that is, they knew of only one that appeared to be genuinely Indian
rather than "white"—the Ralph Dixey story discussed below. Moreover, before
the book appeared, only small, unsatisfying tidbits of Yellowstone information
were known to historians about the Sheepeaters, Shoshones, Crows, Bannocks,
Blackfeet, Flatheads, Kiowas, Arapahoes, Nez Perce, Assiniboines, Northern
Cheyennes, Gros Ventres, Sioux, and other tribes who inhabited the upper
Yellowstone country at various times prior to 1870.[2]

There seems to have been an effort by early whites in Yellowstone
National Park to make the place "safe" for park visitors, first by physically
removing Indians from the park and circulating the rumor that "Indians

feared the geyser regions," and then by attempting to erase completely the cultural history of its former Indian inhabitants from the park, including their legends and myths. If historians cannot conclusively prove that whites conspired to erase Indians from Yellowstone history, many who have spent years studying Yellowstone's literature certainly cannot escape the overarching feeling that something like that happened. Even as early as 1895, the erasure may have been slipping into place, because historian Hiram Chittenden could not find much about what Indians thought about Yellowstone nor about what they told whites of it. "It is a singular fact in the history of the Yellowstone National Park," wrote Chittenden, "that no knowledge of that country seems to have been derived from the Indians.... Their deep silence concerning it is therefore no less remarkable than mysterious."[3]

One wonders whether Chittenden, like so many later writers, simply could not find information about Yellowstone Indians, or whether the Indians would not talk to him because many tribes considered Yellowstone sacred or for other reasons, or whether he purposely fostered this thinking for motives of his own. At this late date it is difficult to point fingers at white forebears and accuse them of such conspiracies, but that belief must figure at least a modicum into the fact that until *American Indians and Yellowstone* appeared, less was known about Indians in Yellowstone than about Indians anywhere else in the American West.

It turns out that there may be a fascinating reason for Chittenden's comment concerning Indians' "deep silence" about Yellowstone. This writer searched for the information for nearly thirty years and only recently found it in a rare book that came to the park with the acquisition of the collections of Jack and Susan Davis of Bozeman, Montana. The source is John Hamilcar Hollister who visited Yellowstone in 1883 with the well-known Rufus Hatch party. Hollister published an account of that trip in 1912, and in it he told the now discredited story of Indians fearing the park's geyser regions. But following that story, Hollister stated that his attempts to find Indian legends about Yellowstone had been unsuccessful. He, like this researcher many years later, wondered why he could not find such Indian legends of Yellowstone. He then made the following statement. Nothing like it appears anywhere else in known Yellowstone literature:

> [T]here are but few Indian legends which refer to this purposely [!] unknown land. Of these I have found but one [other than for the Indians-fearing-the-geysers story], and that is this—that no

white man should ever be told of this inferno, lest he should
enter that [Yellowstone] region and form a league with
the devils, and by their aid come forth and destroy all
Indians. Hence the trappers, who were the first white men
to enter these western lands, learned little or nothing
[about Yellowstone] from that source [Indians].[4]

This is a fascinating assertion. Hollister does not reveal when or where
he obtained this supposed legend of Yellowstone, but the fact that he appar-
ently heard it in 1883, very early in Yellowstone's history when hundreds of
pre-1872 Indians were still living, should give researchers pause. The story of
keeping the place "secret" should be considered possibly true until such time,
if ever, that it can be proven false. In light of all that is known about how fer-
vently some Indian tribes believed in the park as a sacred place, the idea of not
revealing it to whites makes considerable sense. Of course, it is not known
which tribes Hollister referred to or from where he obtained the legend. If
true, the Hollister rendering of this Native American story represents a very
large and possibly final piece of a long puzzle relating to Yellowstone, i.e., the
fact that some tribes may have kept the place a secret and why they did it.

The idea that at least some Indians might have kept the existence of
Yellowstone a secret for religious reasons squares well both with known
native proclivities for not telling certain things to white men and with
Chittenden's 1895 perception of a deep Indian silence about Yellowstone. It
also explains why many researchers have had difficulty finding connections
in white literature between Indians and Yellowstone. And it explains why
there are so few known Indian legends about a place that must have gener-
ated dozens or hundreds of such legends among ancient natives. Thus
researchers should begin asking Native Americans whether there is anything
in their oral traditions to confirm this, and hope that one or more of them
will reveal whether Indians indeed kept the place secret on purpose. After all,
today's park interpreters want to get the story right, whatever that story may
be, and only focused research into such corners will help them do that.

Before the formal Indian legends of Yellowstone are considered, it is
good to examine one of only three known accounts of white contact with
Yellowstone's Sheepeater (Mountain Shoshone) Indians. Historians have had
difficulty finding writings by Euro-Americans who had actual contact with
this reclusive tribe, the only tribe that inhabited Yellowstone National Park
year-round. The classic account is by fur trapper Osborne Russell and it

occurred in 1834, but now another one is known.[5] Chronicled by newspaper editor and Yellowstone traveler Spencer Ellsworth in 1882, it starred a Mr. Topham who visited with Ellsworth that year at Ellsworth's campfire near the mouth of Alum Creek. Ellsworth's account incorporated the usual incorrect white impressions of the Sheepeaters as "renegades . . . who fled here for safety . . . [and who were] excessively timid" and probably "expelled from their kindred for cowardice." Topham was head of a party of road builders working in Hayden Valley, and his undated account located his earlier encounter with Sheepeaters as probably just west of Yellowstone Park. He told his story to Ellsworth who published it this way:

> I was trapping beaver on the Yellowstone, and trading with the Indians for peltry, exchanging coffee, sugar, beads, etc. I had learned of this band of mountain Indians, and believing from their isolation [that] they possessed a good stock of furs, took with me a small quantity of sugar, coffee, etc., and started to seek them. This was no small task, for their camp was in a most secluded and inaccessible part of the Madison range, but guided by certain signs succeeded in reaching it the second day. There was [sic] a dozen or more lodges, the inmates of which were sitting or lying indolently about, when unexpectedly I appeared. I am not considered particularly ferocious, but at sight of me every soul started and ran like so many rabbits. There was no thought of defence [sic], there was no waiting to secure valuables[;] in the briefest possible moment they had utterly vanished and I was left the sole occupant and possesser [sic] of their camp. Here was a quandary not down in the bills, and I was at a loss what to do next, but thinking of their fondness for sugar, took a quantity from my stores and conspicuously displaying it retired some distance and sat down. For twenty minutes or more I waited, when a very old woman came up and seeing she was not hurt the others stole timidly out from the brush. Their only firearms were two old muskets of the Hudson Bay pattern, for which they had no powder and did not even know how to use them. Game was killed with bows and arrows or trapped with snares. There is a sort of sign language common to all nations, by which I made my wishes known, and having arranged to meet them two days later for trade, I departed.

At the agreed upon time I was there again with a supply of
sugar, coffee, and various things for trade, but fear had again
taken possession of them, and they were not to be found.
Taking their trail however, I followed it for twenty miles
and found their camp. My adventure was very successful for
I returned with two horses loaded down with valuable furs
worth one dollar a pound.[6]

Although it contains no Sheepeater legends, Topham's account is important
for representing one of only three known white contacts with Sheepeaters in
the region and because it represents early storytelling about Indians around
a Yellowstone campfire. Ellsworth even captioned this part of his narrative
"Camp-Fire Stories."

For many years, Yellowstone historian emeritus Aubrey Haines
believed that only one Indian legend relating to Yellowstone was genuine,
that is, truly handed down by Indians. It is a tale of the origin of the Snake
and Yellowstone Rivers, apparently handed down in Shoshone and Bannock
families and published in Ella Clark's *Indian Legends of the Northern
Rockies*.[7] Apart from this story, there was, until the production of *American
Indians and Yellowstone*, little reliable information or documentation on the
legends, myths, or other folklore that may have been communicated by
Indians about present Yellowstone National Park. Even after the emergence
of Nabokov and Loendorf's book, the "Coyote" Yellowstone stories that
have been bandied about by both Indian and popular white writers remain
controversial in that historians disagree as to which are genuine and which
are made up by whites.

And, too, there are a great number of other so-called "Indian stories"
that can be dismissed as tales made up by whites, probably to explain what
Indians "should have thought" about Yellowstone. (Again, the most com-
mon example of such misinformation is that Indians "feared the geyser
regions as inhabited by evil spirits."[8]) For example, virtually all of the stories
included in Mary Earle Hardy's *Little Ta-Wish: Indian Legends from
Geyserland* (1913) and La Verne Fitgerald's *Blackfeather: Trapper Jim's Fables
of Sheepeater Indians in Yellowstone* (1937) are, in the opinion of this histo-
rian, "white baloney," that is, faked Indian tales. At the least, if they are real,
there is no documentation to prove it. Why do historians and park inter-
preters care whether the stories are faked or genuine? Because they want to
get the stories right and interpret Yellowstone correctly. And one cannot get

the stories right and truly understand Indians if one does not know whether the stories are genuine Indian tales or faked ones.

One way to study Indian perceptions of a region, which also relates to Indian storytelling, is to examine the region's place names. Nabokov and Loendorf, after years of looking at the ethnological, anthropological, archaeological, and historical literature and interviewing dozens of tribal members, have concluded that certain Indian tribes did have general names for the upper Yellowstone country. Most of those names referred to the park's hot springs and geysers. The Crow Indians called Yellowstone "land of the burning ground" or "land of vapors" while the Blackfeet called it "Many Smoke." The Flatheads called it "Smoke from the Ground." The Kiowas called it "the place of hot water." Only the Bannocks had a name that did not call to mind the park's thermal regions: "Buffalo Country." Additionally, the Crows specifically called the Yellowstone geysers "Bide-Mahpe," meaning "sacred or powerful water."[9] In places other than Yellowstone, such place names are sometimes the actual generators of stories by Indians or otherwise figure into such stories. And occasionally Indian stories themselves generate place names, although so far we do not have examples of it for Yellowstone.

As for stories that Indians told about Yellowstone, the Ralph Dixey story in Clark's *Indian Legends of the Northern Rockies* is thought to be genuine. It is a tale about the origin of the Snake and Yellowstone Rivers and long known to have been handed down in the Shoshone tribe (both Ralph Dixey and his Bannock wife stated that this story was handed down in their respective families). The story begins with "long ago there was no river in this part of the country. No Snake River ran through the land." A man came from the south who was always sticking his nose into everything. He traveled north past the Tetons and went up onto a mountain in what is now called Yellowstone. There he found an old lady with a basket of fish. Hungry, he asked her to boil some fish for him. She offered to make him food but warned him not to bother her basket. He did not listen, stepped on the edge of the basket, and spilled its water and fish. The water spread all over. The man ran fast, ahead of the water, trying to stop it. He piled up rocks to hold the water back, but the water broke his dam and rushed on. That is where the Upper Falls is today. The man ran on ahead of the water and again built a dam of rocks, but it did not hold the water back, either. That is where the Lower Falls is today. The water kept on rushing and formed the Yellowstone River. The man then ran to the opposite side of the fish basket and followed its waters downstream, building several dams of rocks, but the water would

not be stopped. Those broken dams are the sites of American Falls and Shoshone Falls on the Snake River. The big fish basket that the man tipped over is Yellowstone Lake while the old woman with the fish was Mother Earth. The man himself was Ezeppa or Coyote.[10]

Nabokov's and Loendorf's research has revealed other Crow stories about the park. A Crow narrative from a man named Sharp Horn, who passed it down to his son who passed it to his grandsons, concerns the mythic deeds of a character named "Old Woman's Grandchild" and how at least two of Yellowstone's geysers were supposedly created. This Crow said that in one of the thermal regions of the park, Old Woman's Grandchild fought many beasts and turned them into mountains and hills after he killed them. A large buffalo bull that he killed was turned into a geyser formation that continued to blow out hot air. Near it he placed a mountain lion, also a geyser formation blowing hot air, in order to keep the buffalo bull from coming back to life.[11]

Another mythic tale told by the Crow and associated with the park concerns Yellowstone Lake and what happened to the dinosaurs. A thunderbird grabbed a Crow Indian by his hair and took him to "Overlook Mountain," on the southeast side of Yellowstone Lake and placed him in a nest there. The thunderbird told the Crow that he wanted him to help him fight the giant water beast that lived in Yellowstone Lake and ate the thunderbird's young. The Crow built a large fire and heated many rocks and boiled much water. When the beast came out of the lake and climbed up the mountainside, the Indian pitched hot rocks and hot water into its mouth. Steam came out of the monster's mouth and it tumbled down the mountainside and into the lake. Supposedly this was the last "dinosaur," and steam vents around Yellowstone Lake may be remnants of this event.[12]

Hunts-to-Die, a Crow Indian born about 1838, relates that his tribe believed there were spirits in Yellowstone geyser areas who were benevolent and helpful rather than malevolent and dangerous. This tends to correct what is perhaps the worst piece of supposed Indian "information" about Yellowstone—the long-surviving but incorrect notion that "Indians feared the geyser regions." Even though this untrue allegation has been thoroughly discredited by Weixelman, Haines, and Nabokov and Loendorf, look for it to continue to appear in the shallow, unresearched, and thoughtless writings of popular journalists for years to come. It belongs in the same class of malarkey as the notion that "Yellowstone Park was once called Colter's Hell."[13]

The incorrect notion that "Indians feared the geyser regions" seems to have originated in Euro-American literature from a note that William Clark

added to his notes after 1809 when he returned to St. Louis. It is not known where Clark obtained this information, but here is the relevant quote, complete with misspellings and incorrect syntax and punctuation:

> At the head of this [Yellowstone] river the nativs give an
> account that there is frequently herd a loud noise, like
> Thunder, which makes the earth Tremble, they State that
> they seldom go there because their children Cannot sleep—
> and Conceive it possessed of spirits, who were averse that
> men Should be near them.[14]

Perhaps Clark's white informants misunderstood their Indian informants, who believed the Yellowstone area sacred rather than scary, a place for reverence rather than fear. Perhaps the white informant made up the entire story. Or perhaps some group of Indians actually did fear the place, while most did not. Regardless, the story remains in circulation in some white (not Indian) quarters, though historians Joseph Weixelman and Robert Keller have demonstrated that Superintendent P. W. Norris's statements that "these primitive savages" feared the geyser regions was purposefully incorrect. Keller has noted that "nowhere did a myth of fearful Indians become as deeply entrenched as Yellowstone," and Weixelman wrote an entire master's thesis on the subject to discredit the notion of Indian fear. Keller suggests that the geyser taboo "helped justify a national park that excluded natives," because if the fear rumor were true, whites could claim that the Indians feared Yellowstone anyway so it was okay that they were no longer there or, per some whites, that they had *never* been there. In fact, Indians were essentially thrown out of Yellowstone and kept out.[15]

Unexpectedly, the Kiowa tribe is now known to have oral traditions associated with the upper Yellowstone country. The Kiowas, who eventually settled in western Oklahoma, were earlier located in the present Crow country near the headwaters of the Yellowstone River. Lewis and Clark found them below there in 1805 "in seventy tents," somewhat near the Yellowstone Valley. One of their descendants, N. Scott Momaday, has written that around the time of the Revolutionary War the Kiowas migrated from a place near the "headwaters of the Yellowstone River."[16] In this earlier history they were friends and trading partners with the Crows, who recently chose to reveal to Nabokov and Loendorf what so far may be the most important piece of Indian storytelling associated with present Yellowstone National Park.

It is the legend told by the Kiowas about their origins. This legend concerns a man whose name no Kiowa remembers but who "was one of the greatest Kiowas who ever lived." The Kiowa informant called him *Kahn Hayn* for the purposes of the story. He said that when *Doh Ki*, the Kiowa equivalent of the Great Spirit, put people on earth he had no homeland for Kiowas, so he promised them a homeland if they could make the difficult sojourn through a barren and desolate volcanic land where clouds of steam shot from holes and fissures in the ground. Doh Ki called all of the Kiowas around one particularly disturbing steaming pool, a deep caldron of boiling water that surged and smashed against jagged rock walls and made fearsome sounds as if a great beast were just below the surface. Most of the Kiowas ran away, but a few remained including Kahn Hayn. Doh Ki then pointed to the fearsome pool and said that the land there would belong to the tribe of any man who would dive down into it. While some of the Kiowas did not want this hot land, Kahn Hayn knew that Doh Ki was a benevolent spirit whose rewards were always good and lasting, so he decided to partake of Doh Ki's test. He dove into the boiling pool and was immediately panic-stricken. He burned and ached and thrashed and lost consciousness. Suddenly he felt himself being lifted from the water by the hands of many Kiowas who were yelling excited victory cries. As he looked about he saw that Doh Ki had vanished and that the landscape was no longer barren and desolate. Instead it was covered with rich forests, lush meadows, cascading streams, and large animals. This spot in present Yellowstone National Park was now the most beautiful and abundant of all places on the earth, and it became the homeland of the Kiowas.

The Kiowas today have a name for the place where these mythic events supposedly occurred. It is at the Dragon's Mouth Spring near Mud Volcano in Yellowstone National Park, and the Kiowas call it *Tung Sa'u Dah*, which means "the place of hot water."[17]

Historians have long argued about whether Ella Clark's tales of Yellowstone in her book *Indian Legends of the Northern Rockies* are genuine Indian tales or whether Clark made them up herself, either partially or fully, by being careless in translation, by failing to reveal enough about who her Indian sources were, or both.[18]

It turns out, however, that probably the best known of Clark's Yellowstone legends may indeed be a genuine Flathead Indian tale. It is one that she calls "Coyote's prophecy concerning Yellowstone Park," and according to her, it goes like this.

In generations to come this place around here will be a treasure of the people. They will be proud of it and of all the curious things in it—flint rocks, hot springs, and cold springs. People will be proud of this spot. Springs will bubble out, and steam will shoot out. Hot springs and cold springs will be side by side. Hot water will fly into the air, in this place and that place. No one knows how long this will continue. And voices will be heard here, in different languages, in the generations to come.[19]

As one might expect, less discerning writers, especially journalists, have glommed onto this story like flies to a carcass. They have not been able to resist it, in the apparent belief that surely the story contains some kind of ancient Indian wisdom about Yellowstone that accords with the later "good" judgments of whites about the place, and which must thus somehow give dramatic credence to those judgments. But the story sounds fake. It is exactly the type of contrived-sounding piece that white writers could and would make up as a faked Indian legend. It is written too slickly and has too much perfectly balanced drama in it to ring true as a real Indian legend (real Indian legends, to white ears at least, are generally neither slick nor perfectly balanced). The prediction about the pride of future generations sounds European. The business about future voices in different languages seems beyond the reach of the normal Indian legend.

But, again, the story may well be genuine. Clark claims that most of her Flathead stories came from Pierre Pichette or Bon Whealdon.[20] Pichette was a trustworthy source; he was a blind Indian who spent at least fifty years of his life becoming an authority on the traditions and culture of his people. Clark would have readers believe either that Pichette told this story to her from one handed down to him by elders in the summer of 1953, the year before he died, or else that Bon Whealdon told it to her. Whealdon came to Montana's Flathead reservation in 1907, and he, too, spent many years gathering information on the Flathead culture. Unfortunately, Clark not only does not reveal exactly where or when she got the story, but her citation lists only an article by herself, "How Coyote Became a Sachem," as the source.[21] Worse, the story does not appear in a pamphlet by Pichette found and cited by Nabokov and Loendorf. Thus, while this writer is somewhat suspicious of this Yellowstone legend, if it came from Pichette or Whealdon, it may truly be a genuine Flathead story rather than a fabrication. Historians can only hope for better documentation about this story in the future.

Another of Clark's stories, "Defiance at Yellowstone Falls," is a fascinating mystery.[22] It is the supposed Crow legend of thirteen Crow braves and five Crow women taking a raft over Lower Falls to their deaths in a suicide story that Clark says originated because the Crows wanted to escape the U.S. Army. She attributes it to Charles M. Skinner's *Myths and Legends of Our Lands* (1896), and indeed a look at that book reveals that Clark merely rewrote Skinner's "A Yellowstone Tragedy."[23]

Where Skinner got this story is unknown, but he may have gotten it from Charles Sunderlee. Sunderlee's version appeared many years earlier in a purported news story in a Helena newspaper under the headline "A Thrilling Event on the Yellowstone."[24] In it Sunderlee listed the five members of his party and claimed that they witnessed the event above Lower Falls on April 2, 1870. Suspiciously, none of the five men he mentioned appeared in the 1870 Montana census. Historian Aubrey Haines dismissed the Sunderlee story as fiction inspired by Clark's Crow Indian legend.[25]

At first this writer thought that Sunderlee's newspaper story might have inspired a fake white Indian legend that Skinner and Clark passed on. After all, there is no hint of U.S. Army soldiers chasing Crows in the upper Yellowstone country in 1870, as Skinner and Clark claim, and in fact Sunderlee says nothing about soldiers being present. And, too, Sunderlee's story is twenty-six years older than the first known appearance of the legend (some of its details seem at least partially convincing as a news story). But later it became apparent that it was not that simple.

Two present-day Crow experts know nothing about this supposed legend. When this writer ran the story past Burton Pretty-on-Top, the current chairperson for the Crow Tribal Cultural Committee at Hardin, Montana, he said it sounded like "hogwash" to him. "Crow people do not kill themselves," he declared. He also stated that he knew of neither Crow historians nor "tribal elders" who had ever passed this story on in oral history as a Crow legend, at least not to him. While he was not familiar with Ella Clark's book, he stated that he had read numerous comparable works by "white" authors, and he observed that all too often he would have to "put these books down without finishing them" because they were filled with so much bad information. This writer also conferred with Crow expert Tim McCleary, head of General Studies at Little Bighorn College in Hardin. He, too, was suspicious of the Clark "legend," but cautioned how easy it was to be wrong about such things, regardless of which side one is on. He had read the Clark version of the legend but had never heard it in any other form, meaning from Crow elders or

otherwise in Crow oral history. He agreed with Burton Pretty-on-Top's assessment of Crows generally not committing suicide, and expanded on that, saying that those beliefs were based in Crow religion. McCleary says that the Crow belief was and is that if one committed suicide, one's spirit would remain on earth rather than ascending to some Promised Land, so Crows did not generally commit suicide. McCleary was also suspicious of the idea of Crow Indians being on rafts or boats, because "they tend to avoid boats and water and getting onto water."[26]

Haines points out that Ella Clark got a number of her Indian stories from military man Lt. James A. Bradley. A look at Bradley's long Crow discussions makes it clear that Bradley did get a lot of stories, legends, and general information during the period 1871–1877 from Little Face and numerous other Crows.[27] If Clark truly got the story from Bradley—and one of his stories bears some resemblance to it—rather than pirating it strictly from Charles Skinner, then perhaps the Crows do, or did, have such a suicide legend even though certain Crow experts have never heard it. Given these discrepancies, it is difficult to assess the validity of these stories.

These problems with both Clark's "Defiance at Yellowstone Falls" and her "Coyote's prophesy concerning Yellowstone Park" point to the difficulty of determining whether some reputed "Indian" legends are truly Indian. They also point up how easy it is for any researcher to get confused when fabrication, known or suspected, enters the picture. And they point up the reasons why all researchers, including those who talk to Indians simply to write down their stories, must be meticulous in documenting their sources. For those researchers who do not always trust the vagaries of oral tradition—was the story passed down correctly by one person and was it remembered/retrieved correctly by another, especially over many generations?—having to worry about white fabrication adds one more complex and troubling wrinkle to the equation. And again, today's park interpreters want to tell these Indian stories correctly, whatever the stories may be, and only careful research into such corners will help them make certain the stories are genuine Indian ones and will allow them to get the stories right.

Equally if not even more troubling is the problem mentioned by historian Paul Schullery. How do we judge the authenticity of the stories that actually come from Indians? Must not the scholar ask, "If Indians used to 'tell us what we wanted to hear,' and now some of them brag about doing that, how do we know they are leveling with us now? If a white man told us a story as momentous as one of Scott Momaday's, would we believe it?[28]

As mentioned, while Indians appear not to have *feared* the Yellowstone geyser regions, many tribes *revered* them. *Revere* and *fear* are two different things, reverence referring to beliefs in something sacred. There is much evidence put forth by Weixelman, Haines, Nabokov, and Loendorf that a number of tribes considered the Yellowstone country sacred and used it as a vision-questing, prayer-making, and gift-bequeathing place, and there is much other material in their writings that disproves the theory that Indians feared Yellowstone.

These few known Indian stories, then, and probably dozens or even hundreds of others that are now lost or perhaps still in the oral traditions, were among the first known attempts to interpret the strange Wonderland country at the head of the Yellowstone River, because the most basic form of interpretation is simple storytelling. Perhaps the Indians who told these stories even took other persons around Yellowstone on "tours," trying to share the wonder of the place just as interpreters and tour guides do today. One of these early Indians may have thus been the first tour guide in Yellowstone. No doubt they were followed by many more such tour guides, and in 1880, when some park roads were finally improved enough to admit wheeled vehicles, these early storytellers were joined by Euro-American ones—those referred to in this book as "horse and buggy tour guides."

But nearly sixty years before that, the Munchausen storytellers took their turns at spinning yarns of Yellowstone. In the history of storytelling in the Grand Old Park, they are the grist for the next chapter.

CHAPTER TWO

Munchausen Storytellers

Trappers Around the Campfire

It was a place where hell bubbled up....
The Colonel... did not print it because a man
who claimed to know Bridger, told him that he
would be laughed out of town if he printed
any of old Jim Bridger's lies.

—Hiram Chittenden on Col. R. T. Van Horn's
interview with Jim Bridger in 1856

We were compelled to content ourselves with listening
to marvelous tales of burning plains, immense lakes
and boiling springs without being able to
verify these wonders.

—Capt. W. F. Raynolds, 1859, on what Jim Bridger
told him about the Yellowstone country[1]

The germs of Euro-American storytelling began early in the Yellowstone country with "Munchausen" tales told by those who had toured the area on horseback. *Munchausen* is a word that means "extravagantly fictitious." Baron Munchausen was the supposed author of a book (1785) of travels filled with extravagant fictions, and the word today is used to refer to any grandiose fiction.[2] For eons, campfire storytelling has probably entertained anyone who built a campfire. Nineteenth-century trappers and gold prospectors were no exception. While hunting on Montana's Mission Creek

in about 1880, Dr. William Allen opined that "the usual number of stories, wild and improbable, were told that night around [our] camp-fire." "Every hunter who has been out with a number of others," he concluded, "knows what a pleasant past-time story-telling is after a hard day's march, and how often it is kept up for the greater part of the night."[3]

Vague, often fanciful stories about the region by fur trappers and prospectors during the period 1805–1869 contained at least some information about the "wonders of the Yellowstone," and many were designed simply to entertain. In the earliest known reference to the Yellowstone country, an unknown (probably Native American) reporter gave information to a Euro-American traveler about what were apparently hot springs. The traveler stated in 1805 that "among other things a little incredible, a Volcano is distinctly described on Yellow Stone River."[4] Mountain men such as John Colter, Donald McKenzie, Baptiste Ducharme, William Sublette, Daniel Potts, Joe Meek, Johnson Gardner, Manuel Alvarez, Warren Ferris, and Osborne Russell all visited the Yellowstone country and took verbal, sometimes written, accounts back with them. Russell told of trappers "from Mr. Bridger's party" near present Hebgen Lake remaining with them during one night in 1835 and "telling Mountain 'yarns'" around the campfire.[5]

Many of the stories told by these "horse tour guides" were entertainments passed down from the trappers and had to do with the existence of the strange country at the head of Yellowstone River.

Warren Ferris, for example, "heard . . . while at rendezvous" of "remarkable boiling springs," thus indicating that entertaining Yellowstone stories were already being told around campfires by 1833.[6] Boiling springs were, after all, very unusual in western geography and the story would probably have transfixed Ferris and his other listeners.

Yet another example is Osborne Russell's story of present Two Ocean Pass, just south of Yellowstone Park. There in a high meadow, the headwaters of Atlantic Creek flowing east intermingle with the headwaters of Pacific Creek flowing west in a truly remarkable piece of western geography. "Here," wrote Russell in 1835, "a trout of 12 inches in length may cross the mountains in safety. Poets have sung of the 'meeting of the waters' and fish climbing cataracts but the 'parting of the waters and fish crossing mountains' [story] I believe remains unsung as yet by all except the solitary Trapper."[7]

These stories contained elements of interpretation, for even the simplest storytelling is interpretive in some measure. Perhaps the most noted of these early campfire talkers and entertainers was Jim Bridger, a fur trapper

2. *Baptiste Ducharme, one of the earliest fur trappers, who visited present Yellowstone Park in 1824 and 1826 and later told stories of the falls and the geysers, turned 102 years old in 1883. McGee Studio, Livingston, Montana.*

who visited Yellowstone in the 1820s, 1830s, 1840s, and 1850s. That this man "provided most of the information [about the early Yellowstone country] set on paper by intelligent perceptive men," intoned historian Aubrey Haines, "testifies to the good repute in which his serious utterances were held."[8]

As the quote at the beginning of this chapter indicates, Captain W. F. Raynolds, whose expedition of 1859–1860 to the country just southeast of Yellowstone was guided by Bridger, stated that Bridger talked a great deal to

them about the Yellowstone country that they could not then penetrate. Raynolds thought Bridger's stories were "altogether too good to be lost." But because the party could not get across the snowbound country southeast of the present park in order to see the Yellowstone wonders, Raynolds was forced to concede that his party was "compelled to content ourselves with listening to [Bridger's] marvelous tales of burning plains, immense lakes, and boiling springs, without being able to verify these wonders." Captain Raynolds made it clear that Bridger was indeed telling stories of Yellowstone. Raynolds thought it not surprising that men such as Bridger "should beguile the monotony of camp life by 'spinning yarns' in which each tried to excell all others, and which were repeated so often and insisted upon so strenuously that the narrators came to believe them most religiously."[9]

Captain Eugene Ware described Bridger's storytelling in 1864, and thus offered a clue as to Bridger's tale telling abilities:

> Major Bridger... told stories in such a solemn and firm, convincing way that a person would be likely to believe him.... He wasn't the egotistic liar that we so often find. He never in my presence vaunted himself about his own personal actions. He never told about how brave he was, or how many Indians he had killed. His stories always had reference to some outdoor matter or circumstances.... He had told each story so often that he had got it into language form, and told it literally alike. He had probably told them so often that he got to believing them himself.[10]

Bridger was known for seeming to stretch the truth, and, according to Ware, he sometimes deserved the reputation. Ware stated that Bridger "used to state that the mountains were considerably larger and higher than when he first came [West]" and that "one evening he told me that Court House Rock had grown up from a stone which he threw at a jackrabbit." Ware described Bridger's habit of telling stories to newcomers. According to Ware the stories contained "a lot of statements which were ludicrous, sometimes greatly exaggerated, and sometimes imaginary."[11]

Army wife Margaret Carrington met Jim Bridger in 1866, when he was sixty-two years old, and noted that "many stories are told of his past history, and he is charged with many of his own manufacture." She explained his storytelling philosophy as follows: "[W]hen inquired of as to these

[apparently false] statements, he quietly intimated that there was no harm in fooling people who pumped him for information and would not even say 'thank ye.'" When one considers these various sources, it logically appears that Bridger—like many of his contemporaries—purposefully stretched the truth on some occasions and on others did not.[12]

Several Yellowstone tall tales attributed to Bridger have now been exposed as not really originating with him.[13] But Bridger did have at least three stock stories about what today is Yellowstone National Park. Those concerned petrified forests, "Hell-close-below," and the "stream-heated-by-friction." Historian Aubrey Haines has thoroughly discussed Bridger's petrified-forest stories. His Hell-close-below story was fortunately saved by Captain Ware, who quoted Bridger as saying about Yellowstone, "that is the greatest country that I ever see." Bridger described watching two Indians in what was apparently the present park. Ware stated that Bridger said:

> They hadn't gone very far before the crust of the earth gave way
> under them, and they and their ponies went down out of sight,
> and up came a powerful lot of flame and smoke. I bet hell was
> not very far from that place.

"I never could account for this story," insisted Captain Ware, "unless he had seen some Indians drop through the ground in some part of the hot-spring or geyser country."[14]

N. P. Langford heard two of Bridger's Yellowstone stories just after the Civil War:

> I first became acquainted with Bridger in the year 1866....
> He told me ... at that time, of the existence of hot spouting
> springs in the vicinity of the source of the Yellowstone
> and Madison rivers, and said that he had seen a column of
> water as large as his body, spout as high as the flag pole in
> Virginia City.[15]

This story probably referred to Old Faithful Geyser or one of the other tall geysers in the Upper or Lower Geyser Basins. About Bridger's stream-heated-by-friction story, Langford wrote: "Mr. Hedges and I forded the Firehole river.... When I reached the middle of the stream ... I discovered from the sensation of warmth under my feet that I was standing upon an incrustation

formed over a hot spring that had its vent in the bed of the stream. I exclaimed to Hedges: "Here is the river which Bridger said was *hot at the bottom*."[16]

Perhaps it was not one of Bridger's stock stories, but Captain Ware also reported that Jim informed him of the existence of Yellowstone Lake: "He told me that there was a large lake up there which he had seen that was so big he couldn't see across it in places, and that it was fresh water. He had told this story to others, but nobody believed him. He was somewhat indefinite as to its location, because he had taken a roundabout road, and was going through the country all alone, sort of scouting it, and dodging the Indians."[17] Here Bridger was not "yarning." Ware's detailed account of his stories made it clear that Bridger could be truthful. Perhaps the fact that at times few people believed him encouraged him to yarn, because it had to have been frustrating to be told you were lying when you were not.

Another of Bridger's stories reported by Captain Ware, and later by park superintendent P. W. Norris, concerned the "diamond mountain." Because Ware placed the story adjacent to Bridger's Yellowstone Lake story, some writers have assumed that it referred to Obsidian Cliff in the park, although others have placed it on a mountain near present Laramie, Wyoming. This mountain, according to Bridger, was made of solid diamond. Through it he could plainly see Indians on its other side, and it took him half a day to ride around it. He claimed to have knocked a piece off of it which he later showed to another man who proclaimed it diamond. Later versions of the story, probably embellished by Hiram Chittenden, have Bridger shooting an elk through an invisible glass shield that served as a telescopic lens. That elk story was certainly not a genuine Jim Bridger tale.[18]

Unfortunately for us, Jim Bridger was not literate and hence could not write down any of his stories or any of his vast knowledge of the West. But he talked incessantly of the Yellowstone country, and others wrote down some of what he and his fellow fur trappers said. Said Walter DeLacy in 1888, "I have often years ago heard Bridger so thus speak of this [Two Ocean] Pass, of the Geysers, the Yellowstone Lake. . . . I heard of them first, and received a good general description of them in 1855 at Portland Oregon, from old Joe Meek, who had once been a trapper for years with Bridger, in this region."[19]

Another person who heard Bridger's stories, apparently in the 1840s, was a newspaper editor at Kansas City. About this, lecturer W. I. Marshall said:

When I lectured on the [Yellowstone] Park in May, 1879, before the Kansas City, Mo., Academy of Sciences, the editor of the

Kansas City Journal (one of the ablest newspapers west of Chicago), in an editorial, stated that nearly thirty years before he had heard from Bridger's own lips an account of these wonders, and had written it out for publication, but had suppressed it because some of his friends laughed at it as utterly incredible; and, expressing his regret at his folly in thus declining to print what was doubtless the first account ever written of these marvelous objects, he publicly apologized to the venerable mountaineer, who was still living at Westport, Mo., for his incredibility.[20]

Thus, in this vague tradition of fur trapper stories, the interpretation of a great national park got its start. What is important here is that simple talk was occurring about the Yellowstone country among these early travelers and that that very storytelling, which painted word pictures, was itself interpretive in a most basic way.

Later, 1860s gold prospectors, often called "stampeders," added to the Munchausen tales told about the Yellowstone country. They told their stories orally in Montana saloons, and reporters preserved them in the newspapers of that raucous, fledgling territory. Davis Willson, later of Bozeman, Montana, has been identified as the prospector-author of this 1867 newspaper passage[21]:

[T]he Bear Gulch stampeders have returned. . . . For eight days they traveled thro' a volcanic country emitting blue flames, living streams of molten brimstone, and almost every variety of minerals known to chemists. . . . The steam and blaze was constantly discharging from these subterranean channels . . . like the boilers of our steamboats, and gave the same roaring whistling sound. . . . Mr. Hubbel . . . ventured to approach. . . . As he neared its mouth his feet broke through and the blue flame and smoke gushed forth, enveloping him.[22]

Such early storytelling, whether true or merely containing grains of truth like this one, helped spread the word about the strange, new Yellowstone place and decreased the amount of time that would be required for it to become known to the world.

Storytelling fur trappers and prospectors were some of the first tour guides of the upper Yellowstone country. After they passed from the scene,

attempts to tell stories and convey information about the strange region continued in the form of photographs, drawings and paintings, popular published accounts, lectures and lecturers, written guidebooks, signs and "guideboards," individual tour guides, and finally government and concessioner storytellers, many of whom eventually became what Freeman Tilden would call formal interpreters.

But the photographers came first, shortly after the prospectors. They promoted the Yellowstone area visually and established an informational framework upon which later storytellers and horse-and-buggy tour guides could hang verbal word pictures. As such, the photographers are deserving of their own chapter.

CHAPTER THREE

"Everyone Can Understand a Picture!"

Early Yellowstone Photographers
Tell the Stories with Images

While only a select few can appreciate the discoveries
of the geologists or the exact measurements of the
topographers, everyone can understand a picture.

—*New York Times*, April 27, 1875

Commercial photographers first came to Yellowstone in 1871. Many writers have argued that it was photography as much as any other factor that convinced Congress to create Yellowstone National Park in 1872, but its function in park storytelling and interpretation has been little discussed. The raw material of park interpretation that Freeman Tilden would discuss some eighty-five years later in his book *Interpreting Our Heritage* was nothing less than the great American landscape itself. And the people who would initially preserve the "look" of the West for future generations were frontier photographers.

In post-Civil War America, photography was just coming into its own. Technological advancements in the camera had made it profitable to sell stereo views of faraway places to a public hungry for news, and views, of places it had not been. Stereo views—double-image photo cards that could

be viewed through a stereoscope to give the viewer a three-dimensional effect—had been for sale in America since at least 1854, and the stereoscope was quickly becoming America's "first universal system of visual communication before cinema and television." The camera, invented simultaneously in America and France in 1839, dramatically changed the world. "The photograph's mirror-like ability to capture the moment and preserve its uniqueness," declares historian Alan Trachtenberg, "made the camera seem (as it still does) a near-magical device for defeating time, for endowing the past with a presence it had previously had only in memory."[1] By the 1870s, stereo viewing was a hugely popular American pleasure, with millions of distributed images in the parlors of the nation. The stereoview was small in size and inexpensive, and thus ideal for home purchase and use. Intended for public consumption, the medium soon became widespread. Photographers thus had a product that was easy to sell and distribute, unlike what had not occurred with their larger format photographs. "It seemed like everybody had one," says historian Ralph Andrews of the stereopticon viewer and its picture cards, "and it occupied a place in progress as vital as its place in countless homes, in a gilded basket on the parlor center table."[2]

The existence of thousands of stereo photographs dovetailed nicely with revelations of marvelous natural features in the American West and with the recent rediscovery of the significance of nature by Henry David Thoreau and other artist-naturalist philosophers. "The rehabilitation of nature that romantic artists and writers had begun in the early nineteenth century," declares historian Cindy Aron,

> proceeded in the years after the Civil War as photographers,
> painters, and journalists continued to celebrate not only
> the beauties of the East, but the newly discovered wonders
> of the West. Pictures . . . depicting Yosemite, Yellowstone,
> and the Rocky Mountains brought an appreciation of
> nature and the wild to easterners who had neither the
> time nor resources to venture so far. American scenery
> became a source of national pride, a means of countering
> European claims of cultural superiority. As a result, the
> suspicion and dread with which many people had
> approached nature in the early nineteenth century
> was replaced with a rising interest in and appreciation
> for the out-of-doors.[3]

And out-of-doors is where these photographers were. They could bring the landscape to the thousands of easterners who had never seen the American West. When they and others brought the photos to the public, it was to imbue many of those untraveled folks with a powerful image—a sense that the vastness of the western landscape could somehow offer not only a new start in life but also a new type of life. Equipped with that new image, explains historian Greg Nobles, the common man "could test and perhaps transform himself, becoming a hero in his own right and sharing in the mythic history of the American frontier."[4] Or at least that is apparently what many wanted to believe. And they could experience it vicariously through photography.

Photography was and is a form of interpretation of the landscape, through basic information storage that simultaneously promotes that landscape—at least to many people who purchased stereo images. Like the earlier fur trappers in Yellowstone, photographers were, in a sense, "horse tour-guides," for they traveled by horse and produced touring images that guided early travelers and became a component of storytelling in early Yellowstone. These touring images were instantly exciting to everyone who saw them. They exemplified the sentiment expressed by the *New York Times* on April 27, 1875, when it editorialized: "While only a select few can appreciate the discoveries of the geologists or the exact measurements of the topographers, everyone can understand a picture."

Perhaps it was not that simple, but many people at least thought they could understand a photo. That there was much more to it is apparent from Alan Trachtenberg's book *Reading American Photographs* (1989). "The relationship between images and imputed meanings," explains Trachtenberg, "is fraught with uncertainties." Like opaque facts, photos can have "a fringe of indistinct, multiple meanings." "They have a life of their own," he says, which resists the efforts of viewers to give them a single meaning. Thus, early photographers quickly learned that "meanings are not fixed, that values cannot be taken for granted, that what an image shows depends on how and where and when, and by whom, it is seen."[5]

These early photographers were touring the Yellowstone country in the 1870s and early 1880s, at a time when the American public was not; thus, they brought images of the new place to America. All of them promoted the new national park and recorded initial information about it. Moreover, their photographs, which joined sketches, chromolithographs, and woodcuts that accompanied early accounts of the new region, were important in developing

the public's image of Yellowstone as a geographic and humanistic place: a specimen of virgin land and sublime spectacle. As historian Aron noted above, some of these images quickly spread across America and into Europe, and over time they came to influence the way members of the general public perceived and later even described their own experiences in the park and the American West as a whole.[6]

Photography could present "an utterly convincing illusion of factuality while providing a repertoire of techniques that enabled the photographer to make a powerful statement." Thus, photography held great power to explain and therefore transform the American West from the realm of the mythical to a place that could truly be visited and settled. These early photos therefore are repositories of cultural meanings that allow researchers to see the forces engendering those meanings, the way those meanings were embedded in humans and objects, and their effects upon the culture that surrounded them.[7]

But before those "higher" sorts of things can be attempted, researchers must realize how many photographers worked in Yellowstone and how many images they made. Except for William Henry Jackson, historians have overlooked these men almost completely. Most of the photos taken by these men have been seen only by a few stereo collectors and have largely never been viewed or studied by historians. The sheer number of these images is staggering, and their existence offers a fertile new field for geographical, historical, and scientific study.

There seems to have been little interaction between these photographers and other Yellowstone travelers of the 1870s. Jackson and Joshua Crissman were photographers for the 1871–1872 surveys of F. V. Hayden, and Thomas Hine was photographer for Captain John Barlow, who surveyed Yellowstone for the army also in 1871. However most of these photographers appear not to have had contact with other park expeditions or visitors of that time. Yellowstone had no real roads before 1877 and tourists numbered only about 500 regional folks per year through 1877.[8] Following the great Yellowstone "discovery" expeditions of 1869–1872, the new park was a roadless wilderness where few persons ventured until the Northern Pacific Railroad arrived in 1883. These photographers, therefore, seem to have had the place mostly to themselves. One might think that photographers would have routinely encountered each other, but in a place as vast as Yellowstone, it apparently rarely happened although they probably "knew" each other by reputation if not advertising. At least one enterprising photographer posted advertisements for his services in the park's backcountry, for an 1883 tourist

noted that at a location east of Mary Lake he saw "on the rocks, in conspicuous places, the stenciled signs of a dealer in photographic views." "They were new," noted the traveler, "the only advertisements of the kind seen in the park [and] they defaced natural scenery."[9]

Nor did these photographers frequently meet other park tourists, although surely they met more of them than records indicate. Instead, these men seem to have taken hundreds of Yellowstone photos and then to have gone home to peddle them, with scattered and apparently only partial success. It is difficult to know what to do with these men or how to place them into any kind of larger picture, but historians should be glad to at least know they existed even if their photographs have not all been found.

William Henry Jackson became well known for having taken the "first" photographs of the Yellowstone country.[10] His images helped convince a skeptical Congress that the area should in some way be preserved, and he has long been celebrated as photographer, artist, explorer, historian, and pioneer. Jackson first heard of the Yellowstone country in 1866 from a prospector. "In 1866, when I was traveling over the Oregon Trail in the vicinity of South Pass," he recalled, "old frontiersmen told me of the great lake, the waterfalls, and the geysers not far away to the north, and I remember that at the time I had a longing to go there."[11]

As interpretive aids and documents of Yellowstone history, Jackson's photos were and are the most well known and arguably the most important. But numerous other photographers followed him in recording Yellowstone National Park in the 1870s and 1880s. These men are little known today, but their photos had material effects on the development and perceptions of Yellowstone and subsequent interpretation of it, effects and perceptions that are just beginning to be understood. Many of their photos are difficult to find today except in private collections. Their last names were Hine, Crissman, Calfee, Catlin, Marshall, Beaman, Fouch, Thrasher, Train, Bundy, Huffman, Rutter, Nesbitt, and Savage. Along with Jackson, they were the earliest photo storytellers of Yellowstone.

These men took thousands of photographs of early Yellowstone, but what was the subject matter of their pictures? Why were they photographing? What did their photographs mean? What were the most photographed places in the park? What evidence do those photos contain for us today? These and other questions spring instantly to mind.

Most of the early photos were of Yellowstone's scenery—mountains, waterfalls, canyons, rock formations, lakes, streams, and, of course, beautiful

hot spring formations and astounding geyser eruptions. Sometimes the photos contained tourists, stagecoaches, horses, boats, buildings, or bridges, thus giving historians fascinating glimpses of the cultural parts of early Yellowstone. Occasionally the images contained animals, but animals were difficult to photograph in those days because they did not hold still for the picture. Birds, insects, and smaller animals were seldom if ever photographed. It is telling to compare current photos of park natural features with those taken in the park's early days, and in many cases the features have changed greatly due to vandalism, erosion, or natural evolution. Photos make it clear that lakes dry up, different plants become evident in meadows, tree types change due to fires and shifting drainage patterns, roads are abandoned, buildings are razed, creeks and rivers change course, and even waterfalls can look different over time as landscapes around them erode and water amount fluctuates. Geysers and hot springs can change dramatically or they can remain remarkably stable in appearance and activity.

These early Yellowstone photographers were primarily in business to make money, although some claimed to be "artists." Their photos were for sale, and so every photographer composed his images with salability in mind. Initially the men were not sure what would sell well, so they photographed what seemed interesting to them. Adding people to the images sometimes added scale and interest, and so did featuring the most famous park locations, although the photos themselves played a role in making certain park locations more famous than others. At times people, park locations, and composition must have made certain photos sell better than others, but historians do not know which images sold the best or how well the photos sold in general; surely it varied from photographer to photographer and later from company to company. Until color postcards began to be issued in 1897, many of the images were black-and-white stereos—double photos—mounted on colored cardboard and often containing the photographer's name, address, indicia, and other promotional material. It is unlikely that these early Yellowstone photographers were trying to make any overall statements in their photos other than the fact that the park was a strange and wondrous place and that they could thus sell pictures of it.[12] At the same time, they were probably tracking and reflecting the public interest in such photos, although less is known about that.

As for the most photographed Yellowstone places, those were primarily Mammoth Hot Springs, Old Faithful, and the Grand Canyon of Yellowstone. But the park contained such an astonishing array of natural features

that photographers soon began to vie with each other to see who could come up with interesting new places that no one else had photographed. There were, after all, thousands of individual hot springs, geysers, mud pots, and steam vents; hundreds of mountains, lakes, streams, canyons, rock formations, and waterfalls; and, by 1883, even a dozen or so buildings to photograph. In speaking of later park postcard views, experts Jack and Susan Davis of Bozeman, Montana, have stated to this writer that Yellowstone National Park rates number one in the world today—ahead of Washington, D.C., and Niagara Falls—in the number of historic images of it known to have been published and issued: more than ten thousand of them![13] And the reason for that was the sheer number of natural wonders and cultural features that were available for photographing.

The Yellowstone country did, after all, fully qualify as a "wild romantic landscape." Such landscapes had well-recognized features that included all of the following: "references to amplitude or greatness of extent, vast and boundless prospects, great power and force exerted, the thundering cataract of violent storm, a great profusion of natural objects thrown together in wild confusion, obscurity, vagueness, indistinctness, darkness, mystery, suggestion of terror, [and] evidences of cataclysmic force or superhuman power."[14] Yellowstone certainly had every one of those things as well as *geysers*, an otherworldly type of natural feature that other such places, which had served as models for such descriptions, did not possess. 1870s photographers quickly began to shed light on the long undiscovered and still little known Yellowstone wonderland.

Photographer Thomas Hine accompanied Captain John W. Barlow on Barlow's 1871 expedition. At the behest of General Sherman, Barlow made a reconnaissance of the Yellowstone country at the same time as Dr. F. V. Hayden's survey. Just as Jackson was Hayden's photographer, Hine was Barlow's. Unfortunately, the Chicago fire in October of 1871 destroyed the bulk of Hine's photos. While Mr. Hine reportedly saved sixteen prints he had made the previous day, for a long time historians believed that none of his pictures survived. The fire destroyed around two hundred photos, including not only lake and mountain scenes but also many images of the largest Yellowstone geysers taken while they were in eruption, something W. H. Jackson did not succeed in doing. Had those photos survived, they would have competed with Jackson's for forefront prominence. The fact that Jackson's pictures were among the only ones published in 1871 is, according to Jackson, "something for which I have to thank Mrs. O'Leary's cow."[15]

Frontier photo historian Dr. James Brust found seven of Hine's Yellowstone photos on a visit to the New-York Historical Society and published them. Four others have recently turned up in private collections.[16] Virtually all of Hine's photos were of scenery, although Hine's boss John Barlow appears in some of them.

Bozeman photographer Joshua C. Crissman (1833–1922) is likewise little known, but he photographed Yellowstone during the summers of 1871 through 1874. Crissman joined the 1871 Hayden survey at Bozeman, and served with the 1872 party as well. He assisted William H. Jackson, and it is now known that at least some 1871 Jackson images should be credited to Crissman; in fact, Jackson himself credited a number of 1872 images to Crissman.

Jackson met Crissman two summers earlier in Utah and there Crissman allowed Jackson to use his Corinne darkroom. Jackson called Crissman "a good-natured and companionable man who quickly made friends with everyone of the Survey." He told the story of Crissman's camera falling disastrously into the Yellowstone canyon near Artist Point and how he (Jackson) loaned Crissman a camera.

Crissman sold good numbers of his photos to W. I. Marshall and C. D. Kirkland who reproduced and sold them prolifically, so Crissman's Yellowstone images were seen for many years although they were not credited to him. Most important, Crissman was first to get his photos of Yellowstone printed and published, accomplishing that locally in Bozeman in 1871 before Jackson did. Jackson's pictures were published later in Washington, D.C.

At least nine of Crissman's printed photos bearing his indicia have survived in custody of the Montana Historical Society, at least twenty-four are in the Bob Berry private collection, at least twenty-one at Museum of the Rockies in Bozeman, and an unknown number in the Jay Lyndes collection in Billings, Montana. From these it is apparent that Crissman's stereopticon series was called "Views in the Yellowstone National Park" and apparently contained at least one hundred images taken from 1871 through 1874.[17] Crissman's photos were almost all of scenery—including many canyon views, "Finger Rock" in Firehole Canyon, and "Lake Beach" at West Thumb Geyser Basin—but several are of the Bottler brothers skinning elk near Crater Hills. Crissman's catalog of photos appeared on the reverse of some of his stereo cards, and it included some place names used early by him, such as "Firehole Canyon" and "Gallatin Lake."

Crissman's photos that were reproduced and sold by William I. Marshall beginning in 1876 are a special case. Marshall, whose story appears later in this

chapter and in the chapter about lecturers, repackaged Crissman's photos with his own name and insignia and with new explanations and, often, new place names. His Crissman photos were largely scenery—lots of canyons and geysers—but occasionally the photos had people in them: two men at Undine Falls, a single man with Crissman's own darkroom tent at Rustic Falls, and a man and horse at Liberty Cap. An 1874 photo showed seven people including two women at Minerva Terrace with one man holding a chunk of travertine that he was taking with him. And a most interesting one showed three people at Grotto Geyser including one woman, who must have been one of the earliest white women known to have visited the Old Faithful area (the photo is 1872–1874 in vintage).[18]

Henry Bird Calfee (1847–1912) and his partner Nelse Catlin are generally mentioned together when Montana photography is the subject.[19] The two men ran a photographic business in Bozeman during the 1870s. Issues of the *Bozeman Times* and Bozeman *Avant Courier* for 1875–1878 constantly mentioned the two men as photo shop owners, and at one point the *Times* claimed Calfee moved to Radersburg, Montana. By his own account, Calfee came to Montana Territory in 1870 and visited Yellowstone as early as 1871, when he stated that his fellow traveler Macon Josey fell into a Yellowstone hot spring.[20]

However, historian Aubrey Haines did not trust the 1871 date for Calfee's first visit to Yellowstone. Haines instanced a number of reasons why Calfee's first trip to the park must have been in 1873, including the fact that Calfee could not have met "Yankee Jim" in 1871, that Calfee's meeting with the Harlowe gang must have been in 1873, and that the big snow year mentioned by Calfee—which was the cause of his taking "ten days" to reach Yankee Jim's—occurred in 1873. Haines also believed that Calfee's first year photographing in the park was 1874, because it would have taken Calfee at least a year to get camera equipment and "maybe [longer] since learning to do the wet plate process was slow and hard." Haines stated that these years (1873 and 1874) squared with the year (1875) that Calfee opened his Bozeman studio.[21]

Regardless, numerous 1870s Yellowstone accounts mentioned Calfee as constantly being in the park taking pictures. Montana pioneer W. E. Sanders met him in 1880 at Old Faithful, and Calfee told him that he (Calfee) had been in the park photographing it every year for nine seasons.

Including his outsized "boudoir" views, Calfee took at least 295 photos of Yellowstone and figured into some early park history. He conveyed Mrs. Cowan and her party to the safety of Bozeman following their ordeal with the Nez Perce Indians in 1877. In 1879, he and Catlin played a minor role in

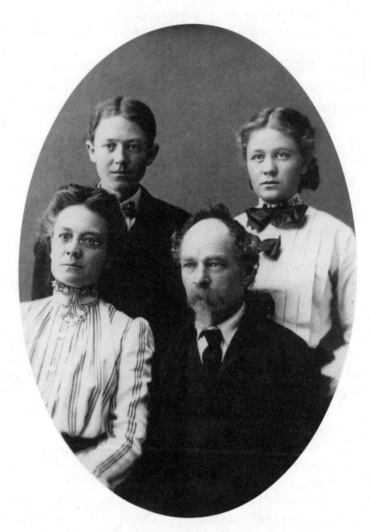

3. *Henry Bird Calfee (1847–1912) and his family, about 1880.*
Calfee was a Montana photographer who photographed
Yellowstone Park every summer from 1871–1881. American
Heritage Center, Laramie, Wyoming.

the naming of Lone Star Geyser, and took photos of a large tourist party. In 1880, park superintendent P. W. Norris, whom Calfee accompanied that year, named a stream in Yellowstone Calfee Creek.[22]

Calfee's stereos were larger in size than those of many other photographers and were mounted on green, orange, yellow, or gray cardboard with crudely stenciled captions. While many of his views were of scenery, Calfee tried hard to get views that no one else had. He traveled the backcountry, searching for interesting places. He rode and walked the Grand Canyon trying to get "different" shots. And he photographed tourists. His number "204 A Dinner in the Park," his "205 Tourists at the Giant Geyser," and his "87 Tourists Traveling" are spectacular examples. Like other photographers, he recorded vandalism to Old Faithful's crater ("81 Crater of Old Faithful"), occasional animals ("182 I Killed Him"), and cultural sites ("200 U.S. Government Buildings Mammoth Hot Springs"). And he loved the Mammoth Hot Springs, taking more different views of them than anyone else did and occasionally showing one, two, or three of his helpers in his pictures.

"It was here," exulted Calfee about Yellowstone, "among these gorgeous scenes of fabulous grandeur, [that] I conceived the idea of getting up my Wonderland entertainment, which I succeeded in doing a few years later." By this, Calfee meant his lecture tour using photographs. During the period 1881–1882, Calfee went on this lecture tour to promote Yellowstone Park with W. W. Wylie, an enterprise that was mentioned frequently in the Bozeman *Avant Courier* newspaper.[23] Woodcuts made from Calfee's photos graced Wylie's 1882 park guidebook entitled *Yellowstone National Park, or the Great American Wonderland.*

An incomplete set of Calfee's stereopticon photos survives at the Montana Historical Society. Likewise, the Yellowstone Park historic photo collection and several private collections all contain a number of Calfee stereopticon views. From these it is apparent that the series reached as high as number 275 and was called "The Enchanted Land, or Wonders of the Yellowstone National Park by H. B. Calfee." Calfee's stereo views indicate that he was probably even responsible for several park place-names, among them *Demon's Cave, Fairies' Fall, Pulpit Basins,* and *Roman Sentinel,* as he searched for captions for his photos.[24] Surely names like those represent interpretation (storytelling) at its finest!

The park's geysers fascinated Calfee, apparently more for their photographic potential than because he was a budding "geyser gazer." He went so far as to set up his traveling studio in the Upper Basin and there to sell his

photos directly to travelers (one of his photos shows this "store" with Calfee's signs proclaiming "Views of the Wonderland" for sale). And Calfee began predicting the eruption times of some geysers, a storytelling or interpretive activity itself, probably to help sell his photos. He did this particularly at Giant Geyser, for traveler Wilbur Sanders ran into him there in 1881 and posed with his party for one of Calfee's photos. Said Sanders, "Calfee expected the Giant to spout today and nearly everybody in the Basin was lounging around it 'from early morn to dewy eve,' awaiting its action."[25]

Much less is known of Calfee's partner Nelse (or Nelson?) Catlin. At least ten of his stereopticon photos are in the Bob Berry private collection at Cody, Wyoming. These bore the notation "Calfee and Catlin" on them and were part of the series known as "Views of the Wonderland or Yellowstone Park." The numbers in this series reached at least to 148. Like those of Calfee and Crissman individually, Catlin stereopticons now represent treasures of early Yellowstone days. Whether Catlin produced any views bearing his own name alone is not known, but Calfee's photo "226 Tourist Camp Near Castle Geyser" probably featured Catlin in the photo.[26]

E. O. Beaman's Yellowstone photos are something of a mystery. Originally a New York landscape photographer who became an official USGS photographer in 1871, Beaman was on his own by 1872. In early 1874, he exhibited in the East "by means of a powerful oxy-hydrogen stereopticon, views taken by himself... of the great Yellow-Stone Basin." Beaman's trip to the park probably occurred in 1873, and perhaps he even ran into William Isaac Marshall in the park that summer. He was photographer for the John Wesley Powell U.S. Geological Survey and made a number of views of the 1876 Centennial Exposition of Philadelphia.[27] Where Beaman's Yellowstone photos are today is a mystery.

Another mystery surrounds the Yellowstone photos of A. Pollock of Deadwood, South Dakota. Collector Bob Berry of Cody, Wyoming, possesses a Pollock catalog that lists twenty-six park views on it, but he has never seen any of the views. Pollock is known in South Dakota circles to have partnered with several other photographers during the period 1877–1892, but his Yellowstone photos remain unknown.

William Isaac Marshall (1840–1906) was a fascinating character, and the photos he sold and otherwise distributed in the 1870s have a lot to say about early Yellowstone Park. Although he was technically not a photographer, he is included here because he purchased the large Yellowstone and Montana photo collection of Joshua Crissman[28] and sold those pictures under his own

copyright notice. By his own admission he arrived in Montana Territory in July, 1866, and resided at Virginia City through October, 1875.[29] He joined the stampede to that town for gold, and the Hayden survey party met him there in 1871 while he was working a mining claim.[30]

Marshall stated that he visited Yellowstone with his family in 1873 and 1875, bragging that he took the first children ever—two of his own and one other of a co-traveler—through the park. He sold Crissman stereo views of Yellowstone beginning in 1876. These views, which were titled simply "The National Park," reached at least to number 122 in his series, with possibly two more if his #97 truly exists and if his #13 consists of two different images. Marshall advertised and sold these views to teachers, clergymen, and others at his lectures on Yellowstone and by mail and promoted them in articles he wrote about the park for *National Education Association Proceedings*, *The New West Illustrated* newspaper, G .P. Brockett's book *Our Western Empire* (1881), and the three broadside sheets cited herein.

In 1879, Marshall proposed to begin conducting commercial tours of Yellowstone, and he did bring at least one such group into the park. Another traveler, H. B. Leckler, met them in 1881:

> The other party we met at Dillon was a party of tourists, composed of one lady and six gentlemen, under the charge of Mr. William I. Marshall, of Fitchburg, Mass., a gentleman who delivers lectures upon the Park during the Winter throughout the Eastern States, and nearly always passes his Summers in the Park. This was the first season he undertook to bring a party with him; and, although managing it satisfactorily to the tourists, he had the pleasure of their company only to recompense him for his trouble, as he found the cost greater than he charged. Next season, I believe he proposes to charge four hundred dollars, which will be twenty-five per cent below the cost of the journey if undertaken at regular rates. We found Mr. Marshall a perfect gentleman in every way; highly educated, a fluent talker and most obliging. He gave us all the information he had about the route we propose taking, and treated us as kindly as though we were members of his [own] party. We afterwards heard that most of the tourists he conducted were pleased with the trip and the arrangements made for their accommodations throughout.[31]

It appears that Marshall planned to take a number of tour groups to Yellowstone. However, best evidence is that he made only four trips to the park: in 1873, 1875, 1881, and 1882. A letter discovered recently in the Fitchburg County (Massachusetts) Historical Society from Marshall's wife gives a good biography of him and states that in both 1881 and 1882, Marshall took tourists to Yellowstone.[32]

From descriptions of Marshall, it is apparent that he was an excellent speaker. He sold his stereos for three dollars per dozen and his eight-by-ten photos for seventy-five cents each, and he bragged that they had received awards at the 1876 Centennial Exposition. In 1877, he boasted that his (really Crissman's) photos were "the only *first-class* views of these wonders which have ever been made."[33] That boast apparently ignored the images of Jackson, Hine, Calfee, Catlin, and Thrasher, for surely Marshall knew of most or all of those men who had photographed in Yellowstone.

Marshall, important here not only for the Crissman photos he sold but also as one of Yellowstone's earliest tour guides, was later an educator in the East, and like so many of his day he was referred to as "Professor." According to the National Union Catalogue, he published several books on Oregon and educational subjects. After 1875, he moved back to Fitchburg, Massachusetts, for his stereo views had the name of that place stamped on them with the copyright date of 1876, and his published articles gave that place as his resi-dence. In 1887, he moved to Chicago where he became principal of the Gladstone School. He apparently remained interested in Yellowstone for the rest of his life, because as late as 1902, he visited the park and obtained a per-mit to collect geological specimens.[34] He sent a book manuscript in 1904 to park superintendent John Pitcher for comments, and that book was subse-quently published. As will be seen in the chapter on lecturers, Marshall gave more than two hundred lectures during his career to various educational associations on Yellowstone, Yosemite, and mining.[35]

John H. Fouch was another little-known 1870s Yellowstone photogra-pher. Mentioned by park superintendent P. W. Norris as one of the photog-raphers who visited the park in 1878, he traveled with Norris to the Custer battlefield in 1877, where he took the earliest views of that renowned place.[36] Some of Fouch's photos of Montana Territory are known, but few of his Yellowstone images seem to have survived.

Fouch is known to have made at least sixteen Yellowstone Park images, of which only three have been found extant. These are a part of the set he issued of sixty-three photos entitled "Stereoscopic Views of the Yellowstone

Country," apparently taken in 1876–1878. Fouch appears to have reissued these photos in 1879 from Minnesota under the title "Artistic Views of the Yellowstone Country and Yellowstone National Park, Series of 1876, 1877, and 1878." Most of these photos are of Montana Territory, and whether any of them exist except for the few published by Dr. James Brust is not known. Fouch's catalogue shows that his photo numbers 48 to 63 were of Yellowstone Park. One of his extant stereo views is labeled "Series of 1879, 1880, 1881, and 1882," making researchers wonder whether he visited the park in other years and took more photos than those known (more likely those photos were merely reissuings of his earlier ones). At any rate, some if not all of his park photos date from the summer of 1878.[37]

A. F. Thrasher was another obscure 1870s Yellowstone photographer. None of Thrasher's Yellowstone photos is known to have survived, but some of his writings on the park have. Thrasher was in Deer Lodge, in southwestern Montana, in 1867–1869, and by 1870 he was living at Bannack as a "daguerrian artist." Sometime during 1870–1871, he located at Lewiston, Idaho, and issued stereo views of Idaho. In late 1871, he was a partner with William Hyde at Deer Lodge, and in that year he went to Yellowstone.

Thrasher accompanied the Raymond-Clawson party into Yellowstone in 1871, and, according to R. W. Raymond, brought a huge load of photographic supplies with him. C. C. Clawson called him "A. F. Thrasher, photographer, and Prof. of the Fine Arts generally." Raymond gushed, in a long description of him, that "he invests the profession of photography with all the romance of adventure" and described how Thrasher would go anywhere to secure a photo. At one point, said Raymond, the park so enthralled Thrasher that the party was forced to abandon him:

I may mention here, that, after we had been several weeks in the mountains, Mr. Thrasher became entirely unmanageable. He had so many views to take that there was no hope of getting him back to civilization until his chemicals were used up—and he had provided a desperately large stock. So on the cañon of the Yellowstone we left him.[38]

Thrasher was apparently successful in taking wonderful, early pictures of Yellowstone, for a Virginia City newspaper proclaimed in October that he had returned to that town bearing around one hundred views of the region. He has "succeeded in what had been pronounced an impossibility by the

Eastern Photographers," crowed the editor, "[by] taking photographic views of all the great Geysers *in action* [emphasis added]." If those geyser photos exist today, no researcher or historian has seen them.[39]

That newspaper editor also reported that Thrasher planned to give an exhibition of the photos "on Saturday next," but the showing was postponed. Thrasher then planned a later showing for November 2 at the Stonewall Hall, said the editor, who opined that he had seen several of Thrasher's projected views "exhibited by the aid of the powerful light which he uses."[40]

Whether Thrasher ever exhibited his Yellowstone pictures to Virginia City residents is not known, but he appears to have tried to make money with them before vanishing utterly from historical records. "We understand that Mr. A. F. Thrasher has sold an interest in his views of the Yellowstone," declared the newspaper in January, "and with his partner has left for Philadelphia where it is the intention to have the views transferred to canvass before exhibiting their wonders to the pilgrims of the Eastern States." The newspaper thought Thrasher's images striking, for it predicted that "A. F. will make a success of his Panorama—[we] hope so at any rate."[41] Thrasher reached Wabash, Indiana, with his photographs for he advertised them in newspapers there.[42]

A Missoula historian, Mary Horstman, has been searching for many years for any of Thrasher's Yellowstone photos without success. Thrasher left Deer Lodge in 1872 apparently for Philadelphia, reportedly died in the mid-1870s, and all in all remains a mystery. Like Hine, Crissman, and Calfee, Thrasher as a Yellowstone photographer took pictures as early, or nearly so, as William Henry Jackson. So where are his Yellowstone photographs today?[43]

Two other 1870s Yellowstone photographers who are today little known were Edgar H. Train (1831–1899) and Oliver C. Bundy (1827–1891) of Helena, Montana. The Yellowstone Park historical photo collection contains at least seventy-four of their stereo viewcards. The total produced is unknown. Nor is anything known of Train or Bundy's association with Yellowstone, although research reveals something of the men themselves. Originally from California, Train arrived in Idaho in 1864 and moved to Helena in 1866, where he bought out the photo shop of a man named Douglass. Bundy, Train's brother-in-law, moved to Montana Territory in 1866, and in 1872, he opened a photo gallery in Virginia City. Bundy went into partnership with E. H. Train in Helena in 1876, and bought Train completely out that same year. Some of their photo cards carried the logo "Bundy and Train."[44] Like C. D. Kirkland and W. I. Marshall, Bundy and Train seem to have republished many of the Yellowstone images of Joshua Crissman.

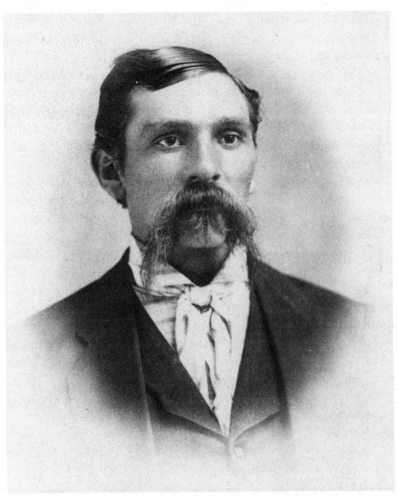

4. *Joshua Crissman (1833–1922), in a portrait probably produced in 1868 or 1869 while he had a temporary shop set up in "Laramie City," Wyoming Territory. He photographed the park during the summers of 1871–1874, and his photos beat those of William Henry Jackson to publication and thus were the first Yellowstone photos ever seen by the public. Courtesy Dr. James Brust, San Pedro, California.*

At least two dozen of the Yellowstone photos of Charles Roscoe Savage (1832–1909) are extant in his series "Views of the Great West." Savage, an Englishman who became a Mormon photographer from Salt Lake City, visited Yellowstone in 1875 and 1884. His photographs from those two years are in the Mormon Church collections and at the Utah Historical Society, both in Salt Lake City. Savage was reputable in Utah in his day, but his Yellowstone photos are little known. His biographer knows little about the Yellowstone trips, but Savage did produce a newspaper article about his 1884 trip through the park.[45]

L. A. Huffman (1854–1931) is today better known than any of these other photographers, but he worked in the park a bit later. He apprenticed under Frank J. Haynes at Moorhead, Minnesota, and then went to Fort Keogh, Montana, in 1879. After setting up a studio in Miles City, Montana, Huffman traveled to Yellowstone. He seems to have made photos of Yellowstone Park only in 1882, but he apparently reproduced thousands as stereopticon views. A page from his 1883 catalogue listed fifty-eight captioned photos taken in Yellowstone National Park. Some of those views are now held by the Montana Historical Society, but many appear either to no longer exist or else to be in the hands of only collectors, a great tragedy, for among those photos were some unusual shots, including one of the rare Excelsior Geyser in eruption.[46]

Huffman seems to have had a grand time in Yellowstone if the letters he wrote to his father are any indication. He called his fifty-six days in the park "among the best of all my wanderings" and rhapsodized about them:

> To repeat what has so oft been said of the "wonderland" or to try
> to expatiate on what one can see there is folly. I had the honor to
> meet John McCullough and "punished several hours" with him
> and others.... I made a raft of logs and taking the faithful
> Kennedy and my new 76 outfit on board after a long hard pull—
> or pole ... crossed the Yellowstone above the falls—[and] went
> down on foot 6 miles and back securing views that no other
> feller got.[47]

While few of Huffman's Yellowstone photos seem to have survived, he apparently produced a fair number. An article in the *Yellowstone Journal* of Miles City, Montana, for January 6, 1883, declared: "L. A. Huffman, the photographer, will have ready for the spring trade fifty thousand views of

the Yellowstone National Park and Indian camps. As an artist Mr. Huffman is chief in the business." A recent biographer of Huffman quoted a letter from him to his father stating that he had "finished and shipped nearly 6000 park views."[48] By 1883, he had a reported eighty-three thousand prints in his inventory.[49] Whether six thousand, fifty thousand, or eighty-three thousand, these numbers are certainly "food for thought" for those researchers looking for old Yellowstone photographs. Assuming Huffman was able to produce between six thousand and eighty-three thousand images, this could be a statement about the potential "reach" that some of these early photographers—or at least that he—had. Currently there is no information available on the numbers of images that were reproduced by any of these early Yellowstone photographers except Huffman. And, like those of Thrasher, Beaman, and Fouch, it is not known where most of Huffman's Yellowstone photos are today.

Thomas H. Rutter and his partner for a time, James Nesbitt, are known to Montana historians as photographers living at Butte, Glendale, and Deer Lodge, Montana, but their Yellowstone views are less well known. Rutter's outsized stereo views state on them that he was "established 1870" but where is not known. By 1879, he was located at Deer Lodge, and he visited Yellowstone Park that year. Some if not all of his Yellowstone photos probably date from 1879. The Montana Historical Society possesses ten of his stereo cards, ten others exist in the private collection of the late Ed Knight of Jackson, Wyoming, and about ten others are in the University of Washington special collections. His number 77, "Grand Canyon of the Yellowstone," has his catalog on its reverse, but a number of Bob Berry's Rutter images are not in the catalog. Thus, the number of Rutter picture series is not known, but if the numbering on his stereo cards is to be believed, he marketed at least 113 views.[50]

There were numerous other companies and photographers who sold commercial views of Yellowstone National Park after 1883, among them T. W. Ingersoll, Webster and Albee, Underwood and Underwood, the Keystone Company, Charles Bierstadt (brother of artist Albert Bierstadt), Lovejoy and Foster (who reissued Joshua Crissman's images), W. E. Hook, Griffith and Griffith, B. W. Kilburn, B. F. Hoyt, C. D. Kirkland, O. S. Compton, H. C. White, Gamble and Stafford, and of course the most famous and prolific, F. J. Haynes, whose earliest views of Yellowstone date from 1881. So many of these Yellowstone stereo photographers have begun surfacing in the past ten years that the number is now very high, and experts Paul Rubinstein and Bob Berry have so far cataloged 127 different companies that produced Yellowstone

stereo views.[51] These photographers have not been studied, and historians do not yet know how customers interpreted their images or how many images they produced.

And of course there were hundreds of amateur photographers who "shot" Yellowstone after the 1870s. One of these, Joseph Paxton Iddings, was also a geologist with the U.S. Geological Survey. Many of his Yellowstone photos were pasted into his handwritten notebooks and reposited in the National Archives.[52]

One illustrator of a different type deserves special mention. He was Thomas Moran, a landscape artist about whom much has been written. Moran accompanied Dr. Hayden's 1871 survey to Yellowstone, and his watercolors, oil paintings, and inked woodcuts recorded and promoted the new national park. "The pictures of Moran have made us impatient to see the wonders of the Yellowstone," exclaimed an 1883 visitor. At least two biographies of Moran exist as well as at least five books on his art, numerous articles about him, and of course his many illustrations. Certainly his paintings told stories about the new park. Along with Jackson's photos, Moran's illustrations gave the American people their earliest look at Yellowstone, "that savage place which seemed, although it was then so much in the news, as mythical as the measureless caverns of Alph, the sacred river."[53]

All of these early image makers promoted Yellowstone National Park at a time when it was just beginning to become known to the world; they stimulated interest in it, froze the raw materials of the landscape in time, and helped begin the long interpretation of it. And they must have materially influenced the way American and European peoples viewed and perceived the new region as a geographic entity. Because they sold their pictures commercially, often in stereoscopic form, to an American public eager for news of the West, their influences on early Yellowstone interpretation were probably greater than those of noncommercial photographers who came later. And, too, the images of all of these men took on a cultural significance, because their images of Yellowstone fit in well with the public's romantic visual expectations.[54]

Measuring the contributions of all of these men to the field of photography, or even in popularizing Yellowstone, is difficult because the surviving remnants of their work are few and scattered. But in the towns where they ran their photo shops, they must have helped spread the word about Yellowstone and helped create a mythic sense of it in the publications of the day. What may be the most remarkable thing about these photographers is how

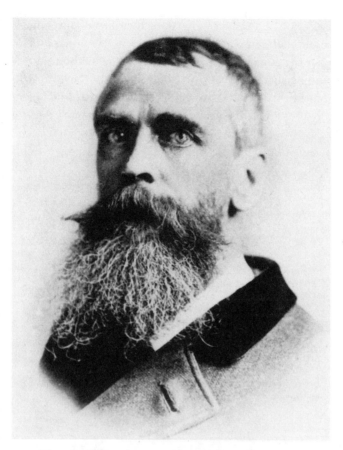

5. *Thomas Moran (1837–1926), a celebrated landscape
painter, whose watercolors, woodcut drawings, and
paintings helped reveal the Yellowstone country to
America. Courtesy YNP Photo Archives,* YELL *36660.*

quickly they were forgotten when one considers how many of them were
photographing Yellowstone during the 1870s.

For now it is enough just to know that their photographs exist as
renewed history, and to enjoy those images as imprints of time travel: for sto-
rytelling, pleasant diversion, cultural reflection, landscape fascination, philo-
sophical musing, and to consider the transitory nature of all things, all
people, and ourselves. For everyone can understand a picture. Or at least
they think they can.

Even as the early photographers were taking their first pictures of the new national park, another element in the mix that started interpretation in .national parks was rearing its head. It was, of course, the methodical discourse intended for instruction, more commonly known as the lecture. It, too, was centered in storytelling and was a horse-and-buggy tour guide of sorts. It would soon utilize those early photographs and illustrations that the image-makers of the 1870s had created and were creating. And most important, these lecturers would soon add sound to the captivating pictures of Yellowstone.

CHAPTER FOUR

Lectures and Lecturers

Langford and Later Men Marry Sound and Pictures

*At the close of this lecture, it is not improbable that I
shall be declared the most absurd enthusiast, of all men
who ever attempted to tell the truth.*

—Nathaniel Langford

*P*romotion, verbal and otherwise, is a form of interpretation and also a
form of storytelling. Nathaniel P. Langford of the 1870 Washburn party,
the party which has been credited with the essential discovery of Yellow-
stone, was one of the great initial promoters of the Yellowstone country and
one of the earliest of Yellowstone's horse-and-buggy tour guides. Upon
returning from that journey of discovery, he wrote a lecture about the
Yellowstone country for delivery to eastern audiences. In standard interpre-
tive fashion, Langford opened his lecture with sentences intended to capture
his listeners' attention: "Nature seemingly delights in surrounding her
grandeur and magnificence with difficulty and danger. . . . I appear before
you this evening, to tell you of wonders that I have seen, the reality of which
it will task your credulity to believe. . . . [A]t the close of this lecture, it is not
improbable that I shall be declared the most absurd enthusiast, of all men
who ever attempted to tell the truth."

Langford went on to mention the earlier fur trappers' and prospectors'
tales of the Yellowstone area, saying "but as they were all believed to be
romancers, their stories were received with great distrust." After many min-
utes of description of the country and his party's toils through it, he ended

his speech with "we were convinced that there was not on the globe, another region where within the same limits Nature had crowded so much of grandeur and majesty with so much of novelty and wonder."[1]

Langford's manuscript, housed in the Yellowstone Research Library and certainly one of America's most important national park documents, consists of 185 handwritten pages. He delivered it on November 18, 1870, to an appreciative crowd at Helena, Montana. He delivered it a second time four days later at Virginia City, and then left for the East Coast where, on January 19, 1871, he read the entire text of the speech at Washington's Lincoln Hall. New York City's Cooper Institute was the site of one if not two more Langford lectures on January 21–22, and he also spoke in Philadelphia and Minneapolis.[2]

These talks by Langford were the first "evening programs" ever given on the Yellowstone country, and as such are noteworthy in the history of national park interpretation. But Yellowstone was not yet a national park, so Langford's lectures were not the first lectures given in or for a national park. Nor were these interpretive programs the first of their kind in a natural area; for example, James Mason Hutchings, a hotel owner in Yosemite, gave "interpretive walks" and horseback rides there beginning in 1855.[3]

The last sentence in Langford's lecture promoted the Northern Pacific Railroad as the vehicle by which the Yellowstone wonders would eventually become reachable. Indeed, correspondence in the Jay Cooke papers indicates that Jay Cooke prevailed upon Langford, whose brother-in-law was a Northern Pacific official, to begin giving official promotional lectures for the benefit of the railroad. Thus Langford wrote a second lecture, this one on the attractions of Montana Territory, and presented it in Philadelphia in May 1871. Nearly simultaneously, his now-famous magazine article, "Wonders of the Yellowstone," appeared in *Scribner's Monthly* magazine.[4]

These interpretive lectures and the magazine articles by Langford were promotional, both for the sake of encouraging future visitors to travel to Yellowstone and indirectly for the idea of preserving it in some way. They may have inspired Dr. Ferdinand V. Hayden to direct the investigative efforts of his 1871 survey toward the Yellowstone region, which would play a large role in the creation of the national park.[5]

There were other people lecturing about Yellowstone during the 1870s and 1880s, and all of them played a role in the evolution of storytelling, interpretation, and education in the national park. Some lecturers, as might be expected, were also photographers who used their own photos to illustrate

their presentations. If photographers W. H. Jackson or L. A. Huffman gave any such lectures during those early days, there are no records. E. O. Beaman gave at least one lecture, and we certainly have to wonder whether or not photographers Crissman, Catlin, Thrasher, Fouch, Savage, Rutter, or Train gave any such lectures on the Yellowstone country; they, after all, had the photos and the travel experience with which to do it. William I. Marshall and Henry Bird Calfee *did* present such early talks, as did park superintendent P. W. Norris and park interpreter G. L. Henderson. Likewise, so did Montana traveler C. C. Clawson, entrepreneur Harry Horr, and journalist Robert Adams Jr. After them would come the Yellowstone lectures of F. J. Haynes, David Curry, John L. Stoddard, E. Burton Holmes, W. N. Jennings, and probably many more no longer known.

Robert Adams Jr. is little known in Yellowstone history. A member of the 1871–1875 Hayden surveys, Adams was also a newspaper correspondent and lecturer. He delivered at least one public lecture on the new Yellowstone National Park at Philadelphia's Academy of Music for the Ladies' Centennial Executive Committee on April 2, 1874. The lecture, illustrated with stereopticon photographs probably taken by W. H. Jackson, was well attended and a newspaper described it as "vivid and entertaining." It was certainly one of the earliest attempts to marry sound and pictures into a Yellowstone interpretive talk. But nothing else about this speech or others by Robert Adams is known.[6]

William I. Marshall, discussed earlier as a seller of Yellowstone photos, was also a prolific lecturer. If more were known about him, historians could probably elevate him to the interpretive status of P. W. Norris and G. L. Henderson, men soon to be discussed. His trips to Yellowstone in 1873 and 1875 from his residence at Virginia City, Montana, stimulated him to purchase the photos of Joshua Crissman and use them to illustrate his lectures. Although family genealogies are often suspect because of their tendency toward boosterism, Marshall's family seemed to get it right when it stated that "to him belongs the credit and distinction of being the original lecturer with illustrations on American subjects"—or at least on Yellowstone.[7]

Beginning in the winter of 1876–1877, he lectured on Yellowstone in Boston, Massachusetts—his home state—and other places, and from a fellow traveler's comment ("nearly always passes his summers in the Park"), it appears that he at least intended to make many more trips to Yellowstone than the four that are known.[8] For example, in an 1879 article intended to promote both his lectures and his proposed Yellowstone tourist business, Marshall wrote:

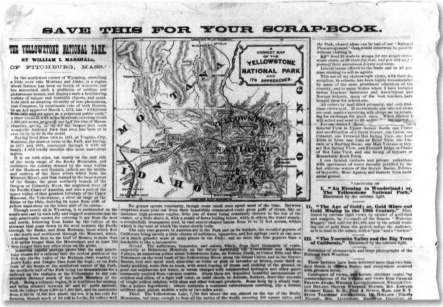

6. *Broadside sheet published by William I. Marshall, 1879, to illustrate his lectures on Yellowstone and the park photographs he sold. YNP Library.*

At the solicitation of many ladies and gentlemen who have heard my lecture, I purpose [*sic*—propose], beginning with [the summer of] 1880, to yearly organize excursion parties to the Park, providing guides, camp equipage, etc., and arranging for all the expenses of the trip. Names of excursionists [will be] registered in the order received. At least one party each year will be under my personal charge.[9]

Apparently his plans to visit the park in 1880 fell through when the necessary tour party failed to materialize, for his wife's account of his life says that he took tourists to Yellowstone only in 1881 and 1882.

Marshall also peddled his photographs and his lectures on Yellowstone in published broadsides, those nineteenth-century handbills that promoted anything and everything:

This account of the Park will be sent to any address on application enclosing a stamp, and to all teachers desiring

it for the use of their schools it will be sent postpaid at the
following rates [he lists them].... I will make a special
reduction of 33½ per cent to all teachers and clergymen, as
well as to all persons attending my lectures, on the catalogue
prices of my stereoscopic and other photographs of the geyser
craters, geyser eruptions, mud volcanoes, hot springs, cañons,
cataracts, lakes, cascades, and other wonders of the Park.[10]

Marshall's primary lecture on Yellowstone National Park was entitled
"An Evening in Wonderland." He also presented two other lectures, one on
the Yosemite country entitled "The Yosemite Valley and the Big Trees of Cali-
fornia," and another on mining entitled "The Age of Gold, or Gold Mines
and Gold Mining in the Nineteenth Century." "These lectures," wrote
Marshall, "have been delivered more than two hundred times, in sixteen
states, and everywhere received with greatest favor."[11] To bolster that claim,
Marshall's commercial catalogues and lecture circulars included commenda-
tions on his speaking ability from such nineteenth century figures as Charles
Francis Adams, Oliver Wendell Holmes, William Cullen Bryant, Henry Ward
Beecher, and numerous college presidents.

Marshall presented his lectures by means of the earliest, lantern-slide
projection techniques, and he described them as follows:

Many of my views, including several moonlight scenes, are
finely colored, and all are photographs of the very finest quality,
taken not from drawings or engravings, but from nature. These
are projected upon a large screen by the calcium light, which
is produced by burning oxygen and hydrogen gases against a
cylinder of lime, and is the most brilliant light available for
illustration that is known to science.... Correspondence [is]
solicited from all parties interested in lecture courses or in
arranging for independent lectures, which are, from the
brilliancy, variety, and beauty of their illustrations, as
entertaining as they are instructive, and which have delighted
the most miscellaneous audiences in the cities East and West
as well as the most cultivated and critical in club-rooms,
parlors, and literary and scientific societies.[12]

Of Marshall's refined speaking ability, there can be little doubt. What

the Williams' Lecture Bureau pamphlet said of him, as he lectured before the Emperor of Brazil, makes it clear that Marshall was one of the earliest accomplished lecturers, and thus interpreters, of Yellowstone:

> Seventeen years' experience as a teacher, most of the time as the principal of large city schools, makes Professor Marshall perfectly at home on the platform, and with a pleasant voice, a very clear enunciation, and a fluent delivery, he always holds the undivided attention of his audiences to the close. He has travelled very extensively in the Rocky Mountains,—has lived for more than nine years at the nearest town to the Park [Virginia City],—knows the whole story of its discovery and exploration,—has, with his family, spent fifty-seven days on horseback in making two trips through it, camping among its wonders and witnessing more than 100 eruptions of great geysers, and can therefore describe from careful personal observation, the unequalled wonders and beauties of a region in which all of us should take a patriotic pride.[13]

Marshall appears to have brought tour groups to Yellowstone only in 1881 and 1882, but he continued giving lectures on the park for many years. He presented one Yellowstone lecture to patrons of the Bucklen Opera House at Elkhart, Indiana, as late as January of 1886. He probably used his traveling to Yellowstone as a platform to present his lectures in towns along his route, and he maintained his interest in the national park until his death in 1906.[14]

Certainly from his contributions in photography, park tour guiding, lecturing, and writing, from his knowledge of Yellowstone's geography, geology, history, fauna, and flora (which by 1880 rivaled P. W. Norris's[15]), from his formal education in geology and history, and from his proven abilities as a communicator and teacher, William I. Marshall deserves a high place in the history of national park storytelling and interpretation. Until now he has been unknown, probably because he did most of these things before 1882 at a time when Yellowstone was only beginning and when other national parks did not yet exist.[16]

Montana traveler C. C. Clawson seems to have given lectures on Yellowstone National Park as early as W. I. Marshall did. Clawson traveled into the park region in 1871 with photographer A. F. Thrasher and may have

used Thrasher's photographs in his parlor lectures. Little is known about these lectures other than what appeared in this advertisement in Harry Norton's 1873 guidebook:

> C. C. Clawson, Deer Lodge, Montana, will lecture in the States during the winter. Subjects: *The Enchanted Lands*, the Regions of the Big Horn and Yellowstone. 2d. The Fire Hole, the Land of Geysers . . . The author has an experience of 16 years in the mountains and 'knows whereof he speaks.' Address, during the winter, Council Bluffs, Iowa, Box 219.[17]

Although information at the Idaho Historical Society makes it clear that Clawson's first name was Calvin, a number of references mention him as "Calcium C. Clawson," and one has to wonder whether the nickname "Calcium" was in any way related to his giving Yellowstone lectures under the calcium light.

After Clawson and Marshall appeared Harry Horr, Henry Bird Calfee, and William Wallace Wylie. Little is known of Harry Horr's speeches other than that the local newspaper saw him as a fine speaker. With James McCartney, Horr claimed Mammoth Hot Springs in 1871, but the government forced him out of the park and he moved north to establish Horr, Montana. A Bozeman editor stated that the "genial, laughter-provoking Horr, who is chuck full of wit, wisdom and 'joakes,' will entertain the public with one of his humorous lectures."[18]

As for Calfee, after his photographic excursions to the park in the 1870s, "he" began to "lecture" on Yellowstone.[19] In April of 1881, he presented his "Yellowstone Panorama" in Bozeman, Montana, using his Oxy-Hydrogen Camera. "Season after season," proclaimed the Bozeman *Avant Courier*, "he has visited, photographed, and studied" the Yellowstone National Park. "All the wonders of the park," bragged the newspaper, "will be thrown upon the canvass in views over 30 feet square." Although the views were ultimately only fifteen feet in size, Calfee projected his pictures to packed crowds on April 22 and 23, accompanied by Professor W. H. Parker who did the actual lecturing.[20]

In Virginia City only a few curious patrons attended Calfee's "Panorama," but in Helena things went better. His large pictures "were so fine that frequent bursts of applause greeted them from the delighted spectators. . . . The remarks of Prof. Parker on each view fully explained the various interesting features, and it seemed, listening to him and gazing at the pictures,

almost as tho' one were making the Wonderland tour in the company of an accomplished guide."[21]

In the fall of 1881, Calfee teamed up with W. W. Wylie, a Bozeman educator, on a lecture tour that one historian has called "unsuccessful." That summer, Calfee and Wylie spent much of the summer in the Upper Geyser Basin and at the Canyon preparing for the lecture circuit by taking pictures. Wylie said:

> These pictures were all taken by the old wet plate process; our chemicals for this work were carried in glass, on pack horse from Bozeman. . . . We were doing this work for the purpose of making slides for stereopticon illustration of the wonders of the Yellowstone. . . . [T]his was tedious work, having to use a dark tent, sensitizing the plate before each and every exposure. . . . My notes show that we had [the] camera set on the Splendid geyser for thirteen days before a satisfactory exposure was obtained; altho[ugh] the geyser then operated every other day and often 12 or more times on that day.[22]

In the fall of 1881, Wylie and Calfee began their lectures. Like others, they used the oxy-hydrogen calcium light to project the pictures onto a screen, making their own oxygen and hydrogen at each location. They exhibited in several surrounding states, including Minnesota—where their audience was mainly Northern Pacific Railroad officials—and Dakota Territory. At Miles City, Montana, the two men "found two enthusiasts who wanted to buy our outfit." According to Wylie, they sold it, and this ended their lecturing.

But twelve years later, Wylie, upon his serious venturing into the semipermanent tent camp business in Yellowstone, decided to try lecturing on the park one more time in order to promote that business. He obtained a set of F. J. Haynes's colored slides, rented a stereopticon lantern from a Chicago company, and sought out Henry Bird Calfee to operate the equipment. The two men lectured on Yellowstone in Chicago, and business was so good that a private company handled their appointments. The following year Wylie's in-park business was so successful that he no longer saw the need to promote via lecture.[23]

Another very early Yellowstone lecturer, a "former teacher turned academic showman," was "Professor" Stephen J. Sedgwick of Newtown, New York. Sedgwick was a photographer for the Union Pacific Railroad during

the 1870s who also gave lectures on various western subjects. He published two now-rare pamphlets on the Wonderland venture in 1874 and 1879–1880. An assistant to UPRR photographer Andrew J. Russell in the 1860s, Sedgwick settled in Utah where he became a friend to well known Utah photographer Charles Savage. He was "an educator, an entertainer, and a shameless promoter," says historian Martha Sandweiss, "who would keep his audience on 'double quick' with a presentation lasting an hour and a half to two hours."[24]

Sedgwick probably began lecturing on Yellowstone in 1874, and he continued it for at least six years. While his 1874 "Catalogue of Stereoscopic Views of Scenery" did not list any specific Yellowstone photographs, it did list "Yellowstone Park" as the subject of two of his lectures. Additionally, it opined that each lecture was "illustrated by one hundred to one hundred and twenty-five pictures." Where and when Sedgwick got the Yellowstone photos is not known, but because he is known to have purchased the negatives of Andrew Russell, perhaps he used those for his lantern slides.[25]

By 1879, Sedgwick was not only advertising his "Lecture Seven" as "Yellowstone Park and Geyser Region," but also listing twenty-seven Yellowstone stereo views. His illustrated lectures appear to have utilized state-of-the-art projection equipment and to have elicited excitement. "To see the splendid instrument used in these entertainments," wrote one patron, "is worth the price of admission." Another concluded: "This is no mere magic lantern show, but in all respects a first-class artistic entertainment." Sedgwick was both a lecturer and a photographer who probably reached thousands of people with his Yellowstone talks over at least six years.[26]

Much has been written about Frank J. Haynes's contributions to photography, transportation operations, writing, and tour guiding in Yellowstone National Park. By extension, Haynes also made these contributions to national park interpretation. It is not necessary to repeat them here except to note that Haynes was a lecturer as well. No doubt he lectured often on Yellowstone and western subjects, for he had his own illustrative photographs at hand. He gave at least one Yellowstone lecture in March of 1888 in Detroit, Michigan, as an advertising poster for it survives.[27] And a Raymond and Whitcomb traveler attested to the fact that Haynes was presenting evening lectures that summer at Mammoth Hot Springs Hotel in the park:

> In the farther end of the hotel is a sort of reading room,
> used also for lectures. The lecturer was F. Jay Haynes, the
> National Park photographer. . . . James Paris was the optician,

who illustrated the lecture by stereopticon slides. Most of
the Raymond party attend[ed] the lecture, and before their
eyes, had the marvels which they had for days been viewing,
reproduced on canvas. They were quite familiar and better
appreciated [by us] than on our outward trip when we
listened to the same lecture and saw the same views.[28]

By 1895, lecturers, armed with lanternslides, were in action nationwide
touting the wonders of Yellowstone Park.[29] A railroad brochure from that
year stated that "lecturers spend much time and money to familiarize them-
selves with it [the park] so that they can recount to their audiences the won-
derful things to be seen there."[30] One of these lecturers was W. B. Hanscom
of Minneapolis. A newspaper explained in 1896 that he was "a lecturer on the
subject of Alaska and the Yellowstone Park" and that he was "well known to
the people all along the railroads of the west."[31]

That may have been stretching it, but two genuinely well known rail-
road lecturers were John L. Stoddard and E. Burton Holmes. These men were
nationally known travelers and lecturers who published their talks in books
consisting of many volumes of photos and text. Both visited Yellowstone in
1896. Stoddard's lecture or account of the park was published in *John L.
Stoddard's Lectures*, vol. 10, while Holmes's appeared in *Burton Holmes
Lectures*, vol. 6.

A newspaper clipping of the day referred to Stoddard as "the most
noted lecturer in America today." That editor described him as someone
"who for the greater part of his life . . . has traveled over the civilized portions
of the globe and . . . brought them back to this country through picture and
story." Certainly Stoddard was renowned as a speaker in his day, and a
Minneapolis newspaper noted:

When a man like John L. Stoddard tours a place and
makes careful notes, his act means more than the visits of
ordinary tourists, for he has the ability, out of his notes to
prepare a series of fascinating picture stories on which
to hang the wonders of the Yellowstone, like so many gems
of a fine gold string. He will be in Minneapolis in April, and
added to those who will remember him from his last visit
12 years ago, there will be those who have explored for
themselves among the geysers and springs of the

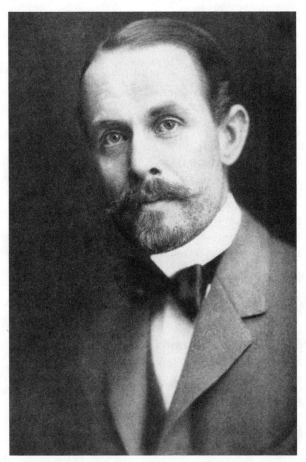

7. *E. Burton Holmes, a lecturer and world traveler, who visited Yellowstone Park in 1896. From* Burton Holmes' Lectures *(1906).*

> Yellowstone... which can not cease to excite wonder
> and awe so long as they flow.[32]

A surviving lecture brochure includes a photo of Stoddard and states: "John L. Stoddard always faces an audience in evening dress. The audience should do likewise." Chicago's elite Tosetti Restaurant was the site of five nights of Stoddard lectures on Yellowstone Park in November 1896.[33]

Like Stoddard, E. Burton Holmes was a nationally known lecturer. After discussing Stoddard, the above newspaper editor effervesced about Holmes:

> Then there is E. Burton Holmes, that other young lecturer who only returned a few days ago from his sojourn among the beauties of Greece, and hastens across the American continent to dip in[to] the wonders of the Yellowstone Park. Mr. Holmes has not announced it as his intention to lecture on the National Park, but should he do so he will have much that is interesting to say.[34]

Both Burton Holmes and John L. Stoddard illustrated their lectures with "lantern slides." Park photographer Jack Haynes claimed, probably accurately, that his father, F. Jay Haynes, made the first set of Yellowstone lantern slides ever to exist for the use of John L. Stoddard, and it is probable that Holmes also utilized Haynes's images.[35] Lantern slides soon became the standard for those who gave illustrated talks.

A famous Yosemite businessman was first a Yellowstone guide and lecturer. He was educator David A. Curry of Denver, Colorado, who in the 1890s ran a small business conducting tourists to Yellowstone and operated a lecture series in connection with it. Curry brought tour parties to Yellowstone in 1892, 1895, 1896, 1897, and 1898. The Ogden *Daily Standard* covered one of his lectures in 1897 in Salt Lake City, where he and his wife then resided, and noted that "[t]he lecture by Prof. David A. Curry, Principal of the New West Academy, last night, was well attended, and was a thorough treat.... Mr. Curry's lecture and views closed one of the most pleasant and interesting evenings ever witnessed in the New West Academy."[36] But Curry's heart and soul were moving to California. Having fallen in love with the Yosemite country in 1894, Curry decided to transfer everything there in 1895. He became principal of a high school at Stanford and ultimately "put all of his eggs" into a Yosemite basket. In 1899 Curry established Curry Village at Yosemite National Park, the beginnings of a park concession that operated for nearly a hundred years.[37]

Three lesser-known 1890s lecturers on Yellowstone Park were W. N. Jennings, A. M. Spangler, and Charles Thomas. Under the auspices of the Photographic Society of Philadelphia, Jennings lectured with photos and "graceful word paintings" about his trip to Yellowstone in 1893. Where his lectures were given and what year they occurred are not known, but Jennings

fascinated his audience with his "color projections which were most satisfying" as projected by arc light, and which were taken by photographer F. E. Ives. Even less is known about A. M. Spangler, who seems to have lectured on Yellowstone in the Minneapolis–St. Paul area in or about 1896, using projected pictures.[38]

We know slightly more about Charles Thomas thanks to the survival of one of his 1899 brochures. The brochure included his photo on its cover and referred to his Yellowstone lecture ("A Trip to Wonderland") as "a dazzling display of nature's wonders and beauties by a 2500 candle power stereopticon."[39]

Yellowstone Park photographer Jack E. Haynes, who eventually took over his father's photographic business, was also a lecturer. He gave many Yellowstone lectures and other interpretive speeches during his long lifetime in the park. For example, in 1903 at the Haynes shop at Old Faithful, Jack and his father installed a "gasoline-heated geyser model, which erupted every three or four minutes to a height of three or four feet." Jack, about nineteen years old at the time, gave demonstrations of this model and

> explained how it worked, what made geysers erupt, the source
> of heat, the source of water, why one hot spring is blue, another
> green, and so on. . . . Being young and even younger looking,
> I made it a point to state that I quoted directly from the
> writings of such recognized authorities as Joseph LeConte,
> Robert Wilhelm Bunsen, and Dr. Arnold Hague.

Jack Haynes was relating that story one evening to an elderly visitor, when the visitor suddenly revealed himself to be the eminent geologist Arnold Hague in the flesh. Flabbergasted, Haynes stayed with Hague for the next two days while the doctor gave him the best geyser training-tour around the Upper Basin available within knowledge of that day. Haynes used the information to give interpretive talks in the park in 1908 and probably other years at Old Faithful. He continued to lecture about Yellowstone Park for his entire life, as is revealed by his extensive files at Montana State University.[40]

Another longtime Yellowstone resident who gave at least one lecture to visitors was perpetual guide and venerable outdoorsman Elwood "Billy" Hofer. A 1904 party ran into him at Canyon Hotel, where he regaled them with an evening recitation. "The old inhabitant," noted one party member, "related some interesting anecdotes. . . . One bore on the democracy of President Roosevelt, whom he guided through the park." According to this reporter, Hofer talked on, giving his audience a description of the park complete with its

history and stories of its animals. He "furnished a fund of interesting data and statistics," explained the diarist, "as well as humorous incidents."[41]

Historians know little about Dr. H. O. Reik of Baltimore as a Yellowstone lecturer, but his use of color pictures of the park in 1915 in his lectures was an uncommon event if not a revolutionary one.[42] Two years later Reik obtained a permit to give further lectures illustrated by lantern slides, but he gave only a few at Lake Outlet and then abandoned the attempt due to insufficient interest from the public.[43]

Likewise, all that is known about J. Frank Pickering is that he was scheduled to deliver his lecture entitled "The Wonderland of America" at a cost of twenty-five cents on July 14, 1911, at the LDS church in St. Anthony, Idaho. The local newspaper reported that it was to be accompanied by one hundred color pictures.[44]

One Yellowstone lecturer seems to have been from Iowa, or at least he gave lectures there. He was Richard E. Hughes, and historians know of him because of two now-rare postcards in the park's Susan Davis collection. One of them reads as follows:

> Through Yellowstone Park with a Kodak by Richard E.
> Hughes. A stereopticon lecture. Sixty hand colored slides.
> Come and see our Great National Park as the Kodak saw it.
> Place—Haskins Iowa [handwritten]. Date—Dec. 28, 1909
> [handwritten]. Admission: Adults, 25 cents Children, 15 cents.
> One hour lecture. Just think of it. A picture every minute.[45]

Whether Hughes used the oxygen-hydrogen or the calcium-hydrogen process is not known, but presumably he did use one of these methods to project photos for his audiences. Regardless, he appears to have been a regular Yellowstone lecturer who spoke in the towns of Ainsworth and Haskins, Iowa, among others.

There probably were many other early lecturers on Yellowstone who are yet to be discovered, but one apparently unique speaker remains to be discussed. He was special, because he utilized both slide projections and motion pictures at a very early date. Howard H. Hays began with the Wylie Company in 1905, and eventually became one of the most important men in Yellowstone with regard to the camping companies. He gave hundreds of park lectures during the period 1909–1916, and probably in other years as well. A surviving lecture brochure of his, entitled "Yellowstone Park—An

YELLOWSTONE
PARK

AN ILLUSTRATED
"TOURING TALK"

By MR. HOWARD H. HAYS
OF THE WYLIE COMPANY
YELLOWSTONE PARK

MOVING PICTURES
THAT ARE DIFFERENT

8. Flyer for lecturer Howard Hays's "Touring Talk" on Yellowstone, 1910. Hays was an early utilizer of motion pictures in his lectures. YNP Document Archives.

Illustrated Touring Talk," describes his numerous lectures on the park to audiences of up to five hundred. In these lectures he used both 150 slides and eight different motion picture strips.

Clearly the sound and pictures were getting better in Yellowstone lectures, and Hays's combination of slides and movies must have been fascinating. As early as 1909, he says he told the Madison "campfire story" to lecture audiences.[46] In 1910, he gave lectures to large crowds in Iowa, Nebraska, Kansas, Missouri, Colorado, Montana, Wyoming, Idaho, and Illinois. The brochure which promoted Hays's foray into "guided imagery" stated:

> In his "Touring Talk" Mr. Hays assumes the role of guide or interpreter, taking his audiences, in fancy, out to Yellowstone and conducting them in natural sequence to all the scenic centers of "Wonderland.".... Most remarkable of all was a series of moving pictures ... showing leaping cataracts, geysers in motion, wild animals in their various moods of curiosity, timidity or fright, and excited schools of mountain trout.... Besides portraying the Park and its attractions as they appear to the traveler, the lecturer spoke interestingly of the section historically and geologically.

Two of the short films that Hays used in his lectures were "Watching Wild Bears at Lunch" and "The Black Pearl and the Laundry," apparently a film on geysers. Whether any of these very early filmstrips still exist is doubtful, but the thought that some might is a fascinating one. Various film archives are yet to be searched for such early Yellowstone motion pictures.[47]

Many of the other Hays items are preserved in the Howard Hays collection at the University of Wyoming American Heritage Center. Three scrapbooks there plus five boxes of his papers document Hays's life in Yellowstone and other national parks. Hays traveled widely during winter seasons to promote Yellowstone for the Wylie Company, usually by lecturing. One scrapbook is filled with clippings from newspapers around the West that tell the story of Hays's various speeches on Yellowstone Park. In Missouri one year he entertained "more than 500 people" and showed "150 views on canvas." At a speech in Boise, Idaho, the Presbyterian church was "filled to overflowing" with persons wanting to hear Hays's talk on Yellowstone. In 1913, Hays spent a couple of weeks giving Yellowstone talks at the Kansas City Land Show. And from 1914 to 1916, Hays spent extended periods giving Yellowstone lectures at the World's

Fair and its preliminary celebrations in San Francisco. Backing up Hays's speeches at the 1915 fair was a nearly life-sized model of Old Faithful Inn and a huge map of the park on which visitors could actually walk.[48]

Howard Hays was just one of many lecturers in horse-and-buggy Yellowstone who have been largely forgotten. In an era that had no mass communications except for newspapers and magazines and where society as a whole was generally untraveled, evening lectures promoted by broadsides and other posters served as entertainment, information, continuing education, and social gathering all at once. Beginning with Nathaniel Langford, these "performers" were educated and well-traveled men—all who have been found so far were men—who, with their "charming powers of description," certainly qualified as Yellowstone storytellers, indeed interpreters, and ones who would probably be celebrated by National Park Service interpretive specialists if their lectures could be heard today.

Of course these lecturers, like their interpretive descendants, used the published materials on Yellowstone for information with which to construct their lectures. Those published materials were, and still are, critical to all Yellowstone storytellers, and they were an important element of early interpretation in Yellowstone. They backed up the lecturers' sound and pictures with solid information. Hence a discussion of the writings and writers of early Yellowstone is in order.

CHAPTER FIVE

Wonders Enumerated and Peculiarities Noted

Early Yellowstone Guidebooks and Writers

... for who shall describe the wonders of a geyser...
or paint the beauties of the Grand Cañon?

—Reau Campbell, 1909 Yellowstone
guidebook writer

*D*iscounting scattered Munchausen newspaper accounts, the men of
the Folsom, Washburn, and Hayden parties (1869–1871) were the first
writers of the Yellowstone country. But shortly after those official reports,
newspapers, journals, and magazine articles, other writers issued a string of
guidebooks on Yellowstone National Park that continues to the present, as
well as a flood of flowery nineteenth-century writings, many of which are
mentioned in this chapter. Production of the vast literature of Yellowstone
had begun!

One historian has characterized many of the early Yellowstone guide-
books as containing exaggerated descriptions.[1] But Yellowstone's wonders
were and are so spectacular that the exaggeration, in the opinion of this
writer, was simply not that great. The park truly did have the wonderful
features of scenery and curiosity that the guidebooks described. These guide-
books romanticized the park. In doing so they played a large role in the shap-
ing of Yellowstone's fabulous nineteenth-century myth, which has been

discussed in this book's introduction, even though that myth was largely based upon truth. In sum, both its romanticization and its true parts made Yellowstone legendary rather quickly.

Of course, guidebooks have been important the nation over in the country's westward expansion. In *See America First*, Marguerite Shaffer spent an entire chapter discussing western guidebooks which she called "Narrating the Nation." Although she did not discuss Yellowstone guidebooks, she gave an overview of the general subject, noting that guidebooks symbolized the coming together of nature, history, and American progress. She also suggested that guidebooks have imbued the country with a feeling that through tourism, every American can have access to pristine nature, "thus insuring that a permanent balance [can] be maintained between the advance of civilization and the virtues of nature."[2]

The Yellowstone guidebook was an attempt to publicize the wonders of the country and to give the visitor a route-finder to pilot him through it on his tour. Although they were qualitatively different from Indians, fur trappers, and prospectors, guidebooks served as a type of storyteller in early Yellowstone.

Because guidebooks were and are information based, they connect logically to storytelling, interpretation, and visitor education in national parks. Everyone associated with Yellowstone Park utilized them in early days, from park superintendents to the U.S. Army to stagecoach drivers and hotel guides, all of whom were park storytellers at some point. Some of the flowery writings were based in theology, as men of the cloth and others used Yellowstone to sell "the glories of the Creator." Thus park tour guiding also appeared in the form of religion. As one would expect, these religious writers used Yellowstone to tell religious stories that "proved" that God existed. After all, they thought, how could anyone doubt the existence of an omniscient creator, when the "evidence," in the form of spectacular mountains, tall waterfalls, colorful canyons, and spouting geysers made it all so clear?

The first Yellowstone "guidebook" consisted of an assemblage of the exploration writings of 1870–1872. Copyrighted in 1872 and published in 1873, it was James Richardson's *Wonders of the Yellowstone Region*, and it added nothing significantly new to the literature. The first guidebook to contain original material appeared in 1873, and it was Harry Norton's *Wonderland Illustrated, or, Horseback Rides Through the Yellowstone National Park*. It was published in Virginia City newspapers prior to its softbound individual appearance, and was the result of Norton's trip to the park in 1872. It can be

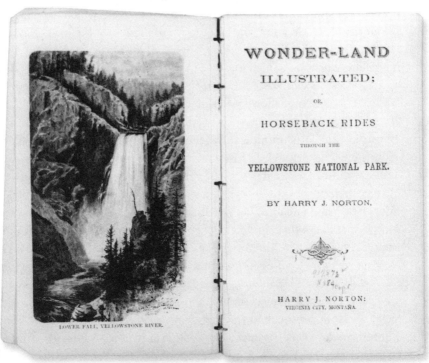

9. *Title page for Harry Norton's* Wonder-land Illustrated *(1873), the earliest original guidebook to Yellowstone Park. YNP Library.*

argued that Norton's book predates Richardson's, if historians count its original publication in newspapers.

After these guidebooks, there were no others until 1881, but writings on Yellowstone continued to appear. Travelogue-type books, so useful in an America where most persons were relatively untraveled and little educated, had begun decades earlier with guides for navigating the Ohio and Mississippi Rivers and with Oregon Trail guidebooks. That tradition continued all over the American West until well after the turn of the century, and the Yellowstone country was no exception. Edwin J. Stanley's *Rambles in Wonderland* was published in 1878, and went into many printings. Stanley was a preacher who visited the park in 1873, and his book was very popular, probably because men of the cloth were often educated and credible during a time when many other persons were not. Stanley's travelogue stimulated other clerics who seized

upon Yellowstone almost immediately as a vehicle from which to "celebrate the glories of the Creator." The best known of these were the Revs. Wayland Hoyt and T. DeWitt Talmadge. Hoyt's descriptions of the Grand Canyon of the Yellowstone were quoted for years in various other western writings such as G .P. Brockett's *Our Western Empire* (1881). As noted, many of these descriptive writings were quite flowery, which was the style of the day.[3]

Until about 1920 when for whatever reason they suddenly did not appear in such large numbers, travelogues continued to be important in Yellowstone's history and the history of the American West. Sometimes overlooked by historians because they are works that feature a bit of this and a bit of that, there were several early ones that affected Yellowstone by giving information and encouraging visitation: J. H. Triggs's *History of Cheyenne and Northern Wyoming Embracing the Gold Fields of the Black Hills, Powder River . . .* (1876), Robert Strahorn's *The Rockies and Beyond* (1878), and Henry N. Maguire's *The Coming Empire, A Complete and Reliable Treatise on the Black Hills, Yellowstone, and Big Horn Regions* (1878). Most travelogues contained one or more chapters on Yellowstone and other chapters on wherever in the West the author had traveled. Some of the later ones were Almon Gunnison's *Rambles Overland* (1884), Maturin Ballou's *Footprints of Travel* (1888), Carter Harrison's *A Summer's Outing* (1891), Edward Marston's *Frank's Ranche* (1886), and Rudyard Kipling's *From Sea to Sea* (1899). Three more were by Mrs. James E. Morris, T. C. Porter, and Edward S. Parkinson.

Yellowstone guidebooks are, of course, the most important of the works examined here. They contained the most concentrated information on the park and thus the information that was most useful to storytellers, horse-and-buggy tour guides, and park interpreters. The next guidebook to appear was Robert Strahorn's beautiful little book, *The Enchanted Land, or An October Ramble Among Geysers, Hot Springs, Lakes, Falls and Cañons of Yellowstone National Park* (1881). It was followed by W. W. Wylie's *Yellowstone National Park, or The Great American Wonderland* (1882), and Henry J. Winser's *The Yellowstone National Park: A Manual for Tourists* (1883). Park superintendent P. W. Norris published his guidebook in 1883 under the title *The Calumet of the Coteau*, and G. L. Henderson's *Yellowstone Park Manual and Guide* appeared in 1885 and 1888. This last guidebook was published in newspaper form and, while widely distributed in its day, not many copies survive. However, it had major impacts on Yellowstone National Park that will be discussed in the chapter on G. L. Henderson. Another important guidebook was Herman Haupt Jr.'s *The Yellowstone National Park*, published

10. *First page of G. L. Henderson's* Yellowstone Park Manual and Guide
(1885), probably the rarest of all Yellowstone guidebooks. YNP Library.

in 1883. It was manufactured with a clever, wraparound binding, which pro-
tected it from inclement weather so that it could be more effectively used on
board stagecoaches. Space prohibits listing all the independent Yellowstone
guidebooks that were published before 1920, but some of the authors were
W. H. Dudley, John Hyde, W. C. Riley, A. B. Guptill, F. J. Haynes, W. Raymond
and I. A. Whitcomb, W. F. Hatfield, Reau Campbell, E. F. Colborn, A. M.
Cleland, and E. F. Allen.

Allied with guidebooks were "viewbooks," that is, books of woodcut
drawings and, later, photos of Yellowstone National Park. The first of these was
F. J. Haynes's *Yellowstone National Park* (1883), a small (about 4"x5") book
of woodcuts. His 1889 book *Souvenir—Yellowstone National Park* was larger
and had foldout woodcuts. Others were A. Witteman's *Yellowstone National
Park Illustrated* (1888), W. C. Riley's *Yellowstone National Park, The World's
Wonderland* (1889), and the Stulz Brothers, *Yellowstone Park Views* (circa 1885).

Early Yellowstone literature fell into several other classes. There were
outsized, "travel America" type books, such as William Cullen Bryant's

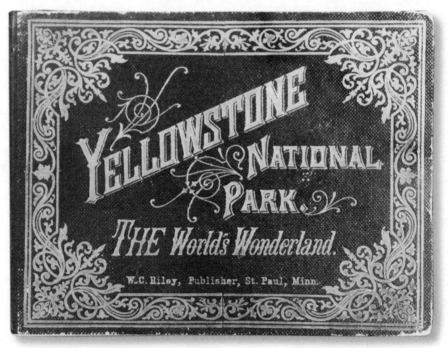

11. *Cover of W. C. Riley's* World's Wonderland *(1889) book of woodcut views. YNP Library.*

Picturesque America (1872), J. W. Buel's *America's Wonderlands* (1893), Joel Cook's *America: Picturesque and Descriptive* (1900), and Robert Schauffler's *Romantic America* (1913). There were works on the Rocky Mountains, such as Sir Rose Lambart Price's *A Summer on the Rockies* (1898), Rossiter Raymond's *Camp and Cabin* (1880), and Edwards Roberts's *Shoshone and Other Western Wonders* (1888). There were works on the Northwest, such as Henry T. Williams's *The Pacific Tourist* (1876), and Frederick Shearer's 1885 book of the same name. There were works by foreign visitors, not all of which are even known: Jules LeClerq, *La Terre des Merveilles* (1886) and Oszkar Vojnich's *Budapest to Sitka: Travel Notes* (1894). And there were at least a dozen pre-1920 books that were completely about the travelers' impressions of their trips to Yellowstone without being guidebooks. This was a testimonial to the size, diversity, and uniqueness of the park. Some of those books were: Georgina Synge's *A Ride Through Wonderland* (1892), John

Atwood's *Yellowstone Park in 1898* (1918), George Wingate's *Through the Yellowstone Park on Horseback* (1886), L. Louise Elliott's *Six Weeks on Horseback Through Yellowstone Park* (1913), Louise Henely's *Letters from the Yellowstone* (1914), Charles Heath's *Trial of a Trail* (1905), Elbert and Alice Hubbard's *A Little Journey to the Yellowstone* (1915), L. L. Quaw's *A Love Affair in Wonderland* (circa 1906), Mrs. Mary Richards's *Camping Out in the Yellowstone* (1910), J. Sanford Saltus's *A Week in the Yellowstone* (1895), Carl Schmidt's *A Western Trip* (1910), and G. S. Turrill's *A Tale of the Yellowstone* (1901). Finally, a number of visitors traveled to Yellowstone and then privately published their own accounts of it in books of (often) low print runs, which makes them hard to locate. Some of these authors were George Bauchle, Marvin Morris, Dr. John Dike, C. G. Fletcher, Jacob Frick, Theodore Gerrish, R. D. Kenny, and Carrie McLaughlin.

Some of the rarest Yellowstone accounts are ones included within personal biographies or autobiographies, wherein the subject took a trip to the park and wrote about it. Researchers are still discovering these, but a few are Edmund Muspratt's *My Life and Work* (1917), John Sherman's *Recollections of Forty Years* (1895), George Adam Smith's *The Life of Henry Drummond* (1901), R. C. Wallace's *A Few Memories of a Long Life* (1900), John Hay's *Letters and Diaries of John Hay* (1908), and several works by and on Henry Adams.

Other early Yellowstone National Park books are those which combine trips to the park with trips to Alaska. Charles Gillis's *Another Summer: The Yellowstone Park and Alaska* (1893), William and Sarah Wiley's *The Yosemite, Alaska, and the Yellowstone* (1893), Charles Taylor's *Touring Alaska and the Yellowstone* (1901), Maturin M. Ballou's *The New El Dorado: A Summer Journey to Alaska* (1889), and Francis C. Sessions's *From Yellowstone Park to Alaska* (1890) are examples of these.

The Northern Pacific Railroad published many Yellowstone works during the period 1883 to 1930, and these were important in the "selling" of the park, surely a storytelling endeavor. There is not room for a full list here, but many are cited in Lee H. Whittlesey's *Wonderland Nomenclature* (1988), and a number are discussed in Chris Magoc's recent *Yellowstone: The Creation and Selling of an American Landscape* (1999). The best known of these books was the "Wonderland" series of 1883–1906. Olin D. Wheeler authored some of them, but other authors were Elia Peattie, A. B. Guptill, John Hyde and Lt. Frederick Schwatka, and Charles S. Fee.

Finally, Hiram M. Chittenden's *The Yellowstone National Park* (1895) is one of the most important of all books on Yellowstone because of its long

history and description sections. Park interpreters have used it constantly since the day it was published, and after some fifteen editions it remains in print today.

In sum, there is massive early literature for Yellowstone National Park. These are some of the more important examples, and in addition to the works listed here, articles on Yellowstone in magazines and newspapers as well as government documents number in the thousands. A complete bibliography of all of them—history, travel, and description material, and excluding hard science material—has been in the works for some twenty years by Dean Larsen and Russell Taylor of Brigham Young University, and they currently list more than thirteen thousand published entries. This means only that Yellowstone literature is so vast that it is not an easy task to make quick generalizations about it.

Today's park interpreters continue to use many of these written works, as did their horse-and-buggy predecessors. The private collectors of Yellowstone literature and ephemera, brought together by common interest and made even larger by today's Internet, number in the thousands. This literature was and is an important element of storytelling in early Yellowstone. But park officials of those early days were learning that simple road signs were also such elements. Signs were needed to inform and warn visitors, to help guide them to desired spots, and to identify important places and objects to see. In addition to sounds, pictures, and literature, the new national park needed graphics. Hence signs would soon play a role in telling the stories of Yellowstone.

"Well Dressed, Lettered, and Affixed"

Signs and Guideboards in Early Yellowstone

Signs inform, warn, guide, and identify.
—Suzanne Trapp,
NPS Interpreters' Handbook

Surely anything that performs the functions described in the quotation above is to some degree interpretive, because it informs and educates and thus becomes a key component of storytelling and touring. Road signs certainly fit that description, and all of Yellowstone's horse-and-buggy tour guides used them. But there were no signs to speak of in the new Yellowstone Park until the summer of 1877.

That year the new superintendent, P. W. Norris, brought with him three hundred copies of the new park rules and regulations printed on waterproof linen. He had already caused the regulations to be published in local newspapers at Bozeman, Montana, and subsequently he placed the muslin signs on trees and other objects around the park. Norris stated: "As a practical mode of attracting general attention I also had a large number of spirited cautions against fire and depredations in the park printed upon durable cloth and affixed to trees, and otherwise at prominent points of interest therein and the adjacent places of resort."[1] Traveler Frank Carpenter recorded the text from one such sign that warned, "Tourists are requested

12. *"Rules and Regulations of the Yellowstone National Park,"
as first posted by P. W. Norris in 1878. Huntington Library,
San Marino, California.*

not to break, destroy, or take away any specimens, under a penalty of fifty
dollars fine, or one year in the penitentiary. By order of the Superintendent
of the National Park."[2] Norris's sign here stretched the truth, for neither he
nor the law could legally impose such penalties upon travelers.

In 1879, Norris erected more formal instructional signs in Yellowstone
that he called "guideboards." Because of the costs of lumber and freight, he

No.84.Crater of Giantess

13. *Nameplate sign at Giantess Geyser, erected by*
P. W. Norris in 1879. Photo by H. B. Calfee.
Courtesy YNP Photo Archives, YELL *129208.*

could not erect "more than was absolutely necessary," but he stated that "all
fragments [of lumber] were carefully preserved, well dressed, painted white,
and then black-lettered with the names of the most important streams, pass-
es, geysers, etc., and tables of distances between them." He lamented, though,
that "many more are needed."[3]

The following year Norris reported that many of his signs had been
stolen, oxidized by chemicals in thermal basins, burned by forest fires (and
probably camp fires), crushed by falling trees, swept away by floods, or just

simply vandalized out of existence by visitors or local persons hostile to the park. Norris decried the latter as "ignorant, selfish ... opponents of improvement ... who robbed tourists, and who, to prevent the latter from following plain roads or trails, and from ascertaining routes and names of objects visited, have destroyed the boards designating the same." According to correspondence from the Secretary of the Interior's office, Norris again placed muslin signs containing rules and regulations all around the park in 1881.[4]

Traveler Carrie Strahorn saw one of Norris's signs in 1880 at "Norris Geyser Plateau," now called Norris Geyser Basin. On it someone had penciled a cynical critique of the park's roads and signs: "Government appropriations for public improvements in the park in 1872, $35,000. Surplus on hand October 1, 1880, $34,500."[5] This inscription was apocryphal, as there were no park appropriations of any kind in 1872.

Mr. Norris referred to his signs as guideboards, but apparently they were simply directional, instructional, or informational signs, rather than the longer and more detailed fully interpretive signs ("wayside exhibits") that would not appear commonly in the park until the early 1930s.

Following Superintendent Norris, there was a period of relative chaos in Yellowstone Park management (1882–1886) that was not remedied until the army with its money and personnel arrived to take over management of Yellowstone in August of 1886. Nevertheless, even during that period, local persons—mainly the assistant superintendents—erected much signage in the park. For example, park employee George Thomas in 1883 observed that "very little attempt had been made to give names to many of the Geysers and springs, or sights that are to be seen, but some were identified by names written on pieces of board with a lead pencil. Some shallow springs were marked by writing the name on a flat piece of stone and lowering it in[to] the water so that the name could be seen."[6]

There are other examples of geyser signs from that period. Assistant Superintendent William H. Terry stated that he put up signs "to mark the principle [sic] Geysers and springs" at Upper Geyser Basin in August of 1884. Someone erected a signboard bearing the name of "Daisy Geyser" during the superintendency of David Wear (July 1, 1885 to August 17, 1886), and thus it is likely that other geyser signs were also then put up.[7] G. L. Henderson erected "finger boards" in 1884 at Mammoth Hot Springs "to inform visitors where to find springs and other objects of interest." By 1885, he could note that these finger boards were "near all the great geysers and hot springs [at Upper Geyser Basin] that enable strangers to know what they are looking at,

also indicating the way to the next object of interest." The existence of those signs in August of 1885 is corroborated by a traveler who noted that sign-boards pointed out some of the geysers at Upper Basin: "Giant," "Little Faithful," and "To the Splendid." Another traveler in 1885 or 1886 commented on the safety notices "printed on boards in great black letters": "Do not walk on the formations"; "Gather no specimens"; "Write no names."[8]

Sometimes Yellowstone signboards were erected in connection with the formal bestowing of a place-name. In particular this happened with regard to thermal springs. Dr. A. C. Peale reported in 1878 that his party found "a stake with the name Locomotive" written on it near a spring at Norris Geyser Basin. Assistant superintendent J.W. Weimer noted in 1884 that he had erected a sign at a thermal spring designating it as "Inverted Sky Pool" per the superintendent's orders. And geologist Walter Weed saw a sign giving the name to Catfish Geyser at Upper Basin in 1884.[9]

Except for P. W. Norris, only one park superintendent prior to the entry of the U.S. Army made any attempt to erect signs, that being Super-intendent David Wear. Wear began this work in 1885, when he received a complaint letter from a visiting Ohio attorney who claimed that he had trav-eled for over two hundred miles through the park and "did not see in any place the slightest notice of any kind in regard to the Government of the park." To remedy this, Wear asked permission to hire someone to paint signs, and before the army replaced him on August 17, 1886, he had erected "over 200 signs to mark the names of places of interest and trails." Traveler E. Catherine Bates, who saw many of Wear's signs in July of that year, cau-tioned that "no shooting is allowed in the park, and notices to that effect greet you at every turn."[10]

Once the army arrived in Yellowstone, order and organization in every-thing became greater because more money and more people were suddenly available; both warning and informational signs increased. An 1887 traveler named H. T. Finck, in discussing park regulations, commented on what signs were visible that year and what was still needed:

> These regulations, with others, are printed on linen and
> conspicuously posted along the road every few miles, so that
> no one can plead ignorance of the law. Scattered throughout
> the Park are also hundreds of signs reading 'NO HUNTING,'
> 'EXTINGUISH YOUR FIRES,' with others indicating good
> places for camps. In the Geyser Basins the principal springs

and geysers are also marked by sign-boards, though not so
liberally as might be desired. There should be more of them near
the road to indicate the most remarkable spots. At present the
'paint pots' and the Gibbon and Tower falls are very apt to be
missed by tourists. Some of the signboards in the Geyser Basins
need renovating. At Norris one of these attracted my attention;
and after getting my eyes within six inches to decipher the
obscure inscription, I read the word 'DANGEROUS!' These
danger signals ought to be much more frequent.[11]

Not only was the army more efficient in putting up park signs than the
civilian superintendents had been, the U.S. Geological Survey under geolo-
gist Arnold Hague demonstrated it could be of service in signing. In 1887,
Hague sent military superintendent Moses Harris a letter with the names of
thermal features to be posted on signboards at Lower Geyser Basin. Hague's
assistant, Walter Weed, says that he (Weed) personally placed a number of
these signboards on features at Lower Geyser Basin in September of 1890.[12]
Weed or others placed similar signs at Upper Geyser Basin earlier that sum-
mer, for a traveler of July 1890, stated:

> [W]e caught a view of Biscuit Geyser [Basin], and along our
> road we met with pools and geysers of all shapes and sizes.
> At almost every one a signboard had been placed with a name
> thereon. In this way we knew "Artemisia" [Geyser] and "
> The Morning Glory" [Pool], and these two introduced us
> to the "Upper Geyser Basin."[13]

The military, of course, erected its own signs or at least tried to. Captain
Moses Harris asked Interior in 1888 for money to provide "sign boards to warn
the numerous visitors of dangerous places, [and] to display the names of the
different geysers and other objects of interest." Unfortunately, lamented a
recent historian of Yellowstone's administrative history, "the lack of appropri-
ations for such essentials ... would continue to plague Harris during his com-
mand at Camp Sheridan."[14]

Likewise, local people erected signs, and one of those was park tour
guide G. L. Henderson. Henderson reported in 1888 with regard to Norris
Geyser Basin that "[v]isitors ought not to cross this basin without a com-
petent guide, and then it is at the risk of their lives. There is a [sign]board

marked 'Dangerous' easily seen from the road."[15] It is not known who erected that danger sign. Traveler J. E. Williams in 1888 thought that the government, meaning the military, was responsible.[16] But tourists and other private parties nailed up *their own* signs at times, just what one would expect in a huge "fairyland" that had fascinating objects to see in it and very few aids for slow, horse-drawn travelers. Traveler George Remington camped near a sign that someone had nailed up at Yellowstone Lake in 1887 proclaiming, "Best fishing in the world, 400 yards." Traveler Louise Elliott stated that some visitor had tacked a card onto a tree in 1912 giving the present place-name to Dragon's Mouth Spring. And military officer Malin Craig claimed to have unofficially tacked up a sign saying "Craig Pass" in 1913 near the park's Isa Lake.[17]

In the fall of 1891, the park superintendent reported that some of the government's signs had become hard to read:

> The sign boards that have been placed to designate the various objects of interest, as well as those conveying warning notices, have become much obliterated by time. At the close of the season I shall have them taken down and repainted, and replaced before the opening of travel in the spring.[18]

An 1892 traveler apparently saw those new signs, for he remarked that "we frequently saw signs put up by the government: 'Do not drive on here' and 'Danger.'"[19] The superintendent confirmed that the government had indeed erected these signs.[20]

After 1891, there was no mention of signs in the annual reports of the park superintendents until 1905, when it was stated that "the mile posts and sign boards at the road junctions and some other signs have all been repainted." But some of the signs that visitors saw in 1896 are known from a traveler's account: "Extinguish Your Fires," "No Shooting," "Gather No Specimens," and "Do Not Deface the Formations."[21] And road engineer Hiram Chittenden reported in 1901 that "signs are . . . provided at all road junctions so as to give full information to travelers, and other signs give the names of all important objects of interest."[22]

After the turn of the century, park officials replaced park signage often. This generally occurred whenever a soldier or other park employee noticed that they needed fixing. It happened in 1903, when Sergeant George Riddell wrote that "many of the sign boards on the formation [here at Old Faithful] are destroyed . . . [or] so weather beaten it is impossible to read them."[23]

A major re-signing of the park occurred in 1907, when park officials placed about six hundred new signs made of enameled steel "throughout the park on iron stakes set in cement." These signs replaced the wooden ones parkwide.[24] Another major re-signing occurred during the years 1918–1920; those signs were, again, made of metal and were green and white in color, except for danger signs that were red. In 1920, the National Park Service officially adopted a policy of standardized signs for all national parks, using these new signs that had a white field with green lettering. Because they were made of metal, they were considered hard to damage if not indestructible.[25] Re-signings occurred whenever signs got old or worn out or whenever park officials wanted a "new look." And civilian scouts routinely posted park rules and regulations on various stretches of park roads whenever it was deemed necessary.[26]

All of the signs referred to so far were directional, instructional, or informational. Only one series of strictly interpretive signs existed in early Yellowstone days. Historian and road engineer Hiram Martin Chittenden conceived and erected those in 1903 to commemorate the passage of the Nez Perce Indians through Yellowstone in 1877. Such signs, later called "wayside exhibits," did not appear in the park in large scale until the 1920s and 1930s, probably because the smaller park visitation of those days did not generate as much need for them.[27]

Road engineer Chittenden discussed his plans for erection of these interpretive signs in his annual report for 1902: "The situation of the prominent historic points on the line of march of General [O. O.] Howard across the park in pursuit of the Nez Perce Indians in 1877," he concluded, "has always been a matter of interest to tourists since the campaign took place." Because his roadwork paralleled a part of the old trail and threatened to obliterate other portions of it, Chittenden thought it desirable to "locate definitely the more important points . . . in order that they may be marked with suitable inscriptions."[28]

To help him with this task, Chittenden pressed into service a number of relevant persons who had knowledge of the 1877 campaign. They were: Colonel W. F. Spurgin, who had led soldiers over the Nez Perce trail; George F. Cowan, one of the captured tourists; J. C. McCartney, a founder of the town of Gardiner and long touted as its unofficial "mayor"; Silas Huntley, transportation director for the park stagecoach operations; O. D. Wheeler, Northern Pacific Railroad historian; James Morrison, government scout ("probably more familiar with the geography of the park than any other individual"); and A. E. Burns, overseer of road construction. Photos of

Mr. and Mrs. Cowan helping Chittenden find old sites in 1901 now reside in park archives.[29]

Because of the importance of Chittenden's signage in the history of park storytelling, the complete text of his proposal and signage is included here:

> *February 7, 1903*
> *Major John Pitcher*
> *Acting Superintendent*
> *Yellowstone National Park,*
> *Fort Yellowstone, Wyo.*
>
> *My dear Major:*
> *Two years ago, as you know I went through the Park and determined a number of points of historic interest on the route of Chief Joseph and General [O. O.] Howard. I have ever since been intending to fix a few signs to mark these places, but I have never had the time to do it. I inclose [sic] herewith eight signs which seem to me to be of importance, and if they meet with your approval I will cause them to be printed.*
> > *Very truly yours,*
> > *H. M. Chittenden*
> > *Captain, Corps of Engineers*

Chittenden's signs were in place by 1904, and all together they marked key locations of the 1877 Nez Perce foray through the park.[30] Unfortunately the signs were mostly removed, destroyed, or lost by the 1930s, leaving the park with the substantial job of trying to rediscover their original locations. Photos taken of some of the signs in place have allowed park resource officials to recover some of the lost information, but some of it may be gone forever. At least one of Chittenden's textual messages, a metal sign with green letters on white enamel, was still in place on the headwaters of Nez Perce Creek as late as 2004, marking the spot where Chief Joseph's men discussed what to do with their captives.[31]

Other attempts at early interpretation included barebones libraries and natural history museums. There were not many of either until the 1920s. But as early as 1902, an attempt was made to establish a library in Yellowstone, for a 1904 traveler reported:

CHITTENDEN'S EIGHT INTERPRETIVE SIGNS

"At this point, August 24, 1877, the Nez Perce Indians, under Chief Joseph, captured a party of tourists from Radersburg, Mont., including Mr. Geo. F. Cowan. The party were taken up the valley of Nez Perce creek by the trail over Mary Mountain."

"Camp Cowan—This is the site of General Howard's second camp (August 30, 1877) within the limits of the Yellowstone National Park during his pursuit of Chief Joseph. It was near this point that the troops found Mr. Cowan, who had crawled back six miles from the foot of Mary Mountain after having been wounded and left for dead by the Indians. He had passed four days without food."

"On this spot, (August 24, 1877) the Nez Perce Chiefs held a council to decide the fate of the Cowan party who had been captured that morning in the Lower Geyser Basin. The party were released, but afterwards recaptured, taken back about a half a mile east of the council ground, and there attacked by the Indians. Cowan was left for dead, Carpenter and the two ladies were taken along as prisoners, and the rest escaped."

"General Howard's headquarters, September 1, 1877. The ford by which the Nez Perces crossed the river is about half a mile distant. Howard did not follow them but took his command down the left bank of the river, over Mount Washburn, and crossed the Yellowstone at Baronet's bridge."

"'Spurgin's Beaver Slide.' Half a mile back from the road is the place where Captain W. F. Spurgin, 21st Infantry, let General Howard's wagon train down the steep side of the mountain. The marks on the trees, burned in by the ropes used to let the wagons down, are still distinctly visible."

"Three fourths of a mile up the valley of this stream is the place where a party of tourists from Helena were attacked by the Nez Perces, August 26, 1877, and one of their number killed."

"On this spot a party of tourists from Helena, Mont. were attacked by Nez Perces, August 26, 1877, and one of their number killed."[32]

"General Howard's wagon train, under Major Spurgin, crossed the cañon of Cascade Creek at this point."[33]

14. *The original wording from one of Chittenden's "wayside exhibit" signs remained in place as late as 2004 on Nez Perce Creek. Author's collection (photo taken 1977).*

Under Major [Hiram] Chittenden's supervision there has also been gathered at engineer headquarters [at Mammoth], in the last two years, a library, as full as it could be made, of Park literature, including magazine articles and newspaper clippings, as well as books—a thing of which many an interested visitor has felt the lack in the past.

In 1908, park superintendent S. B. M. Young wrote to the Secretary of the Interior asking for money to purchase books that had been suggested by Dr. Charles D. Walcott of the Smithsonian Institution "for the better education and information of employees and officials."[34] Park superintendent George S. Anderson (1891–1897) amassed a large personal collection of books

and articles about Yellowstone and donated it to the park. Thus from the books of Chittenden, Anderson, and Young, the present Yellowstone National Park Research Library was born.

Similarly, several early museum efforts are known. In 1874, according to a local newspaper, Yellowstone residents Harry Horr, Jack Baronett, and a Captain Frank Grounds were making plans to exhibit "live elk, black tail deer, antelope, mountain sheep and other animals" from the park area, apparently as part of the U.S. centennial celebration in 1876. Whether these men pulled that one off is not known. The Bottler brothers and F. D. Pease were already penning up wild animals for their own enjoyment and showing them to others as a kind of zoo in nearby Paradise Valley, but this early attempt at a "museum" seems to have failed.[35]

In 1885 area old-timer George W. Rea petitioned the park for a lease of ten acres for the purpose of establishing a museum of natural history. Rea wanted to exhibit animals from Yellowstone as well as from the West as a whole. Probably fearful of promoting hunting in the park with all of the trouble they had had with it, for they knew Rea to be a hunter, park officials did not allow the museum. As will be seen in the chapter about him, G. L. Henderson established a more successful "museum" the same year (1885) at his Cottage Hotel. And around 1910, Milton Skinner, who later became Yellowstone's first official park naturalist, heard of a proposal to build a government museum at Mammoth and became its advocate.[36]

This last proposal may have begun with Superintendent Lloyd Brett. In 1913, Brett called the attention of the Secretary of the Interior to the "necessity for an administration building, housing all that is interesting in historical data and specimens of natural curiosities, etc." Brett's proposal was noteworthy, because it marked the first time a government official called for museum space in the park. Brett also suggested that the museum system be expanded and that it should include hired interpreters—"small branches of the administration building in the shape of bungalows might be erected at Norris, Upper Basin, and the Canyon, containing like data and specimens, and presided over by one able to give intelligent information." Brett acknowledged to the secretary "that information [about] all the [park] natural objects is not well disseminated." "This [activity]," he lamented, "is turned over to guides, bellboys, and porters, by the hotels and camps, and such information as they are able to give is not of much value." Of course, what value it had or did not have was certainly debatable, for thousands of visitors had benefited by it, but Brett's involvement was merely one episode in the

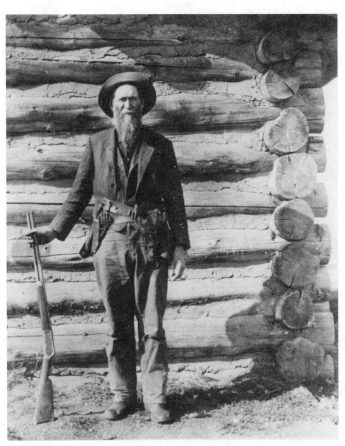

15. *George Rea, no date, hunter from eastern Idaho who petitioned the Department of the Interior in 1885 for permission to erect the first museum in Yellowstone Park. Courtesy YNP Photo Archives, YELL 36656.*

drive to recognize storytelling (interpretation) as something that should be officially acknowledged. A month later, M. P. Skinner, who had heard of the idea for a park museum, echoed the suggestion, but after talking with the secretary admitted, "the consensus of opinion seems to be that the project is a little too advanced for the present. The museum feature in connection with the administration building [seems to be one that] they are not ready to handle yet."[37] Hence, no park museum appeared in Yellowstone until 1919.

Signs, museums, libraries, and wayside exhibits were all elements of storytelling that developed somewhat later in Yellowstone than did the more obvious, personal storytellers. But another early element of park storytelling was the development of a verbal network of persons who exchanged information about Yellowstone geysers. The great geyser eruptions were fascinating and cried out to be predicted, watched, discussed, and raved about. Hence, what follows is a review of those whose interpretive activities told stories of geysers.

"A Pronounced Weakness for Geysers"

Early Geyser "Gazers" In Yellowstone

*He is said to become at times so excited
when present at an eruption of a large geyser,
as to burst into tears.*

—1881 park visitor describing
Dr. F. V. Hayden[1]

Geysers are rare, strange, and wonderful natural treasures. They are treasures because not many of them exist on the face of the earth and because they send hot water hundreds of feet into the air in spectacular, splashing shows. They were the original "wonders of the Yellowstone," the ones truly responsible for the setting aside of the area as the world's first national park, because many other western places similarly contained large mammals, waterfalls, canyons, and lakes. But no place else in the United States contained geysers, at least not in the numbers and sizes of Yellowstone. The earliest Yellowstone travelers loved the geysers fervently and ecstatically. "A geyser!" wrote an 1897 traveler, "How shall one describe it or explain it?" And he waxed poetic in trying.[2]

Early park visitors and guides wanted to know when to expect the great spoutings, especially from the larger and "less regular" geysers such as Beehive, Giantess, Giant, Daisy, and Grand geysers. Accordingly, a network of

oral informers developed among those who possessed significant interest. Often those persons were stagecoach drivers or other "park guides."

The 1870 Washburn party gasped and effervesced over Yellowstone's geysers. By 1871, the first true geyser enthusiasts arrived in the park. These "geyser gazers," for that is what they are called today, were and are a different breed of person. Other park features such as animals, canyons, mountains, lakes, or waterfalls did not and do not matter to them; they lived and live only for geysers and hot springs, which today they call "thermals." From earliest park days, these people generally wanted to tell stories to anyone who would listen about their passion, and that itself caused storytelling about park features. The term "geyser gazer" refers to those who have the passion as distinguished from those who are merely passingly interested in geysers.

The first Yellowstone geyser gazers were probably Drs. F. V. Hayden and A. C. Peale of the 1871 Hayden survey. Dr. Hayden, as described above, would sometimes burst into tears when viewing a geyser. An 1872 visitor added:

> It is said of Prof. Hayden, a man of extremely nervous
> temperament and with an unbounded enthusiasm for the
> sciences, that he cannot compose himself in the presence of a
> geyser in eruption; but, losing recollection of the material world
> for the time, rubs his hands, shouts, and dances around the
> object of his admiration in a paroxysm of gleeful excitement.[3]

To today's observers this reaction may seem extreme, but geysers, as mentioned earlier, are strange and rare treasures whose displays are dramatic. To Dr. Hayden, a man obsessed with geology, geyser displays were apparently so exciting as to evoke this kind of reaction.

Dr. Peale was less prone to theatrics, but he nevertheless had a passion for thermals. He wrote the first treatise on the park's hot springs and geysers, as well as numerous articles on not only Yellowstone's but also the rest of the world's hot springs. Peale, a scientist, was not overly given to writing much about his personal feelings for geysers or his trips around the basins for purposes of explaining them to others, nor were his successors, geologists Arnold Hague and Walter Weed. But the geysers fascinated these four men, and they wrote thousands of pages about them. No doubt all four men gave many short "tours" of geyser areas. Hague in particular conducted a great number of his fellow geologists through the thermal basins of Yellowstone during the summer of 1891. But the four men's contributions to storytelling

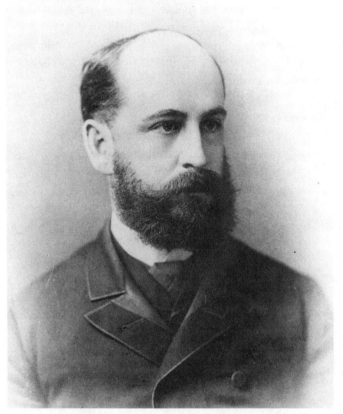

16. Dr. A. C. Peale (1849–1913), mineralogist, and one of
Yellowstone's earliest geyser enthusiasts. National Archives.

are easier to evaluate from a purely informational standpoint than they are
from a lecture standpoint, because very little is known about formal pro-
grams or walks that they must have given.

Some Yellowstone guides such as Wilbur Edgarton Sanders and George
Graham had become geyser enthusiasts and were verbally imparting their
knowledge to visitors by 1880. Sanders first visited Yellowstone that year and
became immediately fascinated with geysers. In 1881, he returned and con-
tinued his journal that detailed many geyser eruptions. He was interested
enough and presumably smart enough to get himself invited to accompany

Arnold Hague, Walter Weed, and the other members of the U.S. Geological Survey on their 1884 trip to Yellowstone to investigate geysers.[4]

A note from Sanders's 1881 journal not only shows his interest in geysers but also is fascinating for the glimpse it provides of early visitors' reactions to the large spoutings. Sanders had no doubt "prepped" his audience in storytelling style for the big event:

> Gen'l [Philip] Sheridan is now camped near us and he with
> the other high officials with him as well as all the civilians in
> the whole basin went over about 4 PM to see the Grand Geyser
> spout. We waited until about 5:30 before she began but it proved
> to be a grand eruption and fully repaid us for our patience.
> She played 8 times of which the 5th and 6th proved the best.
> She at times threw the stream up fully 150 feet. Ladies, Officers,
> Civilians, and soldiers yelled, talked, screamed, laughed and
> nearly danced at the sight.[5]

Another early geyser gazer was George Graham. Graham was a Scotch Canadian around thirty-five years of age during the summer of 1881, when he worked out of the Marshall Hotel. According to a traveler who enlisted his services, Graham had been there for several seasons. He seems to have been quite interested in geysers, as audience members stated when the subject of seeing Giantess Geyser came up:

> George said that probably not a hundred persons had ever seen
> it in action, although many people, when they get out of the
> Park, claim that they have. He was one of the oldest guides
> in the place, and had never seen it otherwise than as still as a
> pond, and rather doubted the great stories told about it.

But the party did see Giantess erupt along with numerous other geysers in the Upper Basin, and their early geyser-gazer guide commented on their luck:

> George was dumbfounded at our good fortune, and said we
> were the luckiest party that had ever been in the Basin; no other,
> so far as he knew or had heard, had ever been able to witness the
> eruptions of all the larger geysers, although many had remained
> a week or two in the Basin.[6]

*17. Arnold Hague (1840–1917), geologist, and one of Yellowstone's
most important early geyser enthusiasts, 1896. National Archives.*

No doubt many of the park guides and stagecoach drivers of that
era were also geyser gazers. Geologist Arnold Hague, in discussing Giant
Geyser's tendency in 1883 to erupt every two weeks, gave that strong impres-
sion: "The average interval was 13 days, 14 hours, and 45 minutes, which was
at that time in accord with the popular opinion of *the guides* [emphasis
added] that it was, as they termed it, a fortnightly geyser." On August 18, 1911,
Hague was able to predict an eruption of Great Fountain Geyser because of
something "he had previously been told by one of the guides." The guide had
noted in good geyser-gazer fashion that an hour and a half after the first
overflow of the pool the final eruption would begin.[7]

A visitor's diary confirms Hague's mention of "the guides" who were in place in 1883. Frances and Henry Reynolds traveled to Yellowstone that summer by wagon and spent three days in the Upper Basin where they saw Giantess, Splendid, Grand, and other geysers in eruption. They mentioned that the "shouting of the park guides" attracted them to Grand Geyser and that "the guides gave out . . . timely information" so that a good crowd could be on hand for an eruption of Beehive Geyser. Two of these guides, whoever they were, personally escorted the Reynolds party around Geyser Hill.[8]

These early geyser enthusiasts imparted much information to visitors as well as to park employees such as stagecoach drivers or park guides, who in turn passed it on to their visitors. In fact, some of these enthusiasts were themselves stagecoach drivers or guides, including the driver who chauffeured Edmund Muspratt to the geyser basins in 1884: "We were lucky in seeing seven or eight [geysers] play, as our driver knew the signs and drove furiously to reach the springs in time for the display."[9]

Other geyser enthusiasts are known. G. L. Henderson often served as geyser gazer, as did George Marshall, an early park guide, and "Geyser Bob" Edgar, a stagecoach driver. An 1885 stage driver named James O'Neill was a geyser aficionado, for a passenger noted that "he knows, apparently, each one of the 600 odd holes in the ground in the National Park from which hot water flows or is projected to greater or less heights, together with their varying characteristics." At Old Faithful, this traveler reported that O'Neill came running to announce, "[T]he Castle is going off!"

Two other early geyser gazers, J. C. Callahan in 1887 and an unnamed man that Mrs. Carbutt met in 1888, are mysteries. Callahan is known only because Leslie Quinn, a twenty-year park employee, recently purchased his 1887 geyser-eruption card in a second-hand store. The Yellowstone Research Library holds a copy of it, but no known library possesses an original. The card reads: "A Record of the Eruptions of the Largest Active Geysers in the World; the Upper Geyser Basin, Yellowstone National Park. Compiled from official reports, personal experience and observations, by Mr. J. C. Callahan, during the season of 1887." The card then lists geyser eruption statistics for twenty-eight geysers, as well as distances and altitudes in the park. Apparently Mr. Callahan, whoever he was, spent much of the summer of 1887 observing geysers and writing down his observations. Mrs. E. H. Carbutt's mention of another early geyser researcher is similarly intriguing. She met the man in 1888 at Upper Basin and noted: "Our [walking] Guide told us he had been on the spot [at Upper Basin] over a year and had watched the geysers carefully.

He said none except Old Faithful worked at regular intervals." Both Callahan and Mrs. Carbutt's guide are puzzles that simultaneously intrigue and torment historians. The two men's notes on geysers, if they exist, have not surfaced, and nothing else is known of them.[10]

George Anderson, who was superintendent of Yellowstone 1891–1897, was also very interested in geysers. He ordered his soldiers stationed in geyser areas to keep records on geyser eruptions during the seasons of 1893–1897. And with one of his compatriots, Anderson constantly looked at and studied geysers. The artist Frederic Remington reported: "Both Captains Anderson and [G. L.] Scott have a pronounced weakness for geysers, and were always stopping at every little steam-jet to examine it."[11]

An 1895 traveler between Fountain Hotel and Upper Geyser Basin mentioned the way the park guides and drivers traded information among themselves, especially with regard to geysers: "It is common to hear the guides say to each other: 'They say that Old Buster went off last night,' or 'Is there any indication of The Grotto [Geyser] doing anything?'"[12] This exchange of information was a form of park interpretation and storytelling and is the same thing that park naturalists, concessioner tour guides, and geyser gazers do today in Yellowstone. Park administrators noticed by 1898 that the trading of such geyser information might be useful for visitors. The superintendent declared that year that eruptions might be predicted from the temperature of the water, and that if so the park would start making geyser predictions to "thus afford tourists the opportunity of seeing them."[13]

F. E. Corey and Roland Grant watched geysers in the first decade of the twentieth century. Corey, a medical doctor from Alhambra, California, got interested in Yellowstone geysers about 1900, and he seems also to have been a lecturer. In 1903, he wrote to the park:

> For several years I have been giving talks and showing views of
> the National Park to entertain my friends and so have become
> much interested in geysers and have formed in my mind a
> theory of their cause; whether new or not I do not know. I have
> engaged to give an exhibition soon and would like very much
> to get some more information.[14]

Nothing more is known of him, but researchers do know something of Dr. Roland Grant whose geyser gazing apparently covered a very long period. An article of his, published in a scientific journal in 1908, discussed visits he

made to the park once "before the railroads" (pre-1883), and then again in 1891, 1899, and 1900. The article hinted that Grant made other visits for the purpose of examining thermal features. If more of his notes or articles could be found, they might shed important new light on the thermal or interpretive history of his period. Like other enthusiasts, Grant no doubt gave impromptu "tours" of geyser areas to anyone who would listen, so it is unfortunate that more is not known about both him and F. E. Corey.[15]

A number of hotel porters— and probably other employees about whom little is known—became geyser and hot spring enthusiasts around the park: at Old Faithful, Fountain Hotel, Norris Hotel, Mammoth Hot Springs Hotel, and even West Thumb. Yellowstone Park Association (YPA) company records indicate that they were hired not only for their hotel duties, but also to conduct walking tours for visitors through park thermal areas. For example "Joe," last name not given in the guidebooks, was a hotel porter at Old Faithful Inn during the first ten years of the twentieth century. In an era when there were no National Park Service ranger walks or talks, Joe, by virtue of his intense interest in and knowledge of the geysers, filled the void. Joe was apparently there for at least the seasons of 1903–1908, and probably for a number of others as well. His storytelling via geyser walks became well enough known to merit these lines in a guidebook, under the heading "The Walk With Joe":

> "The Walk With Joe" over the Geyser Basin will prove a most
> interesting one. Incidentally, "Joe" is the head porter of the Inn,
> was there before it was built [1904], and I may add, he knows
> more about geysers as they play or don't play, than anybody. He
> tells his story well, in a style peculiarly his own, composed of facts
> as to geysers' habits and reliable statistics. Joe gets his information
> first hand; he arrives in the Park early and stays late, and being a
> close observer as to geysers (his stock in trade) he is able to tell
> you when the Giant played last and when due again; with the
> others just the same, and his calculations are accurate. "Joe
> says" is to be relied upon. Joe's hour for starting is usually after
> luncheon; he will make it known when he is ready. Joe's excursion
> over the formation commences at Old Faithful and extends north
> to the Riverside, taking in all the geysers of importance.[16]

Interestingly, these identical lines were included in the 1914, 1916, and 1923

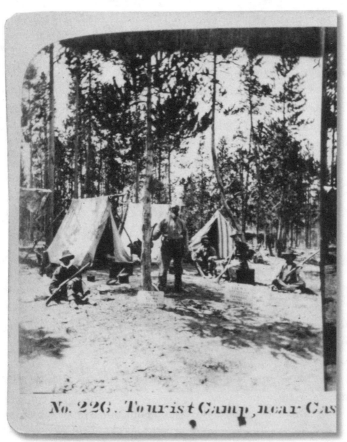

No. 226. Tourist Camp, near Cas

18. Photographer H. B. Calfee's "store" at Upper Geyser
Basin from which he sold photographs of Yellowstone
Park and predicted geyser eruptions, about 1879.
Courtesy YNP Photo Archives, YELL 129275.

editions of the same guidebook, giving us the impression that either Joe was
still there or, more likely, that the same or similar interpretive walks with
other guides had simply become homogenized into "The Walk With Joe."

"Joe" was probably Joseph Peng, an early geyser enthusiast who pre-
pared a 1909 "Geyser Time Table" based on his seventeen years of observa-
tions in the park. Peng was probably the person who conducted these "walks
with Joe," for the time period is contemporary. From this guidebook it

appears that Peng arrived in the park as early as 1893 and watched geysers for at least the next seventeen years while serving as a YPA guide and apparently head hotel porter. If only the notes that he must have kept survived to tell researchers of the geyser eruptions he undoubtedly saw![17]

All of the park stagecoach companies hired "walking guides" to give tours for their patrons of park thermal areas, but the Shaw and Powell Company actually kept a person at the Old Faithful camp—today's Old Faithful Lodge—who monitored geysers to give their predicted times of cruption to visitors. This person, depending upon the intensity of his interest, was probably at times an early geyser gazer.[18]

So few examples of past geyser gazers are known—although it is likely that there were more than are chronicled here—that two others from a later period should be mentioned. They are a somewhat mysterious Dr. John R. Van Pelt, who studied geysers from about 1918 until 1926 or so, and Thomas J. "Geyser Bill" Ankrom of the 1930s. Dr. Van Pelt arrived in Yellowstone sometime just after the National Park Service was created (1916) and appears to have been present most if not all summers through around 1926. He became interested in geysers and reached the point where park personnel routinely consulted him for geyser information. By 1926, he was an NPS naturalist at Old Faithful. Ansel F. Hall, chief naturalist for the NPS, seems to have consulted him regularly, but little else is known about Van Pelt. His geyser notes and reports, if they exist, have not surfaced.[19]

Considerably more is known about "Geyser Bill" Ankrom who arrived in Yellowstone in 1929. His biography, published in a newspaper in 1932 (see Appendix Two), reads as if he could have been one of today's geyser gazers, i.e., a person truly possessed by thermal phenomena and willing to share his knowledge with any visitor who straggles by. He was also an avid defender of the geysers and made it his personal mission to protect them. Ankrom left detailed notes on his observations of geysers for the years 1931–1933 that repose today in the Yellowstone Research Library.

Modern geyser gazers, who join the long host of aforementioned historic geyser enthusiasts, are organized and continue to aid park education and storytelling in Yellowstone. Most of them are members of an organization known as the Geyser Observation and Study Association (GOSA), based in California, and they aid interpretation in Yellowstone by gathering and reporting information on the constantly changing geyser scene in a newsletter, on an Internet chat-line, and in an annual publication. Some of Yellowstone's best thermal experts belong to this organization, and they often give

the same kinds of impromptu talks and walks through thermal basins that their less-organized forebears did. A number of National Park Service personnel in Yellowstone are members of this organization. Many National Park Service persons believe the organization provides a valuable, free service to the park and to visitors, in an endeavor—geyser monitoring—that the NPS has never had the money or the manpower to adequately carry out.

Early Yellowstone geyser gazers were "horse-and-buggy tour guides" who told stories about park thermal features. They helped educate park visitors by telling them what they knew about geysers and hot springs. But two individual personalities have ranked higher to historians of interpretive activities than those who only watched geysers. A discussion of these two forefront guides, P. W. Norris and G. L. Henderson, is critical to any analysis of Yellowstone storytelling.

Philetus "Windy" Norris

The "First" National Park Interpreter

*Farewell Windy. We shall never
look upon thy like again.*

—Bozeman *Avant Courier*,
January 26, 1882

*Style is just the interpreter himself.
How does he give it forth? It emerges from love.*

—Freeman Tilden, 1957

\mathcal{T} he debate as to who was the first "real" interpreter of Yellowstone National Park must, without adequate information on the life of William Isaac Marshall, come down to a contest between Philetus Walter Norris (1821–1885) and George Legg Henderson (1827–1905). If Marshall was earliest of the three, Norris was the first storyteller—interpreter—in the government and thus in a position to accomplish more and for a longer period than Marshall. But G. L. Henderson's interpretive contributions were the deepest and certainly the longest of the three men. Regardless, these men were arguably the three most important of Yellowstone's horse-and-buggy tour guides and the three most important of early park storytellers.[1]

P. W. Norris, the second superintendent of Yellowstone, certainly ranks among the top three contestants for the exalted, indeed iconic, position of "first" national park interpreter. If the style of a storyteller comes from love of what he interprets, then Norris must have had a grand style, for he loved

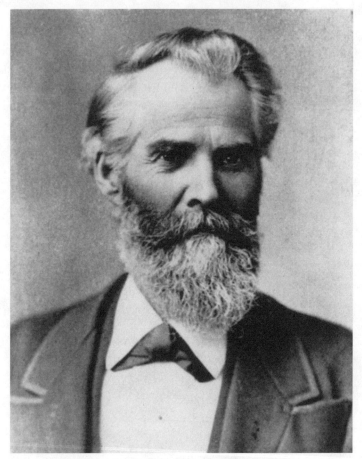

19. P. W. Norris, Yellowstone's second superintendent and early park interpreter, about 1880. From the frontispiece to Norris's Annual Report of the Superintendent of the Yellowstone National Park to the Secretary of the Interior for the Year 1880 *(Washington, D.C.: GPO, 1881).*

Yellowstone above almost all else. In the early gathering of park information and in its communication to visitors and officials, Norris was at the forefront.

Historians have provided several brief studies of Norris, but surely this fascinating man, who opened Yellowstone and therein found his true reason for being at the age of fifty-four, merits a full biography.[2] His successors were

political hacks and army officers. Not until Horace Albright took Yellow-stone's reins forty years later would Wonderland see such a hard-charging, hyperactive personality. Norris was explorer, archaeologist, ethnologist, geol-ogist, zoologist, writer, editor, naturalist, historian, museum collector, tour guide, hunter, camper, fisherman, carpenter, road builder, businessman, supervisor, manager, planner, speechmaker, and poet. In short, he was all of the things that today still make a good national park interpreter.

Born in 1821 at Palmyra, New York, Norris was a storyteller from his ear-liest days. At the age of 8 he guided visitors to the falls of the Genesee River for ten cents a person. This experience, he said, cultivated his love for outdoor adventure and especially for waterfalls: "From the time of my childhood duties as guide at the Portage Falls of the Genesee River in New York, toil and danger have ever been pastime with me in reaching the best point attainable above a cataract for rapturous enjoyment [of the] quivering rainbow mist."[3]

His romantic mention of the "quivering rainbow mist" shows an under-standing of waterfalls: their prismatic, falling waters often produce, in sunlight, a rainbow that shimmers evanescently and gives pleasure to the beholder.

Norris's formal schooling has been described as "neglected," and after that he taught himself, although he seems to have been a voracious reader and later became a competent, if longwinded, writer. After trapping for the Hudson Bay Company, founding the towns of Norris, Michigan, and Pioneer, Ohio, and prospering as a real estate agent, Norris served as a cap-tain in the Civil War. His severe injury in a West Virginia engagement was surely fate changing, for by leaving the army in 1863 he remained alive, where so many Union captains did not, to mightily influence Yellowstone's history. His flourishing real estate business coupled with a newspaper he owned gave him the financial ability to undertake frequent exploring jun-kets into what he called the "Great West." Thus his loves of travel and the West developed into all-consuming passions to the apparent detriment of his family life; he seems often to have left his wife and children to ramble the American West, carrying only a locket with a photo of the woman back home. By the time he got to Yellowstone, he loved to think of himself as a pioneer, and he certainly looked the part: with long hair, flowing white/gray beard, buckskins, and an aristocratic yet rustic personal aura. A traveler who saw him in 1878 described him as conspicuous because of his "gaudy buck-skins and feather."[4]

In 1870, Norris attempted to explore present Yellowstone National Park *before* the famous Washburn expedition saw it, but got only as far as a high

spur of Electric Peak to look south into the place of his ardor before spring freshets and the loss of some equipment drove him back. Norris had met Jim Bridger in 1844, and Bridger or someone else must have told him about the wonders of the Yellowstone country, for Norris wistfully remembered wanting to "reach the famous Yellowstone Lake of the fur trappers by means of the great cañon from below."[5]

After his 1870 failure, Norris tried again to visit Yellowstone, this time in 1875, with more success. Accompanied by Adam Miller and other mountaineer friends, he explored much of the new park, realizing with his life past middle age that Yellowstone was to be, for what was left of it, his life's work.

He applied for the park superintendency in 1877, using such influential friends as N. P. Langford, Morrison Waite, and Truman Everts as references. Everts, lost in Yellowstone in 1870, had been offered by Department of Interior officials the first park superintendency but had turned it down. "You are the one that ought to have it," he admitted to Norris.[6] So Norris petitioned the Secretary of the Interior for "appointment as Superintendent of the . . . Great National Park of the Yellowstone . . . or such other position there as you may . . . deem judicious."[7] His friend J. W. Farrar applauded Norris's selection only a few days later, saying: "I certainly think the Administration have hit upon the right man for once and believe if anyone can successfully explore and bring out to the view of the people of the country the great beauty and magnificence of that Wonderful Land you are the man."[8] That phrase, "bring out to the view of the people of the country," would prove prescient, for Norris was to play a conspicuous early role in the interpretation of the beauty, the wonder, the inspiration, and the spiritual meaning behind Yellowstone.

As park superintendent from 1877 to 1882, Norris approached his job with a flamboyancy that compelled attention. One newspaper correspondent, who stumbled upon Norris in the woods, recalled his encounter with stunned enthusiasm:

> We were carefully following the "blazed" trees up the steep
> mountain trail, when we were startled by a loud voice,
> which echoed and re-echoed through the trees for a long
> distance. . . . In a few moments a strange figure came around
> the point of the mountain. He had on a broad-brimmed
> white hat, looped up at the side and decorated with an

eagle's feather. Long white hair reached far down upon
his brawny shoulders; a white waving beard ornamented his
breast. He wore a buckskin hunting-shirt, decked with a
long, flowing fringe. He wore a belt full of cartridges, and
had a revolver hanging at his side. He also carried a hunting-
knife. He swung a tomahawk in his hand. He rode a gallant
steed. I was struck with awe.[9]

Norris struck others with awe, too. He was, after all, constantly using
his energy and sonorous voice to interpret the new Wonderland, both in
print and in person, for he truly believed one of his primary duties was to
"assist tourists with information and guidance." He began this task in 1877 by
publishing park rules and regulations in Bozeman newspapers, and tacking
interpretive signs up around the park. Another early storytelling task was
conducting a celebrity party, which included General William T. Sherman,
around the park. Thereafter, Norris spent most of that first summer explor-
ing the park, learning its animals, and acquainting himself with its diverse
topography. In the process he discovered he had no park policy to follow, no
funds with which to work, no police force to help him, and no personal
salary.[10] Indeed, he had taken the job for no pay.

In 1878, however, Congress allocated the first monies for Yellowstone's
management, giving Norris the opportunity to undertake the first substan-
tial road-, trail-, and bridge-building efforts in the region. These projects
were to continue for his entire term in office, and for them Norris would
become celebrated as the "pioneer pathfinder and explorer of the park."[11]
He decried vandalism and poaching and proposed that a park police force
be established. In 1879, he built the first park administration building (at
Mammoth) and the first building of any kind at Old Faithful. In 1881, Norris
constructed the Queen's Laundry bathhouse, the first government building
constructed specifically for the use of the public in any national park (it was
intended for bathing). He also set up the first park postal service.[12]

From an interpretive viewpoint, being an enthusiast in everything per-
taining to the park, Norris did more than simply erect cloth signs. He wrote
tables that contained point-to-point distance measurements. He registered
the names of tourists. He gave place-names. He explored the park energeti-
cally and drew maps and made reports of his discoveries, often seasoning
them with stories of the hardships he encountered. The scientist in him was
curious all the time; thus he kept records on a total eclipse of the sun he

observed, and he kept a meteorological record that forms the beginning of the park's weather records. He began the recording of geyser eruptions and became the first to note a relationship between thermal and seismic activity. In the interest of science, he busily collected specimens for the Smithsonian Institution, in one case sending them an entire geyser cone. He saw resource problems. Worrying that Liberty Cap would fall over, he braced it with timbers. Afraid that Devil's Thumb was deteriorating, he piped hot mineral water to the top of it to ensure travertine deposits. And he showed concern for park visitors: at Grotto Pool and Crystal Falls, Norris built a "rustic bridge" with benches "for tourists to linger upon," and erected ladders for them to climb so that "rapturous views" could be had of the "quivering mist of the waterfall." Norris's wide interests would become invaluable not only to the young Yellowstone Park but also to the National Park Service's eventual embracing of park interpretation and ultimately to the pursuit of scientific knowledge in national parks.[13]

Norris was obviously thinking interpretively and beyond simple road construction when he stood in front of his road-building crew and dutifully announced:

> Mountain comrades—while labor in the construction of roads
> and bridle paths will be our main object, still, with trifling care
> and effort, much valuable knowledge may be obtained of the
> regions visited . . . all of which, including the discovery of
> mountain passes, geysers, and other hot springs, falls, and fossil
> forests, are to be promptly reported to the leader of each party.
> As all civilized nations are now actively pushing explorations
> and researches for evidences of prehistoric peoples, careful
> scrutiny is required of all material handled in excavations; and
> all arrow, spear, or lance heads, stone axes and knives, or other
> weapons, utensils or ornaments; in short, all such objects
> of interest are to be regularly retained and turned over daily
> to the officer in charge of each party, for transmittal to the
> National Museum in Washington.[14]

Norris also became the park's first wildlife manager, and there are seeds of storytelling in this, because visitors have always wanted information about Yellowstone's wildlife. Having witnessed the slaughter of Yellowstone animals in 1875, he documented it in his reports and warned that if the slaughter were

*20. This pipe carrying hot mineral water to the top of Devil's Thumb,
a travertine cone at Mammoth Hot Springs, was one example of
P. W. Norris's diverse efforts to preserve the park's natural wonders.
Haynes Foundation Collection. L. A. Huffman, photographer, 1882.
Montana Historical Society Photograph Archives, Helena.*

not stopped, the park's animals could soon become extinct. He urged in let-
ters and reports that they be protected by "a determined resident superin-
tendent and police." By 1879, he could report some progress in protecting park
animals, and in 1880, his official report on the animals was a documentary
milestone in the history of Yellowstone fauna. In full naturalist fashion, Norris
attempted to summarize the abundance, distribution, and condition of park

wildlife. He was an avid if formally unschooled naturalist, but he worked hard to gather information and to present it to the public and his superiors, constantly appealing, as park interpreters do today, for the park's preservation. In 1880, Norris appointed Harry Yount, sometimes touted as the first "park ranger," to be Yellowstone's first gamekeeper.[15]

In history, archaeology, and ethnology, Norris's legacy was even more far-reaching. His reports contained long expositions on the documentary and oral history of Yellowstone. He discovered numerous ancient and modern campsites of the resident Sheepeater (and probably other) Indians and their pottery, arrowheads, and other remnants, and in this became Montana's first archaeologist. He found a tree carved with the initials J.O.R. and the date of 1819, as well as a cache of Hudson Bay Company traps, which to him proved conclusively that white fur trappers traveled through the Yellowstone country fifty-one years before its final discovery. He discussed with visitors the presence of Shoshones, Bannocks, and Crows in the Yellowstone country. Again, the seeds of park interpretation can be seen in all of these areas.

Norris's storytelling was delivered to his contemporaries around nighttime campfires, or in the form of park tours on horseback. Certainly he was a skillful, if garrulous, talker, which earned him the sobriquet "Windy" Norris in a Bozeman newspaper. W. W. Wylie stated that "in all my time in the park I never found so great an enthusiast over the park's various objects of interest." Carrie and Robert Strahorn, two visitors in 1880, found him a little too talkative: "We were lulled to sleep by the deep, sonorous voice of Col. Norris who forgot to stop talking when he went to sleep, and he was still talking right along when we woke up at midnight."[16]

The diary of army officer John G. Bourke revealed that Norris gave verbal interpretation to Bourke's large party in 1880 on at least two occasions in speeches that seem to have been more than just simple directions. For example, at Yellowstone Lake, Bourke stated:

The lake is *crammed* with them [trout], but so many are filled with worms that we did not care to eat any. *Mr. Norris* gave me his explanation of this singular phenomenon. He says that a species of the dragon-fly, which is very numerous about the Lake at certain seasons, deposits its larva on the water and that the trout swallow the larvae either in the water itself or with the fly for which they are always greedy. After hatching out in the intestines of the fish, the larvae pass through an intermediate

state of worm-hood, so to speak, and live upon the flesh of the
trout until they are ready to assume the condition of dragon flies
where they bore their way out through its flesh. Nearly all the
trout and salmon trout in this Lake are thus affected; the wormy
ones have a pale, sickly looking flesh even where the worm itself
cannot be discovered.

In this Norris had apparently talked to or read a work by Edward Campbell
Carrington, zoologist with the 1871 Hayden survey to Yellowstone, wherein
Carrington had attributed the trout worms to the swallowing of insects by
fish. Thus, Norris was conveying the best scientific information of his day
even though the trout worms were later linked more closely to pelicans than
to dragonflies.

At the Grand Canyon, Norris continued his storytelling to Bourke's
party. Bourke reported what Norris said to them:

On the side opposite to our position, a bright green field of grass
spreads down from the timbered hills to the very edge of the
precipice and there terminated in a fringe of a single row of
pines, proving the occurrence of a great land-slide at some not
distant day. *Mr. Norris* says that such slides are occurring
constantly and are brought about not only by the heave frosts of
winter, but by the thermal springs of which this region is so full.
The cañon below the Falls is 1500 [*sic*–800] ft. deep and cannot
be descended in more than one or two places. *Mr. Norris* tells
me that there are so many hot springs jetting out into the river
that for a considerable distance this enormous flow of water is
made too hot to be bearable.[17]

If Norris overestimated the canyon depth here, he was correct in his analysis
of geological processes and water temperatures.

Only one specific interpretive program given by Norris has been found
(no doubt he gave others), a lecture delivered in late 1879, but to whom is not
known. A newspaper editor stated that Norris lectured on his own road
building and other park objects:

Mr. P. W. Norris, the Superintendent of the Yellowstone National
Park, recently delivered a lecture on some of the natural

curiosities of the region, in which, he described, as one of the most notable, a mountain and a road of glass.... Great fires were built on the glass, to thoroughly heat and expand it, after which cold lake water was dashed on it, causing the glass to cool, and large fragments to break off from the surface. These were broken into small pieces with sledges and picks, and thus was constructed *the only glass wagon road on the continent*.[18]

Norris took park interpretation seriously and constantly conveyed information to park visitors. Mrs. L. D. Wickes got some of it from him in 1880. She declared appreciatively that near the Lower Falls "we met the Superintendent of the park, Mr. P. W. Norris, who sent us elk meat for our dinner, and with it much valuable information."[19] Likewise, H. B. Leckler and his party enjoyed their 1881 encounter with "Colonel" Norris, who was no more a colonel than any of hundreds of others who received that honorary nineteenth-century title. Leckler praised Norris's speaking ability as well as his achievements in general: "The Colonel is a most entertaining talker and a pleasant gentleman, and we passed a delightful evening with him. He is completely wrapped up in the Park, and works and slaves for its benefit without a thought of himself.... Colonel Norris is just the man for the position he occupies, and conducts affairs most admirably."[20]

Of course Norris conveyed information in ways other than verbally. He prolifically penned letters to his superiors. He authored an 1883 guidebook to Yellowstone entitled *The Calumet of the Coteau* (Peace Pipe of the Divide) that contained much of his poetry. Here at times his imagination and romanticism ran wild, but he managed to record quite of bit of what otherwise would have been lost history in his poems and in his book's extensive endnotes. His writings were embroidered and flowery, like an old-fashioned quilt, and at times he seemed swept away in his language and his affection for Yellowstone:

My comrades [and I] sat enraptured amid the magic beauties of the petrified forest, [amid] the enameled cornice[s] of the volcanic battlements around us; and down, down [we sat] amid the lengthening shadows of the western mountain peaks in the winding Soda Butte valley, with its ancient geyser cones, its emerald trout lakelets, its evergreen groves alive with elk and antelope.... [And the] snowy crests of its surroundings,

rendered it to us matchless of [all] earthly scenes in all our
wanderings.[21]

"Matchless" was one of Norris's favorite words, and he used it constantly,
making suggestions to his superiors about changing park boundaries, develop-
ing park concessions, and licensing park guides. These were suggestions his
bosses in the Department of Interior long ignored. Not until after he left were
real hotels established, not until the army arrived were guides required to be
licensed, and not until the 1930s were boundary changes completed.

Norris was a sincere and energetic leader who was devoted to the pub-
lic interest. But he had his critics. Historian Hiram Chittenden lambasted
Norris, claiming he

> saw everything there through a magnifying glass; and, like
> Don Quixote, beheld in what he saw the embodiment of
> all his overwrought fancy had led him to expect. It was an
> impossibility for him to talk or write of that region without
> exaggeration. . . . All his distances, descriptions of scenery,
> personal achievements, are grossly overstated.[22]

In this last criticism, Chittenden, too, exaggerated. Norris's distances were
generally correct, and his descriptions were flowery but not otherwise over-
stated. Chittenden's comments smack of jealousy. Norris had an ego, to be
sure, but people have their idiosyncrasies. He was a romantic, but he also
knew that he was accomplishing important work in Yellowstone, and he
knew that he was the first to do it.[23]

Norris's romanticism, however, was partly to blame in bringing him
down. He managed to get on the wrong side of several important interests. The
town of Bozeman, through its newspaper editor, got angry because its people
perceived that he supported the Union Pacific Railroad instead of the
Northern Pacific. The newspaper editor was downright mean at times, stating
on December 23, 1880, that Norris was "an old rattle-brain whose highest
ambition appears to be writing doggerel verses." Bozeman citizens also be-
lieved that Norris supported Virginia City over Bozeman as outfitting point to
Yellowstone. In turn, Virginia City citizens were angry with him because they
thought Norris supported Bozeman over them when he took an honest stand
in the mail fraud scandals that tainted their carriers. None of these beliefs was
true, but in the midst of it all, Interior replaced Norris in early 1882.

Yet another possible reason for Norris's removal is that perhaps Secretary Carl Schurz did not like the condition of the roads in the park.[24] Norris labored valiantly to do the most with his limited resources and against great odds. Forced to spread his money thinly, he probably alienated Schurz. But he loved Yellowstone above almost all and certainly had only its best interests at heart in everything he did.

It can be argued that Norris even gave up his wife and children for his life in Yellowstone, as he left them for years to ramble the West. Except for one of his sons, his family never came to Yellowstone with him even when he was superintendent. After his death in 1885, his wife married his bitterest business rival. One of his poems hints at what must have been an emotional conflict for him:

> Farewell to my business
> Farewell to my home
> Adieu to my loved ones
> My fate is to roam
> 'Mid the pure crystal fountains
> And geysers below
> The wild circling mountains
> White glistening with snow.[25]

No less a park interpreter than G. L. Henderson acclaimed Norris, averring that he "did the preliminary work with an unselfish devotion and enthusiasm that shortened his life." "In all that relates to Yellowstone Park," concluded Henderson, "he should be gratefully remembered."[26] Norris was an unrestrained romantic and had an imaginative, yes, almost a Quixotic mind. In this he was very much like G. L. Henderson, who arrived the year he left.

The blustery, storytelling Norris had truly set the stage for basic visitor education and interpretation in Yellowstone. But more would be required for those things to flower. Something radically deeper was needed, something that would "bring things down and incarnate them," as master interpreter Freeman Tilden would say seventy-five years later. Those things came to Wonderland in full bloom in 1882, in the person of G. L. Henderson. Many of today's National Park Service interpreters would probably call him the greatest storyteller that Yellowstone has ever known.

CHAPTER NINE

G. L. Henderson

The Other "First"
National Park Interpreter

The park became ... a part of my existence. I was
absorbed by it and wished, above all things, to have the
people of the United States and all the rest of the world
realize that in this great Republic there is a World's
Wonderland more marvelous than the wildest dreamers
of the Orient could conceive or imagine. I wished the
world's workers, thinkers, and artists to have access to it
at the least possible expense, and to remain in it for the
longest possible time, see it, admire it, breathe its
delightful and invigorating atmosphere and go
home ... improved in mind and body.

—G. L. Henderson, 1892[1]

*W*ith those words, G. L. Henderson summed up the labor and love of his life in a way that revealed his concern for park visitors—people about whom today's park interpreters share his interest. In 1882, only a few months after P. W. Norris left, there arrived in Yellowstone this very special person who was to devote the rest of his life to its storytelling and promotion. Henderson would become the national park's first real interpreter and the most important of its storytellers. Although Norris did his work earlier, his interpretive activities did not have the depth, length, or diversity of Henderson's.

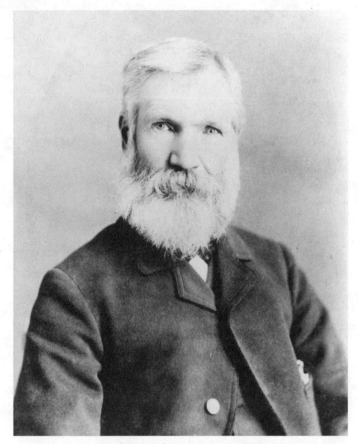

21. George L. Henderson, about 1895.
Courtesy YNP Photo Archives, YELL *36675.*

So important was Henderson as a park interpreter and so little has he been discussed that his biography becomes central in the story of Yellowstone interpretation.

George Legg Henderson, like Norris, was to discover in his mid-fifties that Yellowstone was what he had been looking for all of his life—a raison d'être. During his twenty-plus years of association with Yellowstone, he would become known as *the* recognized authority on the park, while serving as assistant superintendent, park explorer, hotel owner, tour operator and conductor, interpreter, newspaper writer, place-name giver, parlor

lecturer, congressional lobbyist, and finally "Park Nestor"—a nineteenth-century term for wise counselor. He was the acknowledged expert in his day on Yellowstone, and was probably *the* first person to care a great deal about factual accuracy and effective communication in his speeches to park visitors. And, as will be seen, he was also the first person to be formally referred to as "park interpreter."[2]

G. L. Henderson was fifty-four years old and three years divorced when he arrived in Yellowstone just before June 1, 1882.[3] Little is known of his early (pre-Yellowstone) life other than the following: He was born in Old Deer, Scotland, "in a cottage on the banks of the Ugie [River]," on October 5 (or 8), 1827, as the oldest of six sons and five daughters of Thomas and Barbara Legg Henderson, who immigrated to the United States in 1846. Brief biographical materials published late in his life stated that his family settled first for two years in Illinois, then moved to Iowa, and then to Minnesota where G. L. became connected with the selling of farm machinery and the buying and selling of grain.[4]

In Iowa, the Henderson family landed in Fayette County where "Henderson Prairie" was named for them. In Minnesota they landed eventually in LeRoy (Mower County). Because he was nineteen before he emigrated, G. L. Henderson remembered and took great pride in his Scottish heritage for the rest of his life. A life-long Republican—the party of the liberals in those days—Henderson was an Iowa convention delegate for Abraham Lincoln. One of his brothers, David B. Henderson, became an Iowa congressman and later Speaker of the U.S. House of Representatives; so by 1882, G. L. had political "pull." Because of David's influence, park superintendent Patrick Conger appointed Henderson "sight unseen"— something Conger must surely have regretted later—to be his assistant superintendent in early 1882.[5] According to Conger and the local newspaper, G. L. and family arrived in the park at the end of May 1882.[6]

All that is known of this move to Yellowstone is what Henderson wrote for a newspaper called *The Graphic* about a family of "pilgrims" that was probably his own:

> Looking back into the year of grace 1882, we see seven pilgrims
> leaving the Northern Pacific railroad at Miles City, Mont.
> They are headed Parkward on three Rocky Mountain schooners.
> Up hill and down, fording swift-running rivers, through great
> gorges where the schooners were held from swamping by ropes

attached to the rigging. After fifteen days of wearing wandering
they at last entered the sacred portals of the World's Wonder-
land. They see the steam from the Boiling River. . . . Two miles
further they. . . gaze for the first time on the grim faces of the
Sphinx [Liberty Cap], at the foot of the grand terraces.[7]

Henderson brought with him to the "grand terraces" at Mammoth Hot Springs
his son Walter J. and four daughters ages fifteen to twenty-nine: Helen L.
(sometimes called Nellie), Barbara G. (sometimes called Lillie or "Lellie"),
Jennie H., and Mary Rosetta. It is interesting to wonder why all of G. L.'s near-
ly grown children accompanied him on this long journey to the wilds of
Montana and Wyoming instead of remaining back home in Iowa with their
mother Jeannette. Perhaps Jeannette was having trouble making a living for
herself and numerous children. Perhaps a messy divorce was a factor. The chil-
dren were grown or nearly grown, so perhaps they went along for the adven-
ture or for the prospects of later employment.

Whatever the reason, the Henderson family rode the Northern Pacific
Railroad, completed at that time to Miles City, Montana, and boarded wagons
for their fifteen-day journey on to Yellowstone. At Mammoth Hot Springs, the
family initially moved into P. W. Norris's administration building on Capitol
Hill and a year later into an old building that had been constructed by James
McCartney.[8] That latter building was then located immediately north of the
present commissioner's residence, and the family used it as a post office and
store. Henderson later described it as "an old log cabin situated on the Hotel
Plateau, windowless and utterly unfit for habitation." He spent his own money
making it habitable, and eventually the government reimbursed him.[9]

Henderson was appointed assistant superintendent as a replacement for
Norris's man Clarence Stephens, and by thus arriving in 1882, a year ahead of
the rest of the assistant superintendents, he had theoretical seniority over the
others. (As will be seen, this was not to help him.) Henderson's daughter
Barbara G. was appointed postmistress to replace Stephens on July 5, 1882,
beginning a line of Henderson family postmistresses and postmasters that was
to last for almost thirty-five years in Yellowstone. Barbara's appointment, along
with her father's, assured the family a home in the park.[10]

Superintendent Conger and G. L. Henderson disliked each other almost
immediately. They probably started off on the wrong foot when Conger found
Henderson and his family occupying the park administrative headquarters
on Capitol Hill, with Henderson more or less assuming the superintendent's

powers in a *de facto* manner. But apparently the two men got along passably until 1883, when Conger began to believe that Henderson, whose brother was influential in the government, was playing a part in machinations to remove Conger. This was not true—that skullduggery was hatched by the Hobart/Douglas hotel clique—and Henderson's subsequent reports to Conger and to the Secretary of the Interior make it appear that he behaved honorably throughout the affair, even when Conger attempted to scuttle him on several occasions.[11]

Little is known of what Henderson did during his first Yellowstone summer of 1882, but one less-than-positive account has surfaced. The traveling editor of the *Omaha Bee* claimed that Henderson charged him "thirty-five dollars per day for a competent guide to tell me the names of the principal objects of importance." That action may have been attributable to Superintendent Conger's known inability to pay his subordinates, and perhaps Henderson badly needed money because of Conger.[12] At the end of that season, Superintendent Conger left the park, but G. L. and his family remained behind to endure the first of many long, dark, Yellowstone winters. It was during periods like these that Henderson wrote the many newspaper articles that would preserve so much Yellowstone history of the next twenty years.[13]

One 1882 visitor greatly influenced Henderson. He was a Frenchman, M. Massicotte, whom Henderson called the "globe trotter" of Paris. "If France owned these terraces and no more," proclaimed Massicotte to Henderson, "she would expend millions in opening highways and by-ways, so that the whole world might come and see them." This comment that Henderson heard his first summer in the park remained on his mind ten years later as he lobbied Congress for improvements to Yellowstone's roads, hotels, and transportation systems.[14]

On June 1, 1883, just before his reappointment to the position of assistant superintendent was published in the newspapers, Henderson had a confrontation with Superintendent Conger. His handwritten and rather dark account of their imbroglio has come down to us:

> Two weeks ago I had a letter written by my brother David containing [excerpts] from two letters from persons who had heard the major [Conger] declare with the pomp and pride of an emperor that he intended to dismiss me from the service of the Govt. Nellie read the letter and compelled me to destroy it as she did not believe a word of it and that I ought not to

bother my brother with such gossiping details. I consented and tore up the letter but today after I had made up the mail the major entered the office where I was at work and told me with all the pomp of a King and with a malevolent glare in his eye that . . . "I am ready to settle with you." At first I thought he was joking and said "Settle what[?] July 1st the end of this fiscal year[?]" His reply was that he would release me from all further services now. But [he] did not stop to settle and walked away. [Here Henderson mentioned some politics that might have come between him and Conger and stated that as a subordinate he had tried hard to get along.] He has subjected me to every conceivable form of insult and injustice and would now have driven me with my family from the only home we have.[15]

Walking down to confront Conger, Henderson asked him if he meant to order the family out. Conger responded that he had warned Henderson that at the end of the fiscal year he would be fired. Henderson replied that the end of the year was June 30, and that under the new law he (Henderson) had instead been reappointed assistant superintendent. Said Henderson, "He looked thunderstruck and said I had been plotting and conspiring to secure my appointment when I ought to have frankly told him so he could have prevented [it]." Upon learning that Henderson had been reappointed, Conger's attitude softened, and he offered the McCartney building for the family to live in. But G. L. Henderson from this time on was ever to watch his back "against Conger's malicious despotism."[16]

Conger continued trying to get rid of Henderson up to the day he (Conger) was replaced. Their conflicts made it certain that Henderson would work more independently on interpretive ("park guide") matters and less on the administrative matters with which Conger was occupied. While Conger could make life unpleasant, Henderson knew that he and the other assistants had been appointed by the Secretary of the Interior; they reported to the secretary and not to Conger.

Although Congress had intended the assistant superintendents to be policemen to protect the park from poaching and vandalism, neither Conger nor any of his new men except Henderson understood that. It is likely that Conger saw these men as mere tour guides; the local newspaper referred to them as "the park guides, for such will be their duties,"[17] and that is what they did that first summer. According to the newspapers, a few of the new men

scammed tourists by demanding payment for their guide services. And according to a special agent of the Department of the Interior, some of them sold geyser specimens to tourists and flagrantly refused to enforce the new "no hunting" edict.[18] When Henderson showed more interest in being a guide than in being a policeman, Conger logically should have embraced that.

Instead, Conger continued to make trouble for Henderson, noting in one of his reports that "in reference to Mr. Henderson, I know but little of what he does. . . . He has never reported to me in person nor in writing save once, in each case."[19] He attempted to manipulate events to make it look as if Henderson and his family were illegally selling geyser specimens at the Mammoth post office when in fact the specimens were from outside the park and Conger had given his permission for the family to sell them. He refused to replace Henderson's government horse that had been earlier killed, forcing Henderson to use his own animals and saddle. And he indicated in his letters that he wanted to pin illegal game killings on Henderson, claiming falsely that he did not know until December 31, 1883, that Henderson was even still on the payroll. Henderson successfully rebutted the specimen charge by enclosing letters from witnesses to the secretary. Still trying to make Henderson look bad, Conger repeated his claim that he did not know what Henderson did with his time.[20]

What Henderson was doing in 1883 was a myriad of interpretive tasks telling the story of the fledgling Yellowstone Park: giving park rules and regulations in person to each tourist party, continuing to explore the Mammoth area and giving place-names to the terraces, conducting tours for visitors, meeting and escorting VIPs, comparing notes with park photographer Frank Haynes, and gathering statistics on park guides and stagecoaches. He also participated in some law enforcement activities such as watching for poachers, guarding against vandalism of geysers, and warning tourists to put out campfires. And in his spare time he wrote articles for the new *Livingston Enterprise* newspaper and shared poetry with his daughters.[21]

Pat Conger, a petty, crotchety, and vindictive man, believed that these activities were not worthwhile, especially if Henderson was performing them. He continued to write letters to the secretary asking for Henderson's dismissal, stating again that Henderson paid attention only "to his own pursuits." When the secretary refused to fire Henderson without more definite information, Conger resorted to claiming that Henderson was insane. He claimed to have met with Congressman David Henderson at Washington during the winter of 1882–1883, and to have told him then that G. L. Henderson could not stay

longer than a year because "he is of unsound mind and not responsible for his acts at all times." Conger claimed that David Henderson "knows that he [G. L.] has been confined in an asylum for the insane and in my opinion will have to be sent there again should he long survive," an apparent reference to Henderson's age.[22]

The insane asylum business was an astonishing allegation against an honorable if headstrong man by a petty one. At this point historians cannot prove it false, but considering the constant evidence of Conger's vindictiveness in his letters, there are grave doubts as to its truthfulness. Conger was probably afraid of Henderson and/or jealous of him, for he sent one of Henderson's reports to the secretary and stooped to the low level of saying that it should "give some idea of the man. Seven pages of stuff, and not one word of information of any pertinence or importance." That report by Henderson contained statements of his erection of park signs, his addition of a ladder at Devil's Kitchen so that visitors could see that natural feature, an accompaniment of Frank Haynes on a tour for place-names collaboration purposes, an exploration of the Hoodoos area, suggestions for park road improvements, news from the southern park about road and hotel conditions there, and a record of the first park visitor for 1884.

As one might expect from a person who was educated and who perceived himself as persecuted, Henderson fought back by writing at least one negative newspaper column about Conger for the *Livingston Tribune* newspaper. "The 'noble guardian' [Conger] has not carried out the instructions of the Department [of Interior]," wrote Henderson under the pseudonym "Veritas" ("Truth"), "but has acted in direct violation of these instructions." Instancing numerous alleged violations by Conger, Henderson finished by saying, "It is safe to say that his record, and that of his predecessor [P.] W. Norris, is as the crooked trail of a conger eel compared with the perpendicular flight of an eagle soaring into the blue." Thus did Henderson denounce Conger and praise Norris.[23]

Henderson's 1884 activities were obviously important, but Conger may have seen them as insignificant because they were mainly interpretive. Storytelling, like too many other educational activities, is sometimes denigrated, and Conger was probably guilty of it. Why Conger was so angry at Henderson is not known. If he treated his other assistant superintendents as badly, it is not apparent, although he certainly was prone to squabbling with them and got into trouble later for being slow to pay them. Perhaps there was some sort of competition between Conger and Henderson or perhaps

Conger was jealous of Henderson's education or political connections, although he appears to have had at least some of those attributes himself.

Regardless of the reasons, Conger's tactics backfired, for Henderson was now receiving complimentary letters from visitors via Secretary Henry M. Teller, as well as writing his own letters to the secretary. An English professor whom Henderson guided praised him for the great tour and for fixing the road for their party near Summit Lake. The secretary sent Henderson a copy of the letter, and Henderson replied graciously that he would "continue to strive to merit such friendly letters." Henderson knew full well the value of maintaining good public relations, so he sent both Secretary Teller and Assistant Secretary M. L. Joslyn sets of Haynes park photos with captions showing that Henderson and Haynes had given new place-names in the park: "Teller Terrace," "Joslyn's Lake," and "Blaine and Logan Terrace," for the Republican nominees in the upcoming 1884 presidential race. Henderson also apologized to Joslyn for the fact that Superintendent Conger had personally ripped down the signs Henderson had erected at Joslyn's Lake and Joslyn Spring and made sure to tell Joslyn that he (Henderson) had been instrumental in finding the new road route through Golden Gate. Of Conger's I-don't-know-what-he-does allegation, Henderson wrote that notwithstanding it, he had met with the superintendent frequently and told him that he personally greeted nearly all parties who visited the park to give them rules and regulations.

These factors plus Henderson's important brother and Conger's inability to get along with his other subordinates had strong influences in keeping Henderson in place and in ultimately getting Conger fired. Conger's squabbles with the hotel monopoly plus the negative reports on his administration from special agent W. Scott Smith no doubt added further to his problems. And, too, the secretaries were ambivalent in their attitude toward Conger, bending with the shifting of the political winds.[24]

Henderson, however, was having too much fun to fret for too long over Conger, especially when the squabbles had gone his way. Having already given place-names to Orange Spring Mound and Hymen Terrace, he bragged that Mammoth's Bath Lake—his place-name—had been "greatly improved" for bathing by the removal of snags. In the process of conducting tours he gave place-names to Cupid's Cave, Stygian Caves, Painted Pool, Boiling River, Inspiration Point, Ladies' Lake, and many other park features. He erected signboards at many of these places and those signs, coupled with his interpretive tours, Frank Haynes's photos, and his own newspaper articles, helped to press many of his place-names into usage and permanence. (Of the 213 or

more park place-names that Henderson originated, at least forty are still used today.)[25] He was starting to believe that Yellowstone was an enchanted, magical place, the finest place he had ever been. Exploring in the park seemed to him, as it would to many throughout its history, unbeatable and never ending in its adventure.[26]

Henderson was also learning that he loved to show Yellowstone to others. After all, he must have thought, if people came here and saw Yellowstone's beauty, then perhaps they might take some of that beauty back with them, and society might thus be improved if not made completely over for the better. This thinking was becoming almost religious with Henderson. Although he did not write it in those words, that idea percolated through much of what he did write, such as the quote at the beginning of this chapter.

For example, he later recalled that 1883 was the summer in which he truly concluded that Yellowstone was "the pilgrims' Palestine and the pleasure-seekers' Mecca." That year he guided General Albert Ordway of Chicago to the top of Orange Spring Mound and saw the double jets of hot water cascading down its sides "in rhythmic waves like visible music." Said Ordway: "Mr. Henderson, I am satisfied! It is worth coming two thousand miles to see this magnificent, mammoth crystal, were there nothing more to be seen in Wonderland."[27]

The summer of 1883 was a landmark one for VIPs touring the park generally and for Henderson specifically. He conducted a number of important visitors around the Mammoth Hot Springs, and from these men, a number of whom were geologists, he gained much information that he incorporated into his Yellowstone storytelling. Thus, this horse-and-buggy tour guide was receiving scientific information from the best scientists of his day. Ex-superintendent P. W. Norris visited the park that summer "and made his home with me at Mammoth Hot Springs," wrote Henderson many years later. "From him I learned many interesting facts that occurred during his superintendency."[28] In September, Henderson escorted Professor G.M. Von Rath, "the great German geologist" from the University of Bonn, over the terraces. Like any storytelling tour guide, Henderson was not afraid to make use of his guest's knowledge. The professor, said Henderson, "gave a full, scientific and satisfactory explanation" of the causes that compelled "Chameleon Terrace"—probably part of present Angel Terrace—to change its bacterial colors. Henderson named Rath Terrace for the professor, and gave the place-name to Admiration Point, where visitors today look over the Main Terrace from its high western parking area, because Dr. Von Rath there

lifted his hat and exclaimed, "Vonderful! Vonderful! Most Vonderful!"[29] Henderson also conducted W. Lamplugh, an English geologist, over the formations, and much of what he got from Lamplugh Henderson incorporated into a later newspaper article and, as ever, into his tours of Yellowstone.[30]

Henderson met geologists Arnold Hague and Walter Weed of the U.S. Geological Survey that summer. Those men were beginning their long studies of Yellowstone's geology as well as "schmoozing" with the party of President Chester A. Arthur at the park. (Hague and Weed probably served as guides for the President, although escort General Phil Sheridan and a couple of members of his staff had been in Yellowstone before.) Henderson talked to the geologists and probably incorporated some of their scientific information into his interpretive talks. Later, Henderson corresponded with Hague for further information. And in 1884 or 1885, Henderson met geologist John Renshawe of the USGS who gave him geologic information that Henderson used in his forty-page geologic paper "Wonderland—Caves and Terraces."[31]

Henderson's meeting with all these important men and many others during his twenty years of seeking information about Yellowstone brings up the question of his educational background. Although details of his formal schooling are not known, it is apparent that he was educated beyond the ken of most of his day. Superintendent Conger referred to him as "a man who has had quite an extensive reading," and this may have been one of the reasons Conger disliked Henderson: because of fear or jealousy of his education, even if Conger also had education.[32] This is speculation of course, but educated persons are sometimes feared or envied. A 1905 California biography stated of Henderson: "Being a man of culture and education he was one of the most successful [Yellowstone] guides in the district and conducted many of the parties which explored the park for scientific purposes."[33]

Henderson was a teacher in Iowa public schools for a while, and his voluminous writings reveal a keen intellect. His place-names show that he was widely read in classical literature such as Shakespearean plays, Greek and Roman mythology, and the works of many English and American poets. Moreover, a journal he kept for personal writing purposes makes it clear that he had a deep interest in and broad understanding of intellectual matters. For example, two twenty-five-page handwritten essays of his entitled "Sociology" and "Dynamical Sociology," written and delivered in 1873 for the literary society of LeRoy, Minnesota, contain discussions of the importance of the combined disciplines of science, mathematics, and literature in the onward progress of humankind. The included indices make it apparent that Henderson was

familiar with the works of Plato, Aristotle, Descartes, Rousseau, Spencer, Byron, and Shelley, among others.[34] Henderson was well educated, and thus well suited to conduct visitors around Yellowstone National Park.

Another of Henderson's VIP charges that summer was a national figure—U.S. Senator Roscoe Conkling. Conkling had attained notoriety as boss of the New York Republican Party "machine," but had seen his prestige plummet by 1883. He was head of the "Stalwart" wing of the Republican Party that maintained the patronage system, where party loyalty and service were rewarded with jobs in government. An ally of President Chester A. Arthur, Conkling had alienated the other ("Half-Breed") wing of his own party by making vitriolic attacks on them before and during the 1880 convention, and that resulted in the nominating of the Half-Breed candidate Garfield. Chester Arthur was nominated for vice president as a concession to Conkling. After Garfield's election, Conkling continued to make trouble for President Garfield, even resigning in an attempt to have the New York legislature re-elect him with a vote of confidence. That failed, and then the whole sordid mess became a national tragedy and a disaster for Conkling when Charles Guiteau assassinated President Garfield, stood over his body, and stated, "I am a Stalwart, and Arthur is President now."[35]

G. L. Henderson, liberal and progressive in much of his thinking—as Republicans were in those days—had supported Conkling's party politically but must have been hesitant to support the Conkling wing. Nevertheless, he was excited and honored to have the opportunity to guide Conkling around the Mammoth terraces, so much so that when the Senator died of pneumonia following the blizzard of 1888, Henderson wrote a long series of articles about their 1883 tour that showcased his own Yellowstone interpretation while it chronicled the interesting events involving Conkling.[36]

The articles are self-serving, and certainly Henderson painted himself to look as good as possible in them. But they provide interesting insights into Roscoe Conkling as a national figure. More important, if Henderson is to be believed, they offer a fascinating window into the world of one of Yellowstone's earliest storytellers and his Gilded Age park tour.

Arriving at Mammoth in late July of 1883, Conkling proceeded to bathe in Henderson's bathhouse at the foot of Capitol Hill. He managed to scald himself in hot water, and Henderson nominated himself to be nursemaid. Following that misadventure, Conkling entered the log post office where the Hendersons lived, made a graceful bow, and thanked Henderson profusely for his aid. Henderson admitted: "I was profoundly interested in every word, look

and movement of this remarkable man, whose eloquence once swayed and dominated the greatest political party." According to Henderson, Conkling signed the hotel guest book, and then said:

> Professor, I am told by one who knows, that you are the
> acknowledged student and interpreter of these grand
> terraces, caves, boiling lakes, living, dead and dying cones,
> and that you have given all these substantial somethings
> a local habitation and a name. Therefore I ask that
> you will do me the honor of being my interpreter,
> guide, philosopher and friend tomorrow, and if
> need be a monitor.[37]

Even at that early day, Henderson's reputation as park guide was becoming established. According to Henderson, Conkling had used the term *interpreter* twice.

Thus on July 31, 1883, Henderson began to guide Conkling's party around the terraces. Conveyed by carriage to Orange Spring Mound, the party gathered around Henderson. Conkling's niece asked him why the Mammoth terraces insisted upon enveloping and killing innocent trees. Henderson stated that he told them:

> Nature is at once the creator and destroyer. But there is
> this to be said in her favor, that though she seems to be
> deaf, dumb and blind, she has given us ears to hear her
> unconscious music, tongues to voice her emotions, . . .
> eyes to see her wonder-working modes and judgments
> with which to comprehend some of her processes at least.

Henderson then proceeded in good interpretive style to equate the terrace-building world with "our human world."[38]

Continuing the tour, Henderson took the party to one of the Stygian Caves—then called "Stalactic Cave"—to soak up some of the "subterranean glory" there. Henderson got angry a couple of times at the senator's petulances, including his taking of a specimen from the cave, and in that moment became an early example of an interpreter who also helps protect the resources of Yellowstone. And he described to the Conkling party the cave's ability to kill birds, insects, and small animals with its gases:

[It is] literally a cave of the dead. Even its entrance is covered with dead beetles, birds, mice, and whatever comes within the baleful death-dealing carbonic acid. The writer has yet to give his experience in attempting to explore this den of the Basaliak [Basalisk?], one glance of whose eyes expels the spark of life from every mortal thing.[39]

At the White Elephant Back Terrace, Henderson says the party toasted his interpretive skills. After he had walked with his conductees along the length of the terrace and explained the origin of its name, Conkling asked the party whether they thought nature had made the terrace in verisimilitude like an elephant or the elephant in imitation of the terrace. One of the others commented to Conkling's niece, "I think, sis, that our guide is as much poet as philosopher, and we have been made to see Miss Similitude through his poetic glasses."[40]

Near Angel Terrace, Conkling asked Henderson a question that visitors occasionally ask park interpreters today: How could he be content to be located "amid this solitude" three quarters of the year "to meet and mingle with men the other fourth, many of whom will look at these wonders with no more interest than an ox takes in gazing at the sun that calls him from his bed to his breakfast?" Replied Henderson, "Contented men are . . . scarce," but "I am happier at least than he, for my companions three-fourths of the year are silent but instructive, and during the other one-fourth I am satisfied to convey that instruction to as many as are in search of information."[41] Henderson loved living in the wilderness, away from the cares of cities, and he loved telling visitors about Yellowstone's magic. Visitors who denigrated rural people did not intimidate him.

The party then moved to Admiration Point to see Cupid's Cave, "Cleopatra's Bowl," and Anthony's Entrance. It was here that Henderson's vivid imagination had earlier nearly run away with him in the naming and describing of these features, for this had become one of his favorite spots with which to entertain tourists. "Cupid's Cave"—today called Cupid Spring, for the cave has been naturally filled in by spring deposits—was a vapory cavern in the Mammoth Hot Springs, which was then topped with a huge, beautiful, round and dripping hot spring formation called by Henderson "Cleopatra's Bowl." The drippings from Cleopatra's Bowl caused colorful bacteria—then called "algae"—to grow in Cupid's Cave, and the two together made quite a showpiece in 1883. Henderson took every opportunity to

point them out to visitors, including the Conkling party. Henderson says he walked the group into a small alcove south of the cave at a place he called Anthony's Entrance, named for Marc Anthony, the lover of Cleopatra. As usual, Henderson's vivid imagination ran wild when he described the spot:

> Anthony's Entrance admits you . . . to this mysterious labyrinth where the blind god [Cupid] hides in his rose-tinted cave, and the voluptuous queen [Cleopatra] has her toilet and dressing room and a washbowl [Cleopatra's Bowl] that all the wealth of ancient Rome, with all the artists of Greece, could not produce or even imitate. At this entrance there is the round chimney of an extinct [hot spring] with a rim closely resembling a horseshoe, and there is a legend that lovers must sit upon it for good luck, before venturing into the presence of the blind god who haunts the cave. We all sat down on Gluck Auf.[42]

"Gluck Auf," which means "Good Luck" in German, was the name Henderson had given to a travertine rock (now unlocateable) at Anthony's Entrance because its rim was shaped like a horseshoe. It was here that Henderson wished his tour parties good luck. The story he had made up here was and is one of those fanciful tales that makes tour-guiding fun. It is apparent from many accounts that no one in his day could give a park tour like G. L. Henderson.[43]

Near the end of the six-hour tour, Senator Conkling appears to have again paid at least some tribute to G. L. Henderson's tour-guiding abilities. Henderson quotes him as follows:

> Professor, I have been thinking . . . how admirably you have mastered the art of so presenting these wonders as to secure the undivided attention of the pilgrim. You may be either unconscious of the art, or [else] you are artful enough to conceal it under the very simplicity of your method . . . your method of presenting these wonders and the order of their presentment is a triumph of art. . . . It all seemed so natural and simple that, like everything that carries us out of ourselves into any special subject, we never suspect that the chief artist in the drama has anything to do with the emotions that delight us. . . . But when I remember the skill with which you have

conducted us through the intricate mazes of this labyrinth of
unfathomable mystery, I scarcely know which most to admire—
the infinite complexities of nature or your admirable art of
interpreting her.[44]

Henderson says he modestly averred that he did not deserve the compliment.

While Henderson's long account of the Conkling tour is self-serving,
the testimony of many others exists as to his interpretive prowess. According
to these numerous patrons, Henderson's tours of Yellowstone were note-
worthy in their presentation. He entertained and educated his tour groups
with Yellowstone poetry like his "Song of the Sphinx"—a poetic tribute to
Liberty Cap at Mammoth—and his "Song of the Geysers," an 1884 poem
to Old Faithful and other geysers. Other favorite Henderson treats for visi-
tors were his "Thanatopsis Geyser" which he named for Bryant's famous
poem, "Othello's Fountain" which he named for Shakespeare's play, and
"Evangeline Geyser" which he named for Longfellow's epic poem. His
description of "Evangeline," today known less creatively as Thud Geyser, was
typical of the way he let his imagination run wild, so absorbed was he in the
magic of Yellowstone Park. The spring's shape and the thudding sound it
made reminded Henderson of a beating heart, and he linked that image to
the melancholy Evangeline. In the poem, Evangeline and her lover were
long separated. Finally, as an old woman in a convent, she met him, an old
sick man in a pauper's hospital, and they died together. Henderson had a
romantic explanation for his "Evangeline Geyser." In it one can easily see
that he used this kind of imaginative imagery to weave beautiful stories for
Yellowstone visitors:

> The Evangeline... has been recognized by all who have seen this
> beautiful geyser as one of the most appropriate of names. The
> outline [of the spring] is heart-shaped. The pulsations suggest
> the beating and throbbing of a heart. The crimson colors seem
> to flow from a broken, bleeding heart. There is also a heart
> within a heart, suggesting the inseparable union and undying
> devotion. The geyser, as a whole, is a picture, a poem and an
> ideal to those who have read [the poem] Evangeline, and who
> can at once recall all the emotions of sympathy, sadness and
> admiration for the human qualities, that became the theme of
> Longfellow in his divine poem.

As you stand on the outer margin [of the spring] ... you become aware of a tremulous motion, terminating in a slight concussion. These [pulsations] increase in frequency and force until you become convinced that beneath your feet there is a throbbing heart. There are deep drawn sighs, terminating in a convulsive sob. Is it Evangeline agonizing over her lost lover? Are you actually treading on a bleeding heart? Looking to the south side of the crater: there is a crimson current oozing away from the river. The illusion is complete. It is the bleeding heart of Evangeline.[45]

By 1884, G. L. Henderson, with his government appointment seemingly secure, was writing regular reports to Conger. His duties as assistant superintendent continued to include such law enforcement ones as monitoring campfires of tourists, preventing specimen collecting, and trying, often unsuccessfully, to apprehend illegal hunters. Frustrated by a lack of printed circulars to give to the public, by his lack of real authority, and by a seemingly lawless class of men, he did the best with what he had. "It is well understood," fumed Henderson, "that some lawless men know, or seem to know, that there is no legal authority to arrest and punish for any violation of park regulations." Henderson persevered beyond his job description in trying to help visitors. He fixed the wagon road at the west end of Narrow Gauge Terrace when it threatened to envelop the dusty track, and he repaired the main road above Snow Pass. He put out a small fire and helped fight a large one at Cinnabar Basin.[46]

But Henderson was more interested in the park guides and in telling visitors about park wonders than he was in law enforcement or maintenance chores. He reported to Conger that individual guides Billy Hofer and a Mr. Crowel of Bozeman were deserving of praise and enthused: "There seems to be a competition this season among guides and teamsters to establish good reputations in their care of tourists. . . . I do all I can to foster this rivalry among the Park [tour] conductors and think it works admirably."[47] Henderson cleverly appeared to keep statistics for Superintendent Conger by listing the names of park guides that had done an outstanding job for July of 1884. About them he stated: "[O]n their return the parties employing them are quite willing to enter on the record their estimate of the value of their guides."[48] He stated that he had had "finger boards" erected at Mammoth Hot Springs "to inform visitors where to find springs and other objects of

interest."⁴⁹ And Henderson noted that on May 29, 1884, he obtained permission from the park superintendent to construct and insert a ladder into Devil's Kitchen cave. Thus, Henderson originated interpretive tours of that cave. From then until it was closed in 1939, thousands of Yellowstone visitors entered the Devil's Kitchen during their tours of the Mammoth terraces.⁵⁰

Disliked by Superintendent Conger, Henderson was nevertheless cannier than Conger. In August, he penned this clever missive to his superior:

> On one occasion I had with me [in the terraces] a member of
> the British Association, with some friends, who were deeply
> interested in the phenomenal aspects, from a scientific point
> of view, of the Hot Springs and Terraces. It is hoped that quite a
> number of the members of this learned body will be induced to
> visit the Park after their meeting at Montreal. I am well aware
> that you encourage educators and the representative men of
> scientific bodies to make the National Park a field for their
> labor. They expressed themselves as being well satisfied with
> the courtsey [sic] and assistance shown them by the Assistants
> [Superintendents].⁵¹

Thus Henderson shrewdly set the stage for the continuing of his interpretive tour guiding while simultaneously trying to keep good relations with Superintendent Conger.

By 1884, Henderson had done much thinking about visitor education, storytelling, and touring in the Mammoth Hot Springs and had given more than a hundred place-names to the Mammoth area. He had written voluminously about his activities in local newspapers and in his own personal journals. He stated, "Intelligent guides may be secured at the [National] hotel to conduct visitors to all points of interest that lie within six miles of the hotel. To do this well requires three days of honest, faithful, steady work." His comment here about "honest, faithful, steady work" was probably a reaction to his realization that Conger put little value in interpretive work. Henderson then proceeded to name the places to which one should go over the "seven plateaus" of the Mammoth Springs, advising in his usual swept-away fashion that tourists rent a team to take them to the top of the springs so that they can descend "easily and comfortably through the seven great valleys [terraces] with their numerous caves, cliffs, lakes, hot springs and ... complete collection of curiosities in nature's great museum."⁵²

And as ever, he continued to conduct tourist parties over the Mammoth formations. "Asst. Superintendent G. L. Henderson went with us to all the places of special interest at the Mammoth Hot Springs," gushed satisfied English visitor Herbert W. Rowe in June of 1884.[53] And a party Henderson guided in August extolled his tour and applauded his interpretive style:

> On Sunday afternoon we formed one of a party under the kind guidance of assistant superintendent G. L. Henderson that leisurely and carefully explored a great part of that wonderful [Mammoth] formation. Mr. Henderson has lived three years at the Springs and, being a man of much scientific knowledge, rare intelligence and high appreciation of nature, he is better competent than any man living to be the guide and instructor of the stranger visiting Mammoth Hot Springs. He knows all the most interesting spots and how to reach them; his long residence there enables him to explain how the formation of the terraces has proceeded from year to year, and what changes are taking place—how one part is falling into decay, while another is assuming the beauty and freshness of new life as the invigorating water, charged with lime, magnesia, sulphur, arsenic, etc., forms for itself new channels, builds a new terrace, or re-clothes an old one with delicately tinted or gaudy rock. His explanation of the cause of the phenomenon is doubtless the true one, and it is worth recording.[54]

While conducting visitors on Thursday, August 21, 1884, Henderson managed to do a little bit of early park resource protection in the form of stopping thermal vandalism. William Sturgis reported that his party traveled over the Mammoth formations with "one of the Superintendents." That had to be Henderson, considering that Henderson was the only government person conducting tours at Mammoth and considering that Sturgis mentioned the "lucid statements of our guide as to the previous visits of congressional Solons" (probably a reference to Roscoe Conkling, Henderson's earlier charge). Sturgis's party wrote a poem entitled "Washingtonian Episode" in which they discussed how the "eagle eye" of the Superintendent spotted two small boys busily collecting geological specimens with the aid of "that forbidden tool, a hatchet." "Tomorrow morning they must go," chortled the poem, "to make their peace or catch it, from either the Superintendent or the

cook who lent the hatchet." It is apparent that G. L. Henderson was vigilant in protecting the park's beautiful hot spring formations.[55]

Also in 1884, Robert G. Ingersoll, the well-known orator, visited Yellowstone, and Henderson was his guide. Ingersoll, being an agnostic in an era of fire-and-brimstone theology, was a controversial figure in nineteenth-century America. But Henderson, being generally liberal in his thinking, found Ingersoll so interesting as a patron that he named a portion of one of the Mammoth Terraces for him: "Ingersoll Terrace." The two men seem to have become mutual admirers, for Ingersoll wrote to Henderson applauding his interpretive skills, and thus echoing some of the comments Roscoe Conkling had made a year earlier:

> Your philosophy of the Terraces satisfies the intellect. Your
> method of presenting them in the increasing order of interest
> and beauty is an art which you thoroughly comprehend.
> The marvelous aqueducts and levees of Periodical Lake; the
> inexpressible beauty of the Minerva Terraces affected me
> like fine music.[56]

Today's park interpreters can probably identify with this quote in light of Freeman Tilden's declaration that park interpretation is an art.

Still another important man of science that Henderson conducted in 1884 was Dr. George Harley, an inorganic evolution and thermal specialist from England. Henderson got into a long discussion about geysers with him, and ended his account with, "[S]uch are the men whom it has been my privilege to meet in Yellowstone Park." Harley later wrote to Henderson:

> Thanks for your song of the geysers. It recalls the pleasant and
> profitable hours spent with you in the Upper Geyser Basin.
> I concur in your theory of the geysers, as it is supported by
> recent scientific inductions. Your statements sustain my theory
> of inorganic evolution. I send you my pamphlet "Geysers,"
> written on my return to England.[57]

Geysers were one of Henderson's great interests, and he certainly may be called one of Yellowstone's earliest "geyser gazers." In addition to giving dozens of names to thermal features, his newspaper columns contained discourses on what he had observed in the geyser basins. He made several independent

studies of geysers. His long discussions of Excelsior Geyser's eruptions in 1882 and 1888 are among the most important accounts extant of that noteworthy feature. And his keen interest in the geysers may be seen throughout his writings. In 1887, he conducted Dr. Howard Mummery, a Fellow of the Royal Society from London, around the geyser basins. In 1888, he interviewed scientist Robert Law on experiments involving Beehive Geyser.[58]

Even by 1884, G. L. Henderson was becoming well known as Yellowstone's premier tour guide, interpreter, place-name giver, and writer. He regularly wrote columns about the park for numerous newspapers: the *Livingston Enterprise*, the *Helena Daily Herald*, the Helena *Independent*, the Bozeman *Avant Courier*, the Bozeman *Chronicle*, the *Rocky Mountain Husbandman*, the St. Paul *Pioneer Press*, the *Union* (West Union, Iowa), and later the *Livingston Post* and the *Gardiner Wonderland*. Another, called *The Graphic*, was probably an Iowa newspaper. In his newspaper articles he signed himself "Liberty Cap," "L.C.," or "X.X.X." He used these forums until 1903, to record local activities in Yellowstone, thus saving much history for posterity, and to push his personal agendas of preserving the park, improving its transportation, and getting its appropriations increased. "Yellowstone Park is the world's wonderland," declared Henderson on more than one occasion, "and ought to be vigorously protected and generously endowed."[59]

The account of a tourist party he guided in September of 1884 reveals that Henderson was busily pressing his many original place-names into usage at Mammoth Hot Springs. Interestingly, Henderson's politics were starting to creep into his tours. He had given a place-name "Conkling's Cliff" for the senator of a year earlier, and now one of his place-names reflected the upcoming presidential election for 1884. Said a visitor who took one of his interpretive walks:

> From this point we view Blaine and Logan Terrace.
> I inquired for Cleveland and Hendricks terrace[s].
> Our guide [G. L. Henderson] informed me that "they
> hadn't put that up yet." This view not being [e]specially
> attractive to some [Democratic] members of our party,
> we hastened [on].[60]

In fairness, it should be pointed out that following Republican James Blaine's loss to Democrat Grover Cleveland in the 1884 presidential race, Henderson immediately changed the name "Blaine Terrace" to "Cleveland Terrace." But

both of those place-names have long since disappeared from the map in favor of today's name *Highland Terrace*.

Henderson's penchant for exploring Yellowstone in order to discover new wonders to give names to, and to show to visitors, was evident again in the fall and early winter of 1884. With George Marshall, he explored the Great Fountain–Firehole Lake areas of Lower Geyser Basin, "discovering" many new thermal features and giving names to them and the large basins in which they were found. On this trip Henderson warned that vandalism to thermal features had to be carefully guarded against, and he originated the idea of laying planks down in thermal areas for visitors to safely walk on, the forerunner of present-day boardwalks:

> Mr. [George] Marshall has carefully concealed [the] existence
> [of Microcosm thermal basin] from the ordinary pleasure
> seekers who are apt to poke sticks into everything from mere
> wantonness or curiosity. This basin should be enclosed and no
> visitors admitted except unarmed and accompanied by a careful
> guide. Walks of planks should be laid down to insure safety.[61]

By 1905, Frank Haynes's postcard of "Constant Geyser" at Norris Geyser Basin showed that Henderson's safety idea had been pressed into service, at least at Norris.

The Secretary of the Interior relieved Park Superintendent Patrick Conger of his position on September 10, 1884. He had alienated Henderson as well as persons from the earlier Norris administration (all of them people who could have helped him) and thereby "was left to mire himself in ever-greater difficulties." In his place, the park received a superintendent who was even more unfit for the position than Conger. Historians have not treated him kindly, mainly because Robert E. Carpenter saw Yellowstone Park only as an instrument for profit and not as something to be protected.

Carpenter let the condition of the park deteriorate even further than it had under Conger. He was a puppet for the corrupt and inefficient hotel concessioner, the Yellowstone Park Improvement Company, and he even attempted at one point to segregate some park land for himself. Under him, park game was again slaughtered. Because Carpenter spent much of that following winter in Washington lobbying for the hotel company, G. L. Henderson did not come to know him very well. And, too, Carpenter was a Republican, and the Democrats had won in 1884. Thus the Secretary of the

Interior dismissed Carpenter and replaced him on June 20, 1885.[62] Meanwhile, Henderson continued to conduct tours, give place-names, and write about the park.

By June of 1885, Henderson had completed his most important writing, a guidebook to Yellowstone. Titled *Yellowstone Park Manual and Guide*, it was destined to have a great impact upon the national park. Henderson published it in order to "enumerate and designate by name what the tourist ought to see and where to look for it rather than attempt any elaborate description or philosophical explanation of the many wonders that confront him at every step of his journey in the National Park." His guide was a newspaper, with text on its front and back pages and beautiful woodcut drawings of park features on its two inside pages. Initially the text was published in the *Livingston Enterprise* before being published on its own. In 1888, Henderson published a second and longer edition of the guide that contained all text and no woodcut drawings.[63]

Because Henderson's guidebook was a newspaper, it could be cheaply printed and widely distributed, and for this same reason copies are difficult to find today. During the period 1885–1890, his little newspaper saw wide acceptance and usage in Yellowstone. Rudyard Kipling obtained a copy in 1889, and made fun of it, mentioning that he saw the colorful Cleopatra's Bowl, "which some lurid hotel-keeper [Henderson] had christened Cleopatra's pitcher or Mark Anthony's whiskey-jug, or something equally poetical."[64]

But Henderson's newspaper was more important than that. Because it contained so many of Henderson's place-names, those names became even more entrenched in local usage in Yellowstone than they already had from his tours. Place-names and storytelling are tied most elementally in the phrase of a park old-timer: "you've got to call it something to talk about it." The local newspaper celebrated Henderson as a name-giver, promoter, and interpreter by saying:

> If Prof. Hayden is the 'Father of the Park,' Mr. Henderson is its godfather, for he has affixed characteristic and lasting names to [many features] in the park and has done more than any one person to inform the world of its peculiarly wonderful and beautiful features. He is no mere enthusiast but a firm believer that the Yellowstone Park will become the center of tourist travel in the western world.[65]

The pressing of Henderson's place-names into usage by his guidebook assured that a good number of his names would survive even though they were in competition with the many new place-names being simultaneously given by geologist Arnold Hague. Although Hague's names were "official" with the imprimatur of the U.S. Geological Survey, Henderson held the advantages. Hague could not name everything, and he was there only in the summer. Henderson, on the other hand, was there all year long to repeat his place-names again and again during his talks and in writing. Moreover, there is evidence that Henderson kept close company with park photographer Frank Haynes, who helped Henderson out by using many of Henderson's place-names as captions for his photographs. The Henderson guidebook was crucial in preserving many of Henderson's place-names, and probably more of them would have survived had he given clearer locations for the natural features to which he gave names.[66]

Henderson's fondness for the classics—in this practice he followed the Hayden surveys—is reflected in the names he used, such as "Evangeline," "Othello," and "Thanatopsis" springs. And there were so many more! "Bethesda Plateau," "Three Graces Springs," and "Golgotha Geyser" were borrowed from the Bible; "Titian Basin," "Tyrian Spring," "Dome Raphael," and "Dome Angelo" all referred to famous artists; "Walpurgia Lake," Cleopatra Terrace," and "Diana Spring" were taken from mythology or history; and "Marguerite Geyser," "Hiawatha Spring," "Faust Geyser," and "Barbara Frietchie's Well" all came from literature. Henderson's place-names reflected an era when the teaching of the classics was more the norm in the nation's educational system. His classical place-names were interpretive in that they offered a chance for Henderson and his visitors to discuss and learn of analogies between Yellowstone natural features and the classics they represented. Either topic offered a fruitful field for storytelling, but the marriage made them doubly interesting. And, too, his classical place-names offer a comment today on the propensity of interpretation to mimic society or at least to showcase the interests of the individual interpreter.

The local newspaper, which had published Henderson's guidebook, touted his reputation as an interpreter. "We have repeatedly said that Mr. Henderson knows more of the Park than any other man and [we] now repeat it," bragged the publisher. "He yields a graphic descriptive pen, but at the same time his scrupulous Scotch disposition precludes any attempt at misleading. We believe we have seen all the alleged Park guides ever published . . . [and] it is destined to become the standard guidebook of the

Park."[67] Certainly Henderson's guide became at least *one* of the standard guidebooks of its time, and its impact on park place-names is still felt today in the survival of those names.

Almost simultaneously with the publication of Henderson's newspaper, Henderson lost his job as assistant park superintendent. The details of the dismissal are vague, as are many of the reasons for his subsequent falling out with the new superintendent. Although Superintendent David Wear stated that Secretary of the Interior L. Q. C. Lamar dismissed Henderson a short time before Wear took office, that is debatable. The newspapers reported Wear's appointment as the new park superintendent as early as May 23, 1885. He officially replaced Carpenter on June 20, but did not arrive in the park until July 1. Henderson received notice of his dismissal on June 2, and wrote a gracious letter acknowledging to the secretary that he was no longer to occupy his position after June 15.[68]

Why Secretary Lamar dismissed Henderson is uncertain, but probably the action was politically motivated, as had been the dismissal of Superintendent Carpenter. Cleveland and the Democrats won the 1884 election, and Henderson was a Republican who supported Blaine. But it also appears that David Wear's opinion of Henderson was being shaped even before he (Wear) arrived in the park. Geologist Arnold Hague appears to have bent Wear's ear forcefully about affairs in the park on their long train ride out to Yellowstone. What he told Wear is not known, but by Wear's second day in the park (June 2), the new superintendent could write, in what was no doubt a direct reference to G. L. Henderson whom he had barely met, that the superintendent's assistants were "old, worn out, and utterly unfit . . . a change of the entire force would be beneficial."[69] One cannot help but wonder whether Hague was mad at Henderson over their common legacy of giving place names in Yellowstone and had decided to demean him to David Wear.

Regardless, relations between Wear and Henderson appear to have been bad from day one. Part of this was no doubt simple politics and Hague's likely badmouthing of Henderson, but the correspondence between Wear and the secretary indicates that things were quickly getting worse. A postal inspector's letter stated that Henderson and Wear "became involved in a misunderstanding touching some rulings made by the latter to which the former took exceptions. The matter culminated in charges of mismanagement being preferred against Supt. Wear by Mr. Henderson." By August, Henderson's congressman brother was involved, alleging mismanagement of the park, and Wear was angry. In turn, the Hendersons were angry about Wear's stopping

construction of their Cottage Hotel. Wear averred that G. L. Henderson was "a notorious old scoundrel and has made trouble with nearly all the former Superintendents." This was untrue, as of the four former superintendents Henderson had not gotten along with only one (Conger).[70] Regardless, it was just as well that Henderson was no longer an assistant superintendent, for he and his family had come to see that a more prosperous future for them lay in providing services for tourists.

Thus, during the summer of 1885, while Yellowstone was breaking in the new superintendent, Henderson, his son, and four daughters began construction of their new Cottage Hotel. The family already was running the park post office and a store in the post office; now they expanded their businesses. G. L. Henderson's foot was in the door as a park concessioner, a considerable step up from government employee in pay and status. During his three years in the park, Henderson had fallen in love with the place. Now the Cottage Hotel and his family's other park businesses would allow him to stay for seventeen more years, in order to make continuing contributions to the history, literature, concessions, and storytelling of Yellowstone.

Friction between Henderson and Superintendent Wear clouded that rosy picture, however. Wear was angry with Henderson for getting him into trouble at the congressional level. When the Henderson family changed building materials in their hotel from logs to frame, Wear halted construction. The Hendersons fumed and wrote to the secretary. The secretary sided with the Hendersons, but not before relations had become so bad that Wear had his mail delivered to Gardiner because he feared the Hendersons were opening it at Mammoth. That allegation was never proven.[71]

Superintendent Wear's dealings with the Henderson family would prove indirectly to be his downfall. G. L. Henderson may have still been miffed about his removal from the assistantship a year earlier, but there is little doubt that he was angry about Wear's interference with his Cottage Hotel. Thus Henderson made sure his congressman brother was kept abreast of happenings in the park. National politics, including Congress's dissatisfaction with the way the park had been run for several years, was also entering the picture. The result was that David B. Henderson rose on the floor of the House of Representatives and spoke against a bill to continue the salaries of the park superintendent and assistants. He roundly derided Wear's administration and the men who were Wear's assistants. With David Henderson's opposition, the bill died, and suddenly no money was available for the park. This opened the door for the U.S. Army to replace David Wear on August 17,

1886. The Hendersons were now rid of Superintendent Wear and free to continue the unfettered running of their Cottage Hotel.[72]

Before beginning the story of the Cottage Hotel—one of several side stories that shaped and influenced G. L. Henderson—it is well to note that the Hendersons, who put visitors up in their home, considered the idea of running a hotel earlier than 1885. (This probably illustrates that G. L. Henderson had some of the classic interpreter's concern for park visitors, although his practice was at least partly commercial.) The Hendersons obtained their lease for the Cottage Hotel on March 3, 1885, and a business ledger from the hotel—the same volume that was used by the Henderson girls for penmanship and poetry exercises—has fortunately survived. It shows that in the summer of 1885, during the building of the Cottage Hotel, the family lodged guests all season in some sort of temporary quarters, although just what quarters is not known.[73]

The Hendersons began construction of the Cottage Hotel in the summer of 1885. After hiring George Gordon of Livingston to manage it, G. L. Henderson traveled to St. Paul to purchase interior furnishings. His family and hired help began work on the building, which was located just south of the present Mammoth gas station. In keeping with his vivid imagination, Henderson built the hotel at the foot of what he called "Temple Mountain," for the Cottage Hotel was in many ways his temple. By November, the *Livingston Enterprise* could report that "G. L. Henderson's hotel, three stories high, built of round, peeled logs but very finely finished is an imposing as well as unique structure." As an afterthought, Henderson erected an addition, 30 x 85 feet in size and two and one-half stories high. The finished building in 1886 could house 150 guests in seventy-five rooms. Henderson must have been excited. From the hotel he could run interpretive tours of Yellowstone with his own fleet of carriages and staff of tour guides.[74]

Henderson's first guests arrived on Christmas day of 1885: five gentlemen who registered, then swam in seventy-five-degree water in Bath Lake. It was a warm Christmas that year at Mammoth. Henderson celebrated the event by publicizing it in his magazine article "Yellowstone Park—The Great Winter Sanatorium for the American Continent." In this article he extolled the virtues of bathing in the Mammoth Hot Springs and listed those persons supposedly cured of various diseases—consumption, dyspepsia, rheumatism, and genital disorders—by so bathing. Such health ideas were fashionable then, but they eventually fell out of favor. And, too, such bathing is no longer permitted, due partly to the potential for damage to the springs.[75]

To celebrate and promote his new hotel, Henderson held a masquerade ball in February of 1886. He wrote of it: "[A]ll of Yellowstone gathered at the Cottage Hotel to [have] supper, after which the dance went on" and "mystery and metaphor were veiled under impenetrable masks." In a reference to what were probably himself and his dancing partner at the costume party, he declared that "a Highlander with kilt, plume, and sporran, spun round and round with a little frightened Red Ridinghood." He held another such costumed ball in 1888.[76]

The Hendersons ran the Cottage Hotel for three years, offering, in comparison to the park hotel company, lower-priced but quietly competent accommodations and stagecoach tours to Yellowstone visitors. For much of that time they were open year-round, housing employees and occasional off-season visitors. During this period, Henderson was usually feuding with his competitors, the nearby Yellowstone Park Association that ran Mammoth and other hotels in the park and its shadow owners, the Northern Pacific Railroad. Henderson constantly complained that the railroad used every underhanded tactic it could think of to drive him out of business. These tactics included discriminating against his Cottage Hotel customers in other parts of the park and attempting to steal his customers at the Livingston and Cinnabar train stations. Henderson's 1888 guidebook was full of such stories and allegations. The railroad was big and the Hendersons were small. They and their Cottage Hotel suffered constantly under the yoke of NPRR threats, and as a result the entire family had its share of disheartening moments.[77]

But the Hendersons and their hotel also had successes. Henderson fought back by using his newspaper guidebooks not only to promote Yellowstone, but also to sell his hotel and transportation business. He published numerous letters from satisfied patrons and used them as advertising. He hired smart, conversant tour guides and drivers, including his own daughters and their husbands, and trained them to give interpretive tours using his own up-to-date scientific information. He pioneered the hiring of persons who spoke other languages with at least one guide, William C. Douglas, who spoke French. And he used different routes for his guests so that they would see natural features and animals that the NPRR/YPA tourists did not. Then he printed testimonials on the visitors' reactions:

We had the good fortune to have your man Milligan with us
all over the great geyser basins. We went by the way of Sulphur
Mountain and Glen Africa [Basin] down east fork Park, a route

seldom traveled by other tourists. In consequence we saw a band of Antelope sporting as if in an undisturbed Eden . . . Our guide adjusted himself entirely to our wishes, making great speed or lingering to give us ample time to see all the marvels as the case seemed to demand.[78]

Henderson's use of the new route through Hayden Valley to Mary Lake was a smashing success. In late 1887, he conducted writer Frederick Stanhope through Glen Africa Basin, and Stanhope's account makes it clear that Henderson talked about the Bombshell Geyser and the volcanic geology of the area to them. The new route was so successful that the NPRR soon began imitating it.[79]

Henderson's customers loved him, and many wrote long letters to newspapers and to him personally attesting to that fact:

We had Mrs. Helen Henderson Stuart to guide us over the terraces, and if G. L. Henderson, with his world wide reputation of Park interpreter, can make them more interesting than Mrs. Stuart he is more wonderful than the grand terraces themselves. She is said to call attention to all that is most beautiful, while he presents the science and philosophy of them. . . . The Cottage Hotel association has through its members brought out all the marvelous details, for we are informed that G. L. Henderson has been at the baptism of more than three-fourths of the names by which the wonders of terrace, hoodoo, geyser and glen are known. All we meet tell us that he has devoted the best portion of his life to their study, and that while not a single object in Yellowstone Park bears his name, no portion of it is without the impress of his individuality. We hope to see the day when the Cottage Hotel association shall have a hotel at every point of interest in the Park, with just such guides as Stuart, Klamer, Douglas, Milligan and others to make them comprehensible and fascinating.[80]

Another of the interpretive successes of Henderson's Cottage Hotel was its "museum," and here Henderson again scored a first in Yellowstone. Museums are an important information-and-display component of any park's interpretation and education program and, although no official museums

would be established in Yellowstone until the 1920s, G. L. Henderson set his up in 1885. Two advertisements in his 1885 newspaper mentioned his "museum" that seems also to have been a gift shop or store. Apparently it contained coated specimens from the Mammoth Hot Springs, stuffed animal heads, and mounted birds for visitors to look at and perhaps purchase. Although tourists could purchase items there, they apparently had the opportunity to view them in a display setting as well. Henderson advertised his "museum" as follows:

Cottage Hotel Museum!
Has [Ole] Anderson & [John] Fossum's
Splendid Coated Specimens
In every Style, Plain and Lettered,
Crosses, Anchors, Hearts,
Well adapted for mementoes of the
National Park.
Visitors can leave orders at the Museum
on their way into the Park, which will be
carefully executed on their return.

Cottage Hotel Museum!
Mammoth Hot Springs,
Has a fine supply of taxidermist work
of superior quality.
Buffalo Heads,
Heads of Elk, Deer and Mountain Sheep.
And a full Ornithological Department.
Henry Axtt, Salesman.[81]

Henderson's "museum" seems not to have lasted too long for it was not mentioned in the 1888 edition of his newspaper. While coated specimens were legitimately sold in the park as souvenirs until at least 1914, one wonders where Henderson got his stuffed animals and whether he received heat from park officials because of them.

The years 1885–1889 were banner ones for G. L. Henderson. While operating the Cottage Hotel, he used the time to extend his reputation as Yellowstone's most knowledgeable interpreter, and to promote the park as the world's great wonderland. He decried the lack of signboards and trails in the Norris and Lower Geyser Basins, principally because he genuinely wanted

visitors to see them, writing that finger boards and bridle paths were needed: "There are long periods during the spring and fall, when no visitors are in the Park, and when it would be a light and pleasant labor for the employees of the Park to explore, find trails and in many ways add that human increment that is needed to make Wonderland the earth's university and art room."[82] Already smarting in 1886 from pressure and discrimination foisted upon him by the railroad, he took the opportunity that year to needle one of his competitors' interpretive tour guides who had apparently not taken as much trouble to learn Yellowstone as Henderson thought he should:

> We were surprised to see General [E. E.] Stanley, with his so-called Park guide, pass by without noticing the great gas-aqueous geysers in Parnassus Basin [Thud Group]. On inquiry, we ascertained that the [he named six features] were unknown to the guide and were consequently passed unseen.[83]

Thus did Henderson promote his own interpretive services as superior to others, and indeed they probably were. In fact, by 1887 even geologist Arnold Hague, who had been mad at Henderson in 1885, had come to recognize Henderson's expertise in Yellowstone touring. "Notwithstanding all that can be said about Henderson," wrote Hague to a friend, "he is a fairly good guide for carriage travelers, is enthusiastic and people see far more with him than they do through [hotel company] stage drivers who are changed every year."[84]

By 1888, Henderson had begun to fight with the Northern Pacific Railroad for customers. He spent some of that summer at Livingston's Albemarle Hotel near the train depot promoting his own Cottage Hotel to inbound train passengers. A park-bound newspaper editor who ran into him reported that tourists returning from the park were gathering there to tell big stories about what they had seen in Yellowstone "for the benefit of myself and the other 'tenderfeet' about to enter." This editor found Henderson overpowering in his talkativeness to these tourists:

> They divide the time with an elderly person of great eloquence and marvelous loquacity, who runs a sort of opposition to the Yellowstone Park Association. Mr. Henderson is an old-timer in the Park, and a veritable encyclopedia of information upon all matters in connection with it; but he is something like the

22. At Liberty Cap, G. L. Henderson shakes hands with a member of the William McClintock party of Ohio, circa 1888, while one of his "fine Quincy carriages" stands at rear. In the background at left can be seen Henderson's Cottage Hotel. Courtesy YNP Photo Archives, YELL 693.

Encyclopedia Britannica, which is so voluminous that I have never been able to find anything in it that I wanted. Mr. Henderson has given names to many objects in the Park, and in their nomenclature there is ample evidence of his classical education; but if he could in some way repress in part the tide of his voluble enthusiasm fewer tourists would go into the Park with a headache.[85]

Despite that negative characterization of his locution, G. L. Henderson's reputation as a Yellowstone interpreter became more and more widespread. "He is a gentleman of science," wrote the wife of a university professor in 1889,

"and has had every advantage during a number of years [seven] to make himself familiar with the deep canyons, lofty falls, numerous bathing pools, geysers and lakes—in fact with every nook and corner of that most wonderful portion of our continent known as Wonderland." Her husband, Professor L. A. Lowe, added: "Henderson has worked out the romance of the rocks with the patience of a philosopher and the enthusiasm of a poet. His descriptions of Yellowstone Park are as marvelous as the Park itself." English geologist W. J. Morton was a fan of Henderson's geological discourses, and wrote: "I regard your services as interpreter of incalculable value to the Student and Scientist. An hour with you enabled me to arrive at conclusions that would have required months to accomplish the same results." Here Henderson had truly succeeded as a story-teller, for one of the goals of interpretation is to facilitate the process of the visitor's arrival at his own conclusions based upon his observation and experience. A California patron reported that he, too, had reached such a conclusion: "Dear Professor: Your guidance and presentation of the Grand Terraces made us feel that we were indeed in the Fairyland of America."[86]

If we believe one woman's account in *American Field* magazine, by 1889 Henderson's place-names and walking-tour information were cemented into general usage at Mammoth. Mrs. Paris Junior wrote that a soldier escorted her party around the terraces. Either Henderson had schooled the soldier in interpreting the Mammoth terraces or else the soldier was carrying a copy of Henderson's 1888 newspaper, for Mrs. Junior's long account of their walking tour used so much Henderson information that the conclusion is inescapable. Everyone at Mammoth was looking to Henderson for touring information.[87]

Henderson's geological explanations had also become seasoned. After conducting a party over the terraces in September of 1889, he boasted: "[T]he whole party... thanked me for my guidance and explanation of the origin, construction and erosion that had been going on for so many centuries unobserved and unknown [at Mammoth]."[88]

Such testimony indicates that Henderson, as an interpretive guide and storyteller, had become honed and polished by 1889. His interpretive philosophy had become thoroughly seasoned and mortared into place. Not until Milton Skinner in the 1920s, if even then, would an interpreter of Henderson's stature come again to Yellowstone. In what perhaps remains the most important statement of his philosophy of park interpretation, Henderson enthused:

> When I find intelligent and appreciative visitors I give my whole
> soul to the subject, just as histrionic artists, musicians, or pulpit

orators do. The proper presentation of the park is a fine
art. Many will visit it but once in a lifetime. It is expensive
to make the visit once. How important, then, that there
should be men capable of so presenting it as to make it
the one great event of a life.[89]

In using the word "men" here, G. L. Henderson would probably have
been the first to state that the word was not gender specific and also referred
to women, for he hired the first female interpreter in Yellowstone, his daugh-
ter Helen Henderson Stuart, at his Cottage Hotel. She appeared as such in
several places in his 1888 newspaper, and unless Henderson used his other
daughters at times, as seems possible, Helen Henderson Stuart was the only
female to serve as a park interpreter—and apparently stagecoach driver—
until Horace Albright hired Isabel Bassett to work for the NPS in 1920.

Several years later, Henderson further expanded his interpretive phi-
losophy and motivations when he testified before a congressional commit-
tee. His statement, if one believes it, illustrates that he was motivated at least
to some degree by the altruism of wanting to show Yellowstone to visitors in
order to share what he had learned with others:

My contact with the best minds of this country and Europe
who visited the park as specialists and whose knowledge
I availed myself of as explanations of the phenomena . . .
induced me to observe the changes constantly taking place,
to note rates of growth and erosion, and to give names to
the many objects that excited the thought, admiration, and
wonder of visitors. . . . The romance of the rocks tempted me
and I ate of the tree of knowledge, and like Eve plucked the
fruit and gave it to others.[90]

Even today this "eating from the tree of knowledge" is a characteristic of
many park interpreters; they are controlled by their passion for a place or
subject and for knowledge about it.

Also in 1889, G. L. Henderson conducted the famous Brooklyn Presby-
terian minister T. DeWitt Talmadge through Yellowstone. Talmadge referred to
Henderson as the "inspired prophet and evangelist of the mountains" and
praised Henderson's interpretive abilities: "[H]e unrolled to us that which we
would not otherwise have seen." That comment makes it clear that Henderson

stimulated in Talmadge's party some thinking beyond mere information and that Henderson was thus working in the realm of true park interpretation. Talmadge was also pleased with Henderson's informational output. The minister's statement contained some hints of the evolutionary and geologic commentary that Henderson had given them, surprising in an era when Charles Darwin's theory was still in an uphill battle against creationism. Talmadge stated that to his son, "this week in wonderland has been worth one year in college. He has seen plutonic rocks of the Azoic age side by side with the paleozoic rocks in which the lowest of created creatures first breathed the breath of life."[91] In remembering the Talmadge trip, Henderson referred to himself as "interpretor to this famous party of wonder seekers."[92]

This brings up the question: how early was the word *interpreter* used in Yellowstone to refer to a storyteller or tour guide? The famous John Muir first used the term *interpret* in 1870 in Yosemite to refer to interpretation in that place, which would not become a national park until 1890.[93] But Yellowstone was first to see the term used in a national park setting. According to Henderson, Senator Roscoe Conkling used the word three times in 1883 to refer to his guide G. L. Henderson ("your admirable art of interpreting [nature]," "do me the honor of being my interpreter," and "you are the acknowledged student and interpreter of these grand terraces"). A satisfied patron used the word "interpreter" in 1888 to refer to Henderson ("G. L. Henderson, with his world wide reputation of park interpreter"). Professor W. J. Morton used the term in 1889 for Henderson, referring to "your services as an interpreter." And Henderson himself used the term in referring to the trip with Talmadge. The word was thus well established in usage in Yellowstone by 1889. As will be seen, Henderson continued to use the term until his death.

Even with all of this, Henderson was still having trouble with the Northern Pacific Railroad. To read his accounts of his business is to feel intensely sorry for Henderson and his tiny Cottage Hotel Association, being unmercifully driven out of Yellowstone by the giant, grasping, and greedy Yellowstone Park Association and the Northern Pacific Railroad. Gradually the two wore Henderson down. He wrote constantly of the threats and harassment that they executed. "[Charles] Gibson and [E. C.] Waters have given me fair notice," he complained to the park superintendent, "that they will . . . buy, starve, or drive us out." Although he fought the monopolists tooth and nail by charging rock-bottom prices for his hotels, meals, and stagecoaches, eventually the railroad's monopoly on trains to the park and

YPA's Wal-Mart–like ability to charge less because it was bigger won out. So in May of 1889, Henderson joined them. He sold his Cottage Hotel to the Yellowstone Park Association and went to work for the enemy.[94]

Once again, it was a way for Henderson to continue making a living while staying in Yellowstone. As a condition of the sale of his hotel, he included a clause in the contract that put him on the railroad's payroll—$150 per month plus expenses—as a congressional lobbyist for YPA. He would still be working on Yellowstone Park matters during sessions of Congress in Washington, D.C., where his brother David was now speaker of the U.S. House of Representatives. When Congress was not in session, he would return to the Park and "entertain tourists at the Y.P.A. Hotels during the season, thus extending a clearer knowledge of the Park." That quotation from a Henderson letter makes it clear that YPA, a park concessioner, hired him specifically into an interpretive position, the first such position ever to exist in any national park. And of course his son and daughters and their spouses remained in Yellowstone to run the post office and a curio shop.[95]

According to his congressional testimony, Henderson's motivations for joining YPA and the railroad were personal, but they were also altruistic. Having recovered his health in Yellowstone—he had been ill in 1882[96]—as well as having gained "considerable fame" through an increase of knowledge and experience and a number of publications, he now urged upgradings in park transportation and facilities in order to make Yellowstone "accessible to the millions as well as the millionaire." As facilities and transportation improved, Henderson noticed that park visitation increased. One of his assumed missions having been to "popularize the park by every possible means in my power," he came to believe that the vast improvements in transportation that were needed to make Yellowstone accessible to everyone could only be undertaken and consummated by powerful corporations and large sums of money. Thus in early 1889, he joined the corporation that he had formerly opposed.[97]

Initially, Henderson faced troubles in the transition. The Yellowstone Park Association was at the beginning of a period of extended complaints from the public that would, in just over two years, result in the loss of its transportation rights to another lessee. Henderson was serving as a tour guide for YPA that summer, and he ran squarely into those problems, which had to do with the company's collusion with a stagecoach company to accept partial profits when the stagecoach company had no official lease.[98] In August, New York tourist Richard Grant hired G. L. Henderson to be his family's tour guide in a carriage that he said was old and worn out.

"Henderson . . . we were told, was thoroughly familiar with the ground," explained Grant later, "[he] having previously been in the employ of the government for years." Henderson met Grant's party for the tour, but on taking his seat in the carriage "was peremptorily ordered out by [the transportation superintendent]," complained Grant, "without giving any reason, and told he could not go with us." Grant's party was forced to wait an extra day "in that expensive place," and he stated that the following day "we were allowed to proceed . . . more comfortably and [to] take Mr. Henderson with us." A company official who saw the whole thing stated that the problem was that the stage driver did not want Henderson in his coach, but the driver's boss seems also to have been involved. "The driver don't want old Henderson to go on this outfit," said the official, "and he says he won't take him." These annoyances were not G. L. Henderson's fault, but he was caught between an increasingly trouble-prone YPA and its complaining tourists. One can only guess that there was some lingering animosity between company drivers and Henderson. Even today, park tour guides with great knowledge are often envied by other tour guides, and nearly everyone in Yellowstone fancies himself a tour guide. Regardless of the reasons for the discrimination, YPA would later pay dearly for its transgressions by losing its transportation lease.[99]

For the next few years, less is known about G. L. Henderson because, although his lectures about the park seem to have increased, his newspaper writings decreased during the first few years of his employment with YPA. It is known that he spent much time lobbying for YPA in Washington, and his long statement about some of that time is a matter of record. He averred that "my employment as lecturer during the season was highly appreciated by visitors, especially scientists, artists, and clergymen; numerous letters assured me that my lectures enhanced the interest, and extended a knowledge of the Park."[100] These lectures for YPA included both tours of the terraces and formal evening programs at the Mammoth Hotel. Many of Henderson's letters to government officials survive today in the National Archives, and he produced a lobbying pamphlet entitled *Yellowstone Park: Past, Present, and Future* (1891), outlining many of what he saw as needs of the park—better roads and trails, more hotels, and an improved transportation system. Almost as soon as he arrived in Washington, Montana Senator Wilbur Sanders introduced him as "one who had devoted the best years of his life and the first who had remained at his post, summer and winter, for the purpose of studying the phenomenal features of the [Yellowstone] park, giving the names and classification in conformity with scientific methods." Modest

for once, Henderson replied, "no living man could possibly store away the whole of Yellowstone Park in his head."[101]

He had successes in Washington. Henderson, "by determined and persistent efforts," claimed to have successfully lobbied through three sessions of Congress for the total sum of $200,000 for roads and bridges in Yellowstone. He claimed also to have secured the first "generous" park appropriations of $75,000 for the years 1890 and 1891.[102] And his meticulous testimony before Congress in early 1892, along with the many newspaper articles that he submitted and the letters to the Secretary of Interior that he researched "from the files of the Department" for his testimony, resulted in favorable consideration for his YPA employers and a great deal of Yellowstone history saved, even though Henderson was not successful in preventing YPA from losing its transportation contract.[103]

Henderson appears during this period to have continued his practice of giving Yellowstone lectures in distant cities as well as hundreds of lectures both in and out of the park during the twenty-plus years he was in the area. However, only a few of these lectures are individually documentable. His personal handbills (posters) have survived for two of those lectures. One from 1885, complete with some of his original place-names, reads as follows:

> G. L. Henderson, from the National park, will deliver his lecture "The Geysers in Winter," in the Congregational Church, Glendive [Montana], on Monday evening, February 2, 1885, giving a description of the Chemical, Titian, Golgotha, Paranasus, Fountain, Ebony and Mammoth Geyser Basins. These are the Seven Wonders of Wonderland; [they] are not described in any guide book; nor has any explorer heretofore seen these Basins, in Midwinter, with their hundred active geysers. Doors open at 7:30 P.M. Lecture to commence at 8 P.M.

The handbill ended by listing the places tickets could be purchased and the prices: adults twenty-five cents and children ten cents.[104] As a result of that lecture and others, word soon spread in the region that Henderson was available to entertain various groups with Yellowstone lectures. Consequently, he was soon so engaged. "G. L. Henderson," proclaimed the local newspaper in March of 1887, "has been invited to give 'An Evening Tour of the Yellowstone Park' before the Literary Society of Billings while on his way east."[105]

Henderson lectured in a number of cities distant from Yellowstone. One of the patrons at a Wisconsin lecture by Henderson in December of 1889 declared his lecture stimulating:

> Saturday evening he entertained a number of invited guests, at the Kerr residence, on Langdon street, with an informal talk on the famous park, illustrating his remarks with a number of large photographs and water-color sketches of interesting features in the famous wonderland. Professor Henderson is an easy, fluent talker, and greatly interested his little audience, nearly every member of which had already been to the Yellowstone and had met him there.[106]

Using lantern slides and photos, Henderson attempted to "make his audience feel that they are actually in Wonderland and witnessing nature in her most sublime, beautiful, and terrific aspects." One of his published promotional posters for these lectures with its appended press endorsements survives with that message on it. An audience member at another of his lectures stated: "I have seen the Yellowstone Park but to hear Professor Henderson in one of his impassioned descriptions where fun, philosophy and science are in turn touched with a master hand, leads one to regard him as an embodiment of Wonderland itself." G. L. Henderson is known to have given these kinds of lectures for the rest of his life in Montana, Wisconsin, Washington, D.C., his native Iowa, California, and probably other places.[107]

After one of his California lectures, an area newspaper saluted Henderson for having told stories to so many Yellowstone visitors:

> During his residence on the reservation, Prof. Henderson has had the honor of entertaining many distinguished visitors, travelers, authors, artists, statesmen and scientists, and the numerous strongly worded testimonials to the scenic richness of this wonderful region are very precious to the 'grand old man.' Among hosts of others of note, T. DeWitt Talmadge sent a splendid eulogistic testimonial, accompanied by his photograph, to the 'inspired prophet and evangelist of the mountains,' as he was pleased to term the park enthusiast. A year ago, Prof. Henderson visited this region, delivering one of his lectures on Yellowstone Park at Coronado [California].[108]

In 1891 at Riceville, Iowa, Henderson entertained a large group of grade school students with stories of the marvels of Yellowstone. "After giving some account of the geography, geology, and botany of the park, with the chemistry of its rocks and boiling lakes," said the local newspaper, "the professor described the wonders of the grand terraces, chemical basins . . . and the steam [geysers]." Henderson told bear stories and stories of fish cooked in hot waters to the children.[109]

The "park nestor," as he was often called, extolled the magic of Yellowstone in his lectures nearly to his dying day. Two of his last known lectures were apparently in Helena, Montana, in March and April of 1900. A Livingston newspaper placed him in Helena on March 31, giving a lecture entitled "Wonderland and Its Relation to the Intellect and Health of the Wonder-Seeker." In April he lectured on Yellowstone Park place-names at Jackman Commercial College of St. Cloud, Minnesota.[110]

But what may truly have been his last lecture in the region seems to have been given at Billings, Montana, and he or his sponsors actually promoted it as a "last" lecture. The year is unknown, but a reference in his handbill (poster) to "record of a rail" hints that it was late in his Yellowstone career, perhaps in 1902. That undated handbill, which sounds a bit like a carnival barker's spiel, announced:

> Henderson on the Terraces. Last Lecture! Are You Fond of Fun?
> Go and hear Henderson's record of a Rail. Of Philosophy. Go
> and hear Henderson's anatomy of the Terraces. Do you love the
> beautiful? Go and see and hear Henderson's Frozen Temple of
> the Gods. Do you wish to know where the greatest winter resort
> of the world is to be found? Hear Henderson's description of
> the Ten Frozen Pillars, each one of which would contain all the
> snow and ice palaces of Canada and Russia with the Cathedral
> of St. Peters at Rome, and St. Paul of London, set in one corner
> of the frozen Pillars of Minerva at Mammoth Hot Springs in
> winter. Doors open at 7:30. Lecture commences at 8 o'clock
> sharp, in the Congregational Church, Billings, Montana.
> Admission 50 cents. Children 25 cents.[111]

Certainly G. L. Henderson's lectures were a big part of his employment with the railroad, but it is not known how many he did for them, what all of his park topics were, or where all the lectures were held. Nor is it known

exactly when Henderson left the employ of the NPRR/YPA, but it was at least temporarily in late 1891 when his son Walter had health problems. He himself seems to have had throat problems at about this same time—possibly irritated by his long stint of giving speeches about Yellowstone—as a newspaper article in December of 1891 stated that he underwent "twenty-three" operations for a "voice tumor." Whether related to this or not, his family decided to temporarily leave Yellowstone and to establish a home in Chula Vista, California, leaving the Cottage Hotel management in the hands of a Mr. Horner. But the evidence is good that Henderson remained associated with the railroad on and off until 1900, giving lectures and interpretive walks.[112]

For the next eleven years after 1891, Henderson spent his time at the Chula Vista home in winter and in Yellowstone in summer, with intermittent lobbying employment for the railroad. As a lemon grower at Chula Vista, he came to fancy the warm climate of southern California, even writing a California-Yellowstone newspaper article entitled "The Two Wonderlands."[113] But Yellowstone remained his first love. During those retirement years Henderson wrote voluminously about the park for various area newspapers, continued to give summertime tours and winter parlor lectures, and gradually took up the role of a kind of Professor Emeritus of Yellowstone. His family continued to operate the Mammoth area post office as well as one at Old Faithful, and they ran stores at both places. G. L. Henderson was thus ensconced as a park icon.

One visitor encountered him at the time he was composing his essay on the "Two Wonderlands." During the summer of 1897, Henderson worked at the new Klamer store at Old Faithful and there he engaged park visitors with his usual Yellowstone storytelling. W. F. Munro and a friend known only as "the General" met him there, and Munro wrote the following rich discussion of their encounter with Yellowstone's premier storyteller:

> An old habitué of the Park, Mr. G. L. Henderson, whom the General had met on a former visit, introduced us to the "Three Sisters." These are hot springs communicating with each other through rifts in their beautifully-fretted rims. One of them, Mr. Henderson considered, was the greatest curiosity in the Park. Every seven or eight minutes there was seen rising from the crater at the bottom large and small transparent globes of gas, which as they neared the surface burst, throwing up the water, which, as it fell, took on a tinge of heavenly blue, with

touches of carnation. It was a beautiful sight; Mrs. Palmer
was in ecstasies. We watched it subside and begin again. Mr.
Henderson, who lives near it and keeps [his son-in-law Henry
Klamer's] store, had watched it for years, and knew no-change
from what we saw. He had ascertained that the bubbles
consisted of light carbureted hydrogen. If so, they would ignite
if a light was held above the water when the explosion took
place, I said. Mr. Henderson never thought of that, but was of
the opinion that there would be no flame. Thinking it over,
I came to the conclusion that the gas might be so attenuated
by heat that there would be nothing to burn. The General
and I had a long talk with this intelligent old gentleman in his
store. He had all the lore of the Park at his finger ends, and has
been writing about it in newspapers and pamphlets for years.
He is now engaged in publishing his most important work
on the subject, to be called "The Two Wonderlands," which
will contain sketches embracing fifteen years of the Park's
history and development. The Park evidently owes much to
Mr. Henderson, who seems to have been fascinated with it from
the first. It was mainly by his writings and representations to
the Government that the Park has been gradually improved so
as to be made accessible to the public. Being of a metaphysical
turn of mind, he sees in the Park two wonderlands, one without
and another within, the latter being the "human increment,"
as he calls it.[114]

This last sentence suggests that as early as 1897 Henderson saw the park as a
place of both natural and cultural resources, as the National Park Service sees
it today.

Henderson also recorded much local history in many newspaper arti-
cles (more than fifty are cited here and the total number is probably at least
one hundred), all of which have not yet been found. Through 1902, he con-
tinued to discover and write of new Yellowstone thermal wonders, making a
statement in 1901 that today's park interpreters and tour guides should no
doubt keep in mind as they work: "The wonders of Yellowstone are not half
discovered and the guide who thinks he knows all about them is very much
like the good St. Augustine who thought it was possible for a finite mind to
comprehend an infinite God."[115]

During the late 1890s, G. L. Henderson, the nestor—Wise Counselor—of Yellowstone, began looking for younger Yellowstone tour guides to whom he could hand down his scepter of Wonderland storytelling. As mentor to all of them, Henderson had trouble finding someone with the necessary interest, experience, and intent to remain. But he continued to search. He was again summering at Old Faithful in 1899, where his daughter Mary and her husband owned Klamer's store and where he himself worked at the Wonderland Post Office. He wrote there of David Johnson, who had been the Upper Basin guide and interpreter for "the past three years" and who knew the eruptions of Daisy Geyser:

> [H]e is intensely human, earnest, honest and very popular.
> He has made a study of one section of this basin for the past
> three years. I have never seen a man or woman, especially the
> latter, who, on returning from the Johnson cabinet of marvels,
> was not deeply impressed and even convinced, that the man
> and phenomena he unfolded and explained were things never
> to be forgotten.[116]

As elder statesman of park storytelling, Henderson took great joy in encouraging young Yellowstone tour guides like David Johnson. He saw his grandson, George L. Henderson Ash, then only ten or eleven years old, as someone to whom he might pass down his interpretive skills. Ash was guiding at Old Faithful, and Henderson wrote that the boy

> accompanied a party of excursionists from Philadelphia . . . and
> on being asked why it was called the Economic [Geyser] replied,
> they told me, after a moment's thought, 'for three reasons: First,
> it never wastes its own time; second, it never wastes your time;
> third, it never wastes a drop of water.' They were much pleased
> with the young philosopher's explanation.[117]

Another of the young guides that Henderson noticed was H. L. Fuller, again at Old Faithful. Perhaps he could take up the "scepter of interpretation." Henderson wrote in 1901 that Fuller was "the park interpreter at Upper Geyser Basin," and that he

> had done even more than I had predicted he could or would do

as guide, philosopher and friend. Mrs. Richards declared
that Mr. Fuller entertained and instructed a large number
of pilgrims who accompanied him from geysers to boiling
lakes so that they came to the conclusion that he also was a
phenomenon and a credit to the Yellowstone Park Association,
who got the right man in the right place and kept him there
for a number of years.[118]

The year 1901 seems to have been G. L. Henderson's last for tour guiding
in Yellowstone National Park, although he gave at least one speech the follow-
ing season. That summer the *Livingston Post* referred to him as "the ven-
erable naturalist of Wonderland."[119] On June 10, 1901, Henderson, aged nearly
seventy-four, conducted park superintendent and Mrs. John Pitcher, the post
surgeon, and others over the Mammoth terraces. He wrote of the trip:

> It would occupy too much space to give an account of all the
> changes and incidents that have taken place during the almost
> twenty years that I have been a student and explorer of this
> superb and subterranean terrace world. All that one can do
> as a guide would be to follow the example of Horace who
> conducted Dante into the infernal world: "Look at them,
> name them and pass them by."[120]

And in August, Henderson guided Wisconsin congressman Theodore Otjen
over the terraces, showing his party the Narrow Gauge Terrace and its beau-
ties and explaining the changes "that have been constructed by the hydraulic
artist during the last twenty years."[121]

Henderson spent at least part of the summer of 1902 in the park. On
August 22, he visited with Larry Mathews, manager of the tent hotel at Old
Faithful, where Larry asked him to give a talk to a tent full of ladies. This
speech was one of Henderson's last interpretive events—perhaps *the* very last
one—in Yellowstone. His memory was failing, for if the newspaper is to be
believed Henderson got the number of years wrong that he had been in the
park and confused the facts on the origins of the name of Old Faithful
Geyser. Nevertheless the ladies in the audience loved his stories of how wo-
men had influenced the giving of names to park geysers. "That my audience
was pleased," wrote Henderson optimistically, "was manifested not only by
the usual hand clapping but also by the shower of questions that assailed me

on all sides." Like any of today's park rangers at the end of an evening pro-
gram, Henderson spent a good deal of extra time answering the audience's
many questions.[122]

His infirmities were showing by this time, and he spent most of his
time writing and pondering. The *Livingston Enterprise* published his letters
as late as August of 1903.[123] As the end approached for this man in his seven-
ties, he became very philosophical about his place in Yellowstone's history
and about the park's place on the world scene. In an 1899 poem, he wrote
that death would carry him to another wonderland besides Yellowstone:

> The seventh age comes; he's still serene,
> But still at work. Slower, but still more sure,
> Nor fears to see that other Wonderland.[124]

Just two months before he died, G. L. Henderson wrote to park concession-
er E. C. Waters to congratulate Waters on his new steamship for Yellowstone
Lake. Unvarying to the end in the way he perceived himself, Henderson
signed his letter "the old Park interpretor."[125]

In his last years, Henderson seems to have done a lot of thinking about
the future of transportation in Yellowstone. Foreseeing the automobile in the
park and no doubt already familiar with its earliest models, he pushed for a
rapid transit system ("electric carriages") that would replace park stage-
coaches. Seeing Yellowstone more and more as part of a national system of
touring, he promoted the idea of incorporating Yellowstone's transportation
into a worldwide excursion system. He wrote of his dream that thousands of
visitors would someday visit Yellowstone from every country on earth. And
he predicted that it would occur through *air* travel to Wonderland. Here are
his thoughts:

> In our vision we gaze . . . into the future, and into the blue vault
> of heaven and we see what in the distance loom like clouds.
> These specks grow larger and larger, as they come nearer and
> nearer [they are park visitors]. They start from the east and the
> west, the north and the south of our own land; they come from
> the continents and the islands . . . of all lands. These clouds are
> the couriers of the air. . . . Roger Bacon saw them as a dream; we
> shall see them as a verity. They [will] come to Wonderland on
> the wings of the wind. . . . And this wondrous park shall be the

world's stage. . . . Our national park will ultimately become the world's greatest attraction.[126]

The great Yellowstone storyteller died on November 14, 1905, at the age of seventy-eight, at his winter home in Chula Vista, California. His younger brother David Henderson, Speaker of the U.S. House of Representatives, followed him in death a few months later. G. L.'s son and four married daughters survived him. Two of them remained in the park for many years in association with what would become the Hamilton Stores. The local newspaper stated at that time that Henderson had "probably done more than any other one man to advertise Wonderland."[127]

Elwood "Uncle Billy" Hofer, who worked at the Cottage Hotel before joining the government and who was himself celebrated by Henderson and others as one of Yellowstone's foremost guides, wrote that G. L. Henderson had:

spent the best years of his life here and has really done more than any other man to popularize this resort of the health seeker and traveler from every corner of the world. He has made the maps, surveyed the uplands and valleys, climbed the mountains, analyzed the springs and named the geysers. . . . For . . . years Mr. Henderson has labored with pen and voice to make the wonders of this land of Alladin familiar to the American and English public. He has written countless columns for the press, delivered hundreds of lectures, awakened the interest of the scientific world and called the attention of the Government to the untold mineral and chemical riches of this cosmic laboratory of our globe. He ran the first hotels, built the first roads and ran the first tourists' stage lines thro' the Park. He came here with his family when it was a wilderness, and now it blossoms like a rose garden of human interest . . . [he] has by his intelligence and perseverance written his name on the wonder-world of the Yellowstone and become a part of it.[128]

G. L. Henderson was buried near San Diego in the Masonic Cemetery at Mount Hope. The *Livingston Enterprise* said of him at that time:

No man ever labored harder or more faithfully than Mr. Henderson to bring the Park and its many beauties to the

attention of the world at large, and it was doubtless a source of much gratification to him to know that he lived to see the day when its reputation was world wide and when it was regarded as the greatest wonder of nature on the globe.[129]

It is amazing that a man of this stature and importance, whose trail was so wide at the turn of the century and whose contributions so deep, could be so completely forgotten in Yellowstone and in the history of national parks. Although historian Aubrey Haines mentioned Henderson cursorily as an assistant park superintendent, the National Park Service did not know of his role as an interpreter and park educator until the 1980s, with the publication of two books that mentioned him only peripherally.[130] Only now is his importance truly understood. It is likely that the reason for his slide into obscurity is that Henderson's paper trail, as long as it was and is, was left only in newspapers and obscure government letters and documents. Thus scattered, the materials were not easily retrievable. It is a lesson that is repeated over and over through history, that being: *how quickly can people and events be forgotten.*

While historian Richard Bartlett says it is hard to read the National Archives correspondence without disliking Henderson, his letters and other writings make it clear that he was ever an honorable man throughout the unpleasantness with Superintendent Conger. In every case, he replied to Conger's baseless charges candidly and straightforwardly, with protection of the park and service to visitors always foremost in his mind. Had Henderson not been politically well connected, he might have been dismissed early, and history might have been thus denied his critical twenty years in Yellowstone. Though Henderson was at times a difficult person to get along with, his accomplishments force us to acknowledge that he was, at least in national park circles, a hero.[131]

Because he was more formally schooled in science and history than P. W. Norris, because historians can document more actual guidings and interpretive programs by him than by either Norris or W. I. Marshall, because of the much longer time he was in Yellowstone, because of the greater number and depth of his writings, for the quality of his park information—as reflected not only in his writings but in the great number of eminent men of science, history, and philosophy that he guided through Yellowstone and from whom he learned—for the diversity of his interpretive activities, for the fact that he held the first hired interpretive position in any

national park, for his massive contributions to place-names and park history in general, and for the resulting ultimate effects that he had on Yellowstone, G. L. Henderson must truly stand as the first Yellowstone National Park interpreter. Moreover, because the only other national park of the day—Mackinac Island National Park, 1875–1895—had no documented individual interpreters at all, and certainly none of Henderson's stature, Henderson must also be considered the *first national park interpreter*, period. The significance of this for national parks cannot be overlooked or overstated. Even more than Norris, Henderson must occupy this position, which the National Park Service would probably consider iconic if not exalted.

In many ways, G. L. Henderson was very much like P. W. Norris, whom he always revered. That Henderson greatly admired Norris is apparent from his various mentions of Norris and from a letter he wrote directly to Norris.[132] Norris and Henderson were alike in many ways. The two men were from the same generation, and photos show that they even physically resembled each other. In an age of nascent conservationism, both men saw Yellowstone as a magical place and both wanted to keep it that way. And in classic storytelling fashion, both wanted mightily to share it with others. Occasionally their romanticism exceeded their common sense, but Yellowstone does that to many people.[133] The two can be forgiven for these foibles in light of the accomplishments they achieved.

With P. W. Norris and G. L. Henderson, master interpreter Freeman Tilden would have been exceedingly pleased.

CHAPTER TEN

"All Them Fool Tenderfoot Questions"

Stories on the Yellowstone Grand Tour

*Thank heaven, I've seen the Yellowstone at last...
and to say I've seen the greatest congregation of wonders
which nature anywhere else stows away in the same space
is by no means extravagant.*

—W. B., 1886

*If you can take but one Western trip in your life, let it be
through the Yellowstone National Park.*

—Myra Emmons, 1901

*W*hat was the Yellowstone Park tour all about? What were those wonderful Yellowstone natural features that so merited speechmaking and discussion? What questions did visitors ask? Which direction did the stagecoaches travel? What did visitors think of the trip and how long did it take? What stories did the stagecoach drivers and walking guides tell or, at least, what stories were visitors likely to hear? The answers to these questions are presented here, and they form the essence of the Yellowstone Grand Tour.

During those halcyon days of Yellowstone stagecoaches (1878–1916), a general pattern developed that took visitors counterclockwise over the park's essentially frying-pan-shaped road system (the Canyon-to-Tower road did

not open until 1906 and even then was less used than the Canyon-to-Norris stretch) in five and one-quarter days. But every Yellowstone tour had the potential to be different from the last one—in route, time spent, places stayed, features seen, and stories told by charismatic drivers and walking guides. A good number of visitors stayed at the park's large hotels and heard stories of the park's roadside features told by their driver. Of course, not all of the park's spectacular curiosities were conveniently located at roadside—in fact, far from it—but so many *were* that most visitors went away satisfied, resolving to return later for a longer tour.

During stagecoach days, drivers quickly learned that their passengers were wont to ask questions, because they wanted explanations about the strange Wonderland features they were seeing while traveling through the park. While many drivers politely or even joyously consented to "give tours" by talking about the park, others were hesitant to talk to their audiences at all or at least to answer "all them fool tenderfoot questions," a reference to the endless inquiries of tourists.[1] "Drivers are no more profane in the Yellowstone region than they are in New York or Philadelphia," claimed one tourist in 1890. "I have seen them almost exhausted by the stream of foolish questions that are poured into their ears for hours at a time. But I have yet to hear the first offensive word."[2] Thus, if one believes this tourist, Yellowstone drivers did not swear or curse as they answered questions, a rule that surely was broken at times. Likewise, at times some of them must have been shy and hesitant to talk at all to their passengers.

That situation remained the same as late as the 1970s when this author was Communications Specialist for the Yellowstone Park Company's bus-tour operations. A bus driver whom the author hired in 1978 told us bosses that he liked the driving but did not want to tell "those silly stories." Fortunately, this attitude seems to have been the exception rather than the rule in both the stagecoach era and the later bus era in Yellowstone. Pointing out and explaining park roadside phenomena has been a staple of stagecoach drivers' repertoire since the 1880s, just as park bus drivers have performed it from 1917 to the present and park snowcoach drivers from at least 1971 to the present.

Many Yellowstone stagecoach drivers were noteworthy characters. Traveler Elbert Hubbard was a nationally known writer in 1914 when he penned this eloquent description of his driver at the Gardiner train station:

And as we walked out on the platform to get a better look at this model station, thrill Number Two was thrown on the cosmic

screen. Six white horses attached to a great yellow stagecoach came swinging in on a rapid trot. The driver wore a twenty-five-dollar Stetson. A linen duster covered him from collar to heels. Double rows of big yellow buttons were on the duster. This was the only mark of livery. The hat was tilted at that self-confident angle which men of ability assume. The man wore gloves and handled his reins with an easy grace. His shoes were russet and matched the yellow buttons and the yellow of the stage. The harness of the horses was bespangled with silver ornaments and there was a multiplicity of ivory rings. The horses were as proud as the driver.[3]

Like Hubbard, many visitors were ecstatic as they boarded the large park stagecoaches, called Tally-Hos, which carried travelers from the railhead to Mammoth Hot Springs. "Here we climbed on top of a commodious gaily-colored coach," exclaimed a 1904 tourist, "drawn by six prancing horses, matched teams of black, gray, and sorrel."[4] Many visitors found their driver to be a fabulously interesting character if not one next to God himself.

If the driver was special, the Yellowstone tour was even more so. Although historian Aubrey Haines has delineated the typical park stagecoach tour in his book chapter "On the Grand Tour," there is much more to tell. In the 1880s, park visitors who patronized the stage lines, known then as "tourists" or "dudes," tended to be formal and genteel, but that gave way to "a lessening of formality" by 1900.[5] Regardless, tourists wanted to hear drivers' stories, which shaped visitors' opinions of park wonders.

Visitors to Yellowstone National Park were from all states of the union and many other countries as well. They were of all ages, both genders, and largely upper class, although Yellowstone's evolving democracy would, by the 1920s, reach down to the middle class. Most were white. According to a newspaper reporter who scrutinized the railroad platform in Livingston, Montana—the jumping off point for Yellowstone—of other countries represented, most tourists were from Great Britain or France, but there were also a fair number of Germans. These "travel-stained travelers" were often a sight to behold. The reporter was not impressed by "weary looking women with mussed attire and a general air of not having been to bed for several nights," a look almost anyone could get after that long on a train. He described the typical British traveler with his helmeted hat, knickers, and habit of saying things like "Beastly!" or "I cawn't understand." He saw the harried man and

wife with three children attached to her skirts. And here and there, he observed, would be seen the real thing, "the dude, with his four inch collar and a cane with a big knob, which he takes into the dining room of the hotel with him, as he would feel lonely without a companion of his own caliber."[6]

Most visitors came from the north by riding trains of the Northern Pacific Railroad and disembarked at Cinnabar (1883–1902) or Gardiner (1903–1916), Montana. In these small towns, they bought souvenirs or saw the "zoo" at Cinnabar, which gave a hint of animals and other wonders to come.[7] Then they boarded a six-horse "Tally-ho" coach and headed south from Cinnabar for the eight-mile—or from Gardiner, five-mile—trip to Mammoth Hot Springs. And there they would begin the five-day counter-clockwise tour around the park's narrow, dusty road system to Norris, Fountain, Old Faithful, West Thumb, Lake, Canyon, Norris, Mammoth, and back to the railhead at Cinnabar or Gardiner.

Tour guide G. L. Henderson described the scene at Cinnabar in 1885 in his newspaper *Yellowstone Park Manual and Guide*:

> Wakefield and Hoffman's elegant coaches are waiting at
> Cinnabar to transport you to Mammoth Hot Springs in care
> of Adam Deem, who . . . is the model modern Adamic guardian
> of all tourists, man or woman. His face gleams like the painted
> terraces, his heart is a perpetual geyser; he tucks, packs, straps
> and stows [your luggage] with amazing rapidity. "All right!"
> he shouts and away you go over hill and vale in absolute safety
> toward Wonderland.[8]

Between Cinnabar and Gardiner, the visitor encountered his first taste of the all-pervasive dust that plagued Yellowstone's roads. Tour guide Henderson explained:

> When the season fairly opens in July, and all the freight wagons
> and heavy Concord coaches are constantly passing over the
> roads, deep ruts are made by numberless wheels, [and] vast
> clouds of dust rise and hang suspended in the air when there
> are no currents; when the wind blows you either ride in your
> own dust and in that of the carriages behind you, or, if [there is]
> a head wind, the dust is driven into your face with a force that
> blinds and maddens you.[9]

The dust was made continually worse by the hard, narrow wheels of stage-coaches that were constantly pulverizing roads into ever-finer powder. Visitors who stepped out of coaches onto park roads routinely found themselves ankle deep in the fine dirt. Visitor Carter Harrison acknowledged in 1890 that the practice of having stagecoaches travel a couple of hundred yards apart to keep their passengers from choking on the dust of the coach in front of them was a wise one.[10]

On the way to Mammoth, Adam Deem and other stagecoach drivers would usually mention the strange, castellated rock formation known as Eagle Nest Rock where the tourist was "apt to see the great American bird gyrating fondly around her nest."[11] That the bird was often an osprey rather than an eagle meant little to many visitors, but one researcher has found that during the period 1900–1914, 35 percent of Yellowstone travelers' accounts mentioned Eagle Nest Rock—as opposed to around zero percent today—perhaps a patriotic indicator of the "binding up of the nation's wounds" to visitors and park employees who remembered all too vividly the "recent unpleasantness" known as the Civil War.[12]

Passing the hot spring known as Boiling River, a driver might point it out as one of the places in the park where fish could be caught and cooked, right on the hook. Francis Sessions's driver, "a rather facetious character," did just that in 1887, when he opined that he had "often caught trout in the river, and then thrown his line over into the hot spring and cooked them." Observed tourist Sessions: "This does not seem to be merely a stage driver's hallucination, but is vouched for by others."[13] The experience at Boiling River would not be the last time park visitors had a chance to see this strange phenomenon, for the more famous Fishing Cone was yet to come.

At Mammoth Hot Springs, the already dusty tourist would alight from his stage at the rambling National Hotel (440 feet long and with an "air of discomfort" about it[14]) to spend his first night in the park. After taking leisurely strolls to the nearby hot springs or purchasing a "souvenir postal" (postcard) at one of the curio shops, visitors could listen to or dance to the music of the hotel's orchestra that played most evenings, "rendering excellent music." "As we drew up to the hotel," noted an 1891 visitor, "fine orchestral music greeted our ears." As he entered the hotel, he saw the musicians in an upper gallery and opined that "the lively popular airs [that] they were playing made us forget for a time that we were in a primeval region." Declared a 1904 visitor, "On the ample porches all the chairs were occupied and merry voices rang out at all times." This visitor was Clifford Paynter Allen, who loved his stay at

Mammoth Hotel. "After taps had been blown by the post bugler," he conclud-
ed, "the attractions began to fade, and [after] highballs and cocktails were
scheduled at thirty-five cents each the crowd found its way to the rooms pro-
vided and sought rest for the night." Traveler Eva Keene Moger in 1896 found
that the establishment was "a fine hotel for such a place [as Yellowstone], light-
ed throughout with electric lights, [and] it is nicely furnished." A 1902 writer
observed that the hotel was "hung with great flags and at night there are deco-
rations of Japanese lanterns up and down the lower corridors."[15]

At Mammoth, the tourist could purchase a specimen to be coated with
limestone by hot springs while he was away in the park, descend into a cave
called Devil's Kitchen to see bats and formations, examine the hundreds of
birds and insects killed by poisonous gas at Poison Spring, ponder the
strange underground hot stream known as River Styx, go for a swim in Bath
Lake ("after much searching we found it at last"[16]), or "take the waters" in
one of the hot-spring bathhouses near the hotel.[17] There was so much to do
at Mammoth that the tourist was in danger of not having time for the oblig-
atory walking tour of the Mammoth Hot Springs themselves. On the hotel's
broad piazza, he found an interesting mélange of people. "There were trav-
ellers from all over the world, averaging at least five foreigners to one Ameri-
can," proclaimed 1885 visitor George Wingate. "Engineers and army officers,
railroad men and cowboys, travellers and stage drivers, all mingled on a foot-
ing of equality."[18]

Stage drivers, sometimes called "Knights of the Silk,"[19] were romantic
components of the Yellowstone picture. The following morning they would
line up their coaches—four-horse ones instead of the earlier six-horse Tally-
hos—in front of the hotel, ready to begin the continuation of the park tour.
Most of their visitors would have already seen the Mammoth Hot Springs,
having been conducted there on foot the preceding evening by hotel bell-
men, or (less often) by army soldiers serving as tour guides, or in buggies
that the visitors rented. One writer has characterized these departing tourist
hordes as "filled with a nameless exhilaration, everything especially beauti-
ful, especially marvelous." Certainly there was a magic of sorts that perme-
ated the air of Mammoth on these "take-off" mornings, and it somehow fit
with the atmosphere that many stage drivers had come to Yellowstone to be
a part of the carefree summer life that Wonderland offered.[20]

As visitors met their drivers, they were delighted, horrified, or recon-
ciled. "Our driver... combined the independence of America with the civil-
ity of Europe," declared an elated English woman in 1885. Company officers

on the veranda shepherded passengers into groups for seating assignments. "I give the pleasant people the most accommodating drivers," explained one official, "and to the kickers I give some crusty old frost-bitten driver that will fire it right back at them."[21]

Abruptly the stage drivers "popped the silk"—cracked their whips— over their horses' heads and headed south. They would pass Liberty Cap, the tall, hot spring deposit that inevitably evoked comments and jokes about its phallic appearance, give a mention of Devil's Thumb (a smaller such deposit), swear at their horses, and then begin the thousand-foot ascent of Snow Pass. Before 1885, the route took them past Narrow Gauge Terrace ("ready for tie and rail; hence its name"[22]) past Orange Spring Mound, and steeply up Pinyon Terrace through deep woods to a flat spot just north of Jeweled Cave. There drivers would rest the horses while visitors prowled south to the vertical opening of that cave, which many were understandably afraid to enter. After they *clambered*—that nineteenth century word that graced so many tourist accounts—back aboard, drivers conveyed them through Snow Pass to Summit Lake and across Swan Lake Flats.

Beginning in 1885, an alternate road ran south from Mammoth through the limestone Hoodoos and ascended Golden Gate Canyon via Kingman Pass. Here the driver would generally tell his passengers about the $14,000—a great deal of money then—that Lieutenant Dan C. Kingman of the U.S. Army Corps of Engineers had expended to build the road. Passengers would get out and walk so that the empty coach could cross the rickety Golden Gate Bridge. They were obeying in spirit the sign on the bridge, which read "Walk your horses." Visitors could then view "West Gardiner Falls" (today's Rustic Falls), the first of numerous Yellowstone waterfalls to come.

The stretch of road north of Norris offered numerous attractions for visitors and, like most park roads, the chance at seeing wildlife. Drivers generally made a stop at Apollinaris Spring where passengers could find "a glass of as good Apollinaris water as one can buy at a first-class drug store."[23] Some of the tourists who drank the water "so like that from its namesake spring in Germany"[24] mentioned that it tasted like lemonade. "A little sugar put in water from this spring makes good lemonade," wrote visitor Marvin Morris. Later park employees told stories to visitors that the water there would give them the "runs."[25] Passing Obsidian Cliff, the driver could be depended upon to mention that it was an arrowhead quarry site for many western Indian tribes, to describe how the road was built here using huge

fires to heat the obsidian ("the only glass road in the world"), and possibly to tell a fake Jim Bridger story about seeing an elk telescopically magnified in the crystal of the mountain. At Roaring Mountain, especially during the 1890s, the driver would generally comment on the noisiness of the steam vents that could be heard up to a mile away.[26] At Frying Pan Spring, where visitors could usually smell the "rotten egg" stench of hydrogen sulfide gas bubbling through water, the driver often did not explain that the gas made these springs appear hotter than they were. Instead he might tell his passengers that the forest was full of boiled eggs, because after the birds there drank the water, the next eggs they laid were hard![27]

Stage driver Charles Van Tassell, who drove in Yellowstone as early as 1906 and stayed in the park more than twenty years, became well known for issuing at least six editions of a book between 1912 and 1923 called *Truthful Lies: Tourists' Funny Questions, Drivers' Truthful Answers?* These books preserved a picture of the interpretive commentary given by some drivers—or at least by Van Tassell himself—to their (or his) passengers. For example the 1912 edition noted:

> On your trip through the park you pass what is known as Twin Lakes—one a deep green, the other a deep blue. Someone will ask: "Driver, what makes one of those lakes green and the other blue?" The answer: "I don't know what made the one green, but the blue one was caused by the wind." Then the question: "By the wind? How?" The answer: "Oh, you see they had a wind storm along here one day and the wind blew it." On seeing a little brown animal along the road a young lady inquired regarding the species of the animal. The driver answered: "That is what we call Pork Sausage." Then she wanted to know why they called it Pork Sausage. The driver answered: "Well, you see they are what is known as a ground hog, and isn't pork sausage ground hog?"[28]

However humorous this booklet might have been, it presented almost no picture of any serious park information that a driver might have given his passengers. For that information, one must look to other sources.

Passing Hazel Lake, stage drivers began the "pull" up a hill above Norris Geyser Basin—located east of the hill on today's road—and then a long drop down to the Gibbon River where the horses would clip-clop across

a wooden bridge and find their way to the Norris Lunch Station. Situated south of the Soldier Station and across the river at today's roadside parking area with telephone, this place was "Larry's Lunch Station" from 1893 through 1901 when the genial Irishman Larry Mathews ran it.

Larry's banter to his guests along with his always entertaining stories were a part of the park tour that became well known. And entertaining he was! Larry's job every day was to be funny from eleven to two o'clock, during which time he must not only amuse the inbound tourists, but carefully avoid repeating himself to those outbound travelers who were lunching here for the second time. "In wid yees all and rigister!" Larry would say as he welcomed the stagecoaches. A lady asked for a glass of milk, so Larry would shout, "Drive in the cow!" "A drink of water if you please," mumbled a pretty lass, and Larry with pretended solicitude would answer, "Wad ye like it hot or cold?" A standard comment was Larry's loud announcement to all of his guests: "There's no extra charge for flies and dust—always on the bill of fare."[29] In 1901, Larry became the first manager of the new Norris Lunch Station, located on the north side of the geyser basin proper, and from 1902 through 1904, Larry managed the Old Faithful lunch station and then the newly built Old Faithful Inn. "Good luck go with Larry," declared writer Rudyard Kipling, who liked Larry even if he disliked a lot about Yellowstone.[30]

Independent stagecoach operators, that is, ones not affiliated with any in-park company, did not stop at Larry's. Instead they carried lunches for their people, and their drivers told park stories, too. Dr. John Dike went on one such picnic in 1910 and wrote the following account of it:

> The lunch was spread upon the ground and Bill Lewis, the
> driver, while making coffee and serving the lunch, regaled
> us with stories of the wonders of the park. He had been
> promising good sport in the line of fishing and in his chagrin
> at being unable to even get a bite fairly outdid himself in the
> line of yarns. Bill, by the way, is a character. He is tall and lank
> and from 'Old Kaintuck.' He has driven coaches in the park
> for fifteen years and knows his ground.[31]

After lunch, a tour guide hired by the Yellowstone Park Association would generally walk the visitors through Norris Geyser Basin. "At Norris there are growling, jagged holes in the earth belching forth huge volumes of steam," reported Ray Baker, "which, having killed and bleached all the verdure

of the near mountain-side, has given the whole valley an indescribable air of desolation, as if the forces of nature had gone wrong."[32] Eventually, the walking guide would shepherd visitors to a stagecoach-loading platform at Minute Geyser. There travelers would reboard their coaches for the afternoon trip to Fountain Hotel, a hot, dusty, and generally uneventful ride through long stretches of timber. Prior to about 1891, visitors like Theodore Gerrish experienced Gibbon Falls (an eighty-four-foot waterfall on Gibbon River) from its east side by a difficult scramble down an unimproved slope to a somewhat dangerous view. Then it was south through more timber for these tourists, the monotony relieved somewhat by Teton Hill, a place where guests could see the rising steam-plumes of Lower Geyser Basin and the Grand Teton mountains at a long distance.[33]

Breaking out of the trees at Lower Geyser Basin, the visitor would be whirled (before 1891) to Marshall's Hotel or (beginning in 1891) to Fountain Hotel for an evening's stay.[34] At Marshall's (1880–1891), 1884 visitor George Bird Grinnell—destined for later fame as a recorder of much Native American history—painted the following word picture for future researchers as he approached from the west:

> The scene in the valley below is one of life and activity. Horses and cattle are browsing on the flat. Mounted men dash hither and thither on their nimble steeds. Two or three stages move briskly along the roads. Heavy wagons laden with trunks, provisions and bedding stand by tents, about which move numbers of people. Men are chopping wood, building fires, or hobbling and picketing out their horses. There are houses— one, two, three, a dozen. It is the old spot, but how changed by the lapse of a few years. When I last looked upon it, it was as silent and untenanted as if never trodden by the foot of man, and now it is a settlement.[35]

As it turns out, Grinnell's picture of Marshall's would soon change again, when the buildings were torn down and the area fell into disuse and quiet by 1895.

At the Fountain Hotel, which replaced Marshall's in 1891, the evening's entertainment generally consisted of a trip to a bear-feeding area at the garbage dump behind the hotel. Superintendent H. B. M. Young was told about it as soon as he arrived in 1897 and routinely told visitors to "go over to

the Fountain Hotel and there you will see as many bears as you wish." Dan Beard, who started the Boy Scouts of America, noted that bears began to appear merely at the sound of the Fountain garbage wagon as it rumbled to the dump.[36] Hotel bellmen taught visitors to feed sugar cubes to bears gathered there, and the Fountain bear-feeding area became famous and continued through 1916 when the hotel closed.[37]

The third day (second full day) in the park involved a trip to Old Faithful. Stagecoach drivers reined their coaches up to the Fountain Hotel and loaded passengers in preparation for heading south. A few minutes later they would swing into the nearby "Mammoth Paintpots"—today's Fountain Paint Pot—so that tourists could have a view of the colorful hot, bubbling mud there and the well-known Fountain Geyser, which erupted sixty feet high. 1898 traveler John Atwood expended many sentences describing the color of these mud springs and then declared: "The beauty and strangeness of the paint pots, and the brilliant loveliness of the Fountain geyser made the stay at the lower basin a noteworthy day."[38] A 1908 visitor gushed that Fountain Geyser was "a cloud-burst of rarest jewels which . . . seemed suddenly to crystallize into a million radiant forms as it spray[ed] out into the sunlight, a glittering mass of diamonds, moonstones, pearls and opals dancing like fairies far above our heads."[39]

An 1885 visitor, L. D. Luke, did not see Fountain erupt on the way to Old Faithful, and so determined was he to see it that, when his stage driver took the shorter freight road back to Marshall's Hotel that evening, Luke insisted on being dropped on foot to cross creeks and two miles of marshy flats to wait for the geyser. His driver and friends despaired that it would be a three-mile walk in the dark to the hotel for him, but Luke insisted. Crossing the marsh, he spent the night at Fountain Geyser, building a huge fire ("the light of which was seen at the hotel") and watching both a 9 P.M. eruption and a 3 A.M. eruption "while my heart leaped for joy, and my soul glowed with delight." He loved the adventure.[40]

It was here at the Lower Geyser Basin that visitors first encountered the lovely alkaline hot springs and geysers for which Yellowstone was justly celebrated. At Norris, these visitors had seen the less lovely, acidic springs— some people thought they were downright ugly—and at Mammoth they had seen beautiful springs but without spouting geysers. At Lower Basin it became apparent why Yellowstone was *famous*, for the hot springs and geysers here were colorful, deep, clear, dramatic, and exquisite. "Its colors dance through the waters in each vibration," wrote an 1872 horseback tourist who

thought he saw rainbows in a hot spring. "The enameled walls seem set with rarest gems," he continued, "and the sub-aqueous grottoes visible [in] many places to depths of forty or fifty feet are as jeweled arches leading to Palaces of Pearls."[41] Indeed these springs were the fairylike features that caused former fur trapper Benjamin L. E. Bonneville to write this note to N. P. Langford: "[T]he Fire Hole most surely is a great curiosity, and some day may become a place of public resort."[42]

There was simply nothing to compare to these hot springs and geysers anywhere in the United States if not the world. They were the features for which Yellowstone had truly been set aside. They were the features that made Yellowstone so famous so quickly by attracting the attention of a disbelieving world. And there were so many of them! A 1911 railroad pamphlet rhapsodized:

> To count the geysers great and small would be like counting
> the stars, and to measure in words their awful power, or
> picture their splendor of sparkle and symmetry—that no
> one can do. They must be seen to be appreciated, and,
> once seen, the memory and mystery of them will linger
> to the end of the longest life . . . with depths that the eye
> cannot sound, and colors—blues, greens, purples, reds—
> down their deep sides in the wonderful tracery about
> their rims, so blended, so beautiful, that one may well
> believe that all the paints on the palette of the Master
> were commingled in their decoration.[43]

Tour guides and at least some stagecoach drivers must have searched diligently for words like those to describe Yellowstone to their visitors.

At Midway Geyser Basin, known during stagecoach days as "Hell's Half Acre," drivers would often tell their tourists the story of Excelsior Geyser, a huge hot spring and geyser that erupted 300 feet high and 300 feet wide, which raised the water level of Firehole River nearly a foot. Even if they could not see it erupt, they could marvel over its 300-foot-wide crater and twenty-foot-high towering walls that surely were the same as looking down into hell, as well as its beautiful, deep-blue, boiling water which was discharged into the river at thousands of gallons per second. They also could soak up a few of the myth-making descriptions ("a water demon of terror and awful majesty") that visitors told of it. Sometimes called the "Sheridan Geyser" for the legendary

General Philip Sheridan, Excelsior Geyser was, according to one railroad writer, a remarkable hot water fountain:

> Why! to sit on the edge of Hell's Half Acre and watch the
> Sheridan Geyser, is to have a lifetime memory. It is twice as big
> as this hotel (the Metropolitan), and the steam and water ascend
> to a height of 400 feet. It is indescribably grand to watch it first
> sending up a cloud of steam, then water, higher and higher, until
> the stupendous magnitude of a full eruption is reached.[44]

Traveler Ashley Cole recorded what he thought were the first eruptions of Excelsior Geyser, as seen by hotelman George Marshall on January 24, 1881. Mrs. E. H. Carbutt actually saw an eruption of Excelsior in 1888. "We all stood on the brink and watched the water begin to bubble in different places," she noted, "then the center became more and more agitated and the Geyser rose, first quite small, then higher and higher, until we had to fly from the torrent of water and stones that were thrown hundreds of feet high and yards over the edge." She finished her observations by regretting that "one gentleman was badly hit by a stone."[45] Viewing geysers could be dangerous.

But Excelsior was quite worth the risk. A few parties saw it erupt in 1890, including members of the Michigan Press Association:

> It made a noise like thunder, and Fire Hole river was swollen
> five inches by the boiling river which ejected from its mouth.
> A couple of rods out in the pool, for a space of two or three
> square rods, the boiling was violent and constant, with
> occasional spurts of steam and water to the height of six feet
> or so. Suddenly there was a swell twelve feet high and twenty
> feet across, then out from it came streams of water twenty feet,
> forty feet, eighty feet, one hundred feet and higher, hissing,
> roaring, raging, then a solid stream 120 feet high and forty
> feet through.[46]

After this visitors must have wondered if there was anything left to see. But there certainly was. For the tourist it was on for five miles past the exquisite Morning Glory Pool and Castle Geyser to Old Faithful. Morning Glory Pool was "a diaphanous cupful of limpid sky" of the "loveliest, clearest, robin's egg blue" while Castle Geyser's cone resembled "a ruined castle or

tower."[47] Castle would occasionally erupt 100 feet high, and postcard views that one could buy at curio shops showed visitors standing on top of its cone, an activity that is no longer allowed today. Mrs. Townsend stated that in 1906 their walking guide took them up onto the cone, and an 1887 party that climbed to its top was drenched when the geyser erupted.[48]

At Old Faithful, one could easily take a full day to see the many large geysers and hot springs and, after 1904, the Old Faithful Inn, but half a day was all that was allowed (this failure to allow extra time for the stop was the greatest source of complaints during stagecoach days). Here tourists would be lodged, depending upon the year, at the basin's Shack Hotel (1885–1894); at a series of ramshackle tents operated by the Yellowstone Park Association (1894–1903); at Wylie Camping Company's or the Shaw and Powell Company's tents (1883–1916 and 1898–1916); at Old Faithful Inn (1904–1916); or next to one's own campfire.

Old Faithful Inn, which opened in 1904, immediately captivated the already-amazed visitor. Built entirely of logs, the 140-room hotel was at once unique and stunningly beautiful. "A lofty, wide-spreading structure with a touch of Swiss about its gables and windows," it somehow fit perfectly with its surroundings. According to one 1904 visitor, it exhibited "a startling oddness which one learns to adore," while another visitor called it "the craftsman's dream realized."[49] The local newspaper proclaimed it "the largest log structure in the world" and noted that hundreds of miles of forest were searched "for gnarled and twisted branches and trunks of trees." "It was my ambition," stated the Inn's architect, Robert Reamer, "to construct a building without a piece of planed wood in it. In all the big structure there is not a foot of smooth finished board or molding."[50] Old Faithful Inn remains today an iconic cultural wonder for Yellowstone in the midst of great natural wonders.

If Old Faithful village was the place of premier wonders, Old Faithful Geyser, then as now, was the most sought-after individual feature for a look. "When I invest my money in Geysers," averred one stagecoach driver, "I'll take Old Faithful every time. Why if it weren't for him there'd be no Park; the whole thing would be a fraud."[51] Notwithstanding that incorrect assessment, there were many other things to see. Early hotel visitors reported that people ran screaming en masse from the lobby when told that "[t]he Beehive [Geyser] is playing!" Like today, the hotel sometimes made announcements of the warning spurts of Beehive's Indicator, a small geyser nearby that gave notice of its neighbor's bigger eruptions as imminent. "A watchman on the

look-out shouts 'The Bee-Hive! the Bee-Hive!" wrote 1885 visitor Edward Marston, "and people rush out of their beds wrapped up in blankets, or whatever clothing they can find, and off they go."[52] The Giantess Geyser, with its 100-foot jets that forced their way through a sixty-foot dome of water, caused one visitor to confide to her companion, "I'm going to re-form."[53] The Grand Geyser, a two-hundred-footer that had many separate bursts, was one that visitors wished hard to see ("We heard the shouting of the park guides, 'The Grand, the Grand!'" opined 1883 visitor Henry Sheldon Reynolds).[54] The Splendid, Daisy, Grotto, and Riverside Geysers all could entertain, but if one was really lucky, he might see the Fan and Mortar Geysers, which sometimes erupted in concert, or Giant Geyser, which erupted 250 feet high every fortnight.

Yes, at Old Faithful, the atmosphere was at times downright festive. "Hundreds of tourists are to be seen here...all day long," exulted Robert McGonnigle in 1900, "and judging by the multitude around you, it is not difficult to imagine one's self at a circus or a country fair." The place was indeed busy, as journalist Ray Stannard Baker noted in 1903. He described park tent camps as "buzzing with visitors, every one in ecstasies over the geysers, setting up cameras, snapping buttons, filling little bottles with hot water or little boxes with pink mud, all very jolly, all expecting to be astonished, and all realizing their expectations."[55]

H. W. Hutton, an 1881 traveler who camped along the way as everyone did then before there were hotels, encountered a kind of democracy among visitors in the Old Faithful area.[56] This traveler provided one of the only looks at *class* structure in early Yellowstone when he recorded his approval of the democratic atmosphere:

> [It is] here you meet presidents, professors of colleges, teachers, preachers army officers, government outfits, statesmen and grandees, lords barons and noblemen, [and] yet all seem to be on an equality; one does not think himself above another; all are pleasant and communicative; they are seeking rest from the busy cares of life and also to satisfy their curiosity in beholding these great wonders of the world.[57]

Eliza Gillette found a similar class situation at Yellowstone Lake in 1887 when she wrote: "strangers are friends immediately without the formality of an introduction."[58]

There were wonderful stories for visitors to hear and guides to tell at Old Faithful. One involved the "Devil's Ear," a hot spring that was ear-shaped where his satanic majesty below could "hear" messages from the surface.[59] Another involved "Chinaman Spring." Park tour guides told this Chinese laundry story so often that it nearly assumed fairytale status in Yellowstone. An Asian laundryman erected a tent over a hot spring on the river just north of Old Faithful in 1885. Perhaps from the soap he used, the spring erupted one day, tossing the Chinaman's tent and its contents into disarray. Later versions of the story added fictional details such as having the laundryman thrown all the way to the streets of Shanghai.[60] At Old Faithful the wandering visitor might even run into G. L. Henderson, the illustrious old-time park storyteller who worked at the Wonderland Post Office there, and hear one of his grand tales from the past.[61] All of these stories, along with those of stagecoach driver Robert "Geyser Bob" Edgar, became part of the lore of the Old Faithful area and Yellowstone as a whole.[62]

It seemed there was never enough time at Old Faithful. The visitor could dig specimens at Specimen Lake (no longer permitted—the H. W. Hutton party did extensive specimen digging) or marvel at the elaborate formations of the "Devil's Punch Bowl," shown in Haynes's beautiful 1908 postcard.[63] Beginning in 1904, he could opine about the strangely knotted wood in the Old Faithful Inn and shortly after that do the same at the Klamer Store—today's lower Yellowstone General Store. Beginning that same year and until 1948, a searchlight, sometimes colored, on top of the Inn lit night eruptions of Old Faithful Geyser.[64] If all this were not enough, there were surrey side-trips that could be made to Lone Star Geyser, three miles to the south, or to Black Sand Basin, one mile west, where two of the park's most famous hot springs could be viewed: Emerald Pool and Handkerchief Pool. Beginning in 1914, the tourist at Old Faithful could swim in the "Geyser Baths" swimming pool. But he would probably never see dozens of smaller wonders such as Witches Caldron, Lime Kiln Springs, the Seashell, Solitary Geyser, or the petrified Deer Tracks, because these and many more were generally found only by park employees who had an entire summer to discover them. Old Faithful was a strange and fascinating place. One 1884 visitor seemed to shiver a bit as he explained that "all night through you heard the noise of steam blowing off, and mysterious noises of all sorts."[65] But the Chinese cook for Wylie Camping Company hated the place in 1887. His comments sound similar to some the park still receives today: "I no see why you come, no city, no store[,] just heap mud[,] heap smell, me no like him!"[66]

And then there were the nighttime experiences of an 1886 visitor known only as "W. B." His account is so strange and compelling that the only way to get its full effect is to quote it. "The moon was then shining her best," W. B. wrote as he stole out of his tent at midnight, "and everything overhead was quiet as the grave." He proceeded to generalize on the subject of the geysers ("water-wraiths") somewhat after the manner of Shakespeare's Banquo, from *MacBeth*, as he beheld his surroundings:

> I was in the midst of the grandest display of water-works ever exhibited. This consisted of the play of numerous sparkling geysers and boiling springs, which shone like silver in the moonbeams. The geysers shot up into the air with explosions which resembled the rattle of musketry mingled with the rushing noise of rockets. While I was contemplating several of these of rather inferior magnitude that were sending their watery columns high aloft, on both sides of the Firehole River . . . I began to hear the mutterings of 'Old Faithful' behind me, and turning round, I saw such a vision of beauty as is permitted to a person only once or twice in a lifetime, if ever. At first there were the usual subterranean rumbling sounds that precede the advent of one of the giant geysers. Then there were noisy outbursts of steam and vapor, crowning several indistinct objects that looked like waving headdresses on living forms just issuing out of the earth. These forms, scarcely visible at first against the dark background of the wooded hills, kept rising higher and higher, until they assumed the appearance of so many sisters of the same family, towering up in varying heights, but with a marked resemblance to each other. Finally they seemed to blend all in one, and gaining strength and stature from the mysterious depths of the earth, they shot upward in one grand ebullition of splendor hundreds of feet high, the vapors flying off in misty wreaths and curls in every direction, and the water descending on every side, in showers of 'orient pearls,' and sprays of silver and waves of mystic light. The weird effect of this exhibition was immeasurably enhanced by the moonlight as well as by the solemn stillness that rested on all other objects around me. It was not hard, at such a time, for the imagination to magnify these towering columns of water and

steaming vapor into winged figures just taking flight from the ground and soaring toward the heavens. And as we are in the habit of regarding such objects, though possessed of ever so much animation, as remaining in a state of rest at night, it does not require a very great additional stretch of the imagination to picture them as having certain ghostly qualities that lead them to stir abroad . . . and thus 'revisit nightly the glimpses of the moon.' Whether from this cause or some other, it is certain that an inexpressible charm and witchery hang around these ghostly geysers, as they spring forth from their dark caves in the earth, in the night time, which it is impossible to extract from them by daylight.

Our W. B. then proceeded to compare geysers at Old Faithful to the most bewitching tales of the Arabian Nights. In particular he was reminded of the tale in which the princess Parizade showed the Sultan of Persia her remarkable fountain. Her explanation of the beauty was as good, said W. B., as any scientific explanation put forth by savants. This visitor wanted nothing to stand in the way of the magic and romance he saw in the geysers at Yellowstone.[67]

From Old Faithful, stage drivers conveyed their passengers east toward Lake and Canyon areas. Before 1892, drivers took their people back to Fountain Hotel for a second night before using the Mary Lake road east through Hayden Valley to reach the Canyon-Lake road. This route took them past Highland Hot Springs, Sulphur Lake, and Glen Africa Basin before ending at its junction with the Canyon-Lake road. But beginning in 1892, a new road from Old Faithful to West Thumb and Lake was open, so drivers suddenly had new scenic wonders to show and talk about on the fourth day (third full day): Kepler Cascades, Turtle Rock, the Continental Divide, Isa Lake, Corkscrew Hill, Shoshone Lake and the Grand Tetons, and eventually two stagecoach robberies that occurred on this stretch of road in 1908 and 1914. About Kepler Cascades one traveler admonished that "really, in this Park there is so much to be seen that such things as waterfalls, unless of large size, hardly attract notice." This confirmed the impressions of three waterfall explorers one hundred years later who discovered huge numbers of Yellowstone waterfalls that early visitors and present-day rangers had never seen.[68]

The new road from Old Faithful ran up Spring Creek Canyon and was not the same as today's road until it began its ascent of Craig Pass. An 1884 traveler, like today's tourists, was enthralled with the idea that Isa Lake drained

to both oceans backwards: "It is indeed wonderful to think that this little lake, perched up some 8,000 feet, should be the commencement of such rivers as the Missouri-Mississippi system, as well as of the Columbia and Colorado."[69] East of Craig Pass, the stagecoach visitor dropped down Corkscrew Hill in a series of turns that as late as 1926 were "so crooked that you pass one place three times before you get by it, and then meet yourself on the road coming back."[70] Stagecoach drivers like Del Jenkins delighted in terrifying their passengers by rushing them down this crooked stretch of road or sometimes used the road to impress tourists with their driving skills.[71]

Next on the tour came West Thumb, an area that was little visited until 1892 when the road from Old Faithful opened. That summer West Thumb received a lunch station that quickly became a small hotel, and almost immediately lunch station employees began offering walking tours of the geysers there for incoming stage passengers. The hot spring known as Fishing Cone, already proclaimed wondrous by early explorers, became even more famous as park visitors scurried to see it in droves. "It is quite true," marveled an 1884 tourist at the site, "that you can catch a fish and boil it [on the hook] without moving from the spot you are standing on."[72] Originally, visitors did not believe this claim, but by 1903, Fishing Cone had become famous. "Down at the lake-brink," reported journalist Ray Stannard Baker, "a number of girls are trying, with unaccustomed fishing-rods, to perform the feat, without which no visit to the Park would be quite successful, of catching a trout and cooking it, wriggling, in the hot pool behind them."[73]

Boat trips on Yellowstone Lake via the steamship *Zillah* were also available, and for some years in the 1890s boat operator E. C. Waters paid a kickback to stage drivers of fifty cents per passenger to convince tourists to ride his boat. But one day in 1899 when Waters was away from the park, Mrs. Waters decided not to do this, and so the drivers boycotted her and the boat. Holding a meeting at Lake, they appointed one of their numbers to demand money from Mrs. Waters for the people they had put on the boat. When Mrs. Waters refused until her husband could return to the park, the angry drivers wired Fountain Hotel and other drivers and as a result the *Zillah* carried few or no passengers for weeks. On arriving at West Thumb, drivers made statements about the steamer such as: "the boat was not safe," "the boat had sunk once," "prices of the boat company were too high," "lightning was liable to strike the boat," "there was nothing to see from the steamer," or "you missed the finest drive in the Park if you took the steamer." All of these statements were false, and they were a part of what Mr. Waters perceived as attempts by

the hotel company and two transportation companies to hurt his boat business. When he returned to the park, he restored the fifty cents per passenger to the drivers plus payment for all back passengers.[74]

Regardless of the boycott and alleged attempts to scuttle Mr. Waters's boat business, most stagecoach passengers took the boat cruise at West Thumb rather than ride with the stage driver on land to Lake Hotel. Somehow cool breezes in their faces, a temporary escape from mosquitoes, and the opportunity to see animals in pens on Dot Island were preferable to continued dust and heat by land, even when the coach trip was supplemented by a drive through the odd Knotted Woods near Natural Bridge.

Thus, because their boat landed at Lake Hotel, many visitors missed the Natural Bridge, a secondary wonder in Yellowstone that would have been the entire reason for a park in many locales. An 1884 traveler did see it, however, commenting upon handiwork on its summit completed by park superintendent P. W. Norris: "there were railings put [up] to prevent unwary travelers [from] falling over," and the bridle path across its top was "wide enough for a carriage to cross it."[75] Unless they took the land trip to Lake, visitors also missed traveling on the natural, wave-formed sandbar at lakeside near Arnica Creek. Called the "hard road to travel" in more recent times, this sandbar was made easier sometime in the 1890s by means of logs laid down upon it, for visitor Eva Moger declared: "we have rode along here by the lake for 1 1/2 miles on as fine a cordaroy [sic] as ever was."[76]

Visitors who went to Yellowstone Lake before its hotel opened in 1891 found terrible accommodations. Eliza Gillette in 1887, traveling with the Wylie Camping Company, noted that it was seldom that visitors elected to stay overnight there because of the lack of lodging and the easy drive back to Canyon where there was a hotel. However she spoke to an Englishwoman who had stayed at Lake and the woman told her that Mr. Wylie put them up in "three tents, one for dining room, one for kitchen, [and] the other a sleeping apartment." That proved to be troublesome when the woman discovered that she, her husband, and her driver were to occupy the same tent "where there were three or four beds, but no partitions." Asking for a screen, she was met with resistance but finally got her way, and in the morning she found that her husband and the driver had used the only towel. Asking for a towel, she was told that they had already put out the clean towel for that day. Insisting on it, she obtained a towel but overheard the manager commenting about fussy English people.[77]

All of that changed when the Lake Hotel opened for business in 1891.

Its architecture, commented on by many visitors, was unusual for a wilderness setting. "The entrance with its wide porch and massive, high columns," exclaimed a 1904 visitor," is not unlike the entrance to the White House."[78] This visitor had just seen the massive renovation by architect Robert Reamer and was enthralled by the hotel's colonial styling, which remained a feature of its appearance one hundred years later. At Lake Hotel, after a dinner served with wildflowers gracing the tables, visitors could take quiet strolls along the beach, watch bears feeding in a garbage dump behind the hotel, rent boats to go fishing for prized cutthroat trout that inhabited Yellowstone Lake, or simply soak up the atmosphere by looking out on the lake and feeling its breezes. "The winds that sweep across the silver lake of Yellowstone," quipped Myra Emmons romantically in 1901, "bite and thrill like a first kiss."[79] A newspaper reported that boat owner E. C. Waters routinely piloted hotel guests "to remarkable fishing grounds." "He guarantees luck" at fishing, maintained the reporter with some hyperbole, "and his guarantee has never failed."[80]

At Lake, as with any park location, one could meet celebrities, for then as now Yellowstone was a famous place. An 1897 visitor, T. S. Kenderdine, encountered in person on the lakeshore none other than Martha Jane Canary, better known as "Calamity Jane," who wanted to sell him her picture and a small printed book about her adventures. "Who about the Park, from tourist to road-mender and soldier, [doesn't] know her?" he rhetorically asked his readers, then stated that "mentally she is as good as ever, and, from accounts, she has a tongue that neither road-maker, stage-driver nor Park soldier can match in retort." Sounding like the Calamity Jane of legend, she left Mr. Kenderdine on the lakeshore with "her bare head erect and with the march of a grenadier."[81]

The lake area could make visitors almost religious in their outlook, and that was good practice for the upcoming Grand Canyon of the Yellowstone. One visitor seemed to whisper in reverence his appreciation for the twilight hours at Yellowstone Lake. "Then the soft gloaming," he intoned, "with the spectacle of the dying lights of day playing about the crests and pinnacles of the still and solemn upper realm of the sleeping mountains on the opposite side of the lake, created a contrast that offered a text for talk."[82] It seemed that conversation was one of the quiet things visitors could enjoy at Lake Hotel.

The morning of the fifth day (fourth full day) saw travelers preparing to see Hayden Valley and the great Yellowstone canyon. After passing Fishing Bridge—not until 1902 could visitors look east and see this bridge, because

the road to the park's east entrance did not exist until then—and traveling for miles along the forested Yellowstone River, tourists arrived at Mud Geyser, Mud Volcano, and Dragon's Mouth Spring. This locale remains a smelly place today, its air strongly impregnated with hydrogen sulfide gas, but early visitors generally found it fascinating. Mud Geyser erupted forty feet high in the 1870s but ceased by 1905. Mud Volcano threw mud into the tops of trees in 1872, but it too settled down into the role of quiet churning by the following year. The tongue-like, lashing, hot-water action of Dragon's Mouth was responsible for its carrying many different names, including "Gothic Grotto," "Devil's Workshop," and "Belching Spring." Mud Volcano was "a sort of cave, like the lair of a wild beast," shuddered one visitor, "which perpetually vomits a compound of mud, putty, nastiness." An 1873 preacher, as might be expected, saw the place in terms of religion: "We could but think, as we looked into its steaming crater, of that [biblical] passage that speaks of 'an horrible pit.'" Said another visitor about Dragon's Mouth: "The angry dash of rock-bound waves roars within, while a continual jarring report similar to that made by a powerful engine and heavy machinery is heard accompanied by a rush of scalding steam from the portal."[83] From that description, one could almost *feel* it.

As stagecoaches conveyed visitors into Hayden Valley, drivers geared up to tell new stories. The crossing of Alum Creek almost certainly guaranteed that a driver would dust off his "Jim Bridger" tale about the puckering waters of the creek. One version had it that the waters of Alum Creek, when sprinkled on park roads, shortened the distances between points—probably appealing to visitors who wished for an end to certain long stretches of road. "Our veracious driver said that when it was forded it sometimes shrank a four horse team down to a pair of mules in passing through the water," sniffed 1904 visitor Clifford Paynter Allen who did not believe the story.[84] And it was, after all, not a true Jim Bridger tale but rather a stage-driver creation. The story reportedly fell into disuse when a lady visitor suggested to one driver that if the water were so good for shrinking things, he should soak his head in it![85]

Another stage-driver story, this one corrupted from one of Jim Bridger's actual stories, was a tale of the park's petrified trees. Gay Randall says that stage driver "Geyser Bob" told this story in Hayden Valley, probably because the main tourist route did not go past the true Specimen Ridge, which was located on the road to Cooke City. Said Randall:

He [Geyser Bob] was crossing Hayden Valley with a party of

tourists. "Do you see that range of mountain on your right?" asked Bob. "Folks, that is Specimen Mountain; everything petrifies there. The trees, pine cones and everything there. Once there was an elk walking down a steep ridge. He came to a ravine and tried to jump it and he petrified in the air and is still there." This was a little too strong for his party. One of them spoke up, "Bob, didn't you know that couldn't be? The gravity would have brought the elk down." "Well," said Bob, "I don't know what the hell gravity is, but it was petrified too."

Historian Hiram Chittenden picked up a variation of this story for his 1895 book *The Yellowstone National Park* and embellished it into one about petrified birds flying in petrified flight and a petrified sun shining with a petrified light. The real Jim Bridger story was less complicated but probably not as much fun.[86]

In Hayden Valley the traveling visitor soon arrived at "Sulphur Mountain," today known as Crater Hills. This strange place, located in the park's backcountry today, was on the main tourist road before the 1920s and was reached from a triple road junction then located about a mile west of today's Trout Creek crossing. It was the place known to 1830s fur trappers as "Sulphur Mountain" and possibly the place reported to President Thomas Jefferson in 1805 as follows: "among other things a little incredible, a Volcano is distinctly described on Yellowstone River." George Bird Grinnell described it in 1884 as "a great barren white hill, full of hot springs and sulphur vents," although there really were and are *two* such hills here.[87] Many visitors did not mention the spot, apparently being busy with observations about Mud Volcano and the Grand Canyon of the Yellowstone, but some did take the trouble to write about it. They often discussed great amounts of bright yellow sulphur strewn about the area, and the prominent feature known as Sulphur Spring—also called Crater Hills Geyser. An 1873 horseback visitor effervesced about that beautiful feature:

> One sulphur spring here is especially noteworthy. Situated at the foot of the [two] hills, it occupies a circular area fully twenty-five feet across, and is partly covered by a thin rim which extends over the water like a margin of ice around a pond. It constantly boils with violent agitation, lifting the water several feet. The rim and adjacent formation is strikingly beautiful,

surpassing any seen in the Geyser Basin. The finest porcelain is not more delicate than the fanciful embroidery here displayed, glistening in hues of yellow, pink and purple.[88]

The stage road passed directly through Crater Hills, and extant tourist photos taken from stagecoach windows show historians today where it was located. In 1991, park employees Lee Whittlesey, Leslie Quinn, and Julie Gayde (Benden) reconstructed and mapped the route of this old road from the triple junction on Trout Creek north through Crater Hills and down Sulphur Spring Creek to its joining of the present main park road near Alum Creek. Although the name Sulphur Mountain has been moved to a place farther south today, the vestigial trace of the old road may still be seen near Alum Creek in Hayden Valley, heading obliquely southwest toward Crater Hills.[89]

Also in Hayden Valley, an 1883 traveler named Moses Thatcher found a strange monument to someone's anger. "On approaching the river," he wrote, "we pass a rude pine table, upon the face of which is inscribed with charcoal, unflattering lines, to the Rev. Henry Ward Beecher, who was expected to visit the National Park with President Arthur." Mr. Thatcher did not record for posterity what those "unflattering lines" were. The Reverend Beecher was a national figure known for his conservatism on economic issues, liberalism on social ones, and inconsistency in many matters. He supported freeing the slaves and Darwinian theory, both stances that angered many religious conservatives, and was immersed in an 1875 scandal that allegedly placed him with another man's wife. All of these were possible reasons for the graffiti writer's dislike of him.[90]

Beecher did visit Yellowstone in 1883, not in President Arthur's party, and one instinctively wonders whether Beecher saw the graffiti in Hayden Valley. His visit was confirmed by former soldier Thomas Coyne who recalled "visiting the spot in the Gallatin Canyon where Henry Ward Beecher carved his name on a lodgepole pine in 1883."[91] The graffiti found that year by Thatcher and his published account of it make historians wonder what the real story was here. Surely storytelling in Yellowstone would be enriched if more were known about what the graffiti writer's "beef" with Beecher was.

Notwithstanding that strange encounter with an earlier traveler's graffiti, traveler Thatcher reveled in his time spent along the Yellowstone River. "With its subterranean mutterings, silent flow, rushing cataracts, rock-bound shores, foaming falls, magnificent curves, restful banks, craggy heights and mighty depths," he exulted, "how like the flow of time is this king

of mountain streams!" He expended column after column in describing the
river and its glorious canyon.[92]

And many other observers did the same, as writer after writer attempt-
ed to discuss the sublimity of Yellowstone River, its two big waterfalls, and its
magnificent canyon. For many travelers, the Grand Canyon of the Yellow-
stone was the pièce de résistance of the park, and many commented on how
appropriate it was that the counterclockwise park tour saved its best treasure
for last. Olin Wheeler, historian for the Northern Pacific Railroad and a visi-
tor of more than ordinary importance, summed up in 1906 what most visitors
thought of it. The canyon, he enthused, was

> the acme of grandeur found here, twenty miles in length[,]
> 1,200 feet deep, 2000 feet wide; no one can stand before
> its chaste glories unmoved. It thrills, inspires, awes and
> overwhelms. It alone [is] enough, were all else gone from
> the park, to make it the wonderland of the world.[93]

In this description, Wheeler was half right, for the canyon was and is 4,000
feet wide in places.

Of course, most stagecoach drivers agreed with Wheeler's assessment.
A 1904 driver known only as "Deafy" took a hitch in his belt to steady himself
for descriptive narrative as he drawled: "I tell you that there cañon, it's all
right. Now, I've been driving stage for fourteen years, and I've heard people
kick; but I hain't never heard nobody kick about that cañon yet."[94] It was
true that for most visitors, the canyon was the be-all and end-all, the star of
the Yellowstone tour. Perhaps the most famous of the many descriptions of
it—published and republished over time—was one by nineteenth-century
preacher Wayland Hoyt. His two-page description was remarkably free of
religion for a preacher of that period, but it was eloquent, widely quoted, and
personal. Only a small part of it is reproduced here:

> The whole gorge flames. It is as though rainbows had fallen
> out of the sky and hung themselves like glorious banners. The
> underlying color is the clearest yellow. This flushes onward
> into orange. Down at the base the deepest mosses unroll their
> draperies of the most vivid green; browns, sweet and soft,
> do their blending; white rocks stand spectral; turrets of rock
> shoot up as crimson as though they were drenched with blood.

It is a wilderness of color. It is impossible that even the pencil
of an artist can tell it. What you, accustomed to the softer tints
of nature, would call a great exaggeration, would be the utmost
tameness compared with the reality. It is as if the most glorious
sunset you ever saw had been caught and held upon that
resplendent, awful gorge. Through nearly all the hours of that
afternoon until the sunset shadows came, and afterward amid
the moonbeams, I waited there, clinging to that rock, jutting
out into that overpowering, gorgeous chasm. I was appalled
and fascinated, afraid and yet compelled to cling there. It was
an epoch in my life.[95]

There were others who waxed eloquent about the canyon as well, dozens
of them. "Here is where the 'Wonders of the Yellowstone' receive their crown of
glory," stated one. "How paint such a vision," questioned another, "where rela-
tives, proportions, lights, shades, tints, and finally, perspective are absolutely
unmanageable?" An 1896 traveler, Eva Keene Moger, said the canyon's beauty
made her want to cry and to never leave it. Charles Stoddard could think of
nothing to compare it with except perhaps "some imaginary chasm in the
planet Saturn; and of eagles nursing their young upon inaccessible heights,
bathed in unspeakable glory." And even Rudyard Kipling swore after seeing it
that he "had been floating" and thundered, "now I know what it is to sit
enthroned amid the clouds of sunset." Kipling imagined history in the canyon,
bespeaking that its cliffs were "graven by time and water and air into mon-
strous heads of kings, dead chiefs, men and women of the old time."[96]

It remained for visitors to leave the canyon and journey to the nearby
Canyon Hotel for the night. Over time there were three different hotels there:
a primitive one (1886–1889); a large, barn-like structure (1890–1910); and a
huge, ornate castle (1911–1958). Mrs. J. A. I. Washburn stayed at the first such
hotel in 1886. Calling it "a one-story sort of barracks," she described her quar-
ters as "a six by nine room with a single window." The second and much
improved hotel opened in 1890 on a bluff farther to the north, and was "a
most comfortable and commodious house." The third hotel, which opened
with a gala ball in 1911, was the masterpiece of architect Robert Reamer that
was long celebrated in park literature—and in poetry![97]

The mayor of Chicago, Carter Harrison, who stayed at the second hotel
during its first summer of operation (1890), compared it to the Mammoth
Hotel saying that "the beds are clean and soft, the table fair and the attendance

quite good." Harrison hated the band that "tooted" at Mammoth Hotel but seems to have liked the quiet at Canyon. He did not mention the grizzly cub that was kept chained to a pole near the back door of Canyon Hotel, but one historian says it was there.[98]

And well it could have been, because the Canyon area was loaded with bears. The "bear feeding" area at Canyon was the hotel garbage dump, located "about 300 yards west of the hotel, in a narrow, shallow valley near the edge of the forest."[99] It was a place where everyone went for entertainment. The account of several ladies who went there after dinner in 1902—"they returned . . . with glowing accounts of numerous 'silver-tips,' which were almost as dangerous as grizzlies and nearly as big"—illustrates the lack of information most visitors had about animals, for silver-tips and grizzlies were the same bears.[100]

And what animals did Yellowstone tourists look for and hope to see? Bears were most sought after, but elk, deer, pronghorn, and others were also mentioned in various accounts. Bison were seldom seen until 1896, when tourists could encounter them in a pen on Dot Island. Visitors loved seeing animals, but in the 1880s animals were not seen as frequently as today because of a massive slaughter that occurred during the 1870s.[101] Mrs. Washburn and her 1886 party were convinced that their sightings of animals that summer were among the few if not the only ones, because she mentioned that fact *twice*: "We seem to be the only parties favored with a sight of game this year—at least I cannot hear of any having been seen." Apparently she asked around the park and was told that tourists were not seeing game that summer.[102]

At Canyon the following morning, stagecoach visitors headed west across—at least initially—an ocean of cut stumps to Norris and back to Mammoth Hot Springs, lunching with Larry Mathews again and viewing scenery they had seen earlier. This fifth day of the Yellowstone tour was often a time of singing on the stagecoach and shouting greetings to people riding stagecoaches in the opposite direction ("Indiana!" or "Ohio!"). One of the songs that Wylie Camping Company visitors joyously sang was written in old Negro dialect and went, to the tune of "Chicken," like this:

W, am de way to begin,
Y, am de second letter in,
L, dat am de third
And de middle of de word.
I, am nearing de end,

E, and dat is de end.

W-Y-L-I-E—Dat am de way to spell "Wylie."[103]

Visitors sang songs like this one while their stagecoaches were headed "downhill with a vengeance," the road dropping one thousand feet in five miles from Swan Lake Flats to Mammoth Hot Springs Hotel. After dinner there—or at a tent-camp if you were with one of the camps' companies—the outbound tourist rode the stage to Cinnabar or Gardiner where he boarded the train for return to the main Northern Pacific line at Livingston, Montana. Thus his Yellowstone tour became history.

The foregoing represents what most visitors did "on the grand tour" of Yellowstone during stagecoach days. Of course there were variations. During the period 1880–1907, visitors could ride the narrow-gauged Utah and Northern Railroad to wherever its railhead was west of the park and take private stagecoaches to the park's west entrance and on to Old Faithful. That route began to be served by Frank Haynes's Monida and Yellowstone Stage Company in 1898, and it required a much longer stage ride than did the trip from the north entrance. Beginning in 1902, visitors could take Chicago, Burlington, and Quincy trains to the park's east entrance and begin tours there. After 1907, travelers could take Union Pacific trains to the park's west entrance. After 1905, some visitors elected to take the new stage road across Dunraven Pass from Canyon to Tower where they might stay at Uncle John Yancey's hotel, mostly patronized by travelers between Mammoth and Cooke City, Montana. A few visitors had traveled over Dunraven Pass earlier on horseback—1884 traveler Egerton Laird did this, along with some people mentioned in 1886 by Catherine Bates[104]—but most returned the way they had come, heading west to Norris and then north to Mammoth.

How did visitors react to the Yellowstone tour? Most were not like Rudyard Kipling or Mrs. Carbutt, who disliked a lot of what they encountered in the national park. Many were short in their summary comments, such as T. S. Kenderine who said only that "its eruptive wonders; its mountain scenery; its falls, lakes and streams and its untamed wildernesses will forever be held in our memories." At least one visitor was glad to leave because he was overwhelmed. "Strange to say you feel a sense of relief on leaving the wonderful Park," wrote W. B. in 1886. "Your mind is kept on such a stretch and strain of admiration at their wonderful treasures of art that you are glad to get away from them." He longed to rest his eyes on objects more mundane and less exciting.[105]

But many more visitors were like Mayor Harrison who scattered his comments throughout his journal rather than making extended comments at the end of the trip. "The wonders are unique," he wrote without emotion, "and the marvels unequaled elsewhere in the world." As he left the park, Harrison said little except that "we doffed our hats and bade adieu to the eagle sitting on its eyrie" as "we dashed down the defile" at Eagle Nest Rock.[106]

In general most visitors loved Yellowstone. Raymond H. Barker said of it: "Farewell to the Yellowstone . . . its cañons are the grandest, its water-falls the fairest, its geysers the most marvelous and its flowers the most varied and beautiful." But few visitors were as eloquent as artist Frederic Remington who declared:

> Americans have a national treasure in the Yellowstone Park, and they should guard it jealously. Nature has made her wildest patterns here, has brought the boiling waters from her greatest depths to the peaks which bear eternal snow, and set her masterpiece with pools like jewels. Let us respect her moods, and let the beasts she nurtures in her bosom live, and when the man from Oshkosh writes his name with a blue pencil on her sacred face, let him spend six months where the scenery is circumscribed and artificial.[107]

Thus by the mid-1880s the evolving, embryonic travel entity in Yellowstone—composed of hotels, transportation companies, stage drivers, and walking guides—had established an elaborate framework to convey park information to visitors. Stagecoach drivers from four different companies and dozens of independents reined their teams through Yellowstone on a frying-pan-shaped road system and told stories to tourists who were often eager to ask "all them fool tenderfoot questions." A great variety of natural and cultural features—hot springs, geysers, mountains, streams, lakes, forests, waterfalls, canyons, hotels, roads, and animals—gave drivers plenty to talk about and to show to tourists. These stagecoach drivers and the walking guides who supported them knew the route and gave commentary about what their visitors were seeing. They were there to point out the way and to tell tourists all about it.

CHAPTER ELEVEN

"To Point Out the Way"

Early Tour Guides in Yellowstone

The guide shows the visitor all the
points of interest to be seen.

—L. F. J., 1895 Yellowstone stagecoach visitor

*E*arly Yellowstone guides made it their business to "know the park" and to tell stories about it. Moreover, competition seems to have emerged early not only for tour business but also for information. Contests among those tour guides and many later ones to "see who knew the most" about the park seem ever to have been a part of the scene in Yellowstone. For example, assistant superintendent G. L. Henderson observed in 1884 that "there seems to be a competition this season among guides and teamsters to establish good reputations in their care of tourists."[1] As has been seen, Henderson encouraged these activities in the spirit of better service to visitors.

THE HORSE GUIDES

The roots of the Yellowstone stagecoach and guiding operations began in 1872 with mounted riders, for without wagon roads the new national park was accessible only by horse and mule. The earliest travelers qualified instantly—or thought they did!—as Yellowstone guides. For example, David Folsom gave information to the 1870 Washburn party, and Washburn party members subsequently guided others. In particular Lieutenant Gustavus C. Doane was an important early guide for parties that came after 1870, as was

Nathaniel P. Langford. Langford served as guide for Dr. F. V. Hayden in 1872, and then Hayden himself guided VIP groups. Doane, too, guided parties through the park numerous times from 1870–1875, and he served as guide to Capt. William Strong's government VIP party in 1875. Strong thought him an excellent guide and voted to anoint him Creator of Yellowstone: "This is his fourth trip to the Park, and he is perfectly familiar with it and knows more about the wonders it contains than anybody. . . . Doane saw it first, wrote the first report, and brought it all to the notice and attention of the world. Give him the credit."[2]

Prospectors who had been in the Yellowstone area for any amount of time turned to guiding in the 1870s when it proved more stable and lucrative than prospecting. A. Bart Henderson, George Huston, John Werks, Ed Hibbard, James Gourley, and Adam "Horn" Miller all guided parties into the new national park. In fact, his 1872 peers nominated George Huston as "Chief Guide" for Yellowstone. The meaning of the term "guide" in early days ran the gamut from someone who merely outfitted the party, to someone who only drove the wagon or coach, to someone who rode along only to point out the way, to a full tour-giver/storyteller/interpreter. These last persons are the ones most relevant to this study, because they talked to their audiences about park features and history.[3]

The question of who was the first Yellowstone "tour guide," as here artificially distinguished from "interpreter," is a difficult one to answer, but the most likely of known candidates is Gilman Sawtell (1836–1898). Sawtell served in the Civil War, then moved to Montana Territory, "and permanently located at Henry Lake in the spring of 1868." At some point he told stories to the future Mrs. George Cowan, a child of ten, about the Yellowstone country. He also gave the first, or at least the first known, commercial tour of the park in 1871. The Clawson party engaged him for money that summer to conduct them into the new Wonderland from the west entrance. R. W. Raymond, one of the party members, described Sawtell as a "stalwart, blond, blue-eyed, jovial woodsman who for years has kept a solitary ranch on the bank of Henry's Lake." There Sawtell engaged in the businesses of hunting, commercial fishing, guiding, and crop raising from about 1868 until 1896. About Sawtell, park superintendent Langford declared in 1872:

> Ascending Henry's Fork [from the west, the traveler] will arrive
> at the frontier cabin of Gilman Sawtelle [sic] and Levi Wurtz, on
> the shore of Henry's Lake. . . . In Messrs. Sawtelle [sic] and Wurtz

he will find men who, with all the better qualities of sagacious and expert mountaineers, unite fine moral natures and rare culture. Perfectly familiar with the entire region, these gentlemen will give the traveler all needful information as to his future journey.[4]

The biggest problem for Sawtell and Wurtz was that the trip into Yellowstone had to be made on horseback; wagons could not go there, because there were no roads. In fact horses themselves had a great deal of trouble. Langford reported: "The park is at present accessible only by means of saddle and pack trains, a mode of travel attended with many privations and inconveniences." And 1877 traveler Thomas E. Sherman, son of the noted General William T. Sherman, intoned at the mouth of the Gardner River: "Here vehicles must be left behind, for there is no highway into Wonderland, and the visitor who dares to trespass on Dame Nature's secret fastnesses, must bear the fatigues of rough riding, and trust his baggage to the mercy of a pack animal."[5]

Others proclaimed themselves "park guides" during this "marking time" decade of the 1870s. Fred Bottler, Jack Baronett and J. Beltizer all qualified when they guided P. W. Norris on his earliest trips into Yellowstone in 1870 and 1875. Baronett guided General Sherman through the park in 1881 and 1882. John B. "Jack" Bean arrived in Montana about 1870 and guided in the park quite early; in fact he was General Sherman's chosen guide in 1883. A number of these men ran their own early trips to the park. George Ash and E. Fridley placed advertisements in 1876 Bozeman newspapers to outfit Yellowstone travelers, as did "Grounds, [George] Huston, and Buchanan," Zack Root's Express, Clark and Arnholt, and James McCartney. Very few persons traveled to Yellowstone in 1876 due to Indian activity, so it is no surprise that these early tour businesses seem to have failed about that time.[6]

Advertisements revealed the existence of some guides. In the summer of 1872, one advertisement stated that guides were "available at Mammoth Hot Springs" along with pack animals and supplies. If this was so, the service was limited, for prospective visitors had to outfit and acquire their guides outside the park. In 1873 the Bottler brothers—Frederick, Phillip, and Henry—of nearby Paradise Valley were "prepared to furnish all parties visiting the Park with everything necessary to make the tour pleasant and agreeable, and to act as Guides or Hunters." "Their long experience," bragged the advertisement, "and their thorough knowledge of the country give them great advantages." John Werks's 1873 advertisement was captioned "Ho for

Wonderland!" and it stated: "I am now prepared to carry Invalids and Pleasure Parties to the celebrated Mammoth Hot Springs ... and other points in the National Park."[7] Storytelling by these men (for all were men) was likely limited to pointing out the route. However, party conductors like Hayden and Doane—for everyone was a guide in early days—probably told stories to their charges utilizing the best information of the day and performed speeches about the park in good interpretive style.

Interestingly, the earliest known "step-on" (non driving) tour guide seems to have been a military man. Augustin Seguin, an 1879 French traveler, engaged his driver and guide at Bozeman. He stated: "Our caravan was made up of five people: Gessner, the guide; Mr. [George] Ash, our driver, a true gentleman; his assistant; my companion; and myself." This "Gessner" had apparently been involved in the Nez Perce foray in the park two years earlier for Seguin stated that the first time Gessner went through the park's Madison Canyon was "in pursuit of the Indians." The man was also a Ft. Ellis soldier, for Seguin assured his party that "our greatest safeguard [from Indians] lies in the uniform of our guide, the uniform of the American cavalry."[8]

By 1880, many visitors no longer needed guides, according to one guidebook, "to point out the way." Another book echoed this when it stated that "guides are not much needed but packers are." The roads built by park superintendent P. W. Norris eliminated the need for as much route finding. Nevertheless, guides remained available. Superintendent Norris mentioned in one of his reports that "bad guides" were detrimental to the park because of their "greed, ignorance or inefficiency." In fact, he referred to these bad guides as "a small but despicable class of prowlers" who took advantage of tourists' desires to see "this peerless region of wonders." An 1882 guidebook recommended some of the "good" ones: George Huston, Nelson Catlin, George Rowland, Sam Jackson, Elwood Hofer, and F. D. Nelson.[9] An 1881 visitor encountered another good one, George Graham, at Marshall's Hotel in the Lower Geyser Basin:

> We found three guides awaiting employment [from us], and
> asking hundreds of questions of them and of the Proprietor
> about the Park, packing animals, the different camps, trails, etc.
> [W]e came to the conclusion that a guide named George
> Graham, a Scotch Canadian, about thirty-five years of age,
> was the man for us, and we made arrangements with him to
> accompany us ... around the Park to headquarters at the

Bozeman entrance. He furnished his own horse, and we paid him four dollars per day, allowing two days' pay to get back to Marshall's. Graham proved one of the best guides it has been my fortune to travel with: a hard worker, honest, planning and doing everything for the best interest of the party, possessing a knowledge of the Park equaled by few, a good hunter, and, withal, a horse shoer by trade.[10]

Stagecoaches and Their Storyteller Drivers Come to Yellowstone

During the period 1883–1916, park officials recognized (through licensing) the many independent "guides" who, in bringing their own horses and wagons to Yellowstone, were pressing for a share of the tour business. Payment of the park's fee of five dollars per operating wagon was the only requirement for becoming a guide, and hundreds took advantage of easy licensing. These men furnished their own equipment and conducted parties of camping tourists through the park independently of official concessioners and with virtually no supervision.

Park assistant superintendent G. L. Henderson took note of some of the better independent guides during the summer of 1884, and expressed his approval of them to the park superintendent: "There seems to be a competition this season among guides and teamsters to establish good reputations in their care of tourists." Henderson then listed the names of the guides who had done an outstanding job: Henry Van Auteen, James A. Clark, Michael Early, Charles Thoman, Ole Grandberg, John Early, Nelson Catlin, Toney Early, George Young, Charles Chadbourn, John Hoppe, and Frank Hobbs. Henderson opined that "on their return the parties employing them are quite willing to enter on the record their estimate of the value of their guides."[11] Just how much storytelling these men did is not known, for their principal functions seem to have been to transport and to point out the way, but surely at least some of them felt the need to try to explain some of the Yellowstone features that they saw along the way to their interested passengers. Often these independent guides, especially when they camped along the way with their customers, kept themselves physically separate from their "dudes" except when they were driving or interpreting. An 1884 traveler noted that "a fearful hail shower... compelled us to have the guide in the

tent," something that was otherwise unusual.[12] At any rate, what speeches these independent guides made are not known, but they probably were some of the earliest park interpreters in one form or another.

As one might expect, horse-drawn wagons and then stagecoaches eventually became stars of the Yellowstone road. The regular stagecoach, first introduced in America in 1732, was a staple in Yellowstone for thirty-seven years. So important was Yellowstone in the history of that vehicle that the Abbott and Downing Stage Company of Concord, New Hampshire, introduced a special version in 1885 made especially for the park and even named "The Yellowstone Wagon." Its seats all faced forward, for touring purposes, as opposed to the earlier, overland stages where seats faced each other.[13] Yellowstone stagecoach drivers epitomized the essence of storytellers and horse-and-buggy tour guides.

Before stage drivers are discussed, a word or two about stagecoach travel in general is in order. Many travelers hated it. "The ride was simply horrible," lamented an 1869 rider on western roads, "the heat, the dust, the jolting, awful!" Another account was more detailed but just as uncomplimentary:

> the swing to one side, which follows the sinking of the wheels,
> bumps the passengers against the sides and against each other,
> while the jar of the other wheels against the stones, throws
> their heads against the roof or their backs against the front or
> rear of the coach. Thus they learn, in a way alike practical and
> unpleasant, the import of the threat to beat a man into jelly or
> to break every bone in his body.[14]

Regardless, stagecoaches were a necessary evil, as railroads could not go everywhere. Passengers complained about not only the ride but also the bad treatment they received from company personnel, including drivers. And among numerous compliments to drivers' horsemanship, many travelers recorded those drivers' tendencies to swearing and whiskey drinking. "Give him a handy six-team, his powerful blacksnake whip, and the universe to fill with his Titanic language," averred traveler William Baillie-Grohman, "[and] he will take you . . . across almost any chain of mountains there is in the United States or Europe."[15]

Park officials, even the very early ones, wanted to believe that Yellowstone drivers were a kindlier and more upstanding breed. The year 1880 was

noteworthy in Yellowstone for bringing the first commercial stage tour originating inside the park. Robert and Carrie Strahorn both chronicled accounts of that trip on October 1, 1880, Carrie remembering that "the Marshall and Goff Stage Company sent the first public conveyance into the park, 120 miles distant, and we were to be the first passengers." Their driver was George Marshall, owner of both the stage line and the Marshall's Hotel where the party stayed. Thus Marshall has the distinction of being the first commercial stagecoach driver to be duty-stationed inside the park. Drivers were storytellers, and any speeches Marshall made to his passengers would be some of the earliest concessioner interpretation in Yellowstone. This began a tradition that was to continue to the present. As will be seen, Marshall would later become a walking guide as well.[16]

Wagons and stagecoaches, established in the park in 1880, were to last through the summer of 1916. Their drivers were some of Yellowstone's first tour guides. Many drivers performed excellent park storytelling, but others were merely low-bred rustics who said little to their passengers. Several companies, as well as uncountable private individuals, operated stagecoaches in Yellowstone during that thirty-seven-year period, so hundreds, probably thousands of persons gave tours and told stories to park visitors. The companies were the Yellowstone Park Transportation Company (YPT), the Wylie Camping Company, the Shaw and Powell Camping Company, the Monida and Yellowstone Stage Company (later Yellowstone Western), the Bassett Brothers, and Gilmer and Salisbury. The Bassett Brothers ran stagecoaches into the park from Idaho beginning in 1880, and Gilmer and Salisbury did the same as early as 1879. Little is known about the drivers for these two companies and whether they performed storytelling in Yellowstone.[17]

The forebears of the YPT Company began in 1883, when George Wakefield and Charles Hoffman founded the first in-park stage line. That year park employee George Thomas noted that "the stage drivers were well able to explain the objects to be seen from the road, and to tell interesting anecdotes that had come to their attention, and to point out the things that might easily pass unnoticed among the many sights that followed in rapid succession." Clearly park "tours" had begun by that time and many if not most drivers were performing as tour guides. Another interpretive milestone occurred in 1886, when Charles Gibson of the new Yellowstone Park Association "issued the order that the drivers of the stages should act as guides in showing to guests all the curiosities of the park [in order to] save them the expense of guides."[18]

An 1884 visitor described the chaos of locating one's driver at the Cinnabar train station that year as well as some of his driver's interpretive spiel:

> The carriages, with their horses, were called 'rigs.' The drivers, 'carters.' It was for us to select. A fellow passenger who took an interest in our proceedings, waving his hand, so as to indicate the whole assembly, said, 'There is not one of these gentlemen as can't be fully recommended in every way.' Heavens! What an assemblage of sun-baked, frost-dried, grisly faces! brown, hollow-cheeked, dark-bearded, with the skin tightly drawn over the foreheads and ropy veins meandering about their thin temples and necks. Every mouth clinging tightly round a long black cigar, and with a brown smear at the corners. Yet young men, almost all of them, in full health and energy, as the bright eyes rolling in their sunken orbits fully testified. . . . All seemed to be trustworthy in essentials, and under a very rough and swaggering exterior there was plenty of shrewdness and good temper. . . .
>
> As our 'carter,' who has sketched all the scenes mentioned in lively language, begins to expatiate on the fountains, his speech gathers force as he proceeds with his wondrous tale, until, overburdened with expletive and illustrative allusions to the realm of Pluto, a slight incoherence takes place, and, turning a bend, we see before us in the evening light the huge wooden hotel of "Mammoth Hot Springs."[19]

It is apparent that most of these men were hardened, frontier types, many of whom were good at storytelling and some of whom were educated. Sometimes they were silent, sometimes they talked about Yellowstone, and sometimes they talked about anything. For example, traveler George Wingate described the two driver guides he engaged at Bozeman as being honest, reliable, familiar with the park and country, good hunters and mountaineers, and polite. These two men, said Wingate:

> had each spent the best part of their lives on the plains, and although not given to boasting were full of curious and interesting reminiscences. Sam in particular was full of dry wit and quaint sayings which made him very good company.

23. *YPT Company stagecoach and driver loading (or unloading)
passengers at Mammoth's National Hotel, 1905. Courtesy YNP
Photo Archives,* YELL *967.*

A 1904 traveler, Edmund Erk, agreed that, unsurprisingly, park stage drivers
interspersed their speeches about the park with stories about their own his-
tories: "True or untrue, the tales of the past of these reinsmen form the most
interesting narratives imaginable."[20]

As park stage lines and hotels began to serve more visitors in Yellow-
stone, information giving began to be seen as more of a necessity, and thus
attempts at visitor education increased. Traveler Henry Clay Quinby summed
up the concessioners' park information system in 1900. It consisted of both
stage driver/guides and hotel porter/thermal area guides:

> Visitors who are going the regular round are not troubled so
> long as they pay attention to the rules of the Park as explained
> to them by the Coachmen and Guides.... The coachmen know
> their work well, and are able and willing to give all necessary

information about objects of interest in passing; and, what is even more, intelligent guides are provided at all the great central basins. . . . to show the visitors all the wonders of the locality.[21]

This, then, was the pattern that developed in Yellowstone National Park during the period 1880–1916. Stagecoach drivers drove the wagons and told stories along the way, giving mile-by-mile commentary. Guides hired by the YPA hotels or the Wylie tent camps conducted walking tours of park thermal areas or the Grand Canyon of the Yellowstone and interpreted features along the way. And beginning in 1886, U.S. Army soldiers conducted some walking tours or "cone talks," but interpretation from these people seems to have been more limited than that of the concessioners. In general in early Yellowstone days, the army's function had more to do with law enforcement than interpretation.

Because all of them performed slightly different types of storytelling and because their individual park locations influenced that interpretation, a complete examination of these storytellers requires a separate look at stage drivers, hotel guides, government guides, and specific known interpretive events, as well as storytelling at individual park locations.

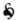

In many ways, the stagecoach driver was the absolute center of Yellowstone touring and storytelling. He set the pace, reined in the horses, talked to his passengers about the sights, and controlled individual stops along the way. So important was he to the mass of Yellowstone tourists during the carriage era that wags have composed a number of poems in tribute to him, including this one:

> The drivers are old and experienced,
> The best that's found in the West.
> They're careful, safe and obliging,
> And to please you, they'll do their best.
> And when you start on your journey,
> Here's a little tip for you—
> Keep cool and trust the driver,
> For it's he who knows what to do.[22]

Many stagecoach drivers were men with fine personalities who could tell

stories well. "The driver of [our] stage is a fellow of infinite wit," declared an 1885 traveler, "and [he] tells marvelous stories in a manner which kept us on a roar the whole way." Later this traveler added: "The drivers are very intelligent, civil fellows, and when once stirred up they tell most amusing stories." Another observer concluded that Yellowstone drivers "were good entertainers, capable of making what would otherwise be a long, tedious . . . ride seem entirely too short to the passenger, who was fortunate enough to have a seat on the box beside him, and hear him relate his experiences with Indian and stage robber."[23]

A slightly different take on the stagecoach driver was written onto the back of a Yellowstone postcard that was never mailed. Dedicated to "Miss Myrtle Renwick" by one David Oliver MacQuarrie, it probably dates from around 1910 and is in the custody of West Yellowstone Historical Society. It carries the following handwritten poem:

The sun was shining brightly,
The river went gliding by;
And Myrtle sat by the driver
On the seat away up high.
He was a careful driver,
With his right hand sure and deft,
He guided the team,
But the lord only knows,
What the mischief he did with his left.

Then as now there were drivers who knew they were outstanding in what they did or who at least could make jokes about their prowess. "Won't you hove a lantern, colonel, for the rest of the road?" asked an 1885 traveler. "No thanks," said the driver. "The brightness of my face and the brilliancy of my wit are quite sufficient to light up the road." Drivers like this one may have seemed to passengers to personify in some way the independence and free-spirited openness of western America. Perhaps this kind of quip represented to Mr. Traveler Everyman the possibility of remaking himself on the trip and suggested that anyone could be what he wanted to be in the carefree spaces of the Great West.[24]

Ultimately many drivers fell in love with the country and became quite proud of the sights they were showing to tourists. Although no actual example of this has been found for Yellowstone, it *must* have happened, because

today's park tour guides report that such sentiments are routine with guides. One example is known from a tourist party that passed through California's Yosemite country in 1882. "The guides and drivers thereabouts," enthused T. S. Hudson, "are genuinely in love with their scenery and pet show-places, and do not perform their part in a mere prefunctory [*sic*] manner." Hudson made it clear that his driver was proud as a peacock of showing them the sights: "This imperturbable individual had, beneath his Californian hide, the *amour patriae* [love of country] of his kind, and drew up his team in majestic style at [one of the big trees], and with a wave of his whip turned a beaming countenance upon us, as much as to say 'There!'"[25]

Of course, some Yellowstone stagecoach drivers told stories that were less than interpretive, as Almon Gunnison has confided about his driver, "Toot," in 1883:

> His name adorns no calendar of saints, although not half those ancient worthies had such nimble-witted tongue.... He swears at times with most provoking volubility; but his oaths are not the common sort, and Toot has lived for half his life upon the plains. He draws the long bow sometimes in the strange tales he tells us; but then he assures us he is not like other drivers in the Park, for when he tells the truth he is not ashamed to own it.... [W]e notice with just a touch of sadness that while he calls us pilgrims without one hint of bitterness, yet when he wishes to put the climax on the list of nouns with which he curses the [horses], he always adds, as the final curse, the word "pilgrim."[26]

But many drivers gave good tours. No less a visitor than John Muir acknowledged the stage driver's role as an informant in 1885:

> The driver will give you the names of the peaks and meadows and streams as you come to them, call attention to the glass road [at Obsidian Cliff]—how the obsidian cliffs naturally pushed the surveyor's lines to the right, and the industrious beavers [at Beaver Lake], by flooding the valley in front of the cliff, pushed them to the left.[27]

Muir also noticed the many questions with which visitors peppered their drivers, including inquiries about hot springs and geysers. Some drivers

were interested enough in geysers to be called early "geyser gazers." But most were like Francis Francis's driver in 1881 ("'Wal, sir, I tell you that that thar Yellowstone Park and them Geysers is jest indescribable. Yes, sir, that's what they are, sure.'"). Or they resembled the driver in 1887, about whom Edwards Roberts recorded the following:

> "Guess you're pretty lucky people," our driver remarked.
> "How so?" I asked. "Cause th' Giantess is goin' to go off
> soon, an' *she* don't blow more'n once a month." The news
> spread rapidly. Every one hastened to the brink of the
> great pool.[28]

Like this man who seems to have merely guessed well about an impending eruption of Giantess Geyser, most park stage drivers did not rise to the level of "geyser gazer," that is, a person who has devoted considerable time to studying geysers. But many did try to serve their passengers with information that would increase their chances of seeing a geyser eruption. Driver Billy McCallister was such a man. One of his guests soaked up his techniques in 1894:

> This, Billy informs us, "is the beautiful Riverside Geyser
> which plays every eight hours." It don't appear to be of much
> account after all we have seen, but Billy's practiced eye has
> detected a slight increase in the flow, so he reins up his
> horses and tells us to "wait a little."

Riverside erupted shortly afterward. Geyser observers today know just as Billy did that an eruption of Riverside Geyser will happen about an hour after overflow. Driver McCallister also commented on a poor eruption of Castle Geyser and stated in Munchausen manner that a "grand eruption" could be heard thirty miles away.[29]

And of course drivers had to give occasional safety information to their passengers about the possibility of falling into a hot spring. Traveler J. S. Dearing confessed that at Norris in 1900, "my guide called out: 'Say, old man, it is sixty miles to the hospital and the horses are tired.'" The hospital, such that it was, was actually located eighty miles away at Livingston, Montana, and Mr. Dearing certainly did not need a boiling-water injury added to his vacation.[30]

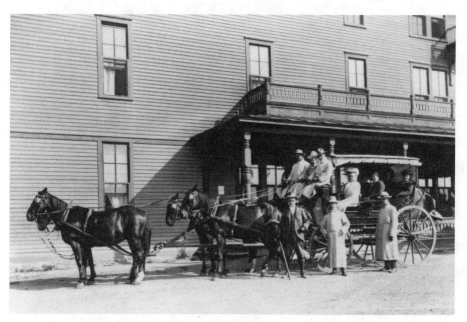

24. Stage driver Billy McCallister, no date, mentioned as an early park interpreter. Montana Historical Society.

Most Yellowstone travelers during the stagecoach era came to expect that they would make the park trip "with experienced drivers thoroughly familiar with all points of interest,"[31] and indeed traveler Donald MacInnes, in 1889, found his driver "very intelligent and entertaining."[32] For safety reasons, of course, it was important that passengers trusted their driver, but his communicative abilities helped engender that trust. "It was my good fortune to ride by the side of Thomas Casey, the faithful and intelligent, as well as the most experienced driver in the Park, for over a hundred miles," gushed a newspaper editor about his 1888 driver. This editor confided that driver Casey's speeches were a notch above those of many interpreters, for he referred to the driver as "our lecturer."[33] Writer Rudyard Kipling, for all the things he did not like about Yellowstone Park, seems to have liked his driver, for he called him the "great chief and man with a golden tongue."[34]

By the season of 1909, the stage driver as interpreter was solidly established as a Yellowstone custom. Campbell's guidebook for that season described the routine and even used the word *interpreter*:

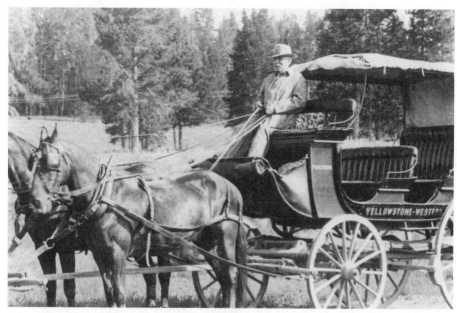

25. *Stage driver Tom Casey, 1914, mentioned as a good "lecturer" and guide by newspaper editor J. E. Williams. Courtesy YNP Photo Archives,* YELL *108782.*

On the drive through the Yellowstone Park the driver must be your guide, interpreter and friend, obliging, not to the extent of being obtrusive, but if you have not asked the question of some attraction that you are passing he will call your attention to it, and pleasantly give you its story that you would have missed but for his courtesy. The drivers are not all old-timers of the Park, but very many of them have been there for many seasons, and some of them since the opening of the first one [1883]. The new drivers learn quickly and in half a dozen trips are sufficiently posted to answer all but the most intricate questions; they learn from observation and from association with the older men; they make a study of their work because it is to their interest to know the road and all about it.[35]

Stage drivers, unlike the thermal-basin walking guides, had less opportunity to stand out as interpreters, but some of them did leave a trail in

Yellowstone history. Such a stage driver was Dutch Louis, a German, known to have been driving in 1894. A minister named Henry M. Field rode with him that year, and saw him combine wit with information:

> We came across him first at the Mammoth Hot Springs. He showed us over the terraces, where everything is so incrusted with lime that it seems as if water was turned into stone, upon which old Louis remarked solemnly that the absence of birds was accounted for by the fact that there could be no young ducks, since the old ducks laid hard boiled eggs! Of course nobody stops to analyze such wit. If it raises a laugh, it answers its purpose, and it matters not if it be repeated to new comers a dozen times a day. But withal the old fellow was a good guide, and nothing escaped his observation. "Look at that tree!" he said, pointing to an old dead trunk by the roadside. "You see the black mass in the crotch! It is an eagle's nest; yet not the bald eagle of the mountains, but the osprey, that feeds on fish, of which he finds an abundant supply in the [Yellowstone] Lake."[36]

In this Dutch Louis seems, like tour guides of today, to have alternated wit with information, prefacing an explanation of osprey and what they eat with a joke about other birds laying hard-boiled eggs.

Another communicative driver was Joe Smith who is known to have been driving in 1895. One of his charges that year referred to him as "Professor Joe Smith," apparently because he was the imparter of so much park information.[37]

Stagecoach drivers were constantly besieged with questions from their passengers and some struggled, as park interpreters and concessioner tour guides do today, to answer them. Olin Wheeler, historian for the Northern Pacific Railroad and a Yellowstone writer of much repute in his day, acknowledged that this was customary: "Many of the drivers have driven in the park for years and are familiar with every mile of road. It is entirely proper to ask them for information, or to have the coach stopped in order to get out to examine some interesting object."[38] An 1890 traveler heard his stageman inundated with questions: "The heavily tanned driver is kept busy handling horses and brakes and the flow of questions with which he is continually plied." Nine-year-old Ida McPherren, who stowed away in a Cinnabar-to-Mammoth stagecoach in 1894, heard her driver's reaction to questions he could not answer: "When the

stage reached Mammoth Hot Springs the driver and the man beside him [another company man] pointed out the different phenomena to the tourists and answered any questions they could answer and to those they could not answer they would say, 'Only God knows that.'"[39]

The Yellowstone Park Transportation Company took great pride in its drivers. One of the company's 1905 advertisements stated:

> [T]he driver is well informed, gentlemanly in his deportment, is always ready to answer questions or volunteer information as to interesting points. His four-horse team is tractable and reliable, and his skill is such that we feel sure the Company has selected its very best man for our safety and convenience. And yet, as we grow older in Park learning, we find that the Transportation Company hires none but the very best of stage drivers, and it is doubtful if another such lot of perfect horsemen and reinsmen are employed in any one place in the world.[40]

In fact most of the company drivers took pleasure in Yellowstone itself and in their job of "pointing out to their passengers its many objects of interest and beauty."[41] But many drivers also "guyed" (kidded) the tourists. Traveler Myra Emmons found that to be true when she met stage driver "Doc" Wilson in the summer of 1901:

> The traveler who sits beside the driver is also perched on the insecure and perilous horns of a dilemma. He may ask questions and be guyed in reply, or he may sit silent and discreet. The wise tourist does the former. He has to stand the derisive jesting which the drivers feel it their privilege to bestow, with sarcastic smiles at "all them fool tenderfoot questions"; but he saves himself from being disliked. There is nothing a Park driver resents more than he does the tourist who by failing to exhibit his own imbecility deprives the driver of his rightful joy of guying.[42]

In answering tourists' questions, kidding seemed always a possibility even if the driver later gave a serious explanation. And of course some drivers could occasionally get annoyed with passengers' questions. Mrs. Townsend in 1906 returned to her coach only to learn that her Wylie driver "would not have

that school teacher from Florida on the seat beside him again" because she asked so many questions. He also pointed out that "that long haired one," Mrs. Townsend herself, asked a good many questions, too. Reminded curtly by Mr. Townsend that the "long haired one" was his wife, the driver tried to right matters "by further stating that [at least] she asked for information and gave attention to his answers while so many asked just for the sake of talking or hearing themselves talk."[43]

If passengers sometimes annoyed drivers, the reverse could be true as well, when some drivers got park information hopelessly wrong or told outright lies to their passengers. One Monida-Yellowstone driver particularly irritated F. Dumont Smith in 1908:

> Our first driver was a boy of fifteen, at least he said that was his age, but no boy of that age could have acquired such a mass of misinformation. I never saw a grown man who knew so much that wasn't so. . . . [A]ll he knew about the Park was wrong. He located Junction Butte on the Firehole River, just eighty miles out of its place. He miscalled every stream and waterfall. And he was just as sure about his misstatements as an almanac, as positive as a patent medicine ad. At the end of the first day, I called up Mr. [Frank] Haynes and sobbingly asked for relief and got it. [Mr.] Dudgeon was detailed as our guide, philosopher and friend, and he filled the bill. . . . [He was a] college boy, earning a few dollars in vacation.[44]

Smith had discovered that drivers, like everyone else, varied in quality.

Tipping, as a courtesy for a job well done and an incentive for stage drivers and hotel porters to give a good tour, seems to have originated early in Yellowstone history, and it remains in place today in park concessioner interpretive operations. Charles Gibson, president of the Yellowstone Park Association, found it in use when he arrived in 1886, in a practice then called "'pickings' like they use at Niagara Falls." He tried immediately to prohibit this practice, ordering that employees including drivers "were not allowed to take any 'pickings'" until their tourists arrived at Mammoth Hot Springs for the outbound trip and at Cinnabar where passengers were finally free of drivers. By 1888, Gibson could claim that "no 'pickings' from the tourists are permitted," but his order was difficult to enforce and drivers continued accepting tips anyway.[45]

L. W. "Gay" Randall, who spent most of his life in Yellowstone, recalled that "every driver . . . had his own technique of making the trip as interesting as possible for his passengers and incidentally, this often paid off in quite liberal tips."[46] That incentive system served as its own inducement for drivers to "learn the park," and hence it affected interpretation. It became so entrenched that guidebooks encouraged the practice:

> You may ride or walk; if you ride, the driver is your guide.
> I may say here that none of these rides to formations and
> other attractions in the Park are included in the transportation
> ticket. The guide accompanying those who walk is dependent
> on the fees he may receive for his services, as no specific charge
> is made.[47]

A hotel porter named "Hot Springs Dan," who gave walking tours of the Mammoth springs in 1892, appears to have solicited "tips" from the visitors that he led. One of his audience members complained that he "collected twenty-five cents apiece from us" at Angel Terrace. Park authorities frowned upon this practice and made later attempts to prohibit it.[48] But those attempts always failed. By 1895, park guides had securely established the tipping system. A traveler mentioned it with regard to Mammoth walking guides:

> A porter from the hotel accompanies every party of tourists, as a
> guide, and he very soon informs you that his pay is very small,
> and that were it not for the generosity of visitors, he could not
> live. Tipping is the rule in the park, but you do not mind it, as
> you are uniformly treated well.[49]

Drivers for the Wylie Camping Company became so attached to the tipping system that they went on strike at least once in 1902–1903, when the company tried to abolish tipping. In 1902, W. W. Wylie received a number of complaints from guests that drivers were openly soliciting tips, so he placed signs at his different camps that read "Requesting guests not to tip or fee employees." That caused an outright drivers' strike and threats from drivers to throw managers "into the creek." Wylie fired the drivers involved, but later took down his "no tipping" signs. Apparently trouble reared its head again shortly after that, for Wylie had similar problems in 1903. Today in Yellowstone,

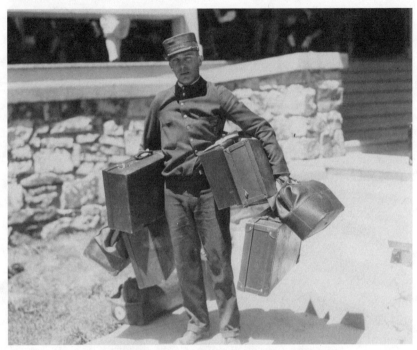

26. *Porter at Mammoth Hot Springs Hotel, about 1905. Men like these gave the park walking tours before 1920. Courtesy YNP Photo Archives, YELL 337577. Photo by Sharpe.*

the Xanterra Corporation allows park tour guides and drivers to accept tips, but prohibits open solicitation.[50]

The effects of tipping upon interpretation are difficult to assess. Certainly tipping initially served as an incentive to *do* storytelling, for the "high and noble" ideas of today about how interpretation should be free of cost and thus somehow "above" crass commercialism have not always been in operation in Yellowstone. Did tipping unhealthily separate guides from their visitors? (Concessioner and private guides today would no doubt say *no*.) Did it somehow "detract" from the resource because the guide sold himself or herself as an entertainer rather than an interpreter? Should interpreters of today care whether or not it "detracted"? Is not entertainment a component of interpretation? Do some parks today not charge fees for ranger-led hikes? Regardless of all of these issues, tipping influenced

interpretation because it created an incentive to perform "well," whatever "well" may have been.

While it is probably partially true, as two writers have alleged, that tipping sometimes unhealthily influenced the quality of information given by early concessioner guides because it put emphasis on "facts" with audience appeal, that was (and is) not always the case—besides which, even park rangers today are not exempt from using "facts with audience appeal." Historian Aubrey Haines has pronounced that Ralph Knight, long known for collecting tips, was a good lecturer, and the literature cited in this book makes it appear that many early concessioner guides functioned superbly in their jobs.[51]

Tipping, however, appears to have influenced the way at least one later observer looked back to give a wrong assessment about interpretation in early Yellowstone. Robert Shankland was convinced enough about the shortcomings of concessioner guides to make the following incorrect comments in his book *Steve Mather of the National Parks*. Sniffed Shankland disdainfully:

> In the early days at Yellowstone, the tourist who neglected to stuff himself in advance at the encyclopedias was liable to have a dark time of it among the volcanic phenomena. There was little on-the-spot enlightenment. Most stagecoach drivers liked to descant to the customers, but in a vein of bold invention. A few voluble guides worked out of the hotels; they cruelly punished the natural sciences. Under the regulations the guides could charge no fees. They did well, however, on tips, which they induced by a classic method: every audience harbored an unacknowledged accomplice, who at the end of a guide's remarks voiced resounding appreciation and, with a strong look around, extended a generous cash award.[52]

While Shankland may have experienced this kind of thing personally, in these comments he was wrong in almost every assertion. There were plenty of guides who gave correct information and it is probably stretching it to say that "most" of them were bold inventors. While some of the less educated no doubt got scientific commentary wrong, others were college students like Ralph Knight who searched for correct information. If there were park "regulations" prohibiting fee charging and tip soliciting, they have not been found and certainly not "every" audience contained a planted tip solicitor.

Paul Schullery has pointed out that it is not correct to state that early visitors had no way to learn about Yellowstone, for early tour guides got much information correct.[53]

The park's "Wylie Way" operations, a linchpin in early Yellowstone interpretation, were especially prone to using correct information in park tours and in doing it well. As mentioned earlier, William Wallace Wylie, a Bozeman schoolteacher, made a trip into Yellowstone in 1880. The publication of Wylie's guidebook in 1882 made him an "expert" on the park, and in 1883 he "began studying" the problems of park travel.[54] In 1884, he began bringing visitors into Yellowstone on conducted tours.[55] Wylie, like other park stagecoach operators, saw the need for increasing visitors' enjoyment of the trip by giving them park information. His background as a public school educator probably influenced and aided him in that practice.

Not only did Mr. Wylie counsel his drivers to give park information, but he also set up nightly campfire programs at his tent camps wherein his camp employees presented park-related skits, informational story-telling, and singing, a practice that continued in Yellowstone's "camps," later called lodges, until after World War II.[56] One company manager mentioned that these skits and singing were performed "with the music of the small organ."[57] A woman visitor, Dorothy Brown Pardo, mentioned seeing such activities at the Wylie camp at Upper Geyser Basin in 1911: "after dark around the camp fire . . . we were entertained by the 'savages' with recitations, impersonations, and songs."[58] As noted earlier Mr. Wylie's competitors, the Shaw and Powell Camping Company, also had talking stagecoach drivers and walking tour guides. But by 1915, Shaw and Powell had added nightly campfires similar to those offered by Wylie, for traveler Grace Hurley applauded "the nightly campfires" that were "one of the most pleasing features of [our] trip." She elaborated on the close-knit atmosphere and warm fellowship that inevitably sprang up:

> After the day's festivities are at an end, it is a very fitting closing
> before retiring. Talented entertainers are always ready[;]
> gathered around the blazing pines, travelers from all sections
> of the world meet on a common basis, cares are forgotten,
> humanity's natural kinship manifests itself and all are friends
> before the 2nd day's trip is completed. The merrimakers soon
> grow enthusiastic[;] laughter and songs, jokes and *storytelling*
> [emphasis added] resound through the air. One feature of the

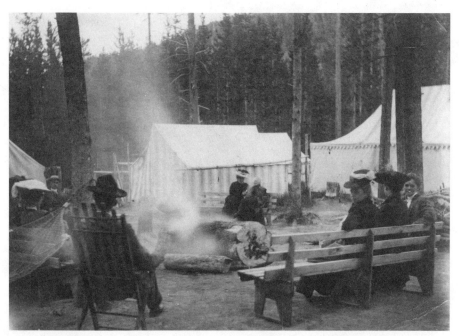

27. *Wylie Camping Company tent camp at Swan Lake Flats, 1906–1914. Courtesy YNP Photo Archives, YELL 128829.*

campfire enjoyed by all is the popcorn feast, which always ends the evening's entertainment and is a fitting close to a day of wonders and an evening's joy.[59]

Regardless of who originated these nightly campfire programs—Wylie or Shaw and Powell—these programs were the forebears of present-day ranger campfire talks in Yellowstone.

A. W. Miles, a later owner of the Wylie Camping Company, understood the value of these storytellers for aiding guests in understanding park features and for enhancing the enjoyment of a park visit. Miles stated in 1911 that his employees were "intelligent and refined [persons], selected from the best homes and colleges, who not only serve the guests, but mingle among them as entertainers and as interpreters of the spirit and scenery of the Park."[60] In these practices, W. W. Wylie has received credit from some writers for originating the idea of hiring college students for seasonal work in

Yellowstone. Whether or not he was really the first to do this is undocument-
ed, as there were numerous Yellowstone concessioners who could have done
the same thing just as early as he did.

Wylie used the comments he received from satisfied guests to promote
his services in annual pamphlets. As early as 1898, his pamphlet promoted stage
drivers as walking guides at Norris and other places, stating, "Here, the driver
again shows tourists all objects of interest."[61] Wylie listed other examples:

> The drivers [were] most pleasant and accommodating, and,
> what was surprising and pleasing to me, were mostly very
> intelligent and apparently educated and refined.
> —Horace L. Gleason, M.D.

> His guides, drivers, and attendants were ladies and gentlemen....
> [T]he drivers were untiring in their efforts to make the trip
> pleasant, and to point out items of interest.
> —H. B. Douglas[62]

Because Wylie had no hotels of his own—only tent camps—he began
the practice of having his drivers conduct visitors through thermal areas
such as Mammoth where he had no camp from which to provide guides.[63]
His 1910 pamphlet included a portion entitled "Yarns by the 'Man on the
Box.'" This acknowledged the stage driver's penchant for telling stories, but it
also included a speech for visitors by a driver about park bears in which the
driver incorporated safety messages.[64] Wylie also practiced putting his guides
in uniform for easy identification by visitors, as an early photo shows. That
custom was also used by the hotel company (YPA) to identify its porters who
served as walking guides.[65]

Jean Crawford Sharpe, a Wylie camps employee in 1909, has painted a
descriptive picture of the Wylie stagecoach drivers and the tours they gave:

> The drivers, each according to his own nature, did their best
> to be entertaining as they guided the same group of tourists
> around the loop, a five day trip. Many tall tales were told,
> embellished according to the gullibility of his listeners. Of
> course, the more entertaining, the more the tip at the end
> of the tour. One driver named Van Tassell enjoyed considerable
> popularity, and being resourceful, he had his routine published

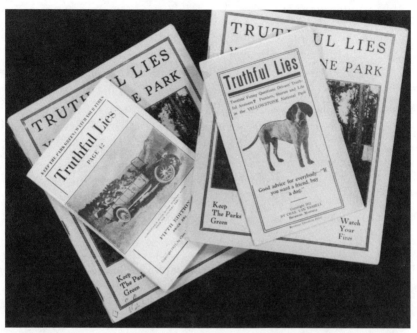

28. *Various editions of Charles Van Tassell's* Truthful Lies. *First published in 1912, this park booklet illustrated some of the stories told to park visitors by stagecoach (and later bus) drivers. YNP Library.*

one winter in the form of a pamphlet entitled 'Truthful Lies.' It was sold in the gift shops for some time after that, giving Van Tassell a prominence which he enjoyed immensely.[66]

Charles Van Tassell's little book went through a number of printings and continued to be sold with revisions during the 1920s, after the automobile had entered Yellowstone Park. Van Tassell, from Bozeman, Montana, drove stages in the park from at least 1902 through 1914, and was a saddle horse guide from 1918 to 1926. His book, which consists mainly of jokes told by stage drivers, was and is an early example of humorous storytelling in Yellowstone.[67]

By 1914, the Wylie Camping Company had elevated its drivers to a special place in the company brochure. "The Yellowstone driver," stated the brochure, "is an important component of the Park trip. While the parties are

riding between stations, he is guide as well as driver, pointing out and explaining the roadside phenomena."[68] It is apparent from this that the company by that time had realized the importance of the storytelling functions of its drivers and considered them worth promoting to potential visitors.

The Wylie Camping Company gave an impetus to early Yellowstone interpretation that was eclipsed only by the stagecoach activities of G. L. Henderson. As already noted, Henderson's entire life in Yellowstone was essentially interpretive, and at his Cottage Hotel, he had a chance to do it with his own staff of guides and fleet of carriages. The letters Henderson received from satisfied customers indicate that his interpretive operations were of high quality and thoroughly enjoyed by park visitors. Here are some of the letters, including ones that mentioned Henderson's daughter Mrs. Charles (Helen Henderson) Stuart:

> I hardly know whether to give the first rank to Douglas among the Geysers or [your guide] Mrs. Stuart among the [Mammoth] Terraces.

> Mrs. Stuart's intimate knowledge of the terraces at Mammoth Hot Springs is a marvel of minuteness and her guidance adds great interest to every locality.

> Mrs. Helen Henderson Stuart, our hostess, piloted us over the terraces. Her thorough acquaintance with these wonders of Wonderland and her willingness to show them made our first afternoon at the Mammoth Hot Springs very enjoyable ... and long to be remembered.[69]

Helen Henderson Stuart, daughter of G. L. Henderson, appears to have been the earliest *female* storyteller or park interpreter in Yellowstone, having begun work in 1885.

Two other stagecoach companies in Yellowstone were the Shaw and Powell Company and the Monida-Yellowstone Company. Little is known about the interpretive activities of their stage drivers and evening camps, but they probably at least imitated the activities of YPT, Wylie, and the Cottage Hotel, and at times they surely must have had some "good" storytelling people. One of the few things known about such activities of the Shaw and Powell Camping Company came from the diary of Myrtle May Kaufmann who

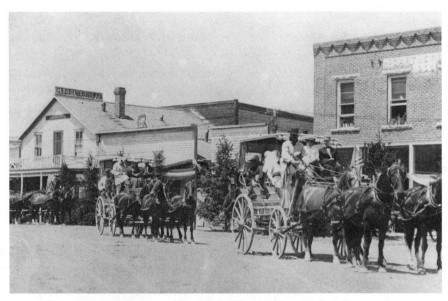

29. *Shaw and Powell stagecoaches at Gardiner, Montana, heading into Yellowstone Park, before 1915. Author's collection.*

traveled through the park in 1913 with that company. Kaufmann recorded that all of their personnel were pleasant and accommodating: "Each evening a camp fire was lighted, songs were sung and there was a jolly time in store for all who cared to join in the fun." As well, there are hints of interpretive activities of the Monida-Yellowstone drivers in a 1908 booklet: "The drivers, gentlemanly and skillful, are full of information," and "the drivers have been especially selected for the service and are well informed and will point out every interesting feature of the Park." Old-timer John Eggar told historian Doris Whithorn that the Shaw and Powell Company had a special guide at Old Faithful who kept a record of the time the different geysers could be expected to play, certainly an interpretive chore. This information was confirmed in the company's 1915 brochure, which stated that "a special guide, stationed at the Old Faithful Camp, keeps a record of the times when the different geysers are scheduled to play, and explains the many phenomena."[70]

Milton Skinner, who would become the park's first chief naturalist in 1920, served as a hotel walking guide in the late 1890s and was working for the U.S. Corps of Engineers by 1913. Skinner thought that drivers were not

doing a good job interpreting for visitors. "Here the trouble seems to be," complained Skinner, "that the driver assumes that his passengers want to be amused and so he directs his attention to securing and giving *amusing* information rather than *accurate* information."[71] In this, Skinner was right about some stage drivers but wrong about others, as not all of them gave inaccurate information. And too, Skinner must have known that amusing information could still be accurate information; indeed ranger naturalists today sometimes use amusing information. Regardless, early accounts indicate that many park visitors had a fierce affection for their driver and his "tour."

One special driver was Robert "Geyser Bob" Edgar (1844–1913), whose reputation for storytelling in the park was exceeded only by his longevity on the job. Bob Edgar came to Yellowstone National Park when he was in his forties—sometime in the 1880s—and remained there for the rest of his life as a stagecoach driver. Bob became well known for the stories he told to his passengers over some thirty years in the park, even if his stories were not sterling examples of accuracy. While he might well have been one of the storytelling guides that Milton Skinner complained about, he left a bigger mark in history than hundreds of later, more informationally correct government interpreters. Bessie Arnold remembered him as "a Scotsman, full of fun, quite a character." Boasting in later life that he had traversed 100,000 miles in the park in his many years of driving, Bob was an outspoken foe of the automobile in Yellowstone and as such "did his best to influence the minds of tourists against favoring the admission of automobiles into the Park."

Bob loved geysers and he loved to tell tall tales about them, hence his nickname. One of his favorite stories to tell was of personally falling into Old Faithful. When asked if he had been hurt, he would reply, "No, I came out of Beehive Geyser." This led him into the topic of how some park thermal features were connected underground. As a variation on this, Bob would sometimes drop his handkerchief into a pool near Fountain Geyser. When his passengers were not looking, he would pick it out and carry it in his pocket to Old Faithful. Then, once again when they were not looking, he would pretend to pick the handkerchief out of a hot spring at Old Faithful and would say, "Look at this! My handkerchief must have traveled underground." And he had a story about how he got the name that was a variant on his Beehive story. According to Bob, he looked down the crater of Old Faithful, and the geyser sucked him down its tube. He was spit back out at Excelsior Geyser, five miles away.

"Geyser Bob" was probably responsible for originating or at least perpetuating other park tall tales. They were not true Jim Bridger stories, but

Edgar and others attributed them to Bridger and kept them alive by telling them. Bob adapted one of Jim Bridger's stories about Specimen Ridge for his own, discussing an elk which was held up from falling into a canyon by the weight of "petrified air." And the "Alum Pool" story—sometimes told as the Alum *Creek* story—never a Bridger story but one perpetuated by stage drivers, was one of Bob's favorites. He recounted:

> This pool is so strong with alum that it is used to sprinkle the Park roads to shorten the distances between hotels. That's how strong its puckering powers are, ladies and gentlemen. Right in this pool a stage coach containing seven passengers and drawn by four big horses were so shrunk up by the power of the alum that when the coach was pulled out on the opposite shore the tourists had dwindled to dolls, the stage coach to the size of a baby carriage and the horses to Shetland ponies.

An obituary stated in typical "Geyser Bob" style that the night he died, "every geyser in Yellowstone erupted," as if to salute Bob's own "eruptions" of stories. Bob died in 1913 in the manner he probably would have preferred, at Lake Hotel while driving a party of visitors around the park. Robert Edgar was buried in the Gardiner cemetery. A printed "In Memoriam" card for him, apparently passed out to his friends, was saved by Verna Somerville's father and pasted into a family scrapbook. It reads:

> Robert Edgar, otherwise known as "Geyser Bob" and by his tribe as "Pos-e-ton-ka." Born in the Bowery of New York [in] the early part of the 19th century. Departed for the Happy Hunting Grounds August 23, 1913, at Yellowstone Park. "A friend to every man, every man his friend." God rest his soul.[72]

HOTEL WALKING GUIDES INTERPRET THE GEYSER BASINS

If stage drivers were the first tier in the concessioner interpretive scheme in early Yellowstone days, hotel walking guides were the second. Hotel porters often served as "formation guides" or "basin guides" once or twice a day or as needed. This arrangement was used at Mammoth Hot Springs, Upper Geyser Basin, Norris Geyser Basin, and Grand Canyon. During at least some

years, such concessioner guides also worked at West Thumb Geyser Basin
and at Lower Geyser Basin. By 1915, walking guides, especially in thermal
areas, were well accepted in Yellowstone, as one writer reported:

> Competent guides may be had at the various points of interest
> throughout the Park. Their trips are of the 'walking' variety
> and cover the most interesting portions of the different geyser
> basins. Parties are usually taken in a body, and as the trips
> are short, ranging from one to two miles, they should not
> be missed.[73]

Concessioners saw the need early for walking guides for specific areas
in Yellowstone. The practice of hiring them probably began in 1883, with the
arrival of the railroad, but it was definitely in place by 1884. Traveler Alice
Liddell noted that summer while at Norris Geyser Basin that "our guide
knew much better than we did the relative importance of the various points
of interest."[74] George W. Marshall, who built Marshall's Hotel at the
confluence of Firehole River and Nez Perce Creek in 1880 and who ran the
first commercial stagecoach tour into the park that summer, had by 1884
become a walking guide himself for the various thermal areas of Lower
Geyser Basin. Marshall's friend G. L. Henderson applauded him for helping
to protect such hidden thermal areas as Microcosm Basin from specimen
collectors and especially for his ardor as a guide:

> I ought to state that Mr. [George] Marshall is an enthusiast
> on all matters relating to the Park and its innumerable objects
> of interest, and but for his guidance, what I am about to
> describe would be a terra incognita to me and to others. I now
> understand one of the secrets of his popularity with tourists.
> He knows where everything of interest is to be found without
> loss of time. He adds to the enchantment of these wonders by
> the earnestness of his admiration and the eagerness with which ·
> he seeks to enthuse others.[75]

According to Henderson, Marshall had what every good interpreter needs
for success: enthusiasm.

Because it was park headquarters and had a large hotel early, Mammoth
Hot Springs seems to have had walking guides each year, beginning probably

in 1883. By 1891, there was at least one guide there, G. L. Henderson, for a traveler that season noted that "a guide is necessary to pilot you safely through the labyrinth of boiling springs and inform you of the names they bear."[76] Lecturer E. Burton Holmes mentioned in 1896 that the guide led "scores" of visitors over the Mammoth formations every day "and from many points of vantage indicates and describes the thousand and one phenomena that here surprise, delight, and mystify."[77] In 1894 J. Sanford Saltus found his guide at Mammoth giving safety lectures: "Often the guide tells us to sit down and rest, as cases of heart failure are not unknown in this high altitude among the gas-charged springs."[78] An 1895 visitor reported that soldiers accompanied his group over the Mammoth terraces, serving to prevent souvenir collecting while the porter gave the tour.[79]

By 1895, visitors at Mammoth could choose between walking the terraces with the porter or driving them with a stagecoach driver. Either way, the guest was sure to receive information: "After lunch we have the choice of walking, accompanied by a guide from the hotel, or riding in a carriage, provided by the transportation company, to penetrate the secrets of the Hot Springs." Because they worked for the same company, porters and drivers promoted each other verbally:

> A guide from the transportation company accompanies every party of tourists [on their walk around the Mammoth Hot Springs], and he very soon informs you that it is a very hard climb to the top of the formations, and at a very small expense one can take a coach to the top. After reaching the same, the guide shows the visitor all the points of interest to be seen.[80]

Even the Shaw and Powell Camping Company had walking guides at Mammoth, for the company's 1915 brochure assured readers that "a special guide takes the Shaw and Powell tourists over this formation and gives all necessary information."[81]

Visitors and employees alike considered walking tours a high point of the Yellowstone trip. In 1895, a railroad brochure stated that the guide at Mammoth would "leave the Mammoth Hot Springs Hotel for a two hours' trip over the formation" at 2:30 P.M. and that all guests of the Association Hotels were "invited to accompany him free." By 1905, more than one visitor ate his or her lunch hurriedly "for fear you will miss the guide, who leaves the hotel [at 2 P.M.], and points out and names for you the phenomena of the

vicinity." Indeed at Mammoth the formation walk was the "event of the day," and no one wanted to miss the guide's announcement of it following lunch.[82] The formation guide at Mammoth in 1915 was a university student who was somewhat snooty. Elbert and Alice Hubbard took his walk to the Devil's Kitchen that year, and asked what the gassy smell was: "'H_2S_2,' sniffed the university student."[83]

One walking guide at Mammoth seems to have been a veteran; in fact, a relative says he worked in the park nearly every year during the stagecoach era, 1880 through 1916. Matt Stewart apparently arrived at the Mammoth Hot Springs Hotel in 1887 and worked for at least nineteen seasons there, traveling back and forth from his home in St. Paul to Yellowstone. Buying into a business in West Yellowstone gave him stability in the area, and he retired after 1916 and died in 1933. Stewart must have given hundreds of tours of the Mammoth Hot Springs while he ran the porter's desk at the hotel.[84]

Another Mammoth Hot Springs guide spoke several foreign languages. Alex Bjornson, whom the local newspaper called "interpreter and entertainer for the Mammoth Hot Springs Hotel," returned in 1904 for another season with the hotel company. The company used him for guide services, foreign language ability, and his "artistic sense" that seems to have figured into remodelings of the hotel's interior. The terms "interpreter" and "entertainer" were often seen as nearly synonymous, a perception of frivolity that caused assistant superintendent G. L. Henderson trouble as early as 1884 and a perception that sometimes hurts park interpretation budgets today.[85]

Still another park guide was destined to become Yellowstone's first chief naturalist. While a college student, Milton Skinner was employed by the hotel company in 1896 to guide visitors around the Old Faithful area. This work heavily influenced the direction that his life took. Of that summer and the origins of a formal park interpretation department, Skinner later said:

> My own connection with the work began in 1898 when I was a
> college student. I spent that summer at Old Faithful. At that
> time the tourists were guided over the formations and given
> lectures by a young chap from Aurora, Ill., employed by the
> hotel company. He did good work but he deplored the fact that
> he had no special training for the work, and that he had no time
> to study, then, anyway. I often substituted for this guide, and so
> began my first work as a guide and lecturer. Every year after that,
> I was in close contact with the guides on all the formations, and

they all complained that they could learn little about
the wonders.[86]

By 1913, Skinner was working for the park engineers, and he was wor-
ried about the "inadequacy" of the information given to visitors. In addition
to fuming about stagecoach drivers, he complained that guests of the hotel
and camping companies were "turned over to the mercies of a porter or bell
boy" who

> has no training in guiding his clients, and what few facts he does
> pick up are often distorted before they reach the tourists. Then
> too, he is often after 'tips,' which turns his attention too much
> towards where he thinks the tips are coming from. The guests
> too are largely dependent on their stage driver. Here the trouble
> seems to be that the driver assumes that his passengers want to
> be amused and so he directs his attention to securing and giving
> *amusing* information rather than *accurate* information.[87]

Of course not every porter or driver gave inaccurate information, as Skinner
implied here; many of them were excellent guides. Apparently Skinner
thought the tour guiding arrangement satisfactory when *he* was a walking
guide but not so later. Perhaps he had come to see the inadequacy of his own
earlier information.[88]

Just when walking guides first worked at Norris Geyser Basin is uncer-
tain, because the hotel history there is so fragmented. Tents were used for a
hotel beginning in 1883, with a large wooden hotel built in 1886–1887. After it
burned on July 14, 1887, tents again served for a while until they, too, burned.
Then a flimsy, semi-wooden structure was built, and it also burned. A large
hotel was finally constructed in 1900–1901. The irrepressible Larry Mathews
arrived to run the Norris lunch station ("hotel") in 1893, so actual walking
tours of the basin could have begun then. But probably they started in 1883.

There is evidence that the Yellowstone Park Association promoted the
walking tours at Norris through Larry Mathews. A placemat card has sur-
vived among the Larry Mathews papers. Larry apparently placed the cards
on the placemats of diners in his dining tent to advertise the walks. The sur-
viving card reads:

Norris Geyser Basin—Immediately after lunch the Association's

Guide will leave this station on a [walking] tour over the Basin.
Guests of the Association's Hotels are invited to accompany him.
No charge is made for this service.[89]

There are at least two mentions of specific walking tours at Norris in
1895. One party ate lunch at Larry's and then, "accompanied by a guide,"
walked around the geyser basin. The other party mentioned that Larry
Mathews himself, well known for his humorous banter with guests at meals,
gave them information on the basin in entertaining if not interpretive style:

> Larry has the history of the basin down to the smallest detail,
> and he gives it all with an Irish flavor that makes it palatable
> every time it is taken along with his luncheon. From the muddy,
> boiling pool which . . . was named the Congress [Pool] . . . to the
> Black Growler and the Emerald Pool, which Larry says is the
> only place on earth where the orange and green commingle, and
> he suspects that this communicates with Hades, he will keep his
> geyser of Irish wit and bustling business going steadily without
> interruption.[90]

By 1895, walking tours of Norris worked like this: guests arrived by
stage from Mammoth, ate lunch at the lunch station ("hotel"), were taken on
foot through the geyser basin by a guide from north to south, tipped their
guide or did not tip him, and then boarded their stages at Minute Geyser for
the continuation of the trip. Later, workmen erected a loading platform at
Minute for this purpose. A 1900 visitor recorded that at Norris a guide took
them in hand "for a two hours tramp."[91]

Walking guides at Norris, like elsewhere in Yellowstone, varied in their
interpretive abilities from terrible to excellent, and they talked about what-
ever there was to see locally. A 1901 traveler appears to have gotten one of the
"geyser-gazing" guides, for the man emphasized geologic changes in Norris
hot springs. "Our guide at this place is a Swiss who calls himself 'Sepp' which
is an abbreviation of Joseph," summarized one visitor. "Sepp told us he
had crossed over the spot where the 'Boiler' [steam vent] now rages about
20 minutes before the earth broke down and formed the basin in which it
[now] seethes." Changes in the thermal landscape at Norris continue to thrill
visitors today, and guides are still useful in a place that raises many questions
for those visitors.[92]

30. Concessioner walking guide Rexford Sheild (in uniform) holds his megaphone at the Minute Geyser loading platform, Norris Geyser Basin, 1911. Sheild scrapbook, Courtesy YNP Photo Archives, YELL 134836.

An oral history interview with a Norris Basin walking guide has survived. In it Rexford Sheild told his story. During the summer of 1911, Sheild heard from another guide, Harold W. Crary, that "more money could be

made at Norris Basin as a guide and porter than anywhere else in the Park." So he went there for the summer in order to make money to return to law school. Sheild says:

> The guide took visitors down from the hotel to Constant Geyser, then past the Black Growler, to the Bathtub; [then by] a path through the woods to the New Crater [Steamboat] Geyser, ending at the loading platform near Minute Man Geyser. The guide gave a 15 or 20 minute talk (as factual as the information allowed—Bunsen's theory, some history and geology). Some guides and drivers [at times] 'spoofed' the tourists... Tips were good—a fine class of people—they could afford to spend money on travel.

Sheild made $325 that summer and stated later that "Jack Haynes told me in 1935 that I was one of the first guides he had come into contact with that had endeavored to give correct, accurate information." If Sheild was claiming that factual interpreters did not exist until 1911, his claim is doubtful considering the long history of guides in Yellowstone.[93]

Like stage drivers all over the park and hotel walking guides at other locations, Norris walking guides accepted tips from tourists. And, like the attempts mentioned earlier by Wylie to stamp out the tipping practice, U.S. Army administrators attempted to eliminate it in several places, notably at Norris. Corporal Alfred Sands wrote to the park superintendent in 1905 that "passing the hat" at Norris looked to him to be too much like begging, such that "I have ordered that this practice be discontinued." But such a prohibition was apparently ineffective, for by 1911 Rexford Sheild and other Norris guides were again accepting tips.[94]

Upper Geyser Basin, too, had walking or "formation" guides, employed by both the hotel company and the Wylie Company. Walking guides there were in place by 1893, but probably started in 1883, when the first tent hotel appeared at Old Faithful. Subsequently a wooden hotel called the "Shack Hotel," built in 1885, guaranteed permanency of the guide business there. Henry E. Smith, an 1893 traveler, worried about breaking through a thermal crust when his area walking guide urged the party to follow him. Mildred Rossini remembered that Wylie tourists at Old Faithful would sometimes "latch on" to the hotel's walking guide to hear what he had to say, but the Wylie Company often hired its own guides as well. Rossini explained, "Each

31. Concessioner walking guide Rexford Sheild prepares to address his visitors at Minute Geyser, Norris Geyser Basin, 1911. The stagecoach loading platform and covered waiting facility can be seen in the background. Sheild scrapbook, courtesy YNP Photo Archives, YELL 134837.

of these guides . . . was quite a performer and had his own line. It was like an act that he had worked up, and he used it over and over with each group of dudes."[95] Clifford Allen considered his "witty professional guide" in 1904 to be "part of the show," and the guide's orders to remove blue or smoked glasses—precursors of today's sunglasses—"were obeyed without a murmur." The guide's favorite expression after describing a geyser, observed Allen, was "Move on! There are sixty more to be seen. Keep moving!"[96]

That fit right in with a common gripe of visitors—that Old Faithful walking trips were shorter than most of them desired. J. Sanford Saltus commented in 1894 about the "short" walk over the formations at Upper Basin, and then averred that he would have liked more time to study the Lion, Lioness, and other geysers, "but the guide hurries us on."[97] Journalist Henry Finck echoed this complaint, which became one of the most common visitor criticisms of that era, saying the stagecoach gave people only four or five

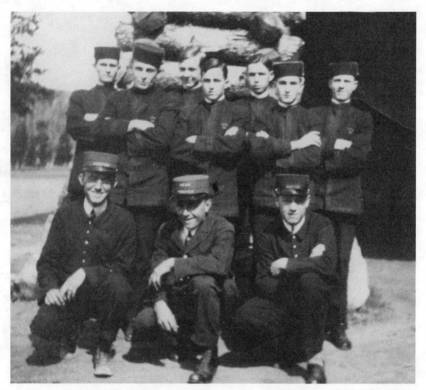

32. *Hotel porters at Old Faithful Inn, summer of 1912. Rexford Sheild is at bottom left. He served as concessioner walking guide for Upper Basin that summer. Sheild scrapbook, courtesy YNP Photo Archives, YELL 134819.*

hours in the basin during which time "a hurried guide takes them hurriedly across the basin."[98] The problem was remedied in 1904 after Old Faithful Inn was built, and then the walking guides gave longer tours, such as the "Walk with Joe," which took several hours and was probably conducted by YPA guide Joseph Peng.

Rexford Sheild, who guided at Norris in 1911, returned for the summer of 1912 to serve as a porter and walking guide at Upper Geyser Basin. His scrapbooks, recently given to Yellowstone National Park, contain many photos of him leading walks at both Norris and Old Faithful. Sheild wore his YPA uniform and sported a megaphone through which he spoke to his legions of park visitors. On the megaphone were painted the words "Call me Rex."[99]

SOME ACTUAL SPEECHES OF EARLY GUIDES

Few descriptions exist of the actual presentations of walking guides, but traveler Charles Taylor has left a general one for 1900: "Our guides are rapid in their descriptions, and from frequent repetition, run over the points of each spring and geyser, much as the European guides describe the attractive features of Stratford-on-Avon."[100] Andy Stewart, a Wylie camp boy at Upper Basin, left another such description in 1909:

> Half the guests stayed over each day for a tour of the [Upper] geyser basin. We had a guide who was a college man. He claimed to be Professor James' son of Harvard . . . [and] to us he was of the favored upper class. We all stood in the background as he started his speech to the guests before taking off [on the walk], with grins on our faces trying to make him feel uncomfortable as possible and making audible imitations of his Harvard accent before he moved entirely out of range.[101]

Dorothy Brown Pardo, a 1911 visitor to the Upper Basin Wylie Camp, chronicled a third such account. She mentioned that the Wylie guide promised them to ring the camp bell during the night should "the delinquent Giant Geyser" play. The next morning her party met one of the better known Upper Basin guides, Ralph Knight:

> Shortly after breakfast on the morning of July 13th, our party started out with the guide—a young medical student from the University of Minnesota. He was a tall, muscular fellow, possessed of a deep, resonant voice, an active imagination, and a fund of humor and good nature. In our morning's ramble we visited the principal geysers and pools of the Upper Basin, lying between our camp and the Old Faithful Inn. Our guide told us all that he knew and some things he did not know about the geysers geologically and traditionally.[102]

Notwithstanding Ralph Knight's humor and good nature, apparently Pardo was skeptical about some of the geology he told them. She also mentioned how her group and guide were picked up by Wylie stagecoaches at the Klamer store—today's lower Yellowstone General store—and conveyed to

Black Sand Basin, where the guide demonstrated the Handkerchief Pool trick and then took them on to Biscuit Basin.[103]

Individual Names of Early Walking Guides at Upper Geyser Basin

The names of most early Upper Basin walking guides are unknown to us, but there is information about Dorothy Pardo's guide, Dr. Ralph T. Knight. Knight served as a Yellowstone guide, mostly at Old Faithful, from 1910 until at least 1914. He is known not only because he was an excellent interpreter, but also from his later life as a doctor and from an incident involving solicitation of tips. A schoolmate of park photographer Jack Haynes in Minneapolis, Knight later became a medical doctor there with a long and distinguished practice. He came to the attention of the park officials in 1913 when the superintendent received a complaint about Knight's alleged soliciting of tips. The offended visitor to Old Faithful called him "very courteous and painstaking and a most competent guide," but then proceeded to complain that Knight's confederate had inconsiderately passed a hat for tips. Knight's boss, A. W. Miles, denied that Knight had done anything wrong and intimated that the story was concocted by the complaining visitor. Knight, too, denied the allegation, noting that he, like all guides, accepted gratuities, but denied soliciting them. The archive file is thick with letters on this incident that ended with the Wylie Company reprimanding Knight.

What is important about the correspondence, however, is the detail it reveals about arrangements at that time for interpretation at Upper Geyser Basin. Knight, a medical doctor, said he received "from the Wylie Co. my board and lodging, stage transportation through the Park, and thirty dollars per month. I have also agreed to take care of sick or injured employees when brought to me. This I do gratis except for a small allowance of $25 for the season for medicines and supplies." Thus, the company got a medical doctor plus a competent, full-time, basin tour guide for its money. Knight got summers in Yellowstone with salary and good tips and a chance to practice medicine as well. Knight, being a medical doctor, was well educated in the science of his day that was so useful for talking to park visitors about geology and other natural subjects. He received excellent comment letters from visitors.[104]

Ralph Knight may have been the writer who wrote a long interpretive column for the 1915 Wylie Way newspaper and signed himself "Robert B. McKnight." This article entitled "Do You Recall Your Walk in Geyser Basin?"

was the story of a guide giving a detailed "tour" of the Upper Basin, written by someone who had obviously given such tours and apparently performed during the summer of 1914. Because it represents the only known more or less "complete" interpretive tour of a geyser basin from early Yellowstone days, it is included in its entirety in the appendix as an example of early storytelling. The guide, possibly Ralph Knight himself, got much information correct. He utilized interpretive techniques such as asking questions of his visitors and giving safety messages about the thermal features, but certainly did a few things interpreters would not do today, such as encouraging the throwing of objects into one of the springs.[105]

Two other known guides at Upper Basin, as recognized by G. L. Henderson in 1901, were H. L. Fuller who was there for a number of years including that one, and David Johnson who was there at least from 1897 to 1899. A fourth, as remembered by park photographer Jack Haynes, was Robert Wylie, the nephew of W. W. Wylie. Robert Wylie was a divinity student "whose guided trips were extremely interesting," according to Haynes. Wylie was there at Turban Geyser in 1905 when tourist Fanny Weeks fell into a hot spring and later died of her burns.[106] And a fifth known guide was Professor James's son, mentioned above. There must have been many of these walking guides over the years, but the names of only these few are known.[107]

WALKING GUIDES AND HORSEBACK GUIDES
IN THE CANYON AREA

Like Old Faithful, the Canyon area had walking guides beginning with the advent of hotels there. Canyon had tents for lodging from 1883 to 1886, a flimsy wooden structure from 1886 to 1889, and a large hotel beginning in 1890. Walking guides probably began that year, but they were definitely in place by 1892, for traveler Charles Gillis checked in at the Canyon Hotel and then stated that four members of his party "accompanied by a guide took a walk toward the Grand Canyon, about half a mile off."[108] William and C. C. Murphy found walking guides present in 1893 but did not reveal the details of stories told by those guides.[109]

The presence of horseback guides at Canyon began very early, probably in 1883, but there is nothing definite on it until 1886, when J. J. Aubertin arrived at the Canyon Hotel, "a wooden house in the woods." "We mounted our ponies," he wrote, "and rode for the river *with the guide* [emphasis added] to the 'points.'" Traveler H. Z. Osborne reported that in July of 1888,

when he arrived at Canyon Hotel "at half past three . . . [we] found horses all saddled and ready to take us around the trails to the Lower Falls, Inspiration Point, and other places of interest in the neighborhood." And In 1895, there was an "extra charge of $1" for a horseback ride covering three hours "accompanied by a guide." All of these accounts document the origins of today's Canyon-area concessioner horseback-riding operations and their story-telling guides.[110]

In 1889 the existence of park guides at Canyon was well enough known to result in the publication of a semi-fictional account of a romance involving one of them. A female writer in the extravagant, four-color pamphlet entitled *A Romance of Wonderland* (1889) penned for her readers the dripping story of her travels from Boston to Yellowstone to search for her lost sweetheart Jack and finding him years later conducting a tourist party to the canyon of the Yellowstone. The guide's voice had such a "familiar intonation," she wrote, "that I turned and looked. It was Jack!" Jack, she lamented, who had left Boston so long ago, but he recognized her at once. "To hide my confusion I begged him to go on with his very interesting remarks," she wrote coquettishly. "He actually did it, though I am sure the listeners must have wondered what there was in his observations to make his voice tremble." This colorful and rare railroad pamphlet combined true Yellowstone touring observations with a fictional story of romance involving a Canyon tour guide.[111]

Walking guides and horseback ones at Canyon apparently continued in place through the stagecoach era in Yellowstone, but only one other mention of them has surfaced, referring to 1909. That year traveler Clifton Johnson indicated that his Canyon guide told tall tales: "My guide as he looked down from the verge of a crag on the warm-toned rocks of the tremendous ravine said: 'There's all kinds of gold in that Canyon.'"[112]

There is the testimony of one 1895 visitor that Canyon guides talked less than other park guides did. That newspaper article is subtitled "Where Guides Are Dumb":

There is no way of preparing for the surprise, nor of getting accustomed to the scene, so as to feel more at home. The guides about the canyon, glib and voluble in every other part of the park, simply stand beside you on the brink of this chasm and share your amazement and entrancement, dumb in the presence of the Grand Canyon of the Yellowstone. They will talk of it at

the hotel or on the drive, but there they simply lead you to the points of lookout and leave you with your own thoughts, or answer your questions in monosyllables. What other scene in America can silence the talkative guide?[113]

Perhaps guides at the Grand Canyon of the Yellowstone were not so much disposed to talk less generally as to just talk less when standing *at the canyon.* The author has run into this phenomenon himself upon leading tour groups there; at least initially there is simply no reason to say anything, nor will most visitors hear it anyway, because they want to silently stare into the canyon, absorbing all of its sublimity.

One guide at Canyon was in a class by himself because of the special licensing arrangements he had with the park. He was H. F. "Uncle Tom" Richardson, who was working for the Wylie Company at Canyon as early as 1896. In 1898, he built a trail into the canyon's south side below Lower Falls. From then until the Chittenden Bridge was finished in 1903, Richardson ferried visitors across the Yellowstone River, then walked them to the canyon where he escorted them down via ropes to the edge of the river below the great fall. This was a difficult climb for some persons, and family descendants say Richardson carried pins with him to pin up the women's long skirts in order to make climbing easier. After obtaining misty, breathtaking views of the spot, the visitors were served a campfire supper before being boated back across the river. This business usually netted Richardson about one thousand dollars per season.[114]

After Chittenden's bridge was finished, Richardson's ferry services were not needed, but he did not let this stop him. "Uncle Tom" moved his operation into a tent at the top of his trail and across the river from the Brink-of-Upper-Falls Wylie Camp from which he had formerly operated. There he continued to charge a fee to conduct visitors into the canyon. In 1904, he conducted 1,147 such visitors, and in 1905, the number was 2,248. At $1 per person, that was a healthy income for Richardson, so it was no wonder he became "anxious" in late 1905, when the government built wooden steps down a portion of his trail. Fearing that he would not be permitted to continue guiding and/or that people would no longer want a guide when steps were available, Richardson nervously applied for his 1906 permit. The Secretary granted it subject to a constraint that he would charge only fifty cents per person. Between the reduced rate and the new wooden steps, Richardson was effectively put out of business for there is no further

33. A. F. "Uncle Tom" Richardson, Canyon area guide, serves lunch to his guests, 1898–1905. Courtesy YNP Photo Archives, YELL 212.

correspondence from him in park files. Although the 1906 permit was granted, no more letters from him reporting tourist numbers or other relevant sources have been found.[115]

According to Ed Moorman, "Uncle Tom" continued at Canyon by managing the Wylie Camp there. Moorman says, "Tom Richardson was, from the

start of our permanent camps, the manager of our Grand Canyon camp." Another man who knew Richardson said "Uncle Tom" was at Canyon as late as 1916. E. W. Hunter remembered Richardson told him then that "when the autos and buses came in 1916 the road to Artist Point was widened and improved for the cars making the side trip." According to Hunter, Richardson suggested to Harry Child that Child have the buses stop there to let tourists go down the trail. Child agreed if the Y. P. Transportation Company was given fifty percent of the receipts, but Richardson refused. Hunter added: "And that was the finish for Tom Richardson in Yellowstone National Park."[116]

Emblazoned in large letters on Richardson's business card were the words "To Foot of Great Falls! To Bottom of Grand Canyon!" and it carried endorsements on the trip from geologist Arnold Hague and engineer Hiram Chittenden. "Uncle Tom" Richardson, arguably the most noteworthy of early Canyon area guides, is remembered today by the stairway-trail and its nearby parking area that both still carry his name.[117]

Walking Guides in the West Thumb and Fountain Areas

There were two other Yellowstone locations at which concessioners sometimes utilized walking guides: West Thumb Geyser Basin, because of the YPA and Wylie lunch stations there, and Lower Geyser Basin, where tours originated from Fountain Hotel. Because mentions of these activities are so few in a vast literature, it appears that guides in those areas were not used every year as they were for Mammoth, Norris, Upper Basin, and Canyon, but rather only sporadically.

The Fountain Hotel opened in 1891, and that is probably the year that porters began guiding visitors around the nearby "Mammoth Paintpots"— present Fountain Paintpot and its nearby features—and to the "bear feeding grounds" east of the hotel. Traveler Moses Ezekiel and his party accompanied their hotel guide in 1896 to the recently opened area near Great Fountain Geyser, Mushroom Pool, and Firehole Lake. The guide of course demonstrated the now illegal practice of throwing sand into Surprise Pool; the sand made the water burst into a boil, and that was the "surprise." From Ezekiel's account it is apparent that hotel guides timed their visits to correspond with eruptions of Great Fountain Geyser, as local "geyser gazers" kept track of it.[118]

Travelers Elbert and Alice Hubbard found a guide at the Fountain Hotel in 1914 who took them to see the "Devil's Tea-Kettle" and nearby "Buffalo Spring" and who told them a tale about an Indian girl who fell into

34. Fountain Hotel, 1891–1916, Lower Geyser Basin. Hotel porters from here gave tours of the nearby geyser formations and the hotel "bear dump." Author's collection.

a hot spring and was never seen again. At least one Fountain Hotel guide was noteworthy—or at least talkative—enough to have acquired a nickname by 1895, for a visitor that year referred to him as "The Fountain Gusher." The visitor stated that this porter "acted as our guide" and took them to the bear-feeding area where he proceeded to feed three black bears sugar from his pockets.[119]

West Thumb interpretive operations seem to have been similarly limited, and probably functioned only when there were persons there capable enough and interested enough to conduct visitors around the hot springs. Concessioner guiding activity around the thermal springs there probably began in 1892 with the establishment of YPA's Thumb lunch station. Traveler W. D. Van Blarcom stated in 1897: "We were taken by a guide to the water's edge where he showed us a cone filled with boiling water." The guide then proceeded to catch a fish and cook it on the hook for his startled charges. This demonstration of the powers of Fishing Cone seems ever to have been a part of the amusement at West Thumb, for the cone is mentioned in numerous accounts. A walking guide at West Thumb seems to have also been present in 1903, for traveler Rube Shuffle noticed him there, "roundin' folks up to visit more hot pools and paint pots."[120]

The most detailed account of a West Thumb guide comes from Mildred Rossini, a Wylie Company employee from 1911 to 1913, who has left audiotapes of her experiences. She says that in the summer of 1912, the Wylie

guide at West Thumb was a "very clever" speaker who walked backwards and talked to his tourists. "That, during the second year I was there [1912], almost proved fatal for him as he stepped into one of the hot pools. And when he did that, he was strong enough to swim across that pool and pull himself out on the other side." Rossini says one of the employees ran to the lunch station for lard—a particularly poor choice as a salve—and returned to smear it on the guide, who was badly burned over a great deal of his body.[121]

Wylie and YPA walking guides continued to exist even into the National Park Service era, as the new Yellowstone Park Camping Company continued that practice in 1917. In 1920, NPS chief naturalist Milton Skinner mentioned that he had conversations with "the guides," but may have been referring to newly hired seasonal interpretive rangers. However concessioner guides were still at work that year, too, for the 1920 Yellowstone Park Camps Company brochure stated:

> For more than twenty years these camps have specialized in free and intelligent guide service to guests. At Old Faithful Camp a guide conducts our parties over the geyser basin, with carefully timed arrivals at erupting geysers. In addition to the active geysers, the guide points [out] and explains the boiling and quiescent springs, the fumaroles and other phenomena of this, 'the most weird spot in the universe.'... [At Mammoth] [o]ur free guide service includes visits to Jupiter, Hymen and Pulpit terraces, Orange Geyser, the Devil's Kitchen and other curiosities. At the Grand Canyon ... a special guide conducts our guests down 'Uncle Tom's Trail' to the very bottom of the Grand Canyon.[122]

In 1921, the National Park Service formally abolished the practice of having hotel and lodge employees work as guides. Park superintendent Horace Albright remembered how unpopular he was with the hotel porters for doing this:

> The guiding was almost all done by porters and bellhops of the hotels and lodges. They were college boys and didn't have any particular knowledge of the area. They might have read up a little on the history of it, they might have been able to tell you about the Nez Perce ... they didn't know much about the

geysers, but they'd tell plenty of stories about them. They developed a pretty good line. Mainly they were interested in the tips. There was no charge, and they'd take the people over these formations, tell them a lot of stories, and take them to the various points of interest all right. They'd bring them back to some narrow bridge or near some door they'd have to pass through, and then they'd have one of their number in the crowd who wasn't a guide telling about what a wonderful guide he was, and he'd throw fifty cents over at him, or maybe he'd have his hat out and he'd take the hat and put the money in, and everybody else would feel they had to give him something or else pass by with head hanging low ashamed of not having done something for the poor college boy. The stage drivers were of the same type. They had a wonderful line of talk that they had . . . developed. . . . Of course it was a racket, and when we got the Park Service going we put an end to it. I remember I was pretty unpopular the year I took over the guiding work up in Yellowstone Park and stopped the [porter leadership].[123]

But even after Albright "terminated" formal guiding by concessioners, park bus drivers continued to give interpretive tours and the Yellowstone "camps" employees continued to present nightly skits and programs all over the park. This practice lasted until at least the mid-1950s. A 1920s visitor left this handwritten message in her 1922 park guidebook:

At nearly every camp some form of amusement was offered. Sometimes a play would be put on by the campfire and at nearly every camp there was dancing. . . . The park board sees to it when hiring help that it gets people who have some talent if possible.[124]

THE U.S. GOVERNMENT'S LIMITED ROLE IN EARLY PARK INTERPRETATION

Stagecoach drivers and hotel walking guides were the spearheads of storytelling in Yellowstone during the period 1880–1916, but the U.S. government, including the U.S. Army, also played an important if lesser role. Superintendent

P. W. Norris was the government's only interpreter during 1877–1881. In late May of 1882, the government hired G. L. Henderson as an assistant superintendent, and he served alone as "park guide" that year. In June of 1883, the government hired more assistant superintendents, and they served as "park guides" at various locations around the park in addition to their other duties of protecting thermal formations, preventing poaching, and watching for fires. There were eight such men in 1885, and traveler George Wingate utilized one that year at Mammoth Hot Springs:

> The government keeps a guide at the springs to prevent
> vandalism, and to avoid accidents to visitors. It is certainly a
> great consolation to have him precede you as you pick your way
> along the formation with boiling springs on either hand. . . .
> He was full of statistical and other information, which would
> be interesting, if I could recall it.[125]

From this, some might conclude that the interpretation Wingate heard was not that interesting or that it did not provoke or make that much of an impression upon him. But just because an interpreter fails to reach one person does not mean he fails to reach everyone in the group. Because interpretation has some very subjective sides to it, a researcher must be hesitant to draw those types of quick conclusions.

Wingate referred to these government men as "fire wardens" and stated that they patrolled the roads warning people against leaving burning campfires. At Lower Geyser Basin, one of these men rode up, warned the party about extinguishing their campfire, and informed them that Fountain Geyser would "go off" about five P.M. Another party of that same year acknowledged at Mammoth that "Mr. S.S. Erret, the genial assistant superintendent stationed at the springs . . . proceeded to show us over the formation." Thus did those early assistant superintendents serve the dual purposes of protection and interpretation.[126]

The U.S. Army took over protection and management of Yellowstone National Park in August of 1886. Sent by the Department of War at the request of Interior, their duties were to prevent poaching and vandalism and to manage the park in a way that the old civilians could not. Initially, soldiers were too busy orienting themselves and constructing Camp Sheridan to perform storytelling or interpretation. By 1888, some soldiers—ones who were interested and who had been there long enough to gather information—in

35. *U.S. Army soldier talks to a visitor about Giant*
 Geyser, no date. This photo has been used to illustrate
 "interpretation" done for park visitors by soldiers,
 but a closer look reveals a uniformed concessioner
 walking guide, third from left, heading off in the
 opposite direction, as if he has just finished a speech.
 Possibly the gentleman asked the soldier for more
 information and the soldier was trying his best
 to oblige. YNP slide file no. 09603.

the Old Faithful and other thermal areas were giving occasional "cone talks" to visitors. But that was the exception; the rule was that the soldiers were there to protect the geyser deposits from pilfering. "Always one and some- times two armed soldiers with two hundred rounds follow you," wrote one visitor in 1910. "They are congenial boys and will do anything for you."[127]

Rather than perform interpretation, it was more likely that soldiers would engage in the kind of conduct described by an unknown "Alexis" in the local newspaper. This writer may well have been tour guide G. L. Henderson making snide comments about the army's inability to do the park interpretation that he himself performed so well. "Alexis" set the stage by noting that an army corporal appeared at Upper Geyser Basin one day in 1888 and that numerous lady tourists soon gathered around him:

> Middle-aged lady timidly addressing the corporal:
> 'Will you please tell us if Old Faithful will probably be
> in astate of eruption again today?' Corporal (swelling
> up and striking an attitude): 'I am not here to be talked
> to deathby a lot of women; neither do I propose to answer
> a thousand and one fool questions.' Lady (quietly): 'Well,
> will you please tell us just what questions we are allowed
> to ask, and how many of them so that we may govern
> ourselves accordingly?' Corporal: 'It is not any part of my
> business to answer questions at all, but if you will keep
> still I will, without being questioned, explain all that
> is necessary for you to know.' Thereupon the ladies
> assumed various awe-stricken positions, and the
> corporal delivers a lecture similar to a man who is
> shooting off a magic lantern.[128]

There were exceptions to this kind of behavior by soldiers. At times the park superintendent would send soldiers to accompany larger and more important tourist parties. Although this function was generally more to prevent specimen collecting than it was to perform interpretation or give information, some soldiers would occasionally rise to the level of park guides. Fred Slocum and members of the Michigan Press Association comprised such a group in 1890, and he reported that the soldier who was "piloting" them made an accurate prediction at Midway Geyser Basin for the legendary Excelsior Geyser.[129] Mrs. Joseph Townsend stated in 1906 that the soldiers were stationed at Mammoth "on guard less some souvenir hunter should destroy the beauty of the formations" but she also noted that they "acted as guides in guarding you against dangerous places and gave you any necessary desired information." That information was sometimes quite thin, for traveler William Myers noted that the soldiers he saw, rather than

giving information, simply followed the party's guide around the forma-
tions "to protect the curiosities against the relic vandal."[130]

Not surprisingly, the soldiers' interest in female visitors seems to have
been greater than their interest in telling stories about park features. Marvin
Morris's party in 1896 found that "the soldiers were very willing to show us
about. [They] [p]aid particular attention to the ladies." Carter Harrison averred
in 1890 that two companies of soldiers patrolled in the park to enforce regula-
tions "and to serve as voluntary guides for the ladies of the daily parties." At
Norris, traveler Morris "waited an hour at Monarch Geyser to see it 'play,' but
it 'played' not, although a soldier kept telling us it was liable to at any moment.
Methinks he cared more for female conversation than he did for veracity."[131]

This attention that soldiers paid to ladies seems to have occasionally
influenced their ability to protect park resources. William Myers noted that
his soldier was "susceptible to softening charms" and might well say to his
female charges, "if you accidentally on purpose pick up some token as I look
the other way, I of course know nothing to report." This offer ran counter to
any soldier's duties, and one naturally wonders how many tourists were
encouraged by the odd behavior to secretly collect souvenir pieces of hot
spring formations.[132]

Notwithstanding their usual protection-only duties, an 1897 traveler
found one soldier who was trying hard to give information to visitors at
Mammoth: "A garrison of the U.S. army, 60 men, are stationed here near the
hotel, and a soldier appears whenever anyone or more start out for a walk,
as a guide. . . . This water, the guide said, is 170 d. [in] heat, and he did not
know the depth of the spring."[133]

And visitor Thula Hardenbrook in 1887 encountered a soldier making
geyser predictions. She observed at Upper Basin that "the soldier guide (for
there is always one, two or more present wheree'er you go) said the Castle
[Geyser] was about due." Later in the army period, the superintendent ordered
that there be a greater attempt made by soldiers to give information to visitors
in a manner similar to what "roving" interpretive rangers do today:

> there will be a patrol of two men on the [Mammoth] formations
> between Liberty Cap and Stygian Cave, between the hours of
> 7:00 A.M. and 8:00 P.M. . . . These men will see that park regula-
> tions are not violated. . . . They will also give any information
> they can, in a courteous manner, when requested to do so.[134]

Occasionally an individual soldier would stand out in informational matters. An 1891 traveler met such a bluecoat:

> The soldiers stationed in the park behaved themselves like
> perfect gentlemen. They were always attentive as guides
> and ready to furnish any information desired. Private
> J. G. Abele, of Troop E, 1st Cavalry, was the guide for
> our party, and he is deserving of special praise for his
> efforts to please.[135]

But of course, soldiers, like everyone else, occasionally gave misinformation. Mrs. E. H. Carbutt visited Grand Prismatic Spring in 1888, and ran into a soldier there who gave her the wrong name for the hot spring. The soldier's attempts at interpretation, she stated, ending up confusing her party more than it helped them.[136]

Again, it was not that common for soldiers to do interpretive work. Park superintendent Horace Albright rebutted the idea that they commonly did it in a 1973 letter. Commenting upon H. Duane Hampton's *How the U.S. Cavalry Saved Our National Parks*, Albright suggested the author took in "far too much territory. For instance he says [1971, p. 169] that the Army even began doing interpretive work. This did not happen! Most [early] guiding was done by bell hops and porters ... [and] transportation people. ... The cavalry protected the park and little else."[137]

In this assertion Albright was generally correct, but so was Hampton. Although the army did do a small amount of the storytelling, early interpretation was mainly the concessioners' bailiwick. That the army's role in storytelling grew smaller and smaller through the years seems apparent from this order issued by army commandants in 1914:

> Formation guards at the various soldier stations are
> forbidden to act as guides[;] they must confine themselves
> to their [protection] duties. Soldiers whether on duty or
> not are forbidden to solicit or receive fees [tips] for courtesies
> rendered by them to tourists.[138]

That summed up the army's attitude toward soldiers doing interpretation, and it lasted until the army left (for the second and final time) in 1918.

Actual Known Interpretive Speeches and Events from Stagecoach Days

The foregoing represents the history of horse, stagecoach, and walking guides in Yellowstone National Park before 1916. Some of their more interesting and entertaining stories and speeches are known, so for the sake of saving them, the few known specific instances of Yellowstone interpretive speeches and events are recorded here.

G. L. Henderson interpreted forest fires in Yellowstone as early as 1884. Two relevant fires, which occurred in August of 1876 and September of 1882, burned an extensive area from Bunsen Peak through the Hoodoos nearly to the terraces at Mammoth Hot Springs. On June 3, 1884, Henderson conducted visitors John Souther and daughter Nellie to the Golden Gate. Henderson used a bit of interpretation that can be appreciated by many of today's post-1988 fire naturalists:

> Mr. Souther asked me why the north side[s] of the pines
> were black and scorched while the south sides were not only
> white but polished like a kitchen floor that had been scoured
> with sand? The explanation is that as the fire came from the
> south that side of the trees had been longest exposed to the
> flames and the bark had been so far consumed as to drop off
> and leave the body of the tree exposed first on that side. Also
> that the great wind and hail storms come down through the
> cañon at Golden Gate from the south and cut into the bark
> and even left the print of the hail stone[s] on the bark of the
> tree, thus not only washing away the charred bark but polishing
> the trunks as we see. The forest when [it] burned was green,
> young, and thriftyso that the conflagration that denuded
> [it] of foliage and bark still left [trees] standing.[139]

Another specific example of known early interpretation occurred in 1888, when traveler Maturin Ballou's party suggested to their stagecoach driver that geyser eruptions were caused by "chemical action." That driver did not buy it, and offered his own version of the geologic "remnant" theory, which, although less than learned, was in keeping with that now-outmoded theory:

> "I know all about the idea that these eruptions of boiling water,

steam, and sulphurous gases are produced by chemical action," said our guide. "I've heard lots of scientific men talk about the subject, but I don't believe nothing of the sort." "And why not?" we asked. "Do you believe," he said, "that chemical action in the earth could create power enough, first to bring water to 212° of heat, and then force it two hundred feet into the air a number of times every day in a column four or five feet in diameter, and keep it up for a quarter of an hour at a time?" "Well, it does seem somewhat problematical," we were forced to answer. "After living here summer and winter for six years," he said, "I have seen enough to satisfy me that there is a great sulphurous fire far down in the earth below us, which, if the steam and power it accumulates did not find vent through the hundreds of surface outlets distributed all over the Park, would seek one by a grand volcanic outburst." "Put your hand on the ground just here," he continued, as we walked over a certain spot where our footfall caused a reverberation and trembling of the soil. "It is almost too hot for the flesh to bear," we said, quickly withdrawing our hand. "Too hot! I should say so. Now I don't believe anything but a burning fire can produce such heat as that," he added, with an expression of the face which seemed to imply, "I don't believe you do either." "The original volcanic condition of this whole region seems also to argue in favor of your deductions," we replied. "That's just what I tell 'em," continued the guide. "Them big fires that first did the business for this neighborhood are still smoldering down below. You may bet your life on that."[140]

Unfortunately, most written examples of park interpretation recorded by early Yellowstone visitors are of the "humorous story" type rather than the excellently communicated and informationally correct type. For example, an 1889 stagecoach driver told his passengers a story "which we were all expected to believe. . . . In the winter, he says 'that they place a toboggan over Old Faithful geyser, and when there is an eruption it carries them to the height of one hundred and fifty feet, the stream freezes to ice, and they ride down and off into the country for miles.'"[141]

This sort of story, when incorrect, could negatively affect place-names in the park. Place-names, as mentioned earlier, are elementally related to interpretation, because one needs names to talk about park features. Traveler

Mary C. Ludwig in 1895 heard a humorous and incorrect story that probably explains why the origin of the name of Congress Pool was wrongly attributed for so long. The park guides had made an erroneous story seeming gospel: "Congress... which, our guide gravely informs us, 'takes its name from the fact that like the Fifty-third congress it splutters and makes a great deal of fuss without accomplishing much.'" Undoubtedly this story was greeted with peals of laughter (humor, too, can figure into legitimate interpretation), and was much more entertaining than the real story, which was that the pool had been named for the 1891 geological congress. In much the same way, park tour bus drivers of the 1960s created the "Congress Lake" story—"It was named because it just sits there and does nothing."[142]

Stories like these abounded in early park days. Charles Taylor's stagecoach driver in 1900 asked his party while viewing geysers if they wanted to see a "milk geyser." When they answered yes, he pointed to a solitary cow walking the road near Old Faithful. As early as 1883, George Thomas reported that "tour guides" told their passengers that the mud from Fountain Paint Pot, a mud spring, was used to paint buildings in the park. That story was around for a long time. Dr. Nicolas Senn, a learned medical doctor, fell for it in 1903, for he stated: "The Mammoth Paint Pots in the Lower Basin... manufacture a white paint that has been used in painting the interior of the adjacent Fountain Hotel." Traveler John Atwood had heard the story in 1898, but had not fallen for it: "So perfect is the resemblance to the lead paint of commerce that when a quizzical soldier told me that all the buildings in the park were painted with paint taken from this pot, I... never dreamed of doubting the statement until I... saw the twinkle in my informant's eye."[143] This long-surviving story probably came from the use of the paint-pot mud to calcimine some of the interiors of the Fountain Hotel.

The park has long been the center of humorous stories and poems. There is something about a place with a lot of hot water, hot air, and big animals that seems to cry out for wags to compose such ditties. One such poem, published in the 1930s but probably of much older vintage, has a stagecoach driver "guying" a lady tourist with wrong information:

> Sez the she dude to the savage,
> "Do those geysers play all night?"
> Sez the savage to the she dude,
> "Not by a doggone sight!
> We turns them off at midnight, lady,

I'm right here to tell,
'Cause heatin' all that water
Is expensiver than hell."[144]

Another is too long to reproduce here, but it became famous around Yellowstone before World War I, following its initial publication in the early 1890s. Titled "The Yellowstone Park and How It Was Named," it had no basis in fact but was merely an entertaining (and long) poem about how Satan was involved in naming Yellowstone. "The Devil was sitting in Hades one day," began the poem, and it proceeded to explain how Lucifer sent one of his minions all around the world to find a place that could be an extension of Hell in order to give the devil more space. This poem was no doubt read aloud by dozens of park stagecoach drivers or memorized by them for presentation to their "dudes."[145]

One of the best known stage-driver stories, and one often wrongly attributed to Jim Bridger, was usually told while visitors traveled through Hayden Valley. Reuben G. Thwaites recalled what he heard in 1903:

> The driver of the stage would say: "This road used to be ten miles long but now it's only seven." "Why, I don't see where it's been relocated," a dude would reply. "Naw, they sprinkled it with water from Alum Crick, and that shrunk it up," was the answer. Such yarns, plus black stumps which passed for distant bears, served to break the monotony of the slow travel of those days.[146]

Indeed, stage travel was slow at times, which was one of the reasons drivers told stories—from those about hardboiled eggs to silly poems to tales about Alum Creek's penchant for shrinking things.

Motorization and the New National Park Service Bring Great Changes to Interpretive Operations

These examples of interpretive stories are among the few known from early Yellowstone days. Although this type of story did not change much during the chaotic period of 1916–1920, almost everything else in Yellowstone did. Those changes were profound and very stressful to longtime park employees.

The year 1916 was the last year of stagecoach operations in Yellowstone, and it was also the year that the Army left the park and the new rangers

entered. These two things brought massive changes to Yellowstone. Auto-mobiles had been admitted in 1915, and the summer of 1916 proved that hors-es and motor vehicles did not work well together. Park officials launched a system of park buses in 1917, which replaced the seven hundred park stage-coaches and two thousand horses. Bus drivers took over the interpretive functions previously performed by stagecoach drivers. Rangers were learning how to function in place of soldiers.[147]

Horace Albright remembered in 1963 that some of the people he and Stephen Mather looked at to become new rangers in 1916 were army soldiers to be sure, but also, interestingly, stagecoach drivers. Albright later said this to historian Aubrey Haines about the coming changeover to a ranger corps:

> The plan contemplated the release of a number of sergeants and corporals [from the army] who had had such experience in leadership and had shown real interest in Yellowstone Park, these men to be appointed park rangers. Other rangers were to be recruited from *stage drivers* [emphasis added], scouts who were on duty to help the soldiers (there were only four or five of them), etc.

It is fascinating to learn that Albright and Mather contemplated the possibil-ity of turning some of the park stagecoach drivers—who had talked to their passengers for so many years about Yellowstone wonders—into full-fledged rangers in the new corps. And at least one stagecoach driver actually did make the transition to ranger. He was Charles J. "White Mountain" Smith, who arrived in Yellowstone in 1908. He drove stages for nine summers, also working in the fall seasons of 1914–1915 as an extra scout for the army. On October 1, 1916, Smith was hired as a "First Class Park Ranger" at $1,200 per annum and sent to Riverside Station to be in charge of the park's west boundary. He served as ranger, scout, and even Assistant Chief Ranger (1918) until 1921, when Superintendent Horace Albright wangled a chief ranger job for him at Grand Canyon National Park.[148]

Bessie Haynes Arnold, who grew up in Yellowstone, remembered how awkward the transition to the ranger corps was and how serious the new rangers were about everything. Bessie did not like the changes in the park atmosphere and spirit, and she did not like the new rangers' attitudes about giving information to visitors. In reflecting upon that era, she remarked that the soldiers had guarded the formations and that some of them were good

guides if they were interested and had been there awhile. She also remembered the differences between stage drivers and the new rangers:

> Each stage driver acted as guide for his passengers. He would tell his stories and show them around and walk with them.... [T]hey had pretty good stories too.... [I]t was fun and I think the people enjoyed it. We noticed when the rangers came in they were very serious. They were going to teach the people exactly how things really are ... no fooling around.... It was a different attitude. And ... they were more bossy ... you can't do this and you can't do that ... giving orders.... The soldiers didn't do that. [They] mingled with the people and everything was [easier].... [W]e didn't like it at all [when the rangers came in]. The feeling of the Park changed.[149]

The transition from stagecoaches to automobiles was very difficult for everyone in Yellowstone. In particular, many of the old stage drivers felt uprooted and displaced. A poem that made the park rounds at the time comments on the emotional upheaval felt by many of the old drivers:

> Here's to you old stage driver,
> We'll hear your shout no more,
> Your stage with rust is eaten,
> Beside the old Inn's door;
> The auto-bus and steam car
> Have cut your time in two;
> Throw up your hands, old 'stage hoss,'
> They've got the drop on you![150]

"They" referred to anyone who was at fault for the transition: army soldiers who left Yellowstone, the internal combustion engine that displaced the horse-drawn coach, the new park rangers who took over, or an evolving society in general.

The new rangers had their hands full. It would be four years before they accomplished anything meaningful about interpretation in Yellowstone. They had numerous, more immediate problems with which to contend: automobiles and buses on park roads made for stagecoaches, a needed merger of stagecoach and lodging concessioners into new companies, the closure

of unnecessary hotels, the establishment of auto campgrounds and extra lodges, disputes between the Army Corps of Engineers and the new National Park Service, the jockeying for authority with the army who returned to the park to stay until 1918, and simply figuring out how to make the new Park Service work. All of these problems made the years 1916–1920 very chaotic ones indeed in Yellowstone, and establishing a "Division of Education," later called the Division of Interpretation, was low in priority for the NPS.

Thus, the new bus drivers initially filled the void in park interpretation until the new NPS could find its way into the education business, a process that creaked slowly into place from 1920 through 1925. It is not the purpose here to give a complete history of bus transportation in Yellowstone; that would be long and complex. But in the context of the history of park interpretation, it is important at least to mention a bit about the role bus drivers played until the new rangers could initiate their own interpretive activities.

The 1923 *Campbell's Guide*, which in 1909 had discussed the stage driver as "your guide, interpreter and friend," used that same passage about the driver as interpreter, but added this statement about the new park bus driver:

> He is not the picturesque figure of the old Concord Stage days, and yet, if possible, he may be one of the few who remained— converted from the reins and whip of the antiquated four-in- hand to the wheel and accelerator of the modern car. And, even if he is of the younger generation and more a mechanician than a horse man, he is withal courteous and polite, and my friend always.[151]

Jean Crawford Sharpe, a Wylie camps employee 1908–1917, has expounded further on the differences between the drivers of the stagecoach era and the drivers of the new park buses:

> The characteristics of the new drivers, as a group, were different from those of previous years. Now they were men who had learned mechanical skills and were fascinated with cars. . . . Some of the old horse drivers came back for the challenge of motors, but not many. No more cowboys or farmers. The new men were more likely to come from the larger cities, and more college students were showing up. There was of course a variety of in-betweens.[152]

A higher education level among bus drivers, as mentioned by Sharpe, was bound to make a difference in storytelling capabilities for the entire bus operation.

Because the people who ran the new bus operation were essentially the same people who had run the stagecoaches, the "park tours" continued without a break, regardless of what Superintendent Horace Albright said or did. Drivers simply had to drive more miles and talk about longer stretches of park roads in one day than formerly. The noise of the internal combustion engines covered some of what the driver said so that he had to shout at times. Within a few years, a backwards-facing megaphone was added to the driver's equipment, so passengers could hear his spiel while he drove.

One of those new bus driver/guides in 1923 was a man who would later become the best known of Yellowstone bus drivers. Ralph Bush Jr. remembers that his father accompanied this young man to Yellowstone that summer from Butte, Montana, and both of them became "gearjammers." A photo from what was probably 1924 shows Ralph Bush Sr. at far right and his friend at the far left of a Yellowstone bus. That Yellowstone gearjammer was Gary Cooper, soon to begin a distinguished Hollywood career as an actor.[153]

The Yellowstone bus drivers indeed soon became known as "gearjammers," and a routine of operations developed. By 1924, one writer described those operations as follows, mentioning drivers' interpretive activities:

> The buses appear at the appointed time, ready for the journey. Your bags have been taken from your room and arranged on the starting platform where they can be packed quickly on the bus you are to take. The transportation clerk calls the names of guests who are going on, and as each is called, that person takes his seat, a whistle is sounded and away he goes enroute for the next station. Nothing is haphazard about the trip. The "gearjammers" know the schedule, make the various stations on time, stop at different places and explain the points of interest along the road and show every courtesy to the passengers.[154]

It did not take long for company managers to notice that new drivers needed training not only on the vehicles but also on the park itself. It is not known exactly when these kinds of training activities began, but they were in place by 1926. Gerard Pesman, a driver who arrived that year, says he and his compatriots were issued copies of Hiram Chittenden's book *The Yellowstone*

National Park, taken on a two-day training trip around the park—called a "frolic"—and told general things about the park as well as specific things about bus schedules and stops. Moreover, Pesman recalled all drivers attended evening lectures at the lodges given by ranger naturalists and much of their learning came from that activity.[155]

By 1928, the YPT Company had made improvements. Each bus driver was "supplied with a book that told all about the history of Yellowstone Park, the formations, the animals and birds, etc." Driver L. Merlin Norris stated that "I found this very interesting and learned as much as I could. The book also told a lot of jokes about the Park and these I also absorbed, and used whenever appropriate." The jokes were either left over from Charles Van Tassell's book *Truthful Lies,* or else were corruptions of Jim Bridger's old stories about Yellowstone or creations of the drivers' own. Said driver Norris:

> I had many other jokes and stories, but this is enough to show
> the type of fun I had with my dudes. They loved it and partly
> because of this plus the true stories I told them about the
> history, fauna and flora and the formations of the park, they
> were always generous with their tips.

Clearly Yellowstone bus drivers were continuing in the communicative traditions of their forebears, the stagecoach drivers. Eventually, many of them became good guides. About this, a railroad promotional brochure stated: "How much more satisfactory to leave such things [as driving] to a bus driver, who not only is thoroughly familiar with the roads in Yellowstone, but who is also an encyclopedia on the Park and can point out and explain things of interest along the way!"[156] Of course this kind of promotion probably reflected visitor desires and expectations more than it reflected guides' competence, but testimony from past Yellowstone bus drivers and trainers claims that most drivers took seriously their task of imparting park information.[157]

In 1918, the new National Park Service instituted three fundamental principles and policies with regard to all national parks. These were as follows:

> First that the National Parks must be maintained in absolutely
> unimpaired form for the use of future generations as well as
> those of the present; second, that they are set apart for the use,
> observation, health, and pleasure of the people; and third, that

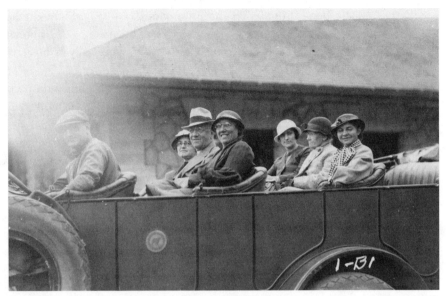

*36. YPT Company bus driver "Boogs" Chenard, about 1927, at
West Yellowstone, Montana. Author's collection.*

the national interest must dictate all decisions affecting public or
private enterprise in the park.[158]

These principles changed interpretation in national parks forever. The practice
became more formal and with more emphasis on correct scientific and his-
toric information, as the new agency took seriously its mandate to serve the
public. By 1919, NPS Director Stephen Mather had become aware that the
parks could and should be utilized more fully for educational purposes. In his
report that year, Mather called the parks underused by schools, universities,
scholars, and scientists. He was "extremely anxious that steps should be taken
in several of the largest parks next year [1920] to demonstrate the practicality
of conducting studies of the natural features at reasonable expense to students
availing themselves of the opportunities for the field laboratory work that
parks afford." He mentioned the LeConte Lectures at Yosemite, campfire talks
at a number of parks, the establishment of museums in several parks, the pub-
lication of a natural history series of pamphlets, and Columbia University's
establishment of a national parks study course in its curriculum.[159]

Probably because of Mather's new awareness, the year 1920 brought the first ranger naturalists into Yellowstone, persons of outstanding educational backgrounds, who began the "Division of Education" specifically to interpret for park visitors.[160]

Interestingly, the first ranger/interpreter ever hired in Yellowstone by the National Park Service to give "lectures" was a woman, Isabel Bassett Wasson, hired in May 1920 by Superintendent Horace Albright. Albright says he discovered her in 1919 with a party of tourists:

> I was walking through the lobby of the Mammoth Hotel one
> evening after dinner just in time to hear a young member of the
> party giving a talk on Yellowstone. She was doing an outstanding
> job of it. So I returned the next evening to hear her talk on the
> geysers and geological features of the park. She really knew her
> subject, and even included comparisons with geysers in New
> Zealand and Iceland. Complimenting her afterwards I learned
> that her name was Isabel Bassett, she was a geology major
> just out of college, and she was on the Eagle tour with her
> parents. . . . I told her that if she would come back next year
> I would be glad to hire her as a seasonal ranger. She was married
> in the meantime, but still came to work for us in the summer
> of 1920, as Yellowstone's first woman ranger, one of the first
> in the National Park Service.[161]

Albright wanted Wasson back for 1921. He told her he expected to "give you more important work than last year," adding that he wanted her "to take full charge of the guide situation at Mammoth Hot Springs, as well as the information bureau." But Wasson was pregnant and could not return.

Wasson mentioned many years later in a taped interview that Albright "thought" she could and should train the park bell porters to "lead geological tours," strange considering that Albright was supposedly in the process of trying to get rid of concessioner interpretation. Because the idea of using concession personnel to lead tours had been the interpretive scheme in Yellowstone since 1880, such an idea was not new and was merely a continuation of what was more or less the norm. But apparently, that was the "last gasp" of such an idea, as Albright proceeded with his plans to stop tour guiding by bell porters. He was not, however, able to stop tour guiding by bus drivers.[162]

As mentioned, concessioner guiding by hotel porters was officially abolished after the 1920 season. Newell Joyner, an employee of that day, stated that "in their stead" that year the park offered "the free guide services of rangers." Milton Skinner had suggested this practice in 1913, although it was not acted upon until 1920: "A Bureau of Information should be established. It should be known as 'official' and its services absolutely free."[163]

The NPS accomplished this in the early 1920s and in so doing simply adopted the existing activity of interpretation and institutionalized it. That program continues today in most if not all of the nation's 390 park units, having evolved from "information" (1919) to "education" (1925) to "naturalist" (1932) and finally to "interpretation" (1940). Interestingly, the name the NPS finally settled on for its people—interpreters—was the name used by and about park tour guide G. L. Henderson at least as early as 1888. But after 1920, concessioner bus drivers, as already noted, continued to give interpretive tours in Yellowstone. There has not been one single year since 1880 when concessioners did not participate in interpretive activities. Indeed, in 1994 Ron Thoman, Chief of Interpretation for Yellowstone, reaffirmed the "partnership in interpretation" that the NPS shares with Yellowstone concessioner AmFac (now Xanterra) Parks and Resorts.[164] And in the year 2000, the park's "Long Range Interpretive Plan" emphasized the help the NPS daily receives from that park concessioner with regard to interpretation.

The early tour guides in Yellowstone would have been sad to learn how quickly their forty-eight years of interpreting the Grand Old Park would be forgotten. Not only was guide G. L. Henderson essentially forgotten for more than eighty years, but so was the entire story of Yellowstone's other horse-and-buggy tour guides. As early as 1931, when many were still alive who knew better, some writers gave the National Park Service credit for establishing interpretation in Yellowstone. An editorial in *Nature Magazine* stated that the visitors "of fifteen years ago" had no real opportunity for true park interpretation because of the "jokes of Munchausen-minded guides who did not know a marmot from a cony [a small animal also known as a pika]." As historian Paul Schullery has pointed out, this incorrect version of events left much out of a rich story, and it improperly began a fifty-year tradition of writers stating that the rangers started park interpretation. Schullery concluded: "It is true that the federal government did not invest significantly in such [interpretive]

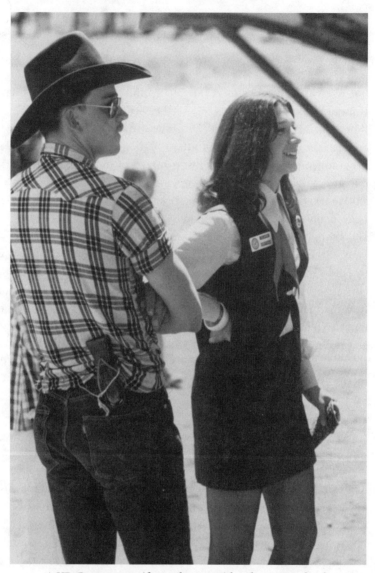

37. *A YP Company uniformed tour guide, about 1973, loads her "dudes" onto a company stagecoach. Guides like these continue the traditions of their forebears in Yellowstone Park by performing mile-by-mile commentary aboard buses. Author's collection.*

activities prior to the creation of the National Park Service, but it is not true that visitors were always at the mercy of ignorant park staff, or that they had no way to learn."

Regardless of the fact that "a strain of malarkey" sometimes but not always permeated the talks of stagecoach drivers and walking guides, one cannot escape the fierce affection that shines through many early park accounts from tourists toward their guides. Perhaps that affection stemmed less from the quality of the guides' information than from the heart-of-gold aura that emanated from those old-timers. Account after historic account makes it clear that early Yellowstone visitors loved their storytelling "horse-and-buggy tour guides." If they only saw the park "as nature's sideshow rather than as some more profound window into wilderness," wrote Schullery, "they were no less appreciative."[165]

Ultimately, what meaning did the Yellowstone storytelling experience have for early visitors who went on these tours with stagecoach drivers, walking guides, bus drivers, and finally rangers? Olin Wheeler's 1921 answer came as close as any can when he wrote: "It may, indeed, be all things to all men inasmuch as every type of humanity, every individual, may place his own *interpretation* [emphasis added] upon what he finds here."[166]

CHAPTER TWELVE

Conclusion

*N*ational park interpretation did not begin with the National Park Service in the 1920s as some writers have claimed. Instead it began with park concessioners in the 1870s and 1880s when Yellowstone became the first tourist destination in the interior of the American West to develop a major network of storytelling tour guides and talking stagecoach drivers who conveyed information to travelers. This embryonic travel entity—consisting of hotels, transportation companies, stagecoach drivers, and walking guides and born as a function of the commerce of tourism—set the stage for formal park interpretation that began under the National Park Service. For Yellowstone's first forty-eight years, park concessioners performed most interpretive chores relating to public education and information, and they generally did it fully and with concern for their visitors. Much of the time, this storytelling shared beauty and wonder through straight information and entertainment rather than provoking visitors into further investigation. But it is likely that early storytelling in Yellowstone served some of the same purposes it serves today: it promoted the park, helped visitors to enjoy it through understanding, and aided in the protection of the place by instilling appreciation. A massive literature on the subject indicates that Yellowstone interpretation was constant and ongoing for forty-plus years before the creation of the National Park Service in 1916.

Interpretation and education in Yellowstone began early and continued in various forms from the park's establishment in 1872 until the new National Park Service entered the field in 1920. While some Native American folklore on the region is known, there is not much of it. The earliest Euro-American forms of interpretation were Munchausen stories told about the country by fur trappers and gold prospectors. Foremost among those

men was fur trapper Jim Bridger, who told at least three stock stories about Yellowstone and had many more stories wrongly attributed to him.

Following formal discovery of the area in 1870, photographers entered the region and began recording it for posterity. The functions they performed were essentially interpretive, because they added to the total information mass on the area and helped to promote it. The most famous of these photographers was and is William Henry Jackson, but at least nine others photographed Yellowstone during the 1870s, and from the 1880s on the numbers of photographers became uncountable.

Lecturers gave the first formal interpretive programs in and for Yellowstone National Park, and the first lecturer on Yellowstone was Nathaniel P. Langford. Close on his heels came William I. Marshall, an 1870s writer, lecturer, photo seller, and tour guide. Although limited by time and depth, Marshall was an important early Yellowstone storyteller and it is regrettable that more is not known about him. Other early park lecturers were H. B. Calfee, W. W. Wylie, Frank Haynes, John L. Stoddard, E. Burton Holmes, Jack Haynes, and Howard Hays.

Other forms of education and interpretation in early Yellowstone consisted of signs, guidebooks and related writings, and the information about geyser eruptions that was exchanged freely in conversations between local park persons and visitors. The first park guidebook appeared in 1873, and with it came magazine and newspaper articles by the dozens as well as travelogue-type books that often carried chapters on Yellowstone. A complete pre-1930 bibliography of only history, travel, and description materials would occupy hundreds of pages. Superintendent P. W. Norris brought signs to Yellowstone in 1877. They were directional, instructional, or informational. Although he referred to them as "guideboards," no strictly interpretive signs or wayside exhibits were erected in the park until 1903 when historian Hiram Chittenden installed a number of them that carried historical messages about the 1877 Nez Perce incursion. Local persons who were fascinated with Yellowstone's geysers served as early park interpreters because they told stories about those features to park visitors and made attempts to actually predict geyser eruptions for visitors.

Once the railroad reached Yellowstone in 1883, visitation increased greatly and true hotels were established. With hotels and visitors came the need for more information about and explanation of park features. Hence park storytelling became even bigger among concessioner stagecoach drivers, hotel walking guides, independent guides, and the U.S. Army. These

persons all performed storytelling for visitors about Yellowstone's flora, fauna, history, geology, geography, and weather in as limited or extensive a fashion as they were individually equipped. Information quality no doubt varied from excellent to terrible. While the names and limited histories of some of those better storytellers are known, actual examples of early interpretive speeches are unfortunately limited.

The three most important individual storytellers, interpreters, and educators in early Yellowstone—men who gathered information and communicated it to park visitors—were W. I. Marshall, P. W. Norris, and G. L. Henderson. All three loved to show Yellowstone to visitors. Historians know little about Marshall, a private tour guide, but Norris was the second park superintendent and Henderson was an assistant superintendent who rose to become a park concessioner. Norris was primarily known as Yellowstone's pioneer pathfinder and road builder, but in his five years as superintendent, he also performed such interpretive functions as tour guide, museum collector, wildlife manager, writer, historian, and naturalist. He and Marshall worked earlier than Henderson, but Henderson stands above them as an educator and storyteller because of the length of time he was in Yellowstone, his formal schooling, the number of his formal guidings and interpretive programs, the number and depth of his writings, the quality of his park information, the diversity of his interpretive activities, and his resulting influences upon Yellowstone National Park. He arguably occupies the iconic position of first Yellowstone interpreter and first interpreter in any national park.

The National Park Service took over Yellowstone in 1916, but four years would pass before public education became part of its agenda. During that time, park bus drivers filled the interpretive void. Their activities continue today aboard concessioner buses and snowcoaches, and since 1880, no year has passed when park concessioners and private tour guides did not play an important role in interpretation in Yellowstone National Park.

Some writers have claimed that interpretation in national parks began with Yellowstone's "Division of Education" in the 1920s. Instead historians must acknowledge that storytelling in Yellowstone National Park was happening in some form or another for forty-four years before the National Park Service was created and for forty-eight years before the NPS formally entered that business itself. The National Park Service merely adopted the existing activity of park interpretation and institutionalized it.

Whether or not these early park guides were formal interpreters, using today's definition of national park interpretation, is really an irrelevant

proposition. No doubt they shared beauty and wonder, and at times they used poetry, rhapsody, or other such communicative devices. On some occasions they defended the resources of Yellowstone and made their audiences want to aid in its protection. At other times they provoked their audiences into wanting to integrate the information into their own lives or philosophies, just as park interpreters do today. Surely the more thoughtful of these people must have been driven by some of the same impulses that park interpreters have today and thus must have done some of the same kinds of things. Even during the times they merely gathered and communicated factual or erroneous information or simply attempted to entertain visitors with Yellowstone stories, they still were interpreting Yellowstone. And most significantly, they were establishing an important legacy for national parks everywhere.

Most modern park interpreters would say that a central goal of interpretation is to make people care about or appreciate, and thus help protect, the subject being interpreted. Because modern interpretation is geared toward preaching preservation, some might argue that historians should decide whether or not these early Yellowstone interpreters fit criteria that had not yet evolved in their day. That is inherently unfair to them as they were working before the discipline had even defined itself. Working with very few actual examples of their speeches, historians cannot know whether these early interpreters preached appreciation and preservation. It is certainly clear that these tour guides, stage drivers, lecturers, and outfitters lived at a time when very few persons looked at the big picture of resource conservation.

Of course, the early Yellowstone tours and speeches seemed to emphasize nature's "freak show" with lots of jokes made about them, and that sometimes still occurs today.[1] The "park tour" was interesting, but was it provocative? Did it cause visitors to want to protect and preserve Yellowstone? Did it cause them to truly tune in to the natural setting around them and to integrate it, usually in an emotional way, into their own lives and thinking? Should historians care whether or not those early speeches contained these ideas? Arguably, they should not. Surely at times those early speeches must have done all of these things, but because preservation philosophy had not really developed and because historians do not have good records of the speeches, it is difficult to know whether many of the early guides were provocative or just simply told stories or mixed the two. Even interpreters like G. L. Henderson, who made his tours something of a rhapsodical stroll, often focused more on the weirdness and grandeur of Yellowstone than on

provoking his listeners intellectually or emotionally, although there are examples in the accounts that make it clear that at times Henderson could be truly provocative.

A tentative conclusion is that these early interpreters must have satisfied some of the elements of formal interpretation most if not all of the time, and all of its elements some of the time. (That remains the case today with the park's ranger naturalists, concessioner tour guides, and private park guides.) Even during the times they merely gathered and communicated factual or erroneous information or simply attempted to entertain visitors with stories, they still were "interpreting" Yellowstone.

It is likely that early Yellowstone storytelling, in the forms of lectures, photographs, informal talks, signs, guidebooks, and geyser eruption information served some of the same purposes it serves today. It promoted the park, aided visitors in their enjoyment of it, and helped protect park resources by instilling appreciation for nature's grandest wonders. Or, as Freeman Tilden stated, "Through information, interpretation; through interpretation, appreciation; through appreciation, protection."

These horse-and-buggy tour guides, then, were the Yellowstone interpreters of their own era. If their performances were poor on some occasions, they were probably magnificent on others, just as occurs today in ranger campfire programs and on board concessioner (and other private) buses and snowcoaches. If hundreds of historical accounts are any indication, these storytellers of old Yellowstone days were listened to, appreciated, talked of, and, yes, even loved by their audiences—the traveling public of carriage days who rode stagecoaches on the Grand Tour in the "blessed old Yellowstone wonderland."[2]

APPENDIX ONE

"Do You Recall Your Walk in Geyser Basin? Take It Again with the Wylie Guide"

By Robert B. McKnight*

*T*his is indeed the best party I have ever had the pleasure of conducting thru the 'Wonderland of the World,' smiled the guide, by way of introduction to the 'Dudes.' The Tent Girl, at work on Geyser View, smiled on hearing this—smiled as she had done many times before. The dudes smiled too; all were satisfied and eager to hear what was to follow.

"Yellowstone contains more geysers than does any other section of the globe," went on the guide. "Other places have them, notably Iceland, New Zealand—"

"And California," interrupted a loyal "native daughter."

"California?" queried the guide.

"Yes, indeed," replied the "1.n.d."

"Indeed! How high do they play, Madame?" courteously asked the guide.

"All of two feet, sir," affirmed the lady.

"So many are the verbs applied to geyser action that I hardly know what would be sanctioned by Funk and Wagnalls," resumed the guide. "They gush, they gurgle, they play, they shoot, they go off, and they erupt. One day a teasing Texas Miss rushed breathlessly into the office tent and gasped, 'Has

* From *The Yellowstone News*, vol. 1, no. 1 (Spring 1915), newspaper of the "Wylie Way." This is one of the only known written Yellowstone tours from park stagecoach days. A tour of the Upper Geyser Basin apparently given in the summer of 1914, it was probably written by longtime Wylie guide Ralph Knight.

"Daisy" done what she was going to do?' Later when 'she had,' her Missouri friend bronchoed in to her corpulent mother with the startling news that Daisy 'had just watered over.' I shall leave it to you teachers of English to decide upon the proper terminology."

. "Ladies and gentlemen, you will note that the cone of the Giant Geyser, which you see before you, resembles a broken horn of a western steer," went on the guide. "Legend has it that the explosion which carried off the missing portion happened in the late seventies. General Grant . . ."

But the story was never completed for at the mention of that famous warrior's name, the Giant burst forth in all its hydraulic fury. The circle of tourists formed on the geyser's self-made hillock, broke into as many pieces as there were individuals forming it. They scampered away as fast as athletic ability permitted them. The guide was in better training than all the rest. He led the retreat as a good guide should always do. Some sort of Providence was surely watching that party.

"Was the Giant due to play?" was asked of the guide.

"No, it was off schedule, a day under-due. But aside from having to scramble from a ducking, you are one of the luckiest parties of the season. Seldom does it happen that an entire party gets to see the Giant in eruption."

"It sure is grand," remarked the man from Chicago.

"On!" commanded the guide. "We cannot pass over the Firehole without some mention of Old Jim Bridger, the celebrated Yellowstone hunter, scout and trapper," said the guide, as he led the party from the rim of Oblong Geyser. "Bridger saw these wonders in the early days before they were known to the civilized world. When he went east he told stories about them. They sounded so strange that his friends acclaimed him the Ch [illegible] of the Ananias Club [four lines illegible]. He declared that out in the Yellowstone country the rivers ran so fast that the stones in the river beds were heated red-hot as a result. In the Firehole, the bed-stones are, indeed, hot and if you were to go wading in the stream, as I saw Frau Elbertus Hubbard do the other day, you might get your 'tootsies' scorched . . . [three lines illegible]

"And here we have the Ink-well hot springs," pointed out the guide. "The only trouble with this office supply is that the well, and not the ink, is black. It would take 'some salesman' to put a sale of that stuff thru. Notice the richly colored edges of this ink fount. It looks like some mineral coloring, but it is not. It is simply an algeous growth. Algae are low forms of plant life growing in water heated as high as eighty degrees Fahrenheit [*sic*—Celsius?]. The color depends on the specie which in turn depends on the temperature

of the water in which found. It is claimed that algae have a great deal to do with the deposition of silica held in solution in the geyser waters. See how jellylike the growth is?" He prodded the mass with his stick. "And right here let me caution you in crossing over any algae-grown formation. 'Watch your step,' because the stuff is very slippery.

"On your right is the Wishing Spring. Around the edges are strewn hair pins of every design. They have been tossed there, in all good faith, by spinsters in the hope that their wishes for masculine protectors and good bread-winners would at last be answered. It is said that the spring never fails in its good offices to its trusting clients." The gentlemen of the party turned their backs as the unattached ladies made their little prayers and offerings. That done, the tourists filed over the narrow foot bridge.

"What," queried the guide, "gives the intense blue color to this and to other pools?"

"Reflections from the sky," ventured the Matter of Fact Business Man.

"Mineral matter, probably copper," suggested the Professor of Metallurgy.

"It's Monday," smirked the Facetious Young Man.

"And Dame Nature has prepared her rinsing tub," added his sister.

"My friends, you are all wrong," broke in the guide. "The blue is due to a refraction of light rays into the depths of the spring. All colors of the spectrum, save blue, are absorbed. You will observe the same phenomenon at sea or on any body of deep water. The water is blue on a cloudy day, tho, perhaps, a little less intense; the water contains no mineral to speak of, is, in fact, probably purer than your drinking water at home; and if you had consulted the office calendar this morning you would know that this is Tuesday—however the days of the week are of no consequence in the Park."

"That black hole over there," said the guide, pointing to a cavern amid the Grand Group of geysers, "I call the Surprise. One day, out exploring it by myself, I climbed down into its dark recesses. It was absolutely quiet. I thot it dead. I carved my initials[1] as far down as I could reach, after which I leisurely climbed out. A hundred feet away, a noise as of a rush of steam and water caused me to look over my shoulder. Imagine my surprise to see my 'lifeless cavern' playing a stream of water as large and as powerful as that ejected from the 'Daisy.' I shuddered at what might have been my fate. Never since have I had the desire to investigate the depths."

"Johnny, do you hear what the gentleman has just said?" inquired the Fond Mother as she shook her only child by the arm. "Don't you ever do a thing like that."

Johnny looked annoyed, but said, "Yes'm."

"We really are in luck to see the Saw-mill Geyser quiet," remarked the guide, "because the crater of this geyser is the best thing about it. Draw up close please. Doesn't it resemble the chalice of the white lily, shading from white to a rich cream? If I had my way, I should have it named the White Lily."

A little chap, who secretly intended to become the president of the United States, vowed to himself that when he took up his duties that this would be one of the changes he would first effect.

"The party must divide here in viewing the Seashell Hot Spring," directed the guide, "because of the thin formation. See how the spring is gradually doming itself over, constantly adding more silica to its rim. For four feet back from the edge it is not more than an inch in thickness."

Here little Johnny got a tug which jerked him back a yard and nearly cost him his arm. He made faces at his mother behind her back.

"The shape of this pool resembles an abellona shell," continued the guide, when the party had arranged itself in a zone of safety. "In one corner you see the water boiling at a temperature of ninety-eight degrees [Celsius], the boiling point at this altitude of eight thousand feet. Just across the river and on this side, too, loom up the geyser cones of the Sentinels. These two geysers were placed there by the Roosevelt administration to prevent the gunboats from coming down the Firehole. Since 1912 they have been quiet, 'watchfully waiting.'"

"The hill we are now climbing was built up entirely by deposits from the Castle Geyser," megaphoned the guide, back-stepping at the head of the party. "It is said to be the oldest geyser in the basin—five thousand and two years of age. When I came here, two years ago, Mr. Haynes told me that the Castle had then been playing for five thousand years."

"How accurate he is. One can always tell a college man," confided the Mathematics Professor to his companion the Divine.

"The Park authorities called this beautiful hot spring, which resembles in shape and color the fringed gentian, the Castle Well, from the legend that the inmates of the Castle used to draw their drinking water from its ultramarine depths. That was in the good old days before the nation-wide prohibition on fire water had touched the West. Just at the foot of Castle, is that fiercely boiling pool, known as the Camper's Spring. Travelers in the early day of the Park used to camp close by. In this hot water they boiled their meats and potatoes. Amid that clump of trees across the road is a bench put up by some humanitarian, the devil knows who, for 'rotten logging swaddies' and 'heavers.'"

"Tee hee," giggled the High School Miss.

The blazered Young Man looked uncomfortable.

The soldier boys were gathered around the kitchen door.

"Look," said one, "what the bears did for us last night." He pointed to a splintered and overturned ice box. Beside it lay two partly consumed hams, a dozen mashed and clawed bricks of butter.

"It is a frequent occurrence with us," admitted one of the boys in olive-drab.

The Nervous Woman shuddered visibly.

"That little shack on the river bank is of vital importance in the soldiers' daily life," the guide informed the Dudes. "It is the soldiers' bathhouse. Winter and summer, night and day, a tiny hot spring sends up water piping hot into a city bath tub. Thru a hole in the floor the bather dips up cold water from the river which flows beneath."

"And when clouds appear in the sky I suppose an orderly removes the roof for the coming shower," sallied the Facetious Young Man.

"Beginning with the season of 1915," resumed the guide, ignoring the jest, "Park tourists will have the supreme pleasure of bathing in the new, log bathhouses, built on the west bank of the Firehole. They will add much to the attractiveness of the basin, especially to the tourist who cares to make an

extended stay at the camp. The bath-house will contain a large pool for swimming and diving, shower baths, and tub baths. The log structure will match in appearance that of the Old Faithful Inn."

"And what is this but the Devil's Left Ear," lectured the guide, "his right one has never been found. Years ago, when the basin was the rendezvous of hunters and trappers, these men of the wilderness used to journey to this diabolical appendange in order to send messages to their dead pals. This practice grew so frequent that his satanic majesty at last tired of it. To end it, he had that tiny hole bored so that when he heard anyone attempting to talk to him, he could hook the lobe of his ear over the opening and thus cut off the distasteful message."

"I could not have done better," commented the Blushing Bride, who before marriage had been a telephone switchboard operator.

"The Sponge Geyser is one of the few that has a solution of iron in its water," vouched the guide. "This geyser bubbles up a foot and a half of water every minute and a quarter. We are extremely fortunate to be here in time to see it play. Its crater is so extremely hard," said he, tapping with his stick, "that I could sit from dawn until sunset at work with a cold-chisel and hammer and chip off a piece no larger than my thumb. I caution you not to try it, for should you succeed in your task, the Federal authorities would let you continue breaking stone for the rest of your life, in Fort Leavenworth."

"Some ten or twelve years ago, when a nephew of Mr. Wylie served as guide, a woman fell into the Vault hot spring," whispered the guide. "It happened this way. The lady was wearing glasses and taking notes. The Vault was filled with water, flush with the formation as you see it now. Steam was arising from its placid surface in dense clouds. Absorbed in her note-taking, with glasses steamed, the unfortunate woman walked straight into the pool." Silently the little group left the spot. Nine bespectacled school marms quietly polished off their glasses.

"Too bad about the Butterfly Springs up there on that elevation," indicated the guide. "A few years ago, they were one of the best sights to be seen in these parts, but steadily their waters have grown cooler and the algeous growth, which has given them color, has died in consequence. Now they are not worth the climb to see them, altho the souvenir cards still portray them as multi-colored as they ever were."

"An' I jes' sent one of them there cards to th' folks," guiltily admitted the Man from Home.

"Soaping the Cascade Geyser resulted in this ruin that you see before you," mourned the guide.

"Whadda ye mean, soaping?" queried the Traveling Salesman, whose specialty was soft soap.

"Simply this, sir," explained the guide, "before the Government prohibited it, tourists, rather than stand around 'kicking their heels' waiting for a geyser to act, would toss a piece of soap into its quiet waters. The soap would cause a vicious [*sic*—viscous?] film to form on the top of the water. This film would impede the escape of steam from the geyser's mouth. The result would be that a surplus of steam would collect in the geyser tube and cause a premature explosion more violent than under normal conditions. Sometimes, as in this case, the explosion was so violent as to cause the tubes to be straightened and the crater to be broken. The Cascade has been inactive since that ruthless celebration. Across the river is placed the Chinaman as another horrible example. The story is that John Chinaman, attracted by the completion of Old Faithful Inn, chose that seldom-active geyser, thinking it a hot pool as his wash tub. He tented it over and took in washing. One day, he carelessly dropped a cake of soap into his 'tub.' A short interval later up went John Chinaman, clothes and tent. But the remarkable thing about the whole affair was that all the way up and all the way down, John Chinaman never missed a rub."

"Station yourselves on this extinct geyser cone. You can see Old Faithful to better advantage; and you (to those who were about to take pictures of the

geyser in eruption) will get the best results by placing the geyser stream between you and the sun. Every geyser in eruption should be taken that way. Thousands of feet of film are wasted in the basin every year because pictures of geysers are taken in the normal way."

"Ah, there she goes!" came the cry from the entire party.

While his 'dudes' exhausted their vocabularies in search of superlatives the guide filled his pipe, lit it and with the inward question, "What will these people have left to say tonight when they see 'Old Glory' under the search-light?" smoked away in evident contentment.

"I trust that you all have pockets full of soiled handkerchiefs, for here we are at Mother Nature's old-fashioned wash tub,—Handkerchief Pool. Toss them all in," suggested the guide. All did as he directed, save two scepti-cal old ladies who didn't believe a word of what the guide had said of the merits of the natural laundry.

"There goes mine," said the High School Miss, as her 'kerchief was caught by the suction and carried to the depths below. It was gone just a minute, then stuck out a hesitant corner. It withdrew it quickly forever. Its owner gave a girlish little scream. Three times it appeared and as many times it disappeared again. The High School Miss had despaired of ever claiming it again when out from the hole it burst to the surface of the water. On the end of the guide's stick the girl received it with a giggle. When all the laundry had been returned and in the possession of the owners, some facetious chap sug-gested that it be taken to Iron Creek for the finishing touches.

"Artists have tried, time and again, to reproduce on canvas the green of Emerald Pool, without avail," reported the guide. "It stands supreme among all the hot springs of the Park. I am reminded of the Irishman, who, when told by his physician that his foot was affected with gangrene, had remarked piously, 'Thank God for the color!' Can we say more than that?... I beg to announce that the next geyser that will play will be the Tea and Coffee Geyser at the Wylie Camp."

Livingston Enterprise
Biography of "Geyser" Bill

*T*he only name by which he is known in Yellowstone National park is "Geyser Bill." To him geysers are pets, hobbies, school, work, and play. He considers a geyser like others might look upon a favorite dog or a book. He cultivates them like one would a friend. He pampers, pets and protects them as one would a child. He studies them as one might a favorite book.

"Geyser Bill" eats, sleeps, and plays with the geysers in the park. He knows their every mood, records their every impulse. A tall, gaunt, weather-beaten man of sixty or more, he can be seen from early morning until late at night on geyser hill near Old Faithful or at any other geyser basin in the park. Unobtrusive, he is rarely singled out by park visitors, for his garb is simple—an old army shirt, khaki trousers and sneakers.

But let anyone lay a hand on a geyser cone or on any of the sinter deposited about the geyser for centuries and old "Geyser Bill" goes into eruption. He simply will not tolerate any tampering with or chipping off any formation. To those who are really eager to learn about the geysers, Bill will unfold a wealth of information gathered from his four years as a geyser observer. He probably knows more about the habits and whims of Yellowstone geysers than any man alive. He comes in long before the season opens and stays long after it is officially closed. This spring he came on May 20, and he declares that he will stay until the heavy snows drive him out.

An old army sergeant, retired from active duty in 1918, this man, who admits to the name of T. J. Ankrom, calls his little car his home. It is equipped with a cot and paraffined canvas, and many a night he sleeps beside a geyser which premonition and close study tells him is about to erupt.

Geyser Bill awakes each morning to the reveille of the Daisy geyser and his lullaby is the sizzling spout of Old Faithful or the Riverside geyser, two reliable and regular vents.

On a day when a number of prominent but irregular geysers choose to play, "Geyser Bill" is a harassed and busy individual indeed. Such an occurrence

brought him near a nervous breakdown recently when the Giant geyser, Yellowstone's greatest spout[er], had hardly ceased playing before the Giantess, consort of the big one, began an unexpected and mysterious show of her own. She played for nearly 36 hours, and it nearly broke "Geyser Bill" up in business when the Beehive, the Grotto and several others began their show while the Giantess was still in play.

To understand his difficulty, it must be explained that Bill keeps voluminous notes. With camera on one side of him, stop-watch on his lap or in hand, and a typewriter placed on his knees or on a log used as a temporary desk, he sits beside the geyser cone and waits. Meanwhile he pecks away at his typewriter, recording every indicator offered by bubbling water, steam, or overflow. His notes read like a statistician's diary, with minutes and heights and distances packed together in a volume understandable only to him.

Like a mother with a restive child, "Geyser Bill" spends many a night watching over his wards. When a geyser is overdue there is no sleep for Bill. He wonders what is the trouble and will not rest until the spout has resumed its regular breathing.

As an army sergeant Bill saw two years service in Alaska, more than two years in Porto [sic] Rico, two and a half years in the Philippines, several months in Cuba in 1898 with Shafter's expedition and later service in the World war. His only known relative is a brother at Cedarvale, Kansas.[1]

Petition to the Secretary of the Interior
to retain P. W. Norris as park superintendent

*T his important and previously unpublished petition (no date, probably
late 1881) to the Secretary of the Interior by many local residents of the
Yellowstone country to retain Norris in the park superintendency is noteworthy
primarily for its summary of Norris's activities in the Park, but also for its recor-
dation of the dates of the first trips into Yellowstone of its authors (some of the
area's earliest residents):*

We the undersigned residents of the Upper Yellowstone valley or other por-
tions of the Territories of Montana, Wyoming or Idaho within or adjacent to
the Yellowstone National Park would most respectfully represent: That by the
dates of our coming to these regions set opposite our respective names it will
be seen that some of us were here and well acquainted with portions of the
Park before the "Washburn Expedition" of 1870[,] others prior to the expedi-
tions of Col. P. W. Norris in 1875, those officially of 1877, or the commence-
ment of his improvements therein in 1878 and all of us with his subsequent
efforts for protection and improvement; That the said P. W. Norris now and
since 1877 Superintendent of the said Yellowstone National Park is the first
and only person who has ever obtained or expended a dollar for the protec-
tion of the "Wonderland" from the vandalism of the Geyser Cones and other
marvels, its forests from conflagrations or its game from wanton slaughter,
or by the construction of bridle paths, roads and bridges, open it up for safe-
ty and enjoyment of visitors, the tourists and the scientists of our own and
other lands. That in the exploration and selection of mountain passes,
Cañon and valley routes for roads he has manifested rare and valuable expe-
rience as a path finding mountaineer, and in his trail, road and other
improvements, peculiar ability and qualifications. In the protection of game
and wonders, expenditures of funds and care of public property, prudence

and economy[,] and in his active intercourse with laborers, with business men and with tourists, the utmost sobriety, integrity and gentlemanly conduct. With constant opportunity for observance of his conduct, thus deeming him preeminently qualified and deserving of continuancy in the work he has commenced under so many difficulties, we most cordially and unitedly recommend the continuancy of Col. P. W. Norris in the position of Superintendent of the Yellowstone National Park, which he has so long, so usefully and so honestly filled.

Name	Date of 1ST visit to Y.N.P.
Samuel Mather	July 1881
Niel Gillis	Jany 1873
J B Tate	September 1877
G A Huston	July 1868
Norval J. Malin	August 1878 & Sept 1881
T. N. Smith	July 1881
C Dewing	July 1870
George Rowland	June 1870
Geo Fisher	Sept 1873
Adam Miller	Aug 1869
M. J. Cunningham	Oct 1871
John G. Stebens	Oct 1871
James George	Sept 1866
Frederick Bottler	Nov 1864
Orville[?] Shaffer	
Legh Beardsly	Aug 1867
D. T. Brand	Aug 1867
Geo W. [Marshall?]	
John F. Yancey	
J. E. Ingersoll	

*[From P. W. Norris, "Meanderings of a Mountaineer,"
following letter number 8, Huntington Library.]*

NOTES

❧

INTRODUCTION

1. Aubrey L. Haines, *The Yellowstone Story* I (Boulder: University of Colorado Press, 1977), p. xv. See also Lee H. Whittlesey, [obituary for Aubrey L. Haines], *Montana: The Magazine of Western History* 50 (Winter 2000): 69–70. Origins of national parks are discussed generally in Alfred Runte, *National Parks the American Experience* (Lincoln: University of Nebraska Press, 1979).

2. National tourism and western tourism are examined in a number of works that include Yellowstone references, among them Cindy S. Aron, *Working at Play: A History of Vacations in the United States* (New York: Oxford University Press, 1999); David M. Wrobel and Patrick T. Long, eds., *Seeing and Being Seen: Tourism in the American West* (Lawrence: University Press of Kansas, 2001); Marguerite S. Shaffer, *See America First: Tourism and National Identity, 1880–1940* (Washington: Smithsonian Institution Press, 2001); Lynne Withey, *Grand Tours and Cook's Tours: A History of Leisure Travel, 1750 to 1915* (New York: William Morrow and Company, 1997); John A. Jakle, *The Tourist: Travel in Twentieth-Century North America* (Lincoln: University of Nebraska Press, 1985); John F. Sears, *Sacred Places: American Tourist Attractions in the Nineteenth Century* (New York: Oxford University Press, 1989); Hal K. Rothman, *Devil's Bargains: Tourism in the Twentieth-Century American West* (Lawrence: University Press of Kansas, 1998); and Earl S. Pomeroy, *In Search of the Golden West: The Tourist in Western America* (New York: Alfred A. Knopf, 1957).

3. See, for example, Thomas A. Chambers, *Drinking the Waters: Creating an American Leisure Class at Nineteenth-Century Mineral Springs* (Washington: Smithsonian Institution Press, 2002), pp. 4, 27, 225.

4. This history is chronicled in Carlos A. Schwantes, "No Aid and No Comfort: Early Transportation and the Origins of Tourism in the Northern West," in Wrobel and Long, eds., *Seeing and Being Seen*, especially pp. 128, 131, 133–34.

5. Paul Schullery, "Privations and Inconveniences: Early Tourism in Yellowstone National Park," in Wrobel and Long, *Seeing and Being Seen*, pp. 227, 240–41; William Wyckoff and Lary M. Dilsaver, *The Mountainous West: Explorations in Historical Geography* (Lincoln: University of Nebraska Press, 1995), pp. 36, 260.

6. "The Yellowstone Park," *New York Times*, March 12, 1873, p. 4; Withey, "Selling the West," in *Grand Tours*, p. 299; Aron, *Working at Play*, pp. 142–44; Sears, *Sacred Places*, p. 157.

7. Rothman, *Devil's Bargains*, p. 45.

8. Daniel T. Rodgers, *Atlantic Crossings: Social Politics in a Progressive Age* (Cambridge: Harvard University Press, 2001), p. 39. The "Grand Tour" of Yellowstone is described in Haines, *Yellowstone Story* II, chapter fifteen. In Europe the "Grand Tour" began in the 1760s. Fred Inglis, *The Delicious History of the Holiday* (New York: Routledge, 2000), p. 15. There were no other national parks in 1883 and few state parks. In the remote Yellowstone region in 1872, there were no established towns or settlers to speak of, so the new national park itself, with the network of hotels, transportation companies, and tour guides that grew up in it, was the earliest such western travel entity.

9. Information on Yosemite is from Stanford E. Demars, *The Tourist in Yosemite, 1855–1985* (Salt Lake City: University of Utah Press, 1991), pp. 33–35, 42, 48 (Yosemite "in a day"), and Lee Whittlesey conversations with Yosemite historian Jim B. Snyder, March 2, 2004, and Linda Eade, Yosemite Librarian, February 8, 1993. Mackinac Island National Park was established in 1875 as the nation's second national park, under the aegis of the U.S. War Department. In 1895 it became Michigan's first state park. Dr. Keith Widder, historian there, says that no early individual storytellers or tour guides can be documented for that park, but that carriage drivers must have been doing tour guiding of some type during the period 1875–1895. Lee Whittlesey conversation with Dr. Keith Widder, Mackinac Island State Park, Michigan, June 10, 1994.

10. Shaffer, *See America First*, pp. 43, 44–50, 56, 61. Shaffer uses "mythic" here to mean "legendary" rather than "imaginary or fictitious." For a discussion of myth in Yellowstone, see Paul Schullery and Lee Whittlesey, *Myth and History in the Creation of Yellowstone National Park* (Lincoln: University of Nebraska Press, 2003), especially chapter ten and p. 118n1.

11. Shaffer, *See America First*, pp. 16, 46–49. John McCullough in Northern Pacific Railroad, *The Wonderland of the World, 1884* (St. Paul: NPRR, 1884), p. 33.

12. Raymond W. Rast, "Vistas, Visions, and Visitors: Creating the Myth of Yellowstone National Park, 1872–1915," *Journal of the West* 37 (April 1998): 80–81. Rast's use of the word "myth" is discussed in Schullery and Whittlesey, *Myth and History*, p. 118n1.

13. Shaffer, *See America First*, p. 21 and discussion at 50–52. For origins of the term "Wonderland," see Whittlesey, *Yellowstone Place Names*, p. 265.

14. Marcy Culpin and Kiki Rydell, *Managing the Matchless Wonders: A History of Administrative Development in Yellowstone National Park, 1872–1965* (Mammoth: National Park Service, Yellowstone Center for Resources, 2006), p. 152.

15. Freeman Tilden quoted in Culpin and Rydell, *Managing the Matchless Wonders*, p. 152; Tilden, *Interpreting Our Heritage* (Chapel Hill: University of North Carolina Press, 1957), p. 8.

16. Paul Schulz quoted in Denise S. Vick, "Yellowstone National Park and the Education of Adults" (Ph.D. dissertation, University of Wyoming, 1986), p. 183; Tilden, *Interpreting Our Heritage*, p. 9.

17. Tilden and Vick quoted in Culpin and Rydell, *Managing the Matchless Wonders*, p. 152–53; Tilden, *Interpreting Our Heritage*, pp. 8–9; Vick, "Education," p. 183.

18. T. H. Thomas, "Yellowstone Park Illustrated," *The Graphic*, August 11, 1888, p. 158. For religion in Yellowstone, see Joel Daehnke, *In the Work of Their Hands Is Their Prayer: Cultural Narrative and Redemption on the American Frontiers, 1830–1930* (Athens: Ohio University Press, 2003).

19. See Chris Magoc, *Yellowstone: The Creation and Selling of an American Landscape* (Albuquerque: University of New Mexico Press, 1999).

20. The classic study of wilderness in America is Roderick Nash, *Wilderness and the American Mind* (New Haven: Yale University Press, 1967, 2001), with Yellowstone examined in chapter seven.

21. Materials on history of thermal vandalism in Yellowstone shared with the author by Steve Mishkin of Seattle, Washington. Mishkin, a lawyer, has been working for some years on a history of the law in early Yellowstone, especially the parts of it relating to vandalism of hot springs and geysers.

22. G. L. Henderson, "Norris Geyser Basin: Wonderful Changes Occur in Cold Weather," *Livingston (Montana) Post*, February 6, 1902.

23. Citations for these Norris and Henderson quotations may be found in the chapters about P. W. Norris and G. L. Henderson. For the W. I. Marshall citation, see the chapter on early Yellowstone photographers.

CHAPTER ONE

1. Published at Mammoth Hot Springs, Wyoming, by the National Park Service, Yellowstone Center for Resources, 2002. It was followed by a University of Oklahoma Press version entitled *Restoring a Presence* (2004).

2. This chapter was published in a slightly different form as "Native Americans, the Earliest Interpreters: What Is Known About Their Legends and Stories of Yellowstone National Park and the Complexities of Interpreting Them," in *George Wright Forum* 19, 3 (2002): 40–51. It also was published under the same title in Roger J. Anderson and David Harmon, eds., "Yellowstone Lake: Hotbed of Chaos or Reservoir of Resilience?" in *Proceedings of the Sixth Biennial Scientific Conference on the Greater Yellowstone Ecosystem* (Mammoth Hot Springs, Wyo.: Yellowstone Center for Resources, 2002), pp. 269–79.

3. Hiram Chittenden, *The Yellowstone National Park Historical and Descriptive* (Cincinnati: Robert Clarke Company, 1895, 1905), pp. 8, 99. For Yellowstone as a sacred place, see generally Joseph Weixelman, "The Power to Evoke Wonder: Native Americans and the Geysers of Yellowstone National Park" (unpublished master's thesis, Montana State University, 1992). The only hint of an exception to Chittenden's "deep silence" statement is in Francis Kuppens's avowal that Piegan Indians guided him to the Yellowstone wonders about 1865–1866. Aubrey L. Haines, *Yellowstone National Park: Its Exploration and Establishment*, (Washington, D.C.: GPO, 1974), pp. 32–33.

4. John Hamilcar Hollister, *Memories of Eighty Years: Autosketches, Random Notes and Reminiscences* (Chicago: privately printed, 1912), p. 145. Nabokov, Weixelman, Janetski, and Haines all dismiss the idea that Indians feared Yellowstone's geyser regions, even though they may have revered them.

5. Russell as cited in Peter Nabokov and Larry Loendorf, *American Indians and Yellowstone National Park* (Mammoth: National Park Service, Yellowstone Center for Resources, 2002), p. 104: "Here we found a few Snake Indians . . ." Another white encounter with Sheepeaters is in the account of the 1869 Folsom party. See Charles W. Cook in Aubrey L. Haines, ed., *The Valley of the Upper Yellowstone: An Exploration of the Headwaters of the Yellowstone River in the Year 1869* (Norman: University of Oklahoma Press, n.d. [1965]), pp. 16–18.

6. Spencer Ellsworth, "A Visit to Wonderland," *Lacon* (Illinois) *Home Journal*, October 25, 1882, p. 1. This is an eighteen-part article.

7. Aubrey L. Haines to Lee H. Whittlesey, July 9, 1982; Ella C. Clark, *Indian Legends of the Northern Rockies* (Norman: University of Oklahoma Press, 1966), pp. 174–77.

8. Nabokov and Loendorf, along with historians Joseph Weixelman and Aubrey Haines, have argued persuasively that Indians did not fear the geyser regions of Yellowstone. Current members of the Nez Perce tribe, such as Clifford Allen and Allen Pinkham, laugh at the idea of such fear. As to this misnomer's possible origins, tribal member Pinkham said to me: "We told you what you wanted to hear." Clifford Allen and Allen Pinkham to Lee Whittlesey, August 27–28, 2001.

9. Nabokov and Loendorf, *American Indians*, pp. 47, 74, passim.

10. Clark, *Indian Legends of the Northern Rockies*, pp. 191–93.

11. Nabokov and Loendorf, *American Indians* as "Restoring a Presence" (unpublished ms., 1999, YNP Research Library), p. 107.

12. Ibid., pp. 107–9.

13. Ibid., p. 83. Even though the Colter's Hell story (that is, the supposed application of that name to Yellowstone National Park) has been thoroughly discredited long ago, journalists continue to mistake it for truth. See Merrill Mattes, "Behind the Legend of Colter's Hell," *Mississippi Valley Historical Review* 36 (September 1949): 251–82.

14. Quoted in Haines, *Exploration and Establishment*, p. 4.

15. Robert Keller and Michael F. Turek, *American Indians and National Parks* (Tucson: University of Arizona Press, 1998), pp. 24–25, quoting P. W. Norris. Joseph Weixelman, "The Power to Evoke Wonder."

16. Nabokov and Loendorf, *American Indians*, pp. 93–96.

17. Ibid., pp. 97–100.

18. Ibid., pp. 129–32. Historian Aubrey Haines believed that we should not always trust Clark, an English teacher with little or no training in history or anthropology. He believed that she was primarily interested in the stories themselves and not in whether they were truly Indian. On the other hand, Nabokov and Loendorf take a more charitable view. As anthropologists, they see in Clark's stories similarities to other Native American folklore, especially to the stories of the Blackfeet and Salish. Inarguably, Clark talked to a lot of Indians and produced three books on Indian legends in the Northwest, so some of her stories are indeed genuine. But she did such a poor job of telling us where they came from that this writer remains cautious. In her earlier book *Indian Legends of the Pacific Northwest*, Clark mentioned that "from the Indians themselves I heard many of [my] stories,

in my brief visits to fourteen reservations" and noted that her two criteria in consideration of whether or not to include a tale were "is it authentic?" and "is it interesting?" Unfortunately she seems to have paid more attention to the second criterion than to the first. To further complicate matters, she stated that some of her stories were "preserved by the early neighbors and friends of the Indians of the Pacific Northwest," making this writer immediately suspicious that these were non-Indian people, and then proceeded to list ten different types of sources, all of them apparently "white" sources. As if she had not done enough to undermine her own credibility, she then stated that "most of the legends [which I obtained] from printed sources I have *rewritten*" (emphasis added). Clark complained that her reasons for rewriting the stories were because they were not "smooth" reading or because they were too wordy. Regardless, there is no telling what important items of documentation or interpretation were lost as she "doctored" the stories. See Ella C. Clark, *Indian Legends of the Pacific Northwest* (Berkeley: University of California Press, 1955), pp. 2–3. Clark listed her (apparently) non-Indian sources as follows: "army officers and army engineers, early missionaries and teachers, a Canadian artist wandering through the Northwest to sketch Indians, a poet of the early West, a nineteen-year-old soldier at Fort Klamath in 1865, government physicians on reservations in the 1870s and 1890s, a pioneer rancher and pioneer housewives, an early resort owner on Lake Chelan, hunters in the Cascade and Wallowa Mountains, [and] early historians at Pacific· University and at the University of Washington."

19. Clark, *Indian Legends of the Northern Rockies*, p. 103.

20. Ibid., p. 79.

21. Ibid., pp. 366, 376.

22. Ibid., pp. 361–62.

23. Charles M. Skinner, *Myths and Legends of Our Lands* (Philadelphia: Lippincott, 1896), pp. 204–6.

24. *Helena Daily Herald*, May 18, 1870. This was also reproduced in William E. Kearns, "Historical Items on Yellowstone from Earliest *Helena Heralds*," *Yellowstone Nature Notes* 17, 3–4 (March–April 1940), pp. 15–18. Another version is in Almon Gunnison, *Rambles Overland: A Trip Across the Continent* (Boston: Universalist Publishing House, 1884), pp. 55–56.

25. Haines, *Exploration and Establishment*, pp. 40–41; Haines, *Yellowstone Story* I, p. 339n49.

26. Author's conversations with Burton Pretty-on-Top and Tim McCleary, February 2000.

27. Aubrey L. Haines to Lee Whittlesey, March 14, 2000, in YNP history files; Lt. James Bradley, "Bradley Manuscript F," *Contributions to the Historical Society of Montana* 8 (1917): 197–250.

28. Paul Schullery to author, January 2005.

CHAPTER TWO

1. Chittenden, *The Yellowstone National Park*, p. 53; William F. Raynolds, "The Report of Brevet Brigadier General W. F. Raynolds on the Exploration of the Yellowstone and the Country Drained by That River," 40th Cong., 1st Sess., Sen. Ex. Doc. No. 77, July 17, 1868, p. 10.

2. His name is corrupted from that of Baron Karl Friedrich Hieronymus von Munchhausen, a German officer in the Russian service who died in 1797. This information is from Webster's Dictionary.

3. Dr. William A. Allen, *Adventures with Indians and Game* (Chicago: A. W. Bowen Company, 1903), p. 177.

4. Quoted in Haines, *Exploration and Establishment*, p. 4. This reference may have been to present Mud Volcano or to present Crater Hills.

5. Osborne Russell (in Aubrey L. Haines, ed.), *Osborne Russell's Journal of a Trapper* (Portland: Oregon Historical Society, 1955), p. 30.

6. Haines, *Exploration and Establishment*, p. 10.

7. Russell, *Journal of a Trapper*, p. 43.

8. Haines, *Exploration and Establishment*, p. 21.

9. William F. Raynolds, "The Report of Brevet Brigadier General W. F. Raynolds on the Exploration of the Yellowstone and the Country Drained by That River," 40th Cong., 1st Sess., Sen. Ex. Doc. No. 77, July 17, 1868, pp. 10, 77.

10. Raynolds, "Report of Brevet," p. 77; Eugene F. Ware, *The Indian War of 1864* (New York: St. Martin's Press, 1966), pp. 214, 206, 250.

11. Ware, *Indian War*, p. 204.

12. Margaret J. Carrington, *Ab-Sa-Ra-Ka Home of the Crows, Being the Experience of an Officer's Wife on the Plains* (Philadelphia: J. B. Lippincott and Company, 1868), p. 113.

13. Aubrey L. Haines, *Yellowstone Story* I, pp. 53, 59.

14. Ware, *Indian War*, pp. 205–6; Haines, *Yellowstone Story* I, pp. 53–59.

15. N. P. Langford, *The Discovery of Yellowstone Park*, p. xxix.

16. *Ibid.*, p. 113 and footnote. Bridger also told this story to Captain W. F. Raynolds during the Raynolds exploration of the Yellowstone country in 1859–60. See W. F. Raynolds, "Report of Brevet," p. 77.

17. Ware, *Indian War*, p. 205.

18. Ware, *Indian War*, p. 206; Haines, *Exploration and Establishment*, p. 21; Chittenden, *The Yellowstone National Park*, p. 54.

19. Walter W. DeLacy to Arnold Hague, December 2, 1888, in National Archives, Record Group 57, Arnold Hague papers, box 5.

20. William I. Marshall, "Yellowstone Park. Its Location and Extent. An Interesting Story of Its Discovery and Exploration," *New West Illustrated*, vol. 2, no. 1, January, 1880, p. 2.

21. Identified by W. W. Wylie in his *The Yellowstone National Park; or The Great American Wonderland* (Kansas City: Ramsey, Millett, and Hudson, 1882), p. 75.

22. [Davis Willson], "The Upper Yellowstone," *Montana Post* (Virginia City), August 31, 1867. Other examples are in Haines, *Exploration and Establishment*, pp. 26–41. Haines, p. 36, attributes this quote to David Weaver. Perhaps the initials "DW" caused the confusion.

CHAPTER THREE

1. Alan Trachtenberg, *Reading American Photographs: Images as History—Mathew Brady to Walker Evans* (New York: Hill and Wang, 1989), pp. 17, 288.

2. Carl Mautz, *Biographies of Western Photographers: A Reference Guide to Photographers Working in the Nineteenth Century American West* (Nevada City, Calif.: Carl Mautz Publishing, 1997), p. 6. A shorter version of this chapter with photographs appears as Whittlesey, "'Everyone Can Understand a Picture!': Photographers and the Promotion of Early Yellowstone," *Montana: The Magazine of Western History* 49 (Summer 1999): 2–15. The quotation is from Ralph W. Andrews, *Picture Gallery Pioneers: 1850 to 1875* (Seattle: Superior Publishing, 1964), p. 111.

3. Aron, *Working at Play*, pp. 156–57. Artists and painters in Yellowstone are well discussed in Peter H. Hassrick, *Drawn to Yellowstone: Artists in America's First National Park* (Seattle: University of Washington Press, 2002). Woodcut artists in Yellowstone, examined at least cursorily by Judith Meyer, took many of their images from Yellowstone photographers. Meyer, *The Spirit of Yellowstone: The Cultural Evolution of a National Park* (New York: Rowman and Littlefield, 1996; revised edition 2003), chapter four and photo inserts.

4. Gregory N. Nobles, *American Frontiers: Cultural Encounters and Continental Conquest* (New York: Hill and Wang, 1997), p. 155.

5. Trachtenberg, *Reading American Photographs*, pp. xv–xvi, 19.

6. Judith Meyer, "The Permanence of Place: The Enduring Spirit of Yellowstone" (unpublished doctoral dissertation, University of Wisconsin, 1994), p. 72. This was published in its essence as *The Spirit of Yellowstone*.

7. Peter B. Hales, *William Henry Jackson and the Transformation of the American Landscape* (Philadelphia: Temple University Press, 1997), pp. 6–7, 30, 124.

8. Haines, *Yellowstone Story* I, p. 244; II, p. 478.

9. E. G. D., "From Geyser to Cataract," *New York Times*, September 23, 1883, p. 3.

10. Martha A. Sandweiss, *Print the Legend: Photography and the American West* (New Haven: Yale University Press, 2002), p. 201. But were Jackson's photos really first? See the following passages on Hine, Crissman, and Thrasher, all of whom were in Yellowstone in 1871. Could some of their individual images have been taken earlier than those of Jackson? We are yet to know, but Crissman's were actually published before Jackson's.

11. William H. Jackson, *The Pioneer Photographer* (Yonkers-on-Hudson: World Book Company, 1929), p. 98. The best Jackson bibliographies are Thomas H. Harrell, *William Henry Jackson: An Annotated Bibliography* (Nevada City, Calif.: Carl Mautz Publishing, 1995), and Beaumont Newhall and Diana E. Edkins, *William H. Jackson* (Fort Worth: Amon Carter Hall, 1974). Jackson's Yellowstone photos are in four celebrated volumes by the U.S. Geological and Geographical Survey of the Territories: *Photographic Views on the Montana Road*, *Photographic Illustrations of the Yellowstone River*, *Photographic Views of the Yellowstone Lake*, and *Photographic Illustrations of the Hot Springs of the Upper Madison and Yellowstone Basins* (all published in 1871). For a study that suggests Jackson's photos were not as influential in the setting aside of Yellowstone as many writers would have us believe, see Howard Bosson, "A Tall Tale Retold: The Influence of the Photographs of William Henry Jackson Upon the Passage of the Yellowstone Park Act of 1872" (unpublished ms., 1981, YNP Research Library vertical files).

12. Although Trachtenberg says his photographers did not take photographs with exhibition and sale in mind, most of these Yellowstone photographers did. Many 1870s photos discussed by Trachtenberg as well as the Yellowstone ones discussed here belong to the category of landscape art, and capturing the tourist's rapture with it was probably one of the motivations of the Yellowstone photographers. Trachtenberg, *Reading American Photographs*, pp. 128, 140.

13. Author's 2004 conversation with Jack and Susan Davis, Bozeman, Montana. The Davises are two of the nation's premier experts on Yellowstone postcards. Most of their collection is now owned by Yellowstone National Park.

14. Demars, *The Tourist in Yosemite, 1855–1985* (Salt Lake City: University of Utah Press, 1991), p. 13.

15. William H. Jackson, *Time Exposure: The Autobiography of William Henry Jackson* (New York: G. P. Putnam's Sons, 1940), p. 203; Haines, *Yellowstone Story* I, p. 153 and note 144; John W. Barlow, "Report of a Reconnaissance of the Basin of the Upper Yellowstone in 1871," 42d Cong., 2d Sess., Sen Ex. Doc. No. 66, 1872, pp. 34–35. Joshua Crissman's photos were actually published in Bozeman, Montana, before those of W. H. Jackson. See Steven B. Jackson, "Joshua Crissman: Yellowstone's Forgotten Photographer," *Montana: The Magazine of Western History* 49 (Summer 1999): 24–37.

16. James S. Brust and Lee H. Whittlesey, "Thomas J. Hine: One of Yellowstone's Earliest Photographers," *Montana: The Magazine of Western History* 49 (Summer 1999): 14–23; Brust and Whittlesey, ["Letters to the Editor," More on Thomas Hine], *Montana: The Magazine of Western History* 52 (Summer 2002): 91–93. "New-York Historical Society" is hyphenated here to distinguish it from another similar repository in New York.

17. Bob Berry of Cody, Wyoming, reports that there were eighty images listed in Crissman's catalog, at least 119 in Marshall's catalog, and a myriad of other known Crissman images; thus, the total is probably around 150. The Bozeman *Avant Courier* (August 7, 1874) gives the summers Crissman was in Yellowstone. The major study on Crissman is Steven B. Jackson, "Joshua Crissman: Yellowstone's Forgotten Photographer." See also W. H. Jackson, *Pioneer Photographer*, pp. 109–11, 114; *Time Exposure: the Autobiography of William Henry Jackson*, pp. 180, 199; and miscellaneous Crissman photocopies in possession of author from Bob Berry collection, Cody, Wyoming. In an 1882 letter to L. A. Huffman, Huffman's father wrote that Crissman had told him that he (Crissman) spent eight days getting a good photo of Old Faithful in eruption. Mark H. Brown and W. R. Felton, *The Frontier Years: L. A. Huffman Photographer of the Plains* (New York: Bramhall House, 1955), p. 38.

18. All of these are in the Bob Berry collection at Cody, Wyoming.

19. "The Calfee Family Collection," Accession no. 3640, American Heritage Center, Laramie, Wyoming. There is much Calfee family genealogy in this collection, and it shows that Calfee married Katie Lattus in 1880. At least two children were born in Missoula, Montana, from that union.

20. H. B. Calfee, "Calfee's Adventures—He and His Companion's Blood Curdling Trip to the Park over a Quarter Century Ago," Ms. made from newspaper clippings, "about 1896," [January 1899], p. 3; Calfee, "Adventurer Tells of Trip Through Yellowstone in 1873 [sic]," *Bozeman Daily Chronicle*, August 9, 1964, p. C1. W. W. Wylie, unpublished Yellowstone National Park History and reminiscences of his days there, 1926, p. 126 (housed at Montana State University Library), says the hot spring incident happened in 1878 rather than 1871, but both of Calfee's accounts say 1871.

21. Aubrey Haines letters to Lee Whittlesey, December 22, 1998, and April 28, 1999, author's files. Copies of these have been placed in the Yellowstone National Park History Files.

22. Citations for these activities are in Lee H. Whittlesey, *Wonderland Nomenclature* (Helena: Montana Historical Society microfiche, 1988), pp. 210–11, 993–94. The tourist party Calfee photographed is discussed by Mary Cook, "Kate Cook Durland's Mother's Notes on the Trip to the National Park," 1879, ms. at Montana Historical Society. The Bozeman *Avant Courier* of June 14, 1877, reported: "Calfee and Catlin are photographing the Hot Spring region, and will make an artistic tour of a Geyser section not yet visited by the photographer. The magnificent Soda Butte country and Clark's Fork will also receive their attention."

23. Issues of April 7, 1881, to March 2, 1882; Haines to Whittlesey, April 28, 1999, citing Calfee's 1899 account, "Calfee's Adventures."

24. Calfee stereos are known from the collections of Bob Berry of Cody, Wyoming; Bill Eloe of Rockport, Maryland; Jay Lyndes of Billings, Montana; and William Hallam Webber of Gaithersburg, Maryland. In 1998 Webber presented color copies of his stereos to the Yellowstone National Park collection in the form of a booklet: "An Amazingly Large Collection of 142 Stereographs and Cabinet-Size Photographs Taken During the 1870s and 1880s of: *The Enchanted Land—Or—Wonders of the Yellowstone National Park, by H. B. Calfee, Bozeman, Mont. Ter.*," Gaithersburg, Maryland, August 1998. In 2001, the park, through a generous donor, was able to obtain Webber's collection of 143 near mint Calfee images. The collection shows that Calfee's stereo set numbered at least 275 and includes twenty more images that are cabinet cards.

25. W. E. Sanders, [Journal of Wilbur Edgarton Sanders Aug 19–Sept 8, 1881], Montana Historical Society, entries for Saturday, August 27, and Sunday, August 28, 1881. The photo of Calfee's store is published in Bartlett, *Wilderness Besieged* (Tucson: University of Arizona Press, 1985), third leaf opposite p. 176. John Bourke's 1880 journal for August 15, 1880, says that Calfee's store was located "near the grand geyser."

26. Stereopticon photocopies in possession of author by Calfee singularly and by "Calfee and Catlin" together from Bob Berry Collection, Cody, Wyoming.

27. "Stereopticon," *Anthony's Photographic Bulletin* 5 (April 1874): 158; T. K. Treadwell and William C. Darrah, *Stereographers of the World* II (no place: National Stereoscopic Association, 1994), E. O. Beaman entry; Carl Mautz, *Biographies of Western Photographers: A Reference Guide to Photographers Working in the Nineteenth Century American West* (Nevada City, Calif.: Carl Mautz, 1997), E. O. Beaman entries.

28. In November of 1993, William Hallam Webber of Gaithersburg, Maryland, discovered that Marshall purchased the bulk of Joshua Crissman's photos from Crissman in or about 1876. Webber located a set of sixteen stereos, owned by William Eloe of Rockville, Maryland, which appears to document what happened between Marshall and Crissman. Eloe's stereos are printed with Crissman's name and labels, but they bear additional purple labels (apparently added later), reading "The National Park" (a Marshall trademark). Handwritten onto each stereo card, probably in Marshall's own hand, is the additional message "Copyright 1876. W. I. Marshall." Webber believes these are the transitional cards that Crissman gave to Marshall at the time of their agreement.

 In August of 1998, Webber obtained a further "Rosetta stone" of the Marshall/Crissman agreement. It is a single Crissman cabinet card of "Fire Hole Cascades" with one of Marshall's purple labels on its verso which reads "The National Park . . . Fire Hole Series." In Marshall's own handwriting is the following message: "The above description applies as well to the views of this [cabinet] size as [well as] to the stereoscopic views of corresponding numbers for which it was especially prepared. Whole number of views of this size 32—of stereoscopic views 122 (at least 124 images in this set). Retail price of stereoscopic views $3.00 a dozen. For catalogue and terms to the trade address the publisher. William I. Marshall, Fitchburg, Mass." Below that Marshall added this personal note to the owners of the cabinet card: "Compliments and good wishes of William and Ellen to Mr. and Mrs. Bates with the hope that they may have many happy returns of their birthdays. July 20th, 1880."

29. William I. Marshall, "The Yellowstone National Park," n.d. [1879], broadside in outsize rare separates file, map drawer 9, YNP Archives; Marshall, "Our National Parks—Yellowstone and Yosemite—California," n.d. [1883], broadside at Brigham Young University, Provo, Utah; "National Park Scenery in Boston," Bozeman *Avant Courier*, July 7, 1876, p. 3. This last article stated that Marshall had been a resident of the region "for the past nine years." He appeared in the 1870 Virginia City census.

30. Marlene Deahl Merrill, *Yellowstone and the Great West: Journals, Letters, and Images from the 1871 Hayden Expedition* (Lincoln: University of Nebraska Press, 1999), p. 101. George Allen stated that Marshall also had a lot to say to him about Virginia City's vigilante activities, so well known in Montana history, and he quoted Marshall extensively on those activities. The original George Allen journal is at Oberlin College in Ohio.

31. H. Banard Leckler, "A Camping Trip to the Yellowstone National Park," *American Field* 2 (February 23, 1884): 190. Marshall's name appeared in the Yellowstone Park register of George Marshall's (no relation) hotel for August 20, 1881, as "Prof. William I. Marshall of Fitchburg, Mass." Norris, *Fifth Annual Report of the Superintendent of the Yellowstone National Park* (Washington, D.C.: GPO, 1881), p. 30.

32. Mrs. Wm. I. Marshall to Mr. Chas. W. Smiley, March 22, 1925, in Fitchburg Historical Society collections, Fitchburg, Massachusetts. See also William Hallam Webber, "A report of the information found at the Fitchburg Public Library, Fitchburg, Massachusetts [on] . . . the life of W. I. Marshall . . . with . . . related . . . material appended . . . [from] the Historical Society of Fitchburg, Massachusetts," September 1998, in YNP Research Library biography file (Marshall).

33. William I. Marshall, "Save This For Your Scrapbook: The Yellowstone National Park," copy at BYU Idaho, Rexburg, Idaho, n.d. [August 1877]; Marshall, "Yellowstone Park. Its Location and Extent. An Interesting Story of Its Discovery and Exploration," *New West Illustrated* newspaper (Robert Strahorn, Omaha, Nebraska), vol. 2, no. 1, January 1880, p. 2; Marshall, "Three Rocky Mountain Lakes," in same newspaper, p. 5; Marshall, "Seasonable Hints: The Best Time to Visit the National Park and the Yosemite Valley," in same newspaper, p. 8; Marshall, "Safety of Travel in Yellowstone Park," in same newspaper, p. 3. See also William I. Marshall, "An Evening in Wonderland," *National Education Association, Proceedings* 1881: 132–43. This article confirms (p. 142) that Marshall traveled throughthe park in 1881.

34. Park Superintendent Pitcher to Marshall, August 7, 1902, in Army Records, Letters Sent, vol. 12, p. 50, YNP Archives. See also Archive Document 7606, YNP Archives.

35. Marshall to Pitcher, July 27, 1904, Archive Document 7606; Pitcher to Marshall, August 6, 1904, in Army Records, Letters Sent, vol. 14, p. 373, YNP Archives. According to the National Union Catalogue, Marshall completed a work on Yellowstone that was published in 1879. Entitled *The Yellowstone National Park* and published in Fitchburg, Massachusetts, it is described as a "broadside" (perhaps only one sheet) of size 31"x50½", and is probably one of those cited in note 29. Yale University has a copy, as does the YNP Library.

36. P. W. Norris, *Report Upon the Yellowstone National Park to the Secretary of the Interior for the Year 1878* (Washington, D.C.: GPO, 1879), p. 992.

37. Author's conversations and correspondence with Dr. Jim Brust, 1993; Brust, "Into the Face of History," *American Heritage* 43 (November 1992): 104–13; Brust, "John H. Fouch First Post Photographer at Fort Keogh," *Montana: The Magazine of Western History* 44 (Spring 1994): 2–17. Brust believes the dates 1876–1878 are correct for Fouch's Yellowstone photos because Fort Keogh, from which Fouch operated, was established in late 1876, and Fouch returned to Minnesota in 1879. Two of Fouch's unseen Yellowstone country views were of Dailey's and Bottler's ranches, but so far no copies are known to be extant.

38. Rossiter W. Raymond, *Camp and Cabin, Sketches of Life and Travel in the West* (New York: Fords, Howard, and Hulbert, 1880), pp. 155–57; C. C. Clawson, "Notes on the Way to Wonderland; or, A Ride to the Infernal Regions," Deer Lodge (Montana) *New Northwest*, series of articles September 9, 1871, through June 27, 1872; A. J. Thrasher, "Route to the Geysers," *Helena Daily Herald*, December 7, 1871, p. 3; Thrasher, "Mammoth Mound Springs," *Helena Daily Herald*, December 20, 1871, p. 1. The Montana Historical Society has some scattered biographical materials on Thrasher. He is also mentioned in Treadwell and Darrah, *Stereographers of the World* II, A. F. Thrasher entry, and in Mautz, *Biographies of Western Photographers*, pp. 212, 292. An advertisement for "Thrasher and Hyde, Proprietors of the Sun Pearl Picture Gallery" in Deer Lodge, Montana, may have been placed by Thrasher's partner William Hyde after Thrasher left for Philadelphia. See *Weekly Montanian* (Virginia City), February 1, 1872. I am indebted to Eugene Lee Silliman of Deer Lodge for information from the *Weekly Montanian*.

39. "A. F. Thrasher," *Weekly Montanian* (Virginia City), October 26, 1871. "I'd kill for a look at those photos," declared geyser expert Rocco Paperiello recently. Author's conversation with Rocco Paperiello, Old Faithful, Wyoming, summer 2003.

40. "The Geyser Exhibition," *Weekly Montanian* (Virginia City), November 2, 1871, p. 5.

41. "Statesward," *Weekly Montanian* (Virginia City), January 4, 1872, p. 5.

42. Calvin C. Clawson, *A Ride to the Infernal Regions: Yellowstone's First Tourists*, ed. Eugene Lee Silliman (Helena, Mont.: Riverbend, 2003), p. 20.

43. A search of numerous Philadelphia, Indiana, and Idaho repositories by this author failed to turn up any Thrasher photographs of Yellowstone.

44. Miscellaneous biographical materials on Train and Bundy at the Montana Historical Society sent to author, including "A Pioneer Gone," *Helena Daily Herald*, June 10, 1899; Mautz, *Biographies of Western Photographers*, p. 292.

45. Dr. Brad Richards to Elsa Kortge, June 13, 1993, and twenty-four photocopy photos, YNP Library. Mr. Richards's biography of Savage is *The Savage View: Charles Savage, Mormon Pioneer Photographer* (Oregon House, Calif.: Carl Mautz), 1995. See also C. R. Savage, "A Strange Country, Geyserland," *Deseret Evening News* (Salt Lake City), September 17, 1884.

46. Brown and Felton, *The Frontier Years*, pp. 36–38, 46. The Brown and Felton book gives Huffman's biography, and the Buffalo Bill Historical Center in Cody, Wyoming, holds a large collection of his personal papers. A recent biography is Larry Len Peterson, *L. A. Huffman Photographer of the American West* (Tucson: Settlers West Galleries, 2003). See also M. E. Hawkins, "L. A. Huffman, the Old Time Photographer," *The Dude Rancher* (Billings, Montana) 2 (April 1934): 3–4, 28–31. Sandweiss (*Print the Legend*, p. 243) is not correct when she says that Huffman is "best known for his pictures of Yellowstone." While it is possible his park photos were somewhat known in the 1880s, they are not widely known today because many of them cannot be located.

47. Peterson, *L. A. Huffman*, p. 40. For an account of Huffman meeting John McCullough in Yellowstone, see Introduction, n. 11.

48. Peterson, *L. A. Huffman*, p. 41.

49. Sandweiss, *Print the Legend*, p. 335.

50. "Views of Montana," Helena *Daily Independent*, June 12, 1879, p. 3.

51. Rubinstein and Berry have begun work on a book on this subject. Their extensive website is at http://megaone.com/yellowstone/stereoview.html.

52. U.S. Geological Survey, Record Group 57, Field Notebooks, Boxes 51–53, notebooks of J. P. Iddings, 1883–1886, National Archives, College Park, Maryland.

53. Thurman Wilkins, *Thomas Moran: Artist of the Mountains* (Norman: University of Oklahoma Press, 1966), p. 5. The quotations are from Gunnison, *Rambles Overland*, p. 11.

54. Katherine E. Early, *"For the Benefit and Enjoyment of the People": Cultural Attitudes and the Establishment of Yellowstone National Park* (Washington, D.C.: Georgetown University Press, 1984), p. 7.

CHAPTER FOUR

1. N. P. Langford, handwritten "Mss. of Lectures Given by N. P. Langford during winter of 1870–71," original at YNP Library manuscript file, p. 1.

2. *New York Times*, January 22, 1871; *New York Tribune*, January 23, 1871.

3. The United States had given Yosemite to the state of California in 1864. It was not returned to become part of Yosemite National Park (established in 1890) until 1906. Albert Matthews, "The Word Park in the United States," *Publications of the Colonial Society of Massachusetts* 8 (April 1904): 382–83; author's conversation with Linda Eade, Yosemite librarian, February 8, 1993.

4. Langford, "Mss. of Lectures," pp. 3, 5, 157, 183, in manuscript file, YNP Library; "Travels in Montana," *New York Times*, January 22, 1871; "The Wonders of Montana," *New York Tribune*, January 23, 1871; Haines, *Yellowstone Story* I, pp. 137–40. Langford's article in *Scribner's Monthly* appeared in the May and June 1871 issues.

5. Haines, *Exploration and Establishment*, pp. 93–99, especially p. 94. Mike Foster, in his *Strange Genius: The Life of Ferdinand Vandeveer Hayden* (Niwot, Colo.: Roberts Rinehart, 1994), disputes the idea that Langford's speech influenced Hayden to explore Yellowstone.

6. Robert Adams Jr., "The Yellowstone," Philadelphia *Daily Evening Telegraph*, April 3, 1874, p. 1.

7. Mr. and Mrs. Frank Burnside Kingsbury, *Marshall Family Record* (Keene, N.H.: Walter T. Nims, 1913), p. 45.

8. "National Park Scenery in Boston," Bozeman *Avant Courier*, July 7, 1876, p. 3; William I. Marshall, "Our New West—Colorado, Utah, Oregon," n.d. [probably 1883], broadside at Brigham Young University, Provo, Utah. Herein Marshall stated that the winter season of 1883–1884 would be his eighth season of giving lectures on Yellowstone and other subjects. Marshall is known to have visited the park in 1873, 1875, 1881, 1882, and possibly other years as well. In another broadside from late 1883, he stated that he had "visited the park four times, and lectured on it for the past seven years." Thus, he must have begun giving his Yellowstone lectures in the winter of 1876–1877. Marshall, "Our National Parks—Yellowstone and Yosemite—California," broadside, n.d. [1883], Brigham Young University.

9. Marshall, broadside [1879].

10. Ibid.

11. Ibid. The figure of two hundred lectures was in use in early 1879, so by 1886 Marshall must have given dozens if not hundreds more.

12. Ibid. In another description of his evening programs on Yellowstone, Marshall stated: "My lecture on the Park . . . is illustrated by the oxy-hydrogen and calcium-light stereopticon, with some fifty transparencies prepared from the original negatives of these photographs, projected upon a screen twenty feet square, many of the views being elegantly colored, and it gives a clearer idea of the appearance of these unique objects and scenes than can be obtained in any other way than by an actual visit to it." Marshall, "Yellowstone Park: Its Location and Extent," *New West Illustrated*, vol. 2, no. 1, January 1880, p. 2. Researcher William Hallam Webber believes that Marshall had found a way by 1880 to exhibit his (Crissman's) pictures in full three-dimensional stereo and is attempting to prove it.

13. Williams Lecture Bureau, "A New Illustrated Lecture, the Wonderland of the World, or The Yellowstone National Park. Illustrated with the Stereopticon, by Prof. William I. Marshall, Late Superintendent of Schools of Madison county, Montana Territory," n.d. [probably 1877]. Original in collection of Jim Crain, San Francisco, California, and copy in YNP Library biographical file under W. I. Marshall, furnished by William Hallam Webber.

14. Marshall's Indiana lecture was mentioned one hundred years later in "Yesterday Here," *The Elkhart* (Indiana) *Truth*, January 18–19, 1986. He was listed as a "lecturer" in the residence directory of Fitchburg, Massachusetts, for the years 1878–1887. Chris Steele, Massachusetts Historical Society, to Lee H. Whittlesey, June 27, 1994.

15. See, for confirmation, his long articles in Strahorn's *New West Illustrated* (1880), cited earlier.

16. Interestingly, a "black mark" on Marshall's reputation might be excusable. In that era, the collecting of geyser specimens was, like illegal hunting, one of those offenses that not everyone thought was criminal. As historian Paul Schullery has pointed out, no one had told these early visitors how they should behave. The local newspaper stated in late 1881 that W. I. Marshall "has been among the busiest of these [geyser specimen] plunderers, having, it is alleged, sold specimens in the East in connection with 'lectures' on the wonders of the Yellowstone." "Practical Suggestions About the Yellowstone Park," Bozeman *Avant Courier*, December 15, 1881, p. 1.

17. Harry J. Norton, *Wonderland Illustrated; or, Horseback Rides Through the Yellowstone National Park* (Butte City, Mont.: Harry J. Norton, 1873), p. 128.

18. Clawson information from Lee Silliman of Deer Lodge, Montana, a historian who has published Clawson's "A Ride Through Wonderland" as a book. The Horr item is quoted from Bozeman *Avant Courier*, April 2, 1875, in Bill and Doris Whithorn, *Photo History of Aldridge* (Minneapolis: Acme Printing, n.d. [1965]), p. 19.

19. "He" is in quotation marks here because Calfee was not a public speaker. Thus, someone else (often William H. Parker or W. W. Wylie) sometimes performed for him even though the publicity was in Calfee's name. For example, a newspaper article noted that "being no public speaker, Mr. Calfee ... modestly declined" the invitation to speak at one of his presentations and instead asked Bozemanite J. V. Bogert to do the honors. "The Calfee Benefit," Bozeman *Avant Courier*, June 30, 1881, p. 3.

20. "Yellowstone Panorama," Bozeman *Avant Courier*, April 7, 1881, p. 3; "Yellowstone Panorama," April 14, 1881, p. 2; "Gratifying Success of Calfee's Panorama," April 28, 1881, p. 3.

21. "The Calfee Entertainment in Helena," Bozeman *Avant Courier*, June 23, 1881, p. 1; "Virginia City and the Park," May 26, 1881, p. 3.

22. W. W. Wylie, unpublished Yellowstone National Park history and reminiscences of his days there, Montana State University, 1926, p. 15.

23. Ibid., pp. 15–17, 125; Haines, *Yellowstone Story* II, p. 134. Issues of the Bozeman *Avant Courier*, April 7, 1881 to March 2, 1882, mention this ongoing lecture venture.

24. Sandweiss, *Print the Legend*, pp. 174–76.

25. Ibid., p. 174.

26. Mautz, *Biographies of Western Photographers*, p. 489; Prof. S. J. Sedgwick, *Catalogue of Stereoscopic Views of Scenery in All Parts of the Rocky Mountains Between Omaha and Sacramento Taken by the Photographic Corps of U.P.R.R....* (Newtown, N.Y.: S. J. Sedgwick, 1874); Sedgwick, *Announcement of Prof. S. J. Sedgwick's Illustrated Course of Lectures and Catalogue of Stereoscopic Views of Scenery in All Parts of the Rocky and Sierra Nevada Mountains...* (Newtown, N.Y.: S. J. Sedgwick, [1879–80]), fourth edition). Copies formerly owned by Dean Larsen of Provo, Utah, are now at Brigham Young University Library.

27. "State Institute! for Becker Co., Minn.," 1888, poster in Haynes collection, Montana State University, Bozeman. In 2002, this poster was framed on the wall at MSU's Special Collections division.

28. J. E. Williams, *Through the Yellowstone Park. Vacation Notes. Summer of 1888. Copied from the Amherst Record* (Amherst, Mass.: n.p. [probably *Amherst Record*], n.d. [probably 1889]), p. 45. These lectures by Haynes represent the earliest known hotel interpretive programs on Yellowstone, and they are the antecedents of present-day "map room" programs at Mammoth Hot Springs. It is probable that G. L. Henderson did some earlier ones, but we do not know of them specifically.

29. Nationwide lecturers and their lanternslides are mentioned in Rodgers, *Atlantic Crossings*, p. 136, and in Sherry L. Smith, *Reimagining Indians: Native Americans Through Anglo Eyes, 1880–1940* (New York: Oxford University Press, 2000), pp. 3, 89, 147–48.

30. Northern Pacific Railroad, *Wonderland Junior* (St. Paul: NPRR, 1895), p. 31.

31. *Livingston* (Montana) *Herald*, July 30, 1896.

32. "Prof. Stoddard in the Yellowstone," newspaper clipping [1896], in Scrapbook 4209, p. 136; K. E. M., "In Yellowstone," newspaper clipping [1896] in Scrapbook 4210, p. 4. See also "America's Wonderland, An Appreciative Audience," [1896], in Scrapbook 4210, p. 7, and "Yellowstone National Park. Stoddard Lecture," [1896], Scrapbook 4210, p. 9, YNP Library, wherein Stoddard lectured to a hall of two thousand people.

33. Stoddard lecture brochure, 1896, in Jack E. Haynes collection 1504, box 151, file 27, Montana State University.

34. K. E. M., "In Yellowstone." See also Archive Document 2780, YNP Archives.

35. Jack E. Haynes to Horace Albright, September 22, 1927, in JEH collection 1504, box 14, file 14, Montana State University.

36. Newspaper clipping in "Curry's Yellowstone Park Excursions, Summer of '97," pamphlet that is Archive Document 2305, YNP Archives. See also documents 2306–12, 2337.

37. Author's conversation with Linda Eade, Yosemite National Park librarian, March 8, 1994.

38. "The Yellowstone's Wonders" and "Some of Its Gorgeous Colors Reproduced by Photography," undated [1890s] news clippings in Scrapbook 4208, p. 152; "Yellowstone Park, Mr. Spangler's Illustrated Lecture," undated [1890s] news clipping in Scrapbook 4210, p. 7, YNP Library. Jennings was also a photographer, as the park collection holds some of his photos.

39. Charles Thomas lecture brochure, 1899, in Jack E. Haynes collection 1504, box 153, file 38, Montana State University.

40. Jack Haynes typed statement, December 16, 1958, in Haynes Collection 1504, box 112, file 1, Montana State University; Newell F. Joyner, "An Outline of the History of Educational Activities in Yellowstone Park," in *Ranger Naturalists' Manual of Yellowstone National Park* (Mammoth Hot Springs: NPS mimeograph, 1929, YNP Library), p. 172.

41. Edmund Frederick Erk, *A Merry Crusade to the Golden Gate... September, 1904...* (no place [San Francisco]: n.p. [privately printed], n.d. [1906]), pp. 110–11. According to Erk, Hofer stated that "the President [Roosevelt] had been given special permission to shoot in the park but refused to accept

any special privileges." This was misinformation. Roosevelt received no such special permission. Paul Schullery to author, January 2005.

42. Reik is mentioned in Jack Haynes's notes in Jack E. Haynes collection 1504, box 143, file 50, Montana State University.

43. Chester A. Lindsley, *The Chronology of Yellowstone National Park* (unpublished bound document, 1939, YNP Library), p. 238.

44. *Teton Peak Chronicle* (St. Anthony, Idaho), July 13, 1911.

45. Richard E. Hughes, "Through Yellowstone Park with a Kodak by Richard Hughes," postcard in Susan Davis collection, Yellowstone National Park, dated December 28, 1909. A second card is dated January 9, 1909.

46. This story, a favorite on the origin of Yellowstone and all national parks for more than sixty years, has fallen into disrepute since 1972. See Schullery and Whittlesey, *Myth and History*.

47. Howard H. Hays, "Yellowstone Park: An Illustrated 'Touring Talk,'" 1910–11 brochure, in Item 84, file 310 ("Annual Report of Acting Superintendent . . . 1911"), YNP Archives; Jack Ellis Haynes, "Rotarian Howard H. Hays," January 16, 1957, in Haynes collection 1504, box 96, file 15, Montana State University; "Many Free Lectures," *Chicago Daily News*, December 10, 1910, p. 2.

48. "Program—Illustrated 'Touring Talk' on Yellowstone Park by Howard Hays," n.d., about 1913, in Hays Scrapbook no. 2, p. 16; "Yellowstone Park An Illustrated 'Touring Talk' by Mr. Howard H. Hays . . . Moving Pictures That Are Different," n.d., about 1913, in Hays Scrapbook no. 2, p. 31; various newspaper clippings on his speeches in Hays Scrapbook no. 3 (B-H334hh); newspaper clipping on 1914 World's Fair slugged *Metropolis* (Illinois) *Journal-Republican*, December 24, 1914, in Hays Scrapbook no. 1; all at American Heritage Center, University of Wyoming, Laramie. For Hays's own "take" on "Old Faithful Inn" at the 1915 World's Fair, see the rare pamphlet Howard H. Hays, *An Appreciation* (San Francisco: J. R. Kathrens and Union Pacific, 1914).

CHAPTER FIVE

1. Rast, "Vistas, Visions, and Visitors," p. 82.

2. Shaffer, *See America First*, pp. 169–220, especially 201.

3. Hoyt's writings are in Scrapbook 4209, YNP Library, p. 130; in J. E. Williams, *Through the Yellowstone Park*, p. 43; in Elbert Hubbard, *Elbert Hubbard's Scrapbook* (New York: William H. Wise, 1923), pp. 28–29; and in Northern

Pacific Railroad, *The Wonderland of the World 1884*, pp. 30–31. Hoyt's most famous quote, about Yellowstone's Grand Canyon, is reproduced in the chapter entitled "All Them Fool Tenderfoot Questions." Three other general categories for Yellowstone books and their authors were national parks (Nicolas Senn, John Muir), automobile travel (W. F. Hallahan, David M. Steele), and God (Alma White, Henry White Warren).

CHAPTER SIX

1. P. W. Norris, *Report Upon the Yellowstone National Park . . . 1877*, p. 837. There is no mention of signs in either Norris's 1878 annual report or in his preliminary report in National Archives records, dated November 10, 1878.

2. Heister Dean Guie and Lucullus Virgil McWhorter, *Adventures in Geyser Land* (Caldwell, Id.: Caxton Printers, Ltd., 1935), p. 80.

3. Norris, *Report Upon the Yellowstone National Park . . . 1879*, p. 7. One of these black-and-white signs erected by Norris is pictured in H. B. Calfee's photo no. 84 of Giantess Geyser.

4. Norris, *Annual Report of the Superintendent . . . 1880*, pp. 14–15; M. L. Joslyn to Patrick Conger, August 3, 1883, in National Archives, RG 48, no. 62, roll 2 (hardcopy at YNP Library).

5. Carrie Adell Strahorn, *Fifteen Thousand Miles by Stage* (New York: G. P. Putnam's Sons, 1915), p. 272.

6. George Thomas, "My Recollections of Yellowstone Park" (unpublished, 1883), p. 8, YNP Library.

7. Terry to P. H. Conger, September 1, 1884, document 1559, YNP Archives; Arnold Hague, "List of Geysers in Yellowstone Park, showing the derivation of their names," n.d., about 1887, in National Archives, Record Group 57, Hague papers, box 12, folder 62.

8. G. L. Henderson in Archive Document 1453, YNP Archives; Henderson, *Yellowstone Park Manual and Guide* (Mammoth Hot Springs: n.p. [Livingston *Enterprise*], 1885), p. 2 below geyser table; Theodore Gerrish, *Life in the World's Wonderland* (Biddleford, Maine: n.p., 1887), pp. 186, 212; W. H. Dudley, *The National Park from the Hurricane Deck of a Cayuse* (Butte, Mont.: Loeber, 1886), p. 75.

9. Peale in F. V. Hayden, *12th Annual Report*, 1883, p. 126; J. W. Weimer, August 10, 1884, Archive Document 1586, YNP Archives; Walter Weed as cited in Whittlesey, *Wonderland Nomenclature*, p. 256.

10. Henry Page to Secretary of Interior, August 30, 1885; D. W. Wear to Secretary of Interior, December 10, 1885, in NA, RG 48, no. 63, roll 3 (hardcopies at YNP Archives); Anonymous, "The National Park Police," *Forest and Stream* 27 (August 12, 1886): 42; E. Catherine Bates, *A Year in the Great Republic* II (London, Ward and Downey, 1887), p.188.

11. H. T. Finck, "A Week in Yellowstone Park," *The Nation* 45 (September 1, 1887): 167.

12. Whittlesey, *Wonderland Nomenclature*, p. xxix and note 14.

13. M. L. A., "Our Summering of 1890" (unpublished ms., University of Colorado), p. 24.

14. Moses Harris, from his 1888 annual report, pp. 14–15, as quoted in Marcy Culpin and Kiki Rydell, "Managing the 'Matchless Wonders': A History of Administrative Development in Yellowstone National Park, 1872–1965," manuscript in preparation for the National Park Service, 2004, chapter 3, p. 55 (see also Culpin and Rydell, *Managing the Matchless Wonders*, pp. 40–43, 47).

15. G. L. Henderson, *Yellowstone Park Manual and Guide*, 1888, p. 2.

16. J. E. Williams, *Through the Yellowstone Park*, p. 26. Williams noted that "these springs and other natural objects are most of them named. The name is painted on a strip of board and attached to a tree, post or something of the kind. The government has caused most of the prominent objects in the Park to be named [signed] in this manner."

17. George A. Remington, "Journal of Trip to Yellowstone Park in 1887 Kept by George A. Remington of Cambridge, Nebraska," compiled November, 1986, YNP Library vertical files; Whittlesey, *Wonderland Nomenclature*, pp. 344, 424.

18. George S. Anderson, *Report of the Superintendent . . . 1891* (Washington, D.C.: GPO, 1891), p. 9.

19. Charles J. Gillis, *Another Summer: The Yellowstone Park and Alaska* (Astor Place, N.Y.: J. J. Little and Company, 1893), p. 24.

20. George S. Anderson, *Report of the Superintendent . . . 1891*, p. 8; Archive Document 1488, YNP Archives. In 1893 Nelse Cornell worked at painting park signs per an order from the Department of the Interior asking that all signboards be "fresh and legible." See "Local Layout," *Livingston Enterprise*, September 30, 1893; and John W. Noble to George S. Anderson, June 13, 1892, document 371, YNP Archives.

21. John Pitcher, *Report of the Acting Superintendent . . . 1905* (Washington, D.C.: GPO, 1905), p. 13; C. A. Stephens, "In the Yellowstone Park," in Perry Mason and Company, *Our Country: West* (Boston: Perry Mason and Company, 1900), p. 80.

22. H. M. Chittenden, "The Government Road System of the Yellowstone National Park," in U.S.D.A., *Proceedings of the International Good Roads Congress* (Washington, D.C.: GPO, 1901), p. 76.

23. Sgt. George Riddell to Commanding Officer, March 31, 1903, archive document 6053, YNP Archives.

24. S. B. M. Young, *Annual Report of the Superintendent . . . 1907* (Washington, D.C.: GPO, 1907), p. 8. See also Lt. Col. L. M. Brett to Milton Skinner, December 12, 1913, in Item 37, folder 1, file 3, YNP Archives.

25. Chester A. Lindsley, *Annual Report for Yellowstone National Park 1918*, 1918, p. 49; Horace Albright, *Annual Report for Yellowstone National Park 1919*, 1919, p. 36; *Annual Report for Yellowstone National Park 1920*, 1920, p. 61; National Park Service, *Report of the Director of the National Park Service for 1920*, 1920, p. 96.

26. See for example James McBride, scout diary no. 17, June 25–27, 1908, YNP Archives. An extensive history of park signage after 1920 has not been attempted here. For detailed information on this later era, see box D-76, file "Signs FY 1929–1930–1931;" Aubrey L. Haines, n.d. [early 1960s], log of signs and structures for entire park, box H-4, file 3.4.6; and Lindsley to Woodring, May 24, 1926, box A-5; correspondence on signs in box K-16, file "154.32 Educational Division FY-1932," YNP archives.

27. Except for Chittenden's Nez Perce Trail signs in 1903, these types of interpretive signs in Yellowstone began with Ansel Hall's 1926 "Nature Trail" signs in the Upper Basin (Box K-10, YNP Archives) and five wayside "shrines" erected in 1933.

28. Hiram M. Chittenden, *Annual Reports Upon the Construction, Repair, and Maintenance of Roads and Bridges in the Yellowstone National Park*, Appendix FFF (Washington, D.C.: GPO, 1902), p. 3039. See also Chittenden, *The Yellowstone National Park*, p. 162; and Merrill D. Beal, *The Story of Man in Yellowstone* (Mammoth, Wyo.: Yellowstone Library and Museum Association, 1956), opposite p. 174.

29. Chittenden, Appendix FFF, pp. 3039–40.

30. John Pitcher, *Annual Report for 1904*, p. 13.

31. In fall of 2003, the author discovered that large-sized Haynes photos of several of Chittenden's Nez Perce signs (showing the signs in place) survive at the Library of Congress.

32. In 2006, Mary Anne Bellingham and Frank Smith discovered Chittenden's wooden sign number seven ("on this sopt, a party of tourists . . .") remains in place.

33. Archive Documents 6055–56, 1903, YNP Archives. Photographs show that this sign was headed "Howard's Crossing."

34. Alfred Talbot Richardson, "Something About the Yellowstone Park," *Out West* 22 (May 1905): 330; S. B. M. Young to Secretary of Interior, January 13, 1908, in Army Records, Letters Sent, vol. 18, pp. 190–91, YNP Archives.

35. "National Park in the Centennial," Bozeman (Montana) *Avant Courier*, July 31, 1874, p. 3.

36. George W. Rea to Secretary of Interior, January 3, 1885, in NA, RG 48, no. 62, roll 3 (hardcopy at YNP Archives); Stephen Mather, "Report of Director of National Park Service . . . 1919," pp. 29–31; Haines, *Yellowstone Story* II, p. 307; H. Duane Hampton, *How the U.S. Cavalry Saved Our National Parks* (Bloomington: Indiana University Press, 1972), p. 171.

37. L. M. Brett to Secretary Franklin Lane, November 4, 1913, in Item 39, box 20, file "Accommodations at Hotel and Camps, 1901–1917," YNP Archives.

CHAPTER SEVEN

1. Leckler, "A Camping Trip," p. 237. This chapter on Yellowstone geyser gazers was published in a shortened form in *GOSA Transactions* 6 (1998): 68–73.

2. Wade Warren Thayer, "Camp and Cycle in Yellowstone Park," *Outing* 32 (April 1898): 19.

3. Norton, *Wonderland Illustrated*, p. 30.

4. W. E. Sanders, [Trip to Yellowstone Nat. Park], 1880; [Journal of Wilbur Edgarton Sanders Aug 19–Sept 8, 1881], both at Montana Historical Society.

5. Wilbur E. Sanders, typescript of 1881 journal at Montana Historical Society, entry for Friday, August 26.

6. Leckler, "A Camping Trip," 236. There has been confusion in various accounts as to men named George Graham at this time. The record was further complicated when the Graham at Marshall's changed his name to George Graham *Henderson*, and that man then became confused in various accounts with George Legg Henderson. Superintendent P. W. Norris (1881, p. 8) mentioned a George W. Graham, who was his blacksmith, and superintendent Patrick Conger hired a blacksmith named George Graham at Virginia City and brought him to Yellowstone in 1882, so it is possible that those two men were the same man although that is not known for certain (Haines, *Yellowstone Story* I, p. 262). What is known is that Leckler's guide above changed his name in 1884, for traveler "F.F.F." recorded: "The gentleman spoken of as George Graham by Mr. Leckler in his article on the Park has changed his name, and is now in partnership with Mr. Marshall." The new partner, George Graham Henderson (no relation to G. L. Henderson), bought into the Firehole Hotel with Marshall. He stayed

there for a while after Marshall sold out to Henry Klamer, and then dropped out of sight. See F.F.F., "A Modern Pilgrimage to the Mecca of the Sportsman and Tourist—No. 2," *American Field* 24 (October 17, 1885): 372. G. L. Henderson, in a letter to Secretary Henry Teller, indicated that George Graham Henderson was a different Henderson from himself (G. L.). NA, RG 48, roll 3, GLH to Teller, December 30, 1884.

7. Arnold Hague, "The Geyser Basins" (unpublished ms., n.d., about 1911), p. 35, in NA, RG 57, Arnold Hague papers, box 11; Hague, "Firehole Geyser Basin" (n.d., about 1911), p. 6, in Hague papers, box 11.

8. "An Excerpt from the Journal of Dr. Henry Sheldon Reynolds incorporating data from the Journal of Frances Adelia Reynolds (his wife), August 22 to September 15, 1883 (typescript, n.d.), pp. 3–4, 8, YNP Library.

9. Edmund K. Muspratt, *My Life and Work* (New York: John Lane Company, 1917), p. 223.

10. Mrs. E. H. Carbutt, *Five Months' Fine Weather in Canada, Western U.S., and Mexico* (London: Sampson Low, Marston, Searle, and Rivington, 1889), p. 47.

11. [Horace White], "In the Yellowstone Park: A Horseback Ride to the Great Geysers," newspaper clipping attributed to *Evening Post*, n.d. [trip in June, 1885], in NA, RG 48, no. 62, roll 3 (hardcopy at YNP Archives); Frederic Remington, *Pony Tracks* (Columbus, Ohio: Long's College Book Company, 1894 [1951]), p. 177.

12. "Yellowstone Park: Brief Notes of a Trip . . . ," 1895, in Scrapbook 4209, p. 60, YNP Library.

13. Superintendent to Secretary, September 30, 1898, in Army Records, Letters Sent, vol. 8, p. 48, YNP Archives.

14. F. E. Corey to Superintendent, February 15, 1903, Archive Document no. 6087, YNP Archives. The return letter to Corey from the park encloses a copy of the superintendent's annual report and gives Corey the address of Frank Haynes in order for him to obtain copies of the *Haynes Guide*. Army Records, Letters Sent, vol. 12, p. 416, February 23, 1903, YNP Archives.

15. Dr. Roland Dwight Grant, "Changes in the Yellowstone Park," *American Geographical Society Bulletin* (1908): 277–83.

16. Reau Campbell, *Campbell's New Revised Complete Guide and Descriptive Book of the Yellowstone Park* (Chicago: Rogers and Smith Company, 1909), p. 112.

17. Edward F. Colborn for the Union Pacific Railroad, *Where Gush the Geysers: Oregon Short Line All Rail Route to the Yellowstone* (Denver: Williamson Haffner Company, 1909), p. 22. Original at Union Pacific Railroad Archives, Omaha, Nebraska; color copy at YNP Research Library.

18. Amos Shaw and L. D. Powell, "Yellowstone Park by Camp," 1915 brochure in Army Records, Item 52, File 130; "Financial Reports: Advertisements of Concessioners, 1914 and 1915," YNP Archives.

19. A. F. Hall, 1926 educational report in box K-10, YNP Archives. See also Dorr Yeager, "Memorandum to Mr. Albright," August 19, 1928 (one page on geysers), vertical files, YNP Library. Van Pelt is mentioned in Monthly Report of Superintendent, June 1926, circular number 5.

CHAPTER EIGHT

1. Although one can make a case for Lt. Gustavus Doane's needing to be in this list (Doane was certainly a Yellowstone writer and tour giver), one can also argue that Doane gave far fewer "tours" over a much shorter time period than these three men and that he did not contribute to interpretation in the substantial other ways that they did.

2. Haines, *Yellowstone Story* I, pp. 240–60; II, pp. 449–50; Bartlett, *Wilderness Besieged*, pp. 213–29; and John S. Gray, "Trials of a Trailblazer," *Montana: The Magazine of Western History* 22 (Summer 1972): 54–63. Norris's own writings may be found in the five annual reports he did while superintendent of Yellowstone, in his book *The Calumet of the Coteau* (Philadelphia: J. B. Lippincott and Company, 1883, 1884), and in his unpublished ramblings entitled "Meanderings of a Mountaineer" that repose in California's Huntington Library. A well-researched but poorly written and organized biography of Norris is Don Binkowski, *Colonel P. W. Norris: Yellowstone's Greatest Superintendent* (Warren, Mich.: C&D, 1995).

3. Norris, "Meanderings," letter 22, n.d. [about 1885].

4. W. H. Holmes, "Extracts from the Diary of W. H. Holmes," typescript of 1878 diary, p. 25, YNP Library. Crapa to H. L. Dawes, March 31, 1881, in NA, RG 48, no. 62, roll 6 (hardcopy at YNP Archives).

5. Norris, "Meanderings of a Mountaineer; or, The Journals and Musings (or Storys) of a Rambler over Prairie (or Mountain) and Plain," ms. prepared from newspaper clippings (1870–75), and annotated about 1885, in P. W. Norris Collection (HM 506), Henry E. Huntington Library, San Marino, California. The YNP Library has a partial bound photocopy of this manuscript, and the author has a complete microfilm.

6. Everts to Norris, April 21, 1877, in National Archives, RG 48, no. 62, roll 1 (hard copy at YNP Archives).

7. Norris to Secretary of Interior, April 18, 1877, in National Archives, RG 48, no. 62, roll 1 (hard copy at YNP Archives).

8. Farrar to Norris, April 21, 1877, in National Archives, RG 48, no. 62, roll 1 (hard copy at YNP Archives).

9. "The Yellowstone Park—Its Management," Bozeman *Avant Courier*, September 30, 1880, p. 1. The "gallant steed" that Norris rode was named, according to Lucius Nutting, "Yellowstone Sam." Lucius Nutting, "The Nuttings" (ms., 1879), in YNP Library Manuscript File, p. 30.

10. Norris, *Report Upon the Yellowstone National Park . . . 1877*, pp. 837–40. The quote is from p. 840.

11. *Livingston Enterprise*, September 19, 1885.

12. Haines, *Yellowstone Story* I, p. 249.

13. See Norris's five superintendent's reports 1877–1881, for these activities. His geyser theories are in his *Annual Report of the Superintendent . . . 1880*, p. 20. Virtually every twentieth-century scientific report about Yellowstone that includes history begins with references to P. W. Norris's activities as superintendent.

14. Norris, *Fifth Annual Report*, 1881, p. 7.

15. Paul Schullery and Lee Whittlesey, "The Documentary Record of Wolves and Related Wildlife Species in the Yellowstone National Park Area Prior to 1882," in *Wolves for Yellowstone? A Report to the United States Congress*, vol. 4, July 1992, pp. 1–118, 1–123 to 1–130. See also Lee H. Whittlesey, "A History of Large Animals in Yellowstone National Park Before 1882" (unpublished draft ms., January 1992), pp. 131–40, YNP Library. Yount is in Norris's 1880 and 1881 reports.

16. Carrie Adell Strahorn, *Fifteen Thousand Miles By Stage*, p. 278; W. W. Wylie, Yellowstone Park History and Reminiscences, p. 10. Norris's extensive accomplishments are in his five reports, and Haines, *Yellowstone Story*, vol. I, p. 251, says he was Montana's first archaeologist.

17. John G. Bourke, "Diary of John Gregory Bourke," vol. 35, [July 28, 1880]—August 20, 1880, pp. 716, 723, original at United States Military Academy Library, West Point, New York. The relevant quote on wormy trout by Carrington is in F. V. Hayden, *Preliminary Report of the U.S. Geological Survey . . . Fifth Annual Report*, 1872, pp. 97–98.

18. Robert Strahorn, "A Mountain of Volcanic Glass," *New West Illustrated* (newspaper), vol. 2, no. 1, January 1880, p. 4.

19. Mrs. L. D. Wickes, "Aged Clipping Gives Account of Camping Trip of Tourists in Yellowstone Park in 1880," *Livingston Enterprise*, July 19, 1927, p. 5.

20. Leckler, "A Camping Trip," 360.

21. Norris, "Meanderings," letter 21.

22. Chittenden in J. V. Brower, *The Missouri River and Its Utmost Source* (St. Paul: Pioneer Press, 1896), pp. 22–23.

23. For harsh critiques of Norris that probably helped bring him down, see Bozeman *Avant Courier*, June 24, 1880, p. 3; August 19, 1880, p. 2; September 9, 1880, p. 2; September 30, 1880, p. 1; "Management of the Yellowstone National Park," December 23, 1880, p. 2; "Peterfunk Windy Norris' Report," March 3, 1881, p. 2; and especially "The Yellowstone Park—Its Management," *Avant Courier*, September 30, 1880, p. 1.

24. A letter from T. C. Everts to "old friends," which Norris probably saw, warned Norris that someone had told Everts that Schurz did not like "what had been done" with roads in the park. Everts to "my dear old friends," February 2, 1880, in NA, RG 48, no. 62, roll 4 (hardcopy at YNP Archives). Another hint may be found in Lucius Nutting's unpublished account "The Nuttings" (YNP Library, p. 26) wherein Schurz's wagon boss complained about the condition of Norris's roads.

25. Norris, *Calumet of the Coteau*, p. 86. Only one of Norris's children, a son named Arthur, seems ever to have traveled with him to Yellowstone.

26. G. L. Henderson, *Yellowstone Park Manual and Guide*, 1885, p. 2.

CHAPTER NINE

1. G. L. Henderson, *Facts Presented Feb. 18, 1892, Before the Senate Committee on Territories, on Senate Bill 1963 for the Incorporation of the Yellowstone Park Company. By G. L. Henderson* (Washington: Gibson Brothers, 1892), p. 4.

2. Lee H. Whittlesey, "A Brief History of Concessioner Interpretive Activities in Yellowstone National Park" (unpublished ms., 1982); Whittlesey, "G. L. Henderson: The Story of an Early Yellowstone Interpreter" (unpublished ms., 1988), YNP Library. A shortened version of this chapter is Whittlesey, "The First National Park Interpreter: G. L. Henderson in Yellowstone, 1882–1902," *Montana: The Magazine of Western History* 46 (Spring 1996): 26–41.

3. G. L.'s great-grandson James Dean Henderson III of Whidbey Island, Washington, has provided Yellowstone National Park with "Family Record, G. L. Henderson[,] Jeanette Thomas and Children Between Them, Copied from a letter dated Jan. 18th, [190]1." Updated by G. L. Henderson himself on April 9, 1902, it indicates that George Legg Henderson married Jeanette Thomas (1825–1912, of Balfron Stirling Shire, Scotland) on July 18, 1853. From that union came ten children, five of whom died young. The surviving children, all of whom went with G. L. to Yellowstone, and their

birth years were: Helen Lucretia (1853), Barbara Gazelle (1861), Walter James (1862), Jeannette Ann (1864), and Mary Rosetta (1870). G. L. and Jeanette Thomas Henderson were divorced in Fayette, Iowa, in 1879. G. L. married Hannah Burke Horton on May 24, 1889, in Portland, Oregon, (this was reported in *Livingston Post*, June 13, 1889). For various reasons this contract (common law) marriage was twice terminated, the last and final dissolution occurring July 1, 1898. On October 5, 1901, G. L. married a childhood sweetheart named Elizabeth Ann Bryant (reported in "A Sensational Story," *Livingston Post*, January 30, 1902), but this marriage was terminated on October 28 of that same year.

4. For Henderson family history, see *History of San Diego County* (n.p.; photocopy in possession of author), pp. 321–22; Gardiner *Wonderland*, June 12, 1902; and "D. B. Henderson Answers 'Here' to Last Call," Des Moines *Register and Leader*, February 26, 1906.

5. Patrick Conger (1819–1903) was a patronage appointee to the superintendency of Yellowstone in 1882. He was the brother of U.S. Senator Omar D. Conger of Iowa, a longtime champion of the Northern Pacific Railroad (NPRR). Historian Chris Magoc says the NPRR used its influence to get rid of former superintendent P. W. Norris in order to place someone in control of Yellowstone who was more sympathetic to its development schemes. Whether that was a factor or not, editorials in the Bozeman *Avant Courier* undoubtedly also contributed. Magoc, "The Selling of Wonderland: Yellowstone National Park, The Northern Pacific Railroad, and the Culture of Consumption, 1872–1903," PhD. dissertation, Yale University, 1992, p. 175.

6. Conger to Secretary of Interior, July 15, 1884, in National Archives, RG 48, no. 62, roll 2 (hardcopy at YNP Archives). See also Henderson's six-page report to Secretary, January 26, 1884, in same record group. "Jelly-Cake," in Bozeman *Avant Courier* (June 1, 1882, p. 3) states that G. L. Henderson, park assistant superintendent, arrived with his family "a few days ago" at the Northern Pacific terminus and went by private conveyance to the national park.

7. Henderson, "Wonderland Well Superintended," clipping from *The Graphic*, February 9, 1899, in Ash Scrapbook, p. 17, YNP Library. It is not known who the seventh person was who traveled with them to the park.

8. This arrangement was short-lived. An 1882 traveler who witnessed it noted: "Mr. Conger the Supt. of the Park and his wife . . . live at the Capitol, a log house built on a high hill near the Mammoth Hot Springs. Mr. Henderson, assistant superintendent, and four daughters live there also. The [daughters] are all strapping scotch lassies, and one of them reminds me of [a friend of mine]." Baldwin Day Spilman, "Yellowstone Diary 1882" (unpublished ms.), Montana Historical Society, Small Collections 383, folder 1/1, p. 24.

9. G. L. Henderson, "Wonderland Caves and Terraces. Excavation, Formation, Erosion. A Gale at the Golden Gate" (unpublished handwritten ms., n.d. [about 1888]), p. 15, YNP Library; Henderson, "In Old Scotland," from *Livingston Post*, July 1902, in Ash Scrapbook, p. 27; Henderson, "A Wonder-Land," clipping from West Union, Iowa, newspaper, January 30, 1884, in Ash Scrapbook, p. 4; Henderson, "Battle Under the Yellow Flag," *Livingston Post*, February 8, 1900, in Ash Scrapbook, p. 20 (verso), YNP Library. About the move, Henderson said: "I went to Yellowstone Park in 1882, and for the first time in a quarter of a century consented to fill a subordinate position as assistant superintendent of the Yellowstone National Park with my constitution greatly impaired." From this we glean that Henderson had formerly occupied more important positions and that his health was not good when he first arrived in Yellowstone. Henderson in Thomas C. McRae, "The Yellowstone National Park," 52d Cong., 1st Sess., H.R. No. 1956, July 20, 1892, p. 284.

10. In a letter in NA, RG 48, no. 62, roll 2 (hardcopy at YNP Archives) from Henderson to Secretary at the time he was decommissioned, Henderson refers to "my connection" with the park in 1882. His entire family, including G. L. himself, helped Barbara and later Jennie run the post office. Henderson family members (daughters and sons-in-law) who served as postmistresses and postmasters in Yellowstone included Barbara G. "Lillie" Henderson (1882–1884), Jennie A. Henderson (1884–1886), Jennie Henderson Dewing (1888–1893), George Ash (1893–1900), Jennie Henderson Ash (1900–1906), and Alexander Lyall (1906–1913). Peter Martin, postal researcher, to Lee H. Whittlesey, telephone conversation, February 9, 2004. See also www.postmasterfinder.com website.

11. Henderson to H. M. Teller, May 10, 1883, in National Archives, RG 48, no. 62, roll 2 (hardcopy at YNP Archives). There is much correspondence in this file that shows that Conger tried constantly to get rid of Henderson.

12. Fitch, "The Milky Way. A Day's Wandering Amid the Wealth of Wonderland," *Omaha* (Nebraska) *Bee*, August 31, 1882. Henderson appears to have considered moving at least part of his family to Bozeman in order that his children (probably Mary Rosetta) could "share the advantages" of that town's "Graded School." See "The Boomerang," Bozeman *Avant Courier*, July 20, 1882, p. 3.

13. Bozeman *Avant Courier*, November 2, 1882, p. 3, has Henderson remaining at Mammoth for the winter. For what may be his first local newspaper writing (although we know there were at least a few of his letters that appeared in the *Pioneer Press* of St. Paul, Minnesota), see "Letter from Yellowstone Park" by "Inhotwater" in the edition of December 28, 1882, p. 2.

14. Henderson in Thomas McRae, "The Yellowstone National Park," p. 288. Massicotte is also mentioned in superintendent Conger's annual report for 1882, p. 9, Conger calling him "Edward Massicott."

15. G. L. Henderson, handwritten letter, June 1, 1883, in bound volume 6290, p. 90, Ash Collection, YNP Library. The St. Paul *Pioneer Press* announced Henderson's official reappointment as assistant park superintendent on June 2, 1883.

16. St. Paul *Pioneer Press*, June 2, 1883. Because of his important brother, Henderson knew about his own reappointment long before Conger did. He wrote to the Secretary of the Interior on May 10, stating that he had been told he would be reappointed and asking to be stationed at Mammoth Hot Springs in order to be near his family. Henderson to H. M. Teller, May 10, 1883, in National Archives, RG 48, no. 62, roll 2 (hardcopy at YNP Archives).

17. *Livingston Enterprise*, June 6, 1883; Bartlett, *Wilderness Besieged*, p. 237.

18. W. Scott Smith (Special Agent) to Secretary of Interior, September 15, 1883, in National Archives, RG 48, no. 62, roll 2 (hardcopy at YNP Archives). Superintendent Conger denied all of the charges brought by Smith, but used the opportunity to accuse G. L. Henderson and his family of selling geyser specimens. Conger to Secretary, November 11, 1883, in NA, RG 48, no. 62, roll 2.

19. Conger to Secretary, January 15, 1884, in NA, RG 48, no. 62, roll 2 (hardcopy at YNP Archives). Haines, *Yellowstone Story* I, p. 299, also mentions this.

20. Conger to Secretary, January 15, 1884; Henderson to Secretary, February 23, 1884; Jennie Henderson to R. P. Miles, January 3, 1884; R. P. Miles to Jennie Henderson, January 12, 1884; R. P. Miles to Secretary, March 8, 1887; all in National Archives, RG 48, no. 62, roll 2; Secretary to Conger (asking for more definite statement on Henderson), July 1, 1884, in NA, RG 48, no. 62, roll 6 (hardcopies at YNP Archives).

21. G. L. Henderson to Patrick Conger, January 26, 1884, in National Archives, RG 48, no. 62, roll 2 (hardcopy at YNP Archives). Said Henderson in this letter: "Even when [I was] absent with distinguished visitors among the Terraces as a privilege [*sic*] if not a duty which I had your permission to exercise, I invariably left orders with those in charge of the Post Office to give the required information to tourists, impressing upon them, the necessity and importance both for their own security and the preservation of the Park, of a strict compliance with its established rules and regulations."

 Moreover, we know that Henderson was involved in 1883 in at least one park law enforcement incident, the shooting of Jim Patterson at Mammoth. For this, see Henderson, "Thoughts of Old," *Livingston Post*, January 11, 1900.

22. Conger to Secretary, June 19, 1884; July 15, 1884, in NA, RG 48, no. 62, roll 2. Conger's comment on Henderson's age is doubly ridiculous when one realizes that Conger was eight years older than Henderson.

23. Veritas [G. L. Henderson], in *Livingston* (Montana) *Tribune*, no date (soon after July 26, 1884), as quoted by himself in McRae, "The Yellowstone National Park," pp. 210–11. Henderson undoubtedly wrote this article, for he readily produced it eight years later for Congress while in Washington, D.C.

24. Conger to Secretary, July 15, 1884; Henderson to Conger, June 16, 1884; Herbert Rowe to Secretary, June 27, 1884; Henderson to Secretary, July 18, 1884; Henderson to M. L. Joslyn, August 1, 1884; Henderson to Joslyn, August 6, 1884; all in National Archives, RG 48, no. 62, roll 2 (hardcopies at YNP Archives). If one puts any stock in handed-down family stories, it is interesting to know what G. L.'s son Walter Henderson told his own grandson, James Dean Henderson, about G. L. Walter told James (a boy at the time) that his father G. L. was badly abused by a Yellowstone superintendent who was a political appointee and that "my father refused to defend himself" because he (G. L.) thought all his actions should be above board and because he did not want to hurt his brother David." This story remained in the family 116 years later. James Dean Henderson of Whidbey Island, Washington, to Lee H. Whittlesey, telephone interview, April 19, 1999.

25. Henderson's definite, probable, and possible place names that are still in use today are as follows: Palpitator Geyser, Golden Gate Canyon, Ladies Lake, Wizard's Hat Terrace, Rath Spring/Terrace, Minerva Terrace, Eagle Nest Rock, Boiling River, Cedar Terrace, Narrow Gauge Terrace, Orange Spring Mound, Hotel Terrace, Hymen Terrace, Infant Cones, Bath Lake, Stygian Caves, River Styx, Cupid Spring, Queen Elizabeth's Ruffle, Glen Africa Basin, the Hoodoos, Swan Lake Flat, Snow Pass, Cathedral Rock, Pillar of Hercules, Kingman Pass, Hazel Lake, Geyser Lake, Steamvalve Spring, Inspiration Point, Silver Globe Geyser, Atomizer Geyser, Chinaman Spring, Black Warrior Springs, Spiteful Geyser, Microcosm Basin, Diana Spring, Admiration Point, Bombshell Geyser, and Maiden's Grave Spring.

26. [G. L. Henderson], "Park Paragraphs," *Livingston Enterprise*, November 21, 28, 1883; Henderson in *Livingston Enterprise*, June 14, September 13, 30, 1884. For Henderson's place-names, see Whittlesey, *Wonderland Nomenclature* specifically, and Whittlesey, *Yellowstone Place Names* generally.

27. Henderson, "To the Hon. Joseph G. Cannon," eight-page pamphlet dated March 25, 1890 (signed "W. J. Henderson") in YNP Library vertical files, "Laws, Regulations, and Documents," U.S. Congress 1892–1920, 1534, part 2 (envelope 2).

28. Henderson, "Names of Geysers," *Livingston Enterprise*, September 13, 1902, p. 1.

29. Henderson, "Down the Terraces," *Helena Daily Herald*, May 17, 1888; Henderson, "The Mammoth Plateau," *Helena Daily Herald*, June 7, 1888.

30. Henderson, "Naming a Geyser," *Norristown* (Pennsylvania) *Weekly Herald*, January 19, 1889, in Ash Scrapbook, pp. 10–11, YNP Library.

31. G. L. Henderson, "Wonderland," newspaper clipping of January 16, 1887, in Ash Scrapbook, p. 5; Henderson, "Wonderland Caves and Terraces. Excavation, Formation, Erosion. A Gale at the Golden Gate" (unpublished handwritten ms., n.d. [about 1888]), p. 3, YNP Library. Henderson's correspondence with Arnold Hague is in NA, RG 57, Arnold Hague papers, box 5.

32. Conger to Secretary, July 15, 1884, in NA, RG 48, no. 62, roll 2 (hardcopy at YNP Archives).

33. Photocopy to author, headed *History of San Diego County*, pp. 321–22.

34. G. L. Henderson ledger, bound volume 6290, p. 1, George Ash Collection, YNP Library; Des Moines *Register and Leader*, February 26, 1906.

35. Harry J. Carman et al., *A History of the American People* II (New York: Alfred A. Knopf, 1967), pp. 231–33.

36. *Helena Daily Herald*, April 25 to June 7, 1888.

37. G. L. Henderson, "In Hot Water," *Helena Daily Herald*, April 25, 1888; Henderson, "After His Bath," April 26, 1888. This occurred on July 30, 1883, for Conkling's signature and those of his party are in bound volume 6290, p. 102, George Ash Collection, YNP Library. Here Henderson, or one of his daughters, seems to have drawn a pencil sketch of their prominent visitor Senator Conkling. Conkling's use of the word *monitor* is puzzling; perhaps in light of his earlier national mishaps, he was worried about his personal behavior.

38. Henderson, "Among the Terraces," *Helena Daily Herald*, May 3, 1888.

39. Ibid.; Henderson, "Among the Caves," *Helena Daily Herald*, May 2, 1888.

40. Henderson, "Down the Terraces," *Helena Daily Herald*, May 10, 1888.

41. Henderson, "Down the Terraces," *Helena Daily Herald*, May 17, 1888.

42. Henderson, "Down the Terraces," *Helena Daily Herald*, May 31, 1888.

43. *Helena Daily Herald*, May 3, 1888; see also Henderson, "San Diegans Viewing Its Sublime Scenery," 1889 clipping in Ash Scrapbook, p. 12, YNP Library.

44. Conkling in G. L. Henderson, "The Mammoth Plateau," *Helena Daily Herald*, June 7, 1888; Henderson, "Changes in Wonderland," n.d., Ash Scrapbook, p. 15, YNP Library.

45. This quote and those of many satisfied patrons who gave their comments on Henderson's tours are in Henderson, *Yellowstone Park Manual and Guide*, 1888, pp. 1–4. See also *Livingston Enterprise*, October 17, 1884, and December 3, 1898.

46. See Archive Documents 1445–1450, 1451, 1453, all 1884, YNP Archives.

47. Archive Document 1449, 1884, YNP Archives.

48. Archive Document 1452, 1884, YNP Archives.

49. Archive Document 1453, 1884, YNP Archives.

50. Henderson, "Down the Terraces," *Helena Daily Herald*, May 10, 1888. In late 2004, the author went to the Devil's Kitchen site and recovered the rungs of Henderson's original ladder for the park museum collection. They had lain near the cavern's entrance for 120 years.

51. Henderson to Conger, August 24, 1884, Archive Document 1445, YNP Archives.

52. Liberty Cap [G. L. Henderson], "The National Park. Three Days at Mammoth Hot Springs—The Terraces," n.d. [July 1884], newspaper clipping in George Ash Collection, YNP Library.

53. G. L. Henderson, *Yellowstone Park Manual and Guide*, 1885, p. 2, Cottage Hotel advertisement. See also Rowe's letter on p. 4 of GLH letter to C. S. Mellen, Feb. 20, 1900, in Ash Collection. This letter, with the writer's name spelled "Roe," is also reproduced in McRae, "The Yellowstone National Park," p. 202.

54. [Henderson], "Notes on a Visit to Mammoth Hot Springs," *Livingston Enterprise*, August 5, 1884.

55. [William Sturgis], *New Songs of Seven: A Record of a Journey in Wonderland* (Cheyenne: Bristol and Knabe, 1884), pp. 35–36.

56. Henderson, "G. L. Henderson's Lectures," 1889 clipping in Ash Scrapbook, p. Adii, YNP Library; Henderson, *Yellowstone Park Manual and Guide*, 1888, p. 1, "Ingersoll Spring and Terrace"; Henderson, "Out of the Past, Memories of Robert G. Ingersoll," *Livingston Post*, July 18, 1901.

57. Henderson, "Wonderland," 1887 clipping from *Rocky Mountain Husbandman*, in Ash Scrapbook, p. 5, YNP Library; Henderson in McRae, "The Yellowstone National Park," p. 285.

58. For citations of Henderson's accounts of Excelsior Geyser, see Whittlesey, *Wonderland Nomenclature*, pp. 478, 485; and Whittlesey, "Monarch of All These Mighty Wonders: Tourists and Yellowstone's Excelsior Geyser, 1881–1890," *Montana: The Magazine of Western History* 40 (Spring 1990): 2–15. For some of his other geyser activities, see Henderson, "Soaping the

Geysers," 1888 clipping, in Ash Scrapbook, p. 9; "San Diegans Viewing Its Sublime Scenery," 1889 clipping in Ash Scrapbook, p. 12; and "Changes in Wonderland," 1898 clipping, in Ash Scrapbook, p. 15, YNP Library.

59. Henderson, "Norris Geyser Basin. Wonderful Changes Occur in Cold Weather," *Livingston Post*, February 6, 1902.

60. "Baths of the Gods. A Visit to the Great Springs," newspaper clipping in Ash Collection attributed to *Baltimore Sun*, September 1, 1884, YNP Library. Henderson's place-names were influenced by his politics on more than one occasion. At Old Faithful, he gave the name "Mugwump Geyser" to reflect the partisan divisions of the 1884 election. Lee H. Whittlesey, "How and Why the Name 'Mugwump' Was Applied to Three Crater Geyser," *GOSA Transactions*, vol. 3, 1992, pp. 27–29. Other place-names he gave reflected American events of the day: "Labor and Capital Geyser," "Arthur's Seat," and "Double Standard River." Whittlesey, *Wonderland Nomenclature*, pp. xxxi–xxxiii.

61. Liberty Cap [G. L. Henderson], "The Geysers in Winter," *Livingston Enterprise*, December 6, 1884; Henderson, "Among the Geysers," *Livingston Enterprise*, October 16, 17, 1884. The other activities are described in Henderson, *Yellowstone Park Manual and Guide*, 1885.

62. Haines, *Yellowstone Story* II, pp. 450–51, 311–18; Bartlett, *Wilderness Besieged*, pp. 242–45. Haines gives Carpenter's dismissal date as June 20, while Bartlett says May 29. The Henderson family seems to have tried to get along with Superintendent Carpenter, for just before he was ousted, they invited him on a sightseeing trip into the park. G. L. wrote: "So pleased was Superintendent Carpenter at the good news [that Blaine had been elected president] that he accepted the proposal of Miss Nellie Henderson, that we make up a party and visit the great geysers at the Firehole river. Later news seemed to act unfavorably on the Superintendent's resolution and he declined to make one of the party." Henderson, "The Geysers in Winter," *Livingston Enterprise*, December 6, 1884.

63. Henderson, *Yellowstone Park Manual and Guide*, July 1, 1885; 2nd ed., 1888. See also Henderson, "The National Park," *Livingston Enterprise*, June 27, 1885.

64. Rudyard Kipling, in Esther Singleton, *Wonders of Nature As Seen and Described by Famous Writers* (New York: Collier, 1911), p. 353.

65. *Livingston Enterprise*, June 9, 1885. The "oldtimer's" quote is in Whittlesey, *Wonderland Nomenclature*, p. 49.

66. Henderson's two guidebooks, his many newspaper articles, and his 1891 pamphlet *Yellowstone Park: Past, Present, and Future* (Washington: Gibson Brothers, 1891) contained more than two hundred of his original place-names. He paid no attention to historical priority in naming, sometimes even renaming features that had already been named. His names were usually high sounding—wildly romantic, mythological, classical, political, or biblical. A number of his place-names stuck. Many did not, but they reflected his classical education, and today they form a romantic part of Yellowstone's past. He resolutely continued using his own place-names, even long after it was certain that those of the USGS would prevail. But many of his names did survive, and they were often highly original, imaginative, and creative. For a complete rundown of Henderson's place-names, see generally Whittlesey, *Wonderland Nomenclature*.

67. *Livingston Enterprise*, August 1, 1885.

68. Haines, *Yellowstone Story* II, pp. 318, 452; Bartlett, *Wilderness Besieged*, p. 248; Secretary to Henderson, June 2, 1885, in NA, RG 48, no. 62, roll 6; Henderson to Secretary, June 11, 1885, in NA, RG 48, no. 62, roll 5; Wear to Secretary, August 26, 1886, in NA, RG 48, no. 62, roll 3 (hardcopies at YNP Archives).

69. Wear to Secretary, August 26, 1886; see also Wear to Secretary, July 5, 1885, and Wear to Secretary, December 10, 1885; all in NA, RG 48, no. 62, roll 3 (hardcopies at YNP Archives). Wear's conversation with Arnold Hague and his June 2 letter are quoted in Bartlett, *Wilderness Besieged*, pp. 244, 254n37.

70. R. E. Spangler (postal inspector) to Secretary, August 31, 1886; Wear to Secretary, August 26, 1886; both in NA, RG 48, no. 62, roll 3 (hardcopies at YNP Archives). A few months later an acquaintance of Henderson's (J. A. Clark) stated to him that Superintendent Wear had asked Clark several months earlier how to get rid of Henderson. Henderson's account quoted Wear as asking Clark how he could "find causes to secure the expulsion of that old Devil G. L. Henderson from the Park. [Clark] also said that Wear declared he would have none but Democrats to help him administer the Park. I do not rely altogether on what Clark has stated. But it is human nature to tyrannize over a vanquished foe. I recollect that Supt. Conger was bitter against his predecessor Norris and all who spoke of him with respect. His ill will was manifestly shown to all employees who had been under Norris." (Henderson family ledger, Army Records, bound volume 141, p. 254, YNP Archives.)

Henderson's reluctance to rely completely on Clark's statement no doubt came partly from the fact that Henderson knew he had been dismissed *before* Wear even arrived, but it also probably shows that Henderson was honorable in his tendency to give Wear the benefit of the doubt on having made the statements.

It appears that Henderson did not think much of any of the three park superintendents after Norris, even though he tried to get along with at least Carpenter. On that subject he wrote in 1891: "The three succeeding Superintendencies [after Norris] were so monarchial in character, so lacking in either inspiration, aspiration, or devotion to anything but their own individual sovereignty, that the brevity of their terms of office was the chief glory of this triumvirate." Henderson, *Yellowstone Park: Past, Present, and Future*, p. 5.

71. Archive Documents 97–99, YNP Archives; Walter and Helen Henderson to Secretary June 11, 15, 1886; R. E. Spangler (postal inspector) to Secretary, August 31, 1886, in NA, RG 48, no. 62, roll 3 (hardcopies at YNP Archives). See also D. W. Wear, "The Park Superintendency," *Forest and Stream* 27 (September 16, 1886): 142–43.

72. Bartlett, *Wilderness Besieged*, pp. 248–249.

73. George S. Anderson to Secretary, September 1, 1891, Army Records, Letters Sent, vol. 3, p. 361; Henderson family ledger, Army Records, Bound Volume 141, YNP Archives. This ledger is fascinating for its look at the Henderson family and their activities. Among other things, it mentions that Superintendent D. W. Wear ordered Henderson to remove his bathhouse on July 27, 1885, and that Henderson agreed to work with E. O. Clark and C. B. Scott in the stage transportation business on October 4, 1885. Strangely, the lease for the Cottage hotel was requested February 1, 1885, under the name of Eva S. Erret (wife of one of the other assistant superintendents), but in the handwriting of G. L. Henderson. Eva S. Erret to Secretary, February 1, 1885, in NA, RG 48, no. 62, roll 3 (hardcopy at YNP Archives).

74. *Livingston Enterprise*, August 1, September 26, October 10, November 7, 21, 1885. The plans for the Cottage Hotel are in the Ash Collection, YNP Library.

75. *Livingston Enterprise*, January 29, 1886. For nineteenth-century bathing, see Sears, *Sacred Places*, especially p. 176, and Edward Frankland's article that carried a title similar to Henderson's: "A Great Winter Sanatarium for the American Continent," *Popular Science Monthly* (July 1885): 290–95.

76. *Livingston Enterprise*, February 13, 1886; January 14, 1888.

77. Henderson, *Yellowstone Park Manual and Guide*, 1888, pp. 1–4.

78. These signed testimonials are in Henderson, *Yellowstone Park Manual and Guide*, 1888, p. 4. According to park correspondence, Cottage Hotel employees wore park identification badges per their lease, a very early example of this still-practiced procedure. Moses Harris to Walter Henderson, June 6, 1887, Army Records, Letters Sent, vol. 2, YNP Archives.

79. Frederick Stanhope, "National Park," undated newspaper clipping [1887], in Ash Scrapbook, p. 7b, YNP Library.

80. Henderson, *Yellowstone Park Manual and Guide*, 1888, pp. 3–4.

81. Henderson, *Yellowstone Park Manual and Guide*, 1885, p. 4.

82. Ibid., p. 2, below geyser table.

83. Henderson, "At the National Park," *Livingston Enterprise*, July 10, 1886.

84. Arnold Hague to William Hallett Phillips, July 26, 1887, in Phillips and Myers Family Papers, number 596, Southern Historical Collection, University of North Carolina, Chapel Hill.

85. H. Z. Osborne, *A Midsummer Ramble. Being a Descriptive Sketch of the Yellowstone National Park* ([Los Angeles?]: [Los Angeles Evening Express?], 1888), pp. 1–2.

86. Henderson in McRae, "The Yellowstone National Park," p. 285; Henderson, "Naming A Geyser," *Norristown* (Pennsylvania) *Weekly Herald*, January 21, 1889; "G. L. Henderson's Lectures," poster, n.d. [1889?], in Ash Scrapbook, p. Adii, YNP Library. For more on the scientists, see Henderson, "Probable Cause of an Election to London Fellowship," in Scrapbook 4209, p. 6, YNP Library.

87. Mrs. Paris Junior, "To the Yellowstone Park in a Wagon—No. 5," *American Field* 34 (August 23, 1890): 177.

88. Henderson, "San Diegans Viewing Its Sublime Scenery," 1889 clipping, in Ash Scrapbook, p. 12, YNP Library.

89. Henderson, "Naming a Geyser," *Norristown* (Pennsylvania) *Weekly Herald*, January 19, 1889, and in Ash Scrapbook, pp. 10–11, YNP Library.

90. Henderson in McRae, "The Yellowstone National Park," pp. 284–85.

91. These quotes from T. DeWitt Talmadge are all in McRae, "The Yellowstone National Park," p. 291. Others are in Jacob Frick, *A Trip Through the Yellowstone National Park, the Wonderland of the World (A Paper Read Before the Century Club of Wooster, Ohio* (no place: n.p., privately printed, 1892; copy at Montana State University), p. 13; and in "Park Lectures . . . Evening Lectures of Professor Henderson," *Helena Daily Herald*, September 7, 1889, p. 8.

92. Henderson, "Thoughts of Old," *Livingston Post*, January 11, 1900.

93. Muir wrote: "I'll interpret the rocks, learn the language of flood, storm and avalanche." C. Frank Brockman, *Evolution of National Park Service Interpretation*, private research paper, College of Forest Resources, University of Washington, October, 1976, p. 1, YNP Library.

94. Henderson in McRae, "The Yellowstone National Park," p. 288; Henderson to Moses Harris, February 27, 1888, in Archive Document 1024 and 1024-A; Henderson, "The Park Hotels," *Helena Daily Herald*, May 1, 1889, p. 6.

For more on his battle with the NPRR, see his 1888 guidebook and the many letters in the Ash Collection, YNP Library. Apparently the Henderson family continued to manage the Cottage Hotel for a couple of years after the sale. About the sale to YPA, Charles Gibson, president of YPA, stated the following: "When the new leases were made [by the Secretary of Interior] in 1889 the Association very shortly afterwards, I think in about a month, bought out the entire outfit and equipment, consisting of horses, stages, carriages, harness[es], and all other necessary appurtenances then owned by Mr. G. L. Henderson, and with which was sufficient for about one-third of the entire [transportation] business of the park." Gibson also stated that he purchased Henderson's Cottage Hotel for $30,000 shortly afterward. Gibson in McRae, "The Yellowstone National Park," pp. 82, 88.

95. Henderson to C. S. Mellen, February 20, 1900; E. C. Waters to Henderson, May 21, 1889, in Ash Collection, YNP Library.

96. Henderson in McRae, "The Yellowstone National Park," p. 286. John C. Tidball, who passed through Mammoth in 1883, made indirect note of Henderson's illness. In a mention that indicted all of the park assistant superintendents, he stated that they were "either cadaverous consumptives who had sought this region to galvanize themselves into a brief continuance of life [read: G. L. Henderson and Patrick Conger], or young, boyish persons entirely unfamiliar with and unsuited to the duties required of them." Tidball in Eugene C. Tidball, "General Sherman's March Through Montana," *Montana: The Magazine of Western History* 44 (Spring 1994): 55.

97. Henderson in McRae, "The Yellowstone National Park," p. 286; "Local Layout," *Livingston Enterprise*, February 16, 1889.

98. This was the main reason for the company's problems, but it had numerous others as well, including the Department of Interior's (and Congress's) suspicion that a company official had attempted to bribe Russell Harrison, son of the President of the United States; the forcing of visitors to walk up a steep hill to save wear on horses and the death of a congressman in that activity; and complaints of overcrowding of park visitors at Firehole Hotel, the charging of inconsistent prices between Livingston and Mammoth, the placing of tourists from other parties into carriages already rented by families, and the use of carriages that were worn out and "rickety."

99. Richard Grant in McRae, "The Yellowstone National Park," p. 32; E. C. Waters in McRae, "The Yellowstone National Park," p. 159.

100. Henderson in McRae, "The Yellowstone National Park," p. 286. See also his full statements: pp. 200–212, 279–95.

101. Henderson, "The Park Wonders," *Helena Daily Herald*, April 2, 1900, in Ash Scrapbook, p. 21, YNP Library.

102. Henderson, "The Two Wonderlands," *Livingston Enterprise*, December 3, 1898; Henderson, *Yellowstone Park: Past, Present, and Future*, passim; Henderson, "Here's Henderson," *Helena Daily Herald*, September 24, 1890. He made the $200,000 claim in the above-cited letter to C. S. Mellen, February 20, 1900. See also archive document 1004, YNP Archives.

103. Henderson in McRae, "The Yellowstone National Park," pp. 200–212, 270, 279–95. Interestingly, Henderson included here some of his heretofore unknown columns from the then-defunct and today-not-extant newspaper called the *Livingston Tribune*.

104. Handbill, "G. L. Henderson, from the National Park," 1885, accession number 10020 in map drawer nine, YNP Library. One of Henderson's earliest lectures seems to have occurred in 1884, for the local newspaper reported that Henderson was to deliver it on the subject of "Winter and Summer Among the Geysers" at Livingston's Congregational Hall on December 10 and 22, 1884. See "Free Lecture," *Livingston Enterprise*, December 6, 1884; "A Two Hour's Ramble Among the Geysers," December 27, 1884; "Lectures on the . . . Park," January 17, 1885; and "Personal Points," March 28, 1885. The newspaper stated that Henderson used F. J. Haynes photos at some of these lectures and charged up to fifty cents for his talk.

105. "Park Notes," *Livingston Enterprise*, March 12, 1887.

106. Clipping from *Wisconsin State Journal*, December 30, 1889, in Ash Collection, YNP Library.

107. Henderson, "G. L. Henderson's Lectures," 1889 clipping, in Ash Scrapbook, p. Adii. See also Henderson, "The Park Wonders," 1900, in Ash Scrapbook, p. 21, YNP Library. The *Livingston Enterprise* for May 25, 1889, mentioned a lecture of Henderson's in Salem, Oregon.

108. "He Was the Superintendent," undated clipping [1892?] from National City, California, newspaper, Ash Collection, YNP Library.

109. "Wonders of Wonderland," *Riceville* (Iowa) *Recorder*, February 19, 1891, in Ash Scrapbook, p. 13, YNP Library.

110. *Park County Republican*, March 31, 1900; Henderson, "The Park Wonders," *Helena Daily Herald*, April 2, 1900, in Ash Scrapbook, p. 21.

111. "Henderson on the Terraces," undated handbill (poster), accession number 10020, in map drawer 9, YNP Library. His newspaper article entitled "Record of the Rail," presumably a subject in this "last" lecture, was published in the *Livingston Post*, September 17, 1903.

112. "Local Layout," *Livingston Enterprise*, December 5, 1891, mentions the voice tumor. "Personal Points," March 28, 1891, has the Hendersons leaving the park. See also George S. Anderson to Secretary, September 1, 1891, in

Army Records, Letters Sent, vol. 3, p. 361, YNP Archives, and Henderson to C. S. Mellen, February 20, 1900, cited above.

113. Henderson, "The Two Wonderlands," *Livingston Enterprise*, December 3, 1898; photocopy to author headed *History of San Diego County*, pp. 321–22. This latter history states that Henderson contributed measurably to the southern California area, and "in his passing Chula Vista lost one of the men who aided in the early development and later upbuilding of the city. He may be classed with the real builders and promoters of San Diego county" (p. 322).

114. William F. Munro, *Diary of the Christie Party's Trip to the Pacific Coast* (Toronto: C. M. Ellis, n.d. [1897]), pp. 40–42. For confirmation of Henderson's presence at Old Faithful in 1897 and 1898, see "Changes in Wonderland" and "Wonderland Well Superintended," in Ash Scrapbook, pp. 15, 17, YNP Research Library. The Wonderland Post Office in which Henderson worked was in operation—apparently from Klamer's store—during the period April 14, 1898, through May 31, 1899. Peter Martin, "Congress Book 2004: The 19th Century Postal History of Yellowstone National Park," unpublished ms. in possession of author, 2004, p. 6.

115. Henderson, "From the Park," *Livingston Enterprise*, August 17, 1901, in Ash Scrapbook, p. 25. See also Henderson, "Record of the Rail," *Livingston Post*, September 17, 1903.

116. Henderson, "Wonderlanders in Wonderland—Wonderland Interpreted," *Livingston Enterprise*, August 19, 1899, in Ash Scrapbook, p. 16, YNP Library.

117. Henderson, "From the Park," *Livingston Enterprise*, August 17, 1901.

118. Ibid. From this it appears that Fuller was a concessioner walking guide at Old Faithful.

119. "The Wonders of Instinct," *Livingston Post*, June 27, 1901, in Ash Scrapbook, p. 23, YNP Library.

120. Henderson, "On the Terraces," 1901 clipping, in Ash Scrapbook, p. 23, YNP Library.

121. Henderson, "The Atomizer Geyser," August 31, 1901, in Ash Scrapbook, p. 24.

122. "Names of Geysers," *Livingston Enterprise*, September 13, 1902, p. 1.

123. "Words of Comfort," *Livingston Enterprise*, August 29, 1903, in Ash Scrapbook, p. 30, YNP Library; the *Gardiner Wonderland*, January 22, 1903, says he left the park "last fall."

124. Henderson, "Wonderland Well Superintended," clipping from *The Graphic*, February 9, 1899, in Ash Scrapbook, pp. 17–18, YNP Library.

125. Henderson to Waters, September 12, 1905, in Ash Collection, YNP Library.

126. Ibid.; G. L. Henderson, "Rapid Transit in the Park," *Livingston Post*, March 10, 1900, in Ash Scrapbook, p. 20, YNP Library; Henderson, "The Two Wonderlands," *Livingston Enterprise*, December 3, 1898. National excursions and touring are in McRae, "The Yellowstone National Park," pp. 287–89.

127. "G. L. Henderson Dead: Known to All Old Timers and Visitors to the Park," *Livingston Enterprise*, November 27, 1905.

128. Elwood Hofer, "Tales from a Journey of the Pacific. IX," *McGregor* (Iowa) *News*, November 20, 1889, p. 1, clipping in Ash Collection, YNP Library.

129. "G. L. Henderson," *Livingston Enterprise*, December 16, 1905.

130. Bartlett, *Wilderness Besieged*, pp. 240–42; Whittlesey, *Yellowstone Place Names*, passim. For Henderson as assistant park superintendent, see Haines, *Yellowstone Story* I, pp. 270–71, 291–326 *passim*.

131. The word "hero," as applied to G. L. Henderson, was applied by historian Paul Schullery in various conversations with the author, 1996–2004.

132. The handwritten letter from Henderson to Norris was dated February 3, 1883, and centered on their mutual love of horses and their mutual respect of the common man. Henderson wrote in part: "Though [I am] personally unknown to you, we are not without kinship. . . . I have traced your spiritual and material footprints in the two great human worlds of thought and action . . . to me, you have left a brighter and more enduring record in the hearts of those with whom you have associated. . . . Geo. Graham holds you in high esteem and from him I gathered many incidents in regard to you." Henderson, in Ledger 6290, pp. 62–66, Ash Collection, YNP Library.

133. John Clark Hunt, "Why People Love Yellowstone," article from *American Forests*, August 1961, in vertical files, YNP Library, p. [5].

CHAPTER TEN

1. Myra Emmons, "From New York to Heaven," *Recreation* 15 (December 1901): 434. For this full quote, see page 213.

2. Joseph P. Read, "The Yellowstone National Park," *The Illustrated American* 4 (October 18, 1890): 136.

3. Elbert Hubbard, "A Little Journey to the Yellowstone" *The Fra*, March [1915?], p. [4], in Minnesota Historical Society, Northern Pacific Railroad Records, President's Subject File, file 210B, folder 4. This account is different from Hubbard's published pamphlet of the same name.

4. Lloyd Vernon Briggs, *California As I Saw It: First-Person Narratives of California's Early Years, 1849–1900* ([Boston]: privately printed [Wright and Potter Printing Company], 1931), p. 162, Library of Congress.

5. "On the Grand Tour" is in Haines, *Yellowstone Story* II, chapter fifteen. The quotes are from pp. 101, 105.

6. Philip Yorick Jr., "The Tourist Observed," *Livingston* (Montana) *Enterprise*, August 18, 1888, p. 4. German travelers to Yellowstone are treated in Johanna Maria Pfund, "Western Nature—German Culture: German Representations of Yellowstone, 1872–1910" (master's thesis, Montana State University, 1994).

7. The "zoo" at Cinnabar was located in someone's place of business, and when one visitor saw it in 1891, it included a bear, a "friendly wolf" (probably a coyote), two horned owls, an antelope fawn, and a rattlesnake. See F. B. Nash, "Vacation Notes," n.d. [1891], in Scrapbook 4208, p. 20, YNP Library.

8. G. L. Henderson, *Yellowstone Park Manual and Guide*, 1885, p. 1, nos. 8–9. Adam Deem, a stage driver in 1885, was a transportation supervisor by 1888, per H. Z. Osborne, *A Midsummer Ramble. Being a Descriptive Sketch of the Yellowstone National Park* ([Los Angeles?]: [Los Angeles Evening Express?], 1888), p. 6.

9. G. L. Henderson, "Rapid Transit in the Park," *Livingston Post*, March 10, 1900 (in Ash Scrapbook, p. 20, YNP Library).

10. Carter Harrison, *A Summer's Outing and the Old Man's Story* (Chicago: Dibble Publishing Company, 1891), pp. 60–61.

11. G. L. Henderson, *Yellowstone Park Manual and Guide*, 1885, p. 1, no. 14.

12. Dr. Judith Meyer personal communication to author, June 9, 1999. See also her book *The Spirit of Yellowstone*, p. 3.

13. Francis C. Sessions, *From Yellowstone Park to Alaska* (New York: Welch Fracker Company, 1890), p. 14.

14. Quoted without citation in Haines, *Yellowstone Story* I, p. 272, but he probably got it from O. S. T. Drake, "A Lady's Trip to the Yellowstone Park," *Every Girl's Annual* (London: Hatchard's, 1887), p. 347. The National Hotel was also known as early as 1885 as Mammoth Hot Springs Hotel, which name it retains today. See Theodore Gerrish, *Life in the World's Wonderland* (Biddeford, Maine: n.p., 1887), p. 184.

15. The 1891 visitor was Jacob Frick in *A Trip Through the Yellowstone National Park, The Wonderland of the World (A Paper Read Before the Century Club of Wooster, Ohio, March 1, 1892)* (n.p., privately printed), p. 4, while the 1904 one was Clifford Paynter Allen, "Pilgrimage of Mary Commandery..." (unpublished ms., Library of Congress, American Memory Collection), p. 24, August 26, 1904, on Library of Congress website, http://memory.loc.gov. See also Eva Keene (Cleaveland) Moger, "Park Trip, 1896," copy of original diary and typescript of it, n.d., p. 2, YNP Library; and "Dudes Are Amused,"

Gardiner (Montana) *Wonderland*, August 21, 1902, p. 1. Existence of the orchestra was noted by Nash, in "Vacation Notes," p. 20A.

16. Georgina Synge, *A Ride Through Wonderland* (London: Sampson, Low, Marston, and Company, 1892), p. 129.

17. T. W. Ingersoll, stereo view no. 1116, probably 1884; Sears, *Sacred Places*, p. 176. Poison Spring and River Styx are in Edgar A. Mearns, "Feathers Beside the Styx," *Condor* 5 (May 1903): 36–38; and in Whittlesey, *Yellowstone Place Names*, pp. 123, 131.

18. George Wingate, *Through the Yellowstone Park on Horseback* (New York: O. Judd Company, 1886), pp. 74–75; Haines, *Yellowstone Story* I, p. 272.

19. Win Blevins, *Dictionary of the American West* (Seattle: Sasquatch Books, 2001), p. 142. Theodore Gerrish referred to drivers as "Knights of the Ribbons" in his 1887 book, *Life in the World's Wonderland*, p. 188. "Silk" referred to the tips of the drivers' whips that were "popped" over the horses, and "ribbons" referred to reins held by drivers.

20. Haines, *Yellowstone Story* II, p. 107. The "nameless exhilaration" quotation is from Ray Stannard Baker, "A Place of Marvels—Yellowstone Park As It Now Is," *Century Magazine* 46 (August 1903): 484.

21. Drake, "A Lady's Trip to the Yellowstone Park," p. 347; H. Z. Osborne, *A Midsummer Ramble. Being a Descriptive Sketch of the Yellowstone National Park* ([Los Angeles?]: [Los Angeles Evening Express?], 1888), p. 6. See also Earl B. Osborn, "I Remember Popping the Silk in Yellowstone," *Montana: The Magazine of Western History* 22 (Summer 1972): 102–5.

22. G. L. Henderson, "The Park Wonders," *Helena Daily Herald*, April 2, 1900, in Ash Scrapbook, p. 21, YNP Library.

23. A. W. Stevens, "Golden Wedding Journey XV... The Grand Tour of the Yellowstone Park," *Sunday Republican*, December 30, 1906, in Howard Hays Collection, University of Wyoming American Heritage Center, Laramie.

24. Haines, *Yellowstone Story* II, p. 109.

25. Marvin Morris, *The Yellowstone National Park* (n.p., privately printed, 1897), pp. 39–40, copy at Montana Historical Society, Helena. See also Gay Randall's story of drivers carrying sugar with them to make lemonade in his *Footprints Along the Yellowstone* (San Antonio: The Naylor Company, 1961), p. 57; and J. Sanford Saltus's lemonade story in his *A Week in the Yellowstone* (New York: The Knickerbocker Press, 1895), p. 24. The author and many of his tour guide friends routinely told the "runs" stories to park bus passengers in the 1970s.

26. Edward S. Parkinson, *Wonderland; or, Twelve Weeks In and Out of the United States* (Trenton: MacCrellish and Quigley, Book and Job Printers, 1894),

p. 246. Whittlesey, *Wonderland Nomenclature*, Roaring Mountain entry, elaborates on this phenomenon.

27. Story in untitled article from *Harper's Weekly*, 1893, in Scrapbook 4208, p. 8, YNP Library.

28. Charles Van Tassell, *Truthful Lies: Tourists' Funny Questions, Drivers' Truthful Answers?* (Bozeman: Bozeman Chronicle Print, 1912), pp. 9–10.

29. E. Burton Holmes, *Burton Holmes' Travelogues*, vol. 6 (New York: The Travelogue Bureau, 1920), pp. 37–38.

30. Rudyard Kipling, *From Sea to Sea: Letters of Travel*, vol. 2 (New York: Doubleday and McClure Company, 1899), p. 100. Kipling was annoyed by the crudeness and stupidity of American tourists, the noises and smells of thermal areas, the loudness of rivers, hillsides that "had never known an ax," and "monster" animals in the forest. In short, he was cranky about nearly everything he encountered in Yellowstone.

31. Dr. John Dike, *Log of a Western Journey* (n.p., n.d. [ca. 1910]), pp. 15–16.

32. Ray Stannard Baker, "A Place of Marvels," *Century Magazine* 46 (August 1903): 485.

33. Teton Hill entry in Whittlesey, *Yellowstone Place Names*, 2nd edition (Gardiner, Mont.: Wonderland Publishing Company, 2006). Gibbon Falls is in Gerrish, *Life in the World's Wonderland*, pp. 200–201. A woodcut of Teton Hill is in Haynes, *Souvenir*, (Fargo, Dakota Territory: F. Jay Haynes, 1889).

34. The story of Marshall's Hotel is in Lee H. Whittlesey, "Marshall's Hotel in the National Park," *Montana: The Magazine of Western History* 30 (Autumn 1980): 42–51. The story of Fountain Hotel is in Whittlesey, "Music, Song, and Laughter: Yellowstone National Park's Fountain Hotel, 1891–1916," *Montana: The Magazine of Western History* 53 (Winter 2003): 22–35.

35. [George Bird Grinnell], "Through Two-Ocean Pass," *Forest and Stream* 24 (January 29, 1885): 3–4. A photo of the first Marshall's Hotel under construction in 1880 was taken by Thomas Rutter and is number RU-092 in the Bob Berry collection, Cody, Wyoming.

36. Superintendent Young is quoted in Dan Beard, "In a Wild Animal Republic," *Recreation* 15 (December 1901): 423.

37. For bears at Fountain Hotel, see Whittlesey, "Music, Song, and Laughter." A recent treatment of park bears that deals with garbage feeding of bears including after the stagecoach era is Alice Wondrak, "Wrestling With Horace Albright: Edmund Rogers, Visitors, and Bears in Yellowstone National Park," *Montana: The Magazine of Western History* 52 (Autumn 2002): 2–15 and 52 (Winter 2002): 18–31.

38. John H. Atwood, *Yellowstone Park in 1898* (Kansas City: Smith-Grieves, 1918), p. 16.

39. Mabel Fidelia Hale Knapp, "Trip Through Yellowstone 1908" (copy of unpublished ms., 1908), p. 3, YNP Library.

40. L. D. Luke, *Adventures and Travels in the New Wonder Land* (Utica: Press of Curtiss and Childs, 1886), pp. 22–24.

41. James Mills, "The Grand Rounds. A Fortnight in the National Park. Number III," *New Northwest* (Deer Lodge, Montana), October 12, 1872.

42. B. L. E. Bonneville to N. P. Langford, May 7, 1874, in Box 1, file "Correspondence 1874–1888," Northern Pacific Railroad records, Minnesota Historical Society, St. Paul.

43. San Pedro, Los Angeles, and Salt Lake Railroad, *Yellowstone National Park Excursions Salt Lake Route* (n.p. [San Pedro, Los Angeles, and Salt Lake Railroad], June 1911), p. [8] of pamphlet, in Howard Hays scrapbook no. 2, opposite p. 35, Howard Hays Collection, American Heritage Center, University of Wyoming, Laramie.

44. The story of Excelsior Geyser is in Lee H. Whittlesey, "'Monarch of All These Mighty Wonders': Tourists and Yellowstone's Excelsior Geyser, 1881–1890," *Montana: The Magazine of Western History* 40 (Spring 1990): 2–15. The water demon quote is from Briggs, *California As I Saw It*, p. 165, while the Sheridan (Excelsior) Geyser quote is from Northern Pacific Railroad, *The Wonderland of the World, 1884* (St. Paul: Northern Pacific Railroad, 1884), pp. 33–34.

45. Mrs. E. H. Carbutt, *Five Months' Fine Weather in Canada, Western U.S., and Mexico* (London: Sampson, Low, Marston, Searle, and Rivington, 1889), pp. 44–45. Cole's account is Ashley W. Cole, "The Yellowstone National Park," *The Manhattan* 4 (August 1884): 139.

46. C. M. Barnes, "As Seen by Others, A Journey Through Montana," *Helena Daily Herald*, December 29, 1890, p. 2.

47. Charles Warren Stoddard, "In Wonderland," *Ave Maria* 47 (August 27, 1898): 260; Mode Wineman, "Through Yellowstone National Park into Jackson Hole Country…," (unpublished ms., 1908), p. 56; Alice Wellington Rollins, "The Three Tetons," *Harper's New Monthly Magazine* 74 (May 1887): 886; J. W. Barlow and David P. Heap, "Report of a Reconnaissance of Basin of the Upper Yellowstone in 1871," 42nd Cong., 2d Sess., Sen. Ex. Doc. 66 (Washington, D.C.: GPO, 1872), p. 28.

48. Mrs. Joseph Lawrence Townsend, "Quaker Cottages, Greenport, L.I. [New York]" (untitled handwritten account of her trip to Yellowstone, 1906), p. 65; Eliza Gillette to Mrs. White, October 5, 1887, p. 6, in collection 2388, file 1:1, Montana State University Special Collections.

49. Erk, *A Merry Crusade*, [1906], p. 93; Mrs. Edward H. Johnson, "Diary of Trip Thru Yellowstone Park 1905 (Our Western Trip)" (typescript of original diary provided by descendants, n.d.), p. 2, YNP Library. The Swiss quote is from San Pedro, Los Angeles, and Salt Lake Railroad, *Yellowstone National Park Excursions Salt Lake Route*, p. [11].

50. "Old Faithful Inn—W. H. Merriman Talks to Butte Evening News About Park," *Gardiner* (Montana) *Wonderland*, March 23, 1905, p. 1. There are several studies of Old Faithful Inn, but the best one is Karen Wildung Reinhart and Jeff Henry, *Old Faithful Inn: Crown Jewel of National Park Lodges* (Emigrant, Mont.: Roche Jaune Pictures, Inc., 2004).

51. Quoted in Margaret Andrews Cruikshank, "Notes on the Yellowstone Park by M. A. C. (August 1883)" (unpublished ms., n.d.), pp. 22–23, YNP Library.

52. Mrs. James Hamilton, "Through Yellowstone National Park in 1883 with Mrs. James Hamilton" (ms., n.d.), p. 11, YNP Library; Edward Marston, *Frank's Ranche; or My Holiday in the Rockies* (London: Sampson, Low, Marston, Searle, and Rivington, 1886), p. 121.

53. Myra Emmons, "From New York to Heaven," 434. This visitor was apparently reminded a little too closely of Satan and hell by the geyser's hot water.

54. Henry Sheldon Reynolds, "An Excerpt from the Journal of Dr. Henry Sheldon Reynolds Incorporating Data from the Journal of Frances Adelia Reynolds (his wife): A Trip to Yellowstone Park, August 22–September 15, 1883" (unpublished typescript), YNP Library, p. (8).

55. Robert McGonnigle, *When I Went West from the Badlands to California* (Pittsburgh: n.p., 1901), p. 110; Ray Stannard Baker, "A Place of Marvels, *Century Magazine* 46 (August 1903): 484. Giant Geyser, a "fortnightly geyser," is in Whittlesey, *Wonderland Nomenclature*, under Giant Geyser, as described by William Hallock who quoted 1883 guides.

56. Even the McCartney's (1871) and Marshall's (1880) "hotels" were little more than crude cabins that barely offered shelter.

57. Hiram Wright Hutton, "Account of Trip Through Yellowstone Park With Party in September 1881 from Madison Valley, Montana" (typescript of original diary), p. 11, entry for September 22, 1881, YNP Library.

58. Eliza Gillette to Mrs. White, October 5, 1887, p. 11, in collection 2388, file 1:1, Montana State University Special Collections.

59. L. Louise Elliott, *Six Weeks on Horseback Through Yellowstone Park* (Rapid City: Rapid City Journal, 1913), p. 168.

60. Lee H. Whittlesey, *Wonderland Nomenclature*, Chinaman Spring entry. The spring today is known as Chinese Spring.

61. As William F. Munro did in 1897. See Munro, *Diary of the Christie Party's Trip to the Pacific Coast* (Toronto: C. M. Ellis, n.d. [1897]), pp. 40–42.

62. General history of the Old Faithful area may be found in Karl John Byrand, "The Evolution of the Cultural Landscape in Yellowstone National Park's Upper Geyser Basin and the Changing Visitor Experience, 1872–1990" (unpublished master's thesis, Montana State University, 1995).

63. F. J. Haynes, 100 Series, no. 127, "Punch Bowl Spring," [1908].

64. Hugh and Fanny Harris, "A Dream Come True, 1908 and 1909, Diaries of the Summer Journeys by Wagon . . ." (unpublished ms., 1970), Montana Historical Society, SC-1225, p. 27. Old Faithful Inn's spotlight is discussed in Reinhart and Henry, *Old Faithful Inn: Crown Jewel of National Park Lodges*, p. 48. The Klamer store, built in 1897, was a clapboard structure until after 1903. The author thanks Ruth Quinn who has done the research on the store and on architect Robert Reamer.

65. Egerton K. Laird, *A Trip to the Yellowstone National Park in 1884 by Egerton K. Laird* (Birkenhead [England]: Willmer Brothers and Company, Chester Street, 1885), pp. 15–16.

66. Quoted by Eliza Gillette to Mrs. White, October 5, 1887, p. 7, in collection 2388, file 1:1, Montana State University Special Collections.

67. W. B. "Letters from the Yellowstone—No. 7," *American Field* 26 (November 13, 1886): 470.

68. Laird, *A Trip to the Yellowstone*, p. 19. For the 1990s waterfall discoveries, see Paul Rubinstein, Lee H. Whittlesey, and Mike Stevens, *The Guide to Yellowstone Waterfalls and Their Discovery* (Denver: Westcliffe Publishers, 2001), especially p. 17; and Alex Tresniowski and Vickie Bane, "Going with the Flow—Searching for Ten Years, 3 Friends Find 240 Unknown Waterfalls—in Yellowstone," *People* (November 5, 2001): 101–2.

69. Laird, *A Trip to the Yellowstone*, p. 18. Isa Lake's east side feeds the Columbia but not the Colorado River.

70. Henry Peabody quoted in Whittlesey, *Yellowstone Place Names*, p. 39. Jack Haynes also mentions Corkscrew Hill in Aubrey L. Haines, interview with Jack Haynes, Bozeman, Montana, December 7, 1961, audiotape 61–5, YNP Library.

71. Henry Del Jenkins, "The Lucky Cowboy," n.d., p. 148, unpublished manuscript read by Aubrey L. Haines onto audiotape 61-2, side two, YNP Library. See also [Henry] Del Jenkins as told to Kathryn Saunders, "Last Days of the Park Reinsmen," *Old West* 6 (Winter 1969): 32; and Chittenden, *The Yellowstone National Park*, p. 302.

72. Laird, *A Trip to the Yellowstone*, p. 20. This confirmed a story that members of Congress continued to dismiss in 1894 as impossible, that is, catching a fish and cooking it on the hook. See Scrapbook 4208, p. 54, YNP Library, pasting up *Congressional Record*, April 7, 1894, pp. 4281–82.

73. Baker, "A Place of Marvels," 483.

74. Stage driver H. C. Jewett, in pamphlet *Explanation and Argument of the Yellowstone Lake Boat Co. Yellowstone National Park by E. C. Waters, President* . . . (Ripon, Wisc.: E. L. Howe, Printer, 1903), pp. 19–21 in Item 33, folder 1, YNP Archives.

75. Laird, *A Trip to the Yellowstone*, p. 20. The width of the bridal path on top of Natural Bridge was confirmed by a Northern Pacific Railroad pamphlet. It noted that "the roadway is thirty feet across and wide enough to admit the passage of a carriage." [Northern Pacific Railroad], *The Yellowstone National Park* (Chicago: Rand McNally, n.d., probably 1883), p. 22.

76. Moger, "Park Trip, 1896," p. 10. A photo of a stagecoach on this natural sandbar is shown on the back cover of Bill and Doris Whithorn, *Pics and Quotes of Yellowstone* (Livingston: Park County News, n.d. [1972]).

77. Eliza Gillette to Mrs. White, October 5, 1887, pp. 11–13, in collection 2388, file 1:1, Montana State University Special Collections.

78. Erk, *A Merry Crusade to the Golden Gate* . . . (no place [San Francisco]: n.p., [privately printed], n.d. [1906]), p. 106.

79. Emmons, "From New York to Heaven," p. 433. Eva Keene Moger mentioned wildflowers on the tables at Lake Hotel.

80. "Dudes Are Amused," *Gardiner* (Montana) *Wonderland*, August 21, 1902, p. 1.

81. T. S. Kenderdine, *California Revisited, 1858–1897* (Newtown, Pa.: n.p., 1898), pp. 299–300.

82. Erk, *A Merry Crusade*, p. 105.

83. Charles Warner in Paul Schullery, ed., *Old Yellowstone Days* (Boulder: Colorado Associated University Press, 1979), p. 161; Edwin J. Stanley, *Rambles in Wonderland* . . . (New York: D. Appleton and Company, 1878), pp. 86–88; Anonymous, "Scrambles in Wonderland. By One of the Scramblers," *New Northwest* (Deer Lodge, Montana), October 25, 1873, p. 1. Mud Volcano's history is chronicled in Lee H. Whittlesey, "Early History of Mud Volcano and About Recent Changes in the Area," *Commentary Newsletter* 7, 1, (August 1979): 3–11. For histories of Mud Geyser and Dragon's Mouth Spring, see Whittlesey, *Wonderland Nomenclature*.

84. Allen, "Pilgrimage of Mary Commandery," p. 57. For yet another version of this story, see the Robert "Geyser Bob" Edgar materials in chapter eleven.

85. The lady's response is mentioned without citation in Haines, *Yellowstone Story* II, p. 129, but it probably comes from either Reau Campbell, *Campbell's New Revised Complete Guide and Descriptive Book of the Yellowstone Park* (Chicago: Rogers and Smith Company, 1909), p. 82, or Henry Mallon et al., interview by Aubrey L. Haines at Mammoth Hot Springs, July 5, 1961, audiotape 61-2, YNP Library. This long interview with stage drivers Henry "Society Red" Mallon, Herb French, and Pete Hallin, and park photographer Jack E. Haynes, is remarkable for its length and the detail with which it illuminates Yellowstone's stagecoach era. The earliest known version of the story is in "Putting Down a Munchausen," *Salt Lake Tribune*, December 31, 1896.

86. Randall, *Footprints Along the Yellowstone*, p. 54; Chittenden, *The Yellowstone National Park*, p. 57. For the three known genuine Jim Bridger stories and a discussion of them, see Haines, *Yellowstone Story* I, pp. 53–59.

87. The report to President Jefferson is quoted in Haines, *Exploration and Establishment*, p. 4. [George Bird Grinnell], "Through Two-Ocean Pass," *Forest and Stream* 24 (February 5, 1885): 22.

88. Anonymous, "Scrambles in Wonderland," p. 1. A color lithograph of this spring ("Hot Sulphur Spring near the Yellowstone River") appeared in the *Illustrated London News*, January 11, 1873, p. 3c.

89. For details, see Lee H. Whittlesey, "The Crater Hills Road (Report of reconnaissance of possible stagecoach route in Yellowstone National Park, September, 1991)" (unpublished ms., 1991), YNP Library.

90. Moses Thatcher, "Falls of the Yellowstone," *The Contributor* 5 (January 1884): 141. For Beecher, see William G. McLoughlin, *The Meaning of Henry Ward Beecher* (New York: Alfred A. Knopf, 1970), pp. 10, 30–31.

91. Coyne quoted in National Park Service, Press Memo no. 109, p. [2], in *Monthly Report of Superintendent*, August 1932.

92. Thatcher, "Falls of the Yellowstone," p. 141.

93. Olin D. Wheeler, *Eastward Through the Storied Northwest* (St. Paul: NPRR, [1906]), p. 45.

94. Quoted in Stephen M. Dale, "Through the Yellowstone on a Coach," *Ladies Home Journal* 21 (August 1904): 6.

95. Dr. Wayland Hoyt quoted in Elbert Hubbard, *Elbert Hubbard's Scrapbook*, p. 29. A slightly different version is in Mary C. Ludwig, "A Summer in the Rockies" (n.d. [1895]), Scrapbook 4209, p. 130, YNP Library.

96. Norton, *Wonderland Illustrated*, p. 38; Bishop Earl Cranston quoted in Olin D. Wheeler, *Wonderland '98* (St. Paul: NPRR, 1898), p. 75; Moger, "Park Trip, 1896," p. 13; Charles Warren Stoddard, "In Wonder-Land. VI. The Grand Cañon of the Yellowstone," *Ave Maria* 47, 11 (1898): 330; Rudyard Kipling quoted in Esther Singleton, ed., *Wonders of Nature as Seen and Described by Famous Writers* (New York: Collier, 1911), pp. 365–66.

97. Mrs. J. A. I. Washburn, *To the Pacific and Back by Mrs. J. A. I. Washburn* (New York: Sunshine Publishing Company, 1887), pp. 169, 171. F. A. Boutelle, *Annual Report of the Acting Superintendent of Yellowstone National Park* (Washington, D.C.: GPO, 1890), p. 10. See generally John Raftery, *A Miracle in Hotel Building* (Mammoth Hot Springs, Wyo.: Yellowstone Park Company, n.d. [1912]). A poetic tribute to Canyon Hotel is Dan W. Gibson, *Building the Big Hotel: Souvenir of the Construction of the New Canyon Hotel* (No place: Acorn Press, 1910).

98. Harrison, *A Summer's Outing*, pp. 80, 59–60. The chained bear is mentioned without citation in Haines, *Yellowstone Story* II, p. 130, but he may have gotten it from F. H. Worswick, "The Yellowstone Park," *Journal of the Manchester Geographical Society* 15 (January–March, 1899): 53, which says "there are a number of cubs chained to trees near each hotel."

99. Nicolas Senn, *Our National Recreation Parks* (Chicago: W. B. Conkey, 1904), p. 47.

100. Anonymous, "Yellowstone Park from a Car Window," *Forest and Stream* 59 (August 9, 1902): 103.

101. A contemporary account is Olin D. Wheeler, "Game in the Yellowstone National Park," *Recreation* 4 (May 1896): 221–25. A 1906 bison is in Townsend, "Quaker Cottages," pp. 52, 71. The history of animals in Yellowstone, including the 1870s slaughter, is documented in Paul Schullery and Lee Whittlesey, "The Documentary Record of Wolves and Related Wildlife Species," pp. 1–173.

102. Washburn, *To the Pacific and Back*, p. 175. On page 170, she stated: "This [six elk and one antelope] is the first game any party has seen in the park this season."

103. Quoted in M. M. and L. L. Quaw, *A Love Affair in Wonderland* (Des Moines: The Kenyon Company, n.d., probably 1907), p. [17]. The shouting out of states' names is mentioned by Jenkins, in "Last of the Park Reinsmen," pp. 30–32, and indirectly by Elliott, in *Six Weeks on Horseback*, p. 116.

104. Laird, *A Trip to the Yellowstone*, p. 25; Bates, *A Year in the Great Republic* 2:191. Laird noted great views of the canyon, a boundless horizon, and the vastness of the panorama. Bates reported that in 1886, a few of her fellow travelers elected to travel by horseback over Dunraven Pass to Yancey's even though the stage from Yancey's to Mammoth ran only twice per week.

105. Kenderdine, *California Revisited*, p. 304; W. B. "Letters from the Yellowstone—No. 8," *American Field* 26 (November 20, 1886): 494.

106. Harrison, *A Summer's Outing*, pp. 62, 83.

107. Remington, *Pony Tracks*, p. 120; Raymond H. Barker, *Camping in the Rockies* (Cleveland: Samuel Barker and Son, 1892), p. 65.

CHAPTER ELEVEN

1. Henderson to Pat Conger, August 2, 1884, Archive Document 1449, YNP Archives.

2. Strong in Richard A. Bartlett, *A Trip to the Yellowstone National Park . . . 1875* (Norman: University of Oklahoma Press, 1968), pp. 43, 51. N. P. Langford is discussed thoroughly in Schullery and Whittlesey, *Myth and History*.

3. H. R. Horr et al. to Columbus Delano, March 28, 1872, in NA, RG 48, No. 62, roll 1 (hardcopy at YNP Library).

4. Gilman Sawtell to G. S. Boutwell, January 5, 1874, in NA, RG 48, No. 62, roll 1 (hardcopy at YNP Library); N. P. Langford, *Annual Report of the Superintendent of Yellowstone National Park*, 1872, p. 6; Raymond, *Camp and Cabin*; Clawson, "Notes on the Way to Wonderland." The account of stories Sawtell told to Mrs. Cowan is in Mrs. George F. Cowan, "Reminiscences of Pioneer Life," *Contributions to the Historical Society of Montana* 4 (1903): 157. An uncited biography of Sawtell is in James L. Allison and Dean H. Green, *Idaho's Gateway to Yellowstone: The Island Park Story* (Mack's Inn, Id.: Island Park–Gateway Publishing Company, 1974), pp. 26–27. A recent treatment of the Clawson-Raymond-Sawtell party's 1871 trip is Lee Silliman, ed., *A Ride to the Infernal Regions: Yellowstone's First Tourists* (Missoula, Mont.: Riverbend Publishing, 2003).

5. Langford, *Annual Report*, 1872, p. 2; T[homas] E[wing] S[herman], "Across the Continent. II—The National Park," *Woodstock Letters* 11 (1882): 25.

6. For mentions of these men, see Haines, *Yellowstone Story* I, various, and *Bozeman Times*, June 1, July 20, August 3, 1875; May 4, July 6, August 24, 1876; May 21, 1878, p. 3. For Jack Bean, see Archive Document 682, YNP Archives; and John C. Tidball, "Report of Journey Made by General W. T. Sherman in the Northwest and Middle Parts of the United States in 1883," in William Tecumseh Sherman and Philip H. Sheridan, *Travel Accounts of General William T. Sherman to Spokan [sic] Falls, Washington Territory, in the Summers of 1877 and 1883 by William Tecumseh Sherman and Philip Henry Sheridan*, ed. Glen Adams (Fairfield, Wash.: Ye Galleon Press, 1984), pp. 165–66.

7. Norton, *Wonderland Illustrated*, pp. 73, 129, 131.

8. Par M. Augustin Seguin, "Dix Jours aux Sources du Missouri," *Bulletin De La Societe De Geographie De Lyon* 4 (1881): 59–84, translated for the author by Christina MacIntosh, pp. 19–20 of translation.

9. Norris, *Annual Report for 1880*, pp. 14–15; W. W. Wylie, *The Yellowstone National Park; or The Great American Wonderland* (Kansas City: Ramsey, Millett, and Hudson, 1882), pp. 87–88.

10. Leckler, "A Camping Trip," p. 117.

11. Henderson to Conger, August 2 and July 5, 1884, in Archive Documents 1449, 1452, YNP Archives. Of the guides listed here, Chadbourn, Hoppe, and Clark have known history, while the others are unknown. Chadbourn was a relative of A. W. Chadbourn of Cinnabar, and ran independent tours into Yellowstone beginning in 1882 (Whittlesey, *Wonderland Nomenclature*, p. 267). Clark owned a livery business beginning in 1885 at Mammoth, for a newspaper note on him says that he "is preparing to meet all calls for carriages, saddle horses and guides" (Henderson, *Yellowstone Park Manual and Guide*, 1885, p. 1, no. 22). John Hoppe was a relative of Hugo Hoppe, whose descendants have lived near (north of) Yellowstone Park for six generations.

12. Laird, *A Trip to the Yellowstone*, p. 19.

13. Seymour Dunbar, *A History of Travel in America* I (New York: Greenwood Press Publishers, 1968), p. 180.

14. William Robertson and W. F. Rae, quoted in Robert G. Athearn, *Westward the Briton* (New York: Charles Scribner's Sons, 1953), pp. 13–14.

15. William A. Baillie-Grohman quoted in Athearn, *Westward the Briton*, p. 14.

16. Carrie Adell Strahorn, *Fifteen Thousand Miles by Stage*, p. 255; Robert E. Strahorn, *The Enchanted Land* (Omaha: New West Publishing Company, 1881), p. 3. For the history of George Marshall's hotel, see Lee H. Whittlesey, "Marshall's Hotel in the National Park," *Montana: The Magazine of Western History* 30 (Fall 1980): 42–51.

17. Bassett Brothers to Secretary of Interior, July 26, 1884, in NA, RG 48, no. 62, roll 2 (hardcopy at YNP Archives). Gilmer and Salisbury are mentioned by P. W. Norris in his various reports of the superintendent, in Robert E. Strahorn, *The Enchanted Land*, and in greater detail in B. N. and B. D. Madsen, *North to Montana! Jehus, Bull-whackers, and Mule Skinners on the Montana Trail* (Logan: Utah State University Press, 1998), and William Pettite, *Memories of Market Lake: A History of Eastern Idaho*, 4 vols. (no place: n.p., 1965–1984). Historians have not yet done the needed newspaper work on these two stagecoach companies to flesh out their histories in Yellowstone.

18. George Thomas, "My Recollections of the Yellowstone Park," (unpublished ms., 1883), p. 8, YNP Library; Charles Gibson in McRae, "The Yellowstone National Park," p. 187.

19. T. H. Thomas, "Yellowstone Park Illustrated," *The Graphic*, August 11, 1888, p. 158.

20. Wingate, *Through the Yellowstone Park on Horseback*, pp. 33–34; Erk, *A Merry Crusade*, p. 78.

21. Henry Clay Quinby, "Yellowstone Park," pamphlet dated May 1, 1903, in Box YPC-3, file "Historical 2," YNP Archives, pp. 1–2.

22. A. Nnony Mouse, "Ode to the Drivers of Yellowstone Park," in Gwen Petersen, *Yellowstone Pioneers: The Story of the Hamilton Stores and Yellowstone National Park* (Santa Barbara: Hamilton Stores, Inc., 1985), p. 24.

23. Marston, *Frank's Ranche*, pp. 108, 124; C. S. Walgamott, *Reminiscences* (Twin Falls, Id.: privately published, 1926), II, p. 78, as quoted in Beal, *The Story of Man in Yellowstone* (revised edition, 1960), p. 196.

24. Marston, *Frank's Ranche*, pp. 110–11. My thanks to Betsy Watry for this.

25. T. S. Hudson, *Scamper Through America; or, Fifteen Thousand Miles of Ocean and Continent in Sixty Days* (New York: E. P. Dutton and Company, 1882), p. 174.

26. Gunnison, *Rambles Overland*, pp. 29–30. A "pilgrim," in the vernacular of the day, was a traveling person new to the region.

27. John Muir, *The Yellowstone National Park* (Olympic Valley, Calif.: Outbooks, 1978), pp. 30–31. This was originally published as "The Yellowstone National Park," *Atlantic Monthly* 81 (April 1898): 509–22.

28. Francis Francis, "The Yellowstone Geysers," *Nineteenth Century* 11 (March 1882): 369; Edwards Roberts, "The American Wonderland," *Art Journal* 40 (November 1888): 326.

29. Saltus, *A Week in the Yellowstone*, pp. 42–43.

30. J. S. Dearing, *A Drummer's Experience* (Colorado Springs: Pike's Peak Publishing Company, 1913), p. 331.

31. *Hot Springs* (S.D.) *Star*, October 19, 1888.

32. Donald MacInnes, *Notes of Our Trip Across British Columbia . . . to the American National Park . . .* (Hamilton, Ont.: Spectator Printing Company, 1889), p. 27.

33. J. E. Williams, *Through the Yellowstone Park. Vacation Notes. Summer of 1888. Copied from the Amherst Record* (n.d. [1888]), p. 16. Assuming it was the same Thomas Casey, of Deadwood, South Dakota, this driver was to spend

much of his life in Yellowstone, for Jack Haynes mentioned him later as having been a Monida/Yellowstone driver 1898–1916. If he arrived 1880–1883, as seems probable, Thomas Casey was a driver who drove *every year* in Yellowstone (or nearly so) during the stagecoach era, 1880–1916. If this is true, he was one of the few and perhaps the only such man. Aubrey L. Haines, interview with Jack Ellis Haynes, December 9, 1963, audiotape 63–5, YNP Library.

34. Kipling in Schullery, *Old Yellowstone Days*, 1979, p. 87.

35. Campbell, *Campbell's Guide*, p. 140.

36. H. M. F., "The Yellowstone Park. Last Look at Old Faithful" (n.d. [1894]), in Scrapbook 4208, p. 149. This also appeared in Henry M. Field, *Our Western Archipelago* (New York: Charles Scribner's Sons, 1895), p. 243.

37. L. F. J., "Stagecoach Trip" (n.d. [1895]), in Scrapbook 4209, p. 123, YNP Library.

38. Olin D. Wheeler, "How to See Yellowstone Park," *Northwest Magazine* 15 (June 1897): 24. Wheeler's job was to promote his company's enterprises in the park and that included stage drivers: "The best drivers to be obtained are used, and are under orders to afford all possible facilities and information to passengers to see, and understand what they see." Wheeler, *Six Thousand Miles Through Wonderland* (St. Paul: NPRR, 1893), p. 69.

39. Fred Slocum, *23d Annual Conclave and A Royal Outing. Michigan State Press Association. A Story Written By the Editors Themselves* (Saginaw: Seeman and Peters, 1891), p. 34; Ida McPherren, *Imprints on Pioneer Trails* (Boston: Christopher Publishing Company, 1950), p. 252.

40. "Yellowstone Park," pamphlet of Yellowstone Park Association hotels (n.d. [1905]), in possession of author, p. 11.

41. W. F. Hatfield, *The Wonderland. View and Guide Book of Yellowstone National Park (Containing 36 Superb Views)* (Los Angeles: R. Y. McBride, n.d., [probably 1899]), p. 54.

42. Myra Emmons, "From New York to Heaven," *Recreation* 15 (December 1901): 434.

43. Townsend, "Quaker Cottages," p. 46.

44. F. Dumont Smith, *Book of a Hundred Bears* (Chicago: Rand McNally, 1909), p. 100.

45. Gibson in McRae, "The Yellowstone National Park," pp. 19, 187.

46. Randall, *Footprints Along the Yellowstone*, p. 57.

47. Campbell, *Campbell's Guide*, 1909, p. 97. Stage driver Del Jenkins (1897–1914) has stated that "we" gave commentary and the visitors asked lots of questions. He says one load would tip liberally and the next one would not. A. L. Haines interview with Henry Del Jenkins, July 3, 1961, Jackson, Wyoming, audiotape at YNP Library.

48. Eliza Upham, "'A Fine Day for Travelling': Diary of Eliza A. Upham," (handwritten, 1892), copy at YNP Library. Original is owned and currently being edited for publication by M. A. Bellingham, Emigrant, Montana.

49. "Yellowstone Park Brief Notes of a Trip."

50. Edward H. Moorman, "Yellowstone Park Camps History" (mimeographed reminiscence [1899–1948], dated April 2, 1954), p. 6, YNP Library; "Local News," *Livingston Post*, July 30, 1903; "The Drivers Make a Kick," *Gardiner Wonderland*, July 30, 1903. Perhaps Moorman misremembered the year and there was only the 1903 strike.

51. Haines, *Yellowstone Story* II, p. 137; Karl John Byrand, "The Evolution of the Cultural Landscape in Yellowstone" (master's thesis, Montana State University, 1995), p. 54.

52. Robert Shankland, *Steve Mather of the National Parks* (New York: Alfred A. Knopf, 1970), p. 257.

53. Paul Schullery, "Searching for Yellowstone: Ecology and Wonder in the Last Wilderness" (ms. being prepared for publication loaned by author, 1996), pp. 103, 133; see also Schullery, *Searching for Yellowstone: Ecology and Wonder in the Last Wilderness* (New York: Houghton Mifflin, 1997), pp. 103–4.

54. [A. W. Miles], "Wylie Way," 1914 pamphlet of Wylie operations (in Ed Moorman scrapbook "Yellowstone Park Travel Folders 917.87," YNP Library, p. 9), p. 14.

55. The 1910–1912 "Wylie Way" pamphlets all confirm this. See also the Moorman scrapbook, pp. 5–7.

56. In 1923, when the Yellowstone Park Camps Company had taken over the Wylie camps, and employees there were performing for tourists, a traveler visiting the Canyon camp noted that "one of the requisites of a 'savage' is the ability to entertain." A. M. Simms and Bill Allen, "The Trip from Salt Lake City to Yellowstone National Park & Jackson's Hole, Wyoming, Wasatch Mountain Club," 1923 typescript with photos, p. 10, included on CD given to Yellowstone National Park Museum Collection by David Amott, 2003.

57. Moorman, "Camps History," p. 4.

58. Dorothy Brown Pardo, "Dorothy in Wonderland" (unpublished ms., 1911), p. 8, YNP Library. "Savages" was a slang term for park concessioner employees.

59. Grace L. Hurley, "Coast to Coast 1915" (typescript of unpublished diary, August 18, 1915), p. [45], YNP Library.

60. Miles in "Wylie Way," 1914 pamphlet, Moorman scrapbook, p. 9, YNP Library. A shorter version of this quote is in C. Frank Brockman, "Chronology of Interpretation in the National Park Service" (College of Forest Resources, University of Washington, June 1976), p. 27. A later manager of the Wylie Camps, Howard Hays, enlarged these entertainments a great deal in 1919, awarding prizes for the best skits and songs. This arrangement naturally led into the publication of several editions of a booklet called *Songs of the Yellowstone Park Lodges*. Ed Moorman, who recorded this information, also stated that this entertainment feature of the Wylie Camps began "previous to the 1899 season." Moorman, "Yellowstone Park Camps History," p. 18. A 1928 park bus driver noted that by that time Camps Company employees "were hired partly for their skills at entertaining." L. Merlin Norris, "My Yellowstone Park Days" (unpublished ms., 1987), YNP Library, p. 4. According to numerous employees of Yellowstone's old Canyon Lodge, that practice continued at least through the closing of the Canyon Lodge at the end of the 1956 season.

61. "Yellowstone National Park, Wylie Permanent Camps," 1898 brochure, p. 5, in Edward Moorman scrapbook of "Yellowstone Park Travel Folders," p. 1, YNP Library.

62. George H. Lamar and James A. Blanchard, *In the Department of the Interior, Washington, D.C. Before the Secretary. In the Matter of the Application of William W. Wylie for a Lease in The Yellowstone National Park . . . Reply to Protest of Captain Anderson . . .* (Washington: J. S. Tomlinson and Son, 1898), pp. 39–41.

63. Page three of a circa-1903 Wylie brochure says: "Our drivers take the tourists over the terraces, showing and describing the chief points of interest." "Wylie Permanent Camps" brochure (cover shows rapids above Upper Falls), (n.d., about 1903), in Moorman Scrapbook, p. 1.

64. [A. W. Miles], "Wylie Way, Teachers' Vacations in Yellowstone National Park," 1910 color pamphlet, in Moorman scrapbook, p. 12. The driver's speech is on page 8 of the pamphlet.

65. Haines, *Yellowstone Story* II, pp. 137, 139. G. L. Henderson's employees and later those of YPT Company wore identification badges but not uniforms. McRae, "The Yellowstone National Park," mentions the YPT badges. The Henderson badges are mentioned in the chapter on him.

66. Jean Crawford Sharpe, "A Yellowstone Story 1908–1917"; or, "This Is Me and This Is What I Remember" (unpublished ms., 1985), p. 3, YNP Library. Charles Van Tassell's book is *Truthful Lies: Tourists' Funny Questions Drivers' Truthful Answers?* (Bozeman: Bozeman Chronicle Print, 1912).

67. Some of Van Tassell's history is known because of an incident he was involved in during 1906 while a YPT Company driver. A party of tourists in another stagecoach complained that he would not yield the road. Van Tassell, when dressed down by the park superintendent, claimed that he thought YPT drivers had special privileges. See Archive Document 6116, August 17, 1906; and John Pitcher to President of YPT, August 21, 1906, in Army Records, Letters Sent, vol. 16, p. 304, YNP Archives. Van Tassell's personal history is in the Jack E. Haynes collection 1504, box 157, file 9, Montana State University.

68. [A. W. Miles], "Yellowstone Park Dictionary, What's What Wylie Way," pamphlet in Moorman Scrapbook, p. 15. The quote is from page 5 of the pamphlet.

69. These letters appeared in G. L. Henderson, *Yellowstone Park Manual and Guide*, 1888, pp. 3–4.

70. Diary of Myrtle May Kaufmann, 1913, p. 12, copy of original at YNP Library; Oregon Short Line Railroad, *To Geyserland The New and Splendid Train Service of the Oregon Short Line Railroad* (n.d. [1908]), pp. [7], [37], museum accession number 1040, YNP Museum Collection; Whithorn, *Photo History from Yellowstone Park* (Livingston, Mont.: Park County News, n.d. [1970]), p. (24); Whithorn to author, June 7, 1996; Shaw and Powell, "Yellowstone Park by Camp," 1915 brochure in Army Records, Item 52, File 130, "Financial Reports: Advertisements of Concessioners, 1914 and 1915," YNP Archives.

71. Milton Skinner to Col. L. M. Brett, November 5, 1913, in Item 37, folder 1, file 3, YNP Archives.

72. Material about Robert Edgar is from the following sources: Randall, *Footprints Along the Yellowstone*, pp. 53–54; Steve Johnson, interview with Bessie Haynes Arnold, audiotape 74-4; A. L. Haines interview with Edith Ritchie, November 7, 1961, audiotape 61-3, YNP Library. Robert Edgar's obituary is "'Geyser Bob,' Most Famous of All Yellowstone Park Characters Dead," *Livingston Enterprise*, August 23, 1913. See also "Dudes Are Amused," *Gardiner Wonderland*, August 21, 1902; "Blythe Tells Funny Stories," *Livingston Enterprise*, September 14, 1911; and "Geyser Bob's Body Is Laid at Rest," *Livingston Enterprise*, August 27, 1913. The Somerville scrapbook is in the YNP Museum Collection.

73. Arthur J. Gilles, *Geyser Questions Answered: A Book of Useful Information for People Planning a Trip to Yellowstone Park* (no place: n.p., privately printed, 1915), p. (4).

74. Northern Pacific Railroad, *Alice's Adventures in the New Wonderland*, 1885, pamphlet of a trip narrative printed on the reverse of a large folding map of the park. This text is also in Scrapbook 4209, p. 16, YNP Library.

75. G. L. Henderson, "The Geysers in Winter," *Livingston Enterprise*, Dec. 6, 1884. In this article and in his *Yellowstone Park Manual and Guide*, 1885, Henderson described his explorations of the Lower Geyser Basin with George Marshall and their giving of names to many features there. See also Henderson, "Lower Geyser Basin. A Glance at the Unfrequented Wonders of That Region," *Livingston Enterprise*, July 18, 1885.

76. Lyon, "The Nation's Art Gallery," clipping from Watertown, South Dakota, newspaper, August 7, 1891, in Scrapbook 4208, p. 16, YNP Library.

77. Holmes, *Burton Holmes' Travelogues*, vol. 6, p. 19.

78. Saltus, *A Week in the Yellowstone*, p. 18.

79. "Yellowstone Park Brief Notes of a Trip."

80. Mary C. Ludwig, "Summer in the Rockies" (1895), in Scrapbook 4209, p. 125; L. F. J., "Stage Coach Trip," (n.d. [1895]), in Scrapbook 4209, p. 123, YNP Library. Visitors who were headed *to* Mammoth from Norris were given a choice by stage drivers: get out at the top and walk down through the formations to Mammoth Hotel, or else ride with the driver to the hotel, thus possibly missing some of the beauty of the walking "tour." Today northbound park bus drivers often give their guests the same choice. See anonymous, "Yellowstone Park from a Car Window," *Forest and Stream* 59 (August 9, 1902): 103.

81. Shaw and Powell, "Yellowstone Park by Camp," p. 17.

82. "Yellowstone Park," brochure of YPA hotel company (n.d. [1905]), in possession of author, p. 7; Olin D. Wheeler, *Yellowstone National Park: Descriptive of the Beauties and Wonders of the World's Wonderland* (St. Paul: W. C. Riley, 1901), p. 55; Northern Pacific Railroad, *Wonderland Junior*, p. 38.

83. Elbert and Alice Hubbard, *A Little Journey to the Yellowstone* (East Aurora, N.Y.: The Roycrofters, 1915), pp. 4–6.

84. "Our Local Field," *Gardiner Wonderland*, October 10, 1903; "Yellowstone Park" (n.d. [1905]), brochure of YPA hotel company, in possession of author, p. 6; Jack E. Haynes interview with Sam P. Eagle, March 30, 1956, in JEH collection 1504, box 151, file 14, Montana State University. A photo of Stewart, or perhaps of one of his contemporaries, wearing the YPA uniform with tourists at Devil's Kitchen is a Berry, Kelley, and Chadwick stereo image, copyrighted 1906 (BKC-001, Bob Berry collection, Cody, Wyoming).

85. "Local Layout," *Livingston Enterprise*, May 21, 1904. The likely denigration of G. L. Henderson's interpretive activities by Superintendent Patrick Conger is explained in the chapter on Henderson.

86. Skinner to C. P. Russell, January 25, 1932, as cited in Haines, *Yellowstone Story* II, p. 307. The relevant portions of this letter are also in Aubrey Haines to Tom Tankersley, January 25, 1994, letter in vertical files, YNP Library. Skinner's work in the park actually began in the summer of 1896.

87. Skinner to Col. L. M. Brett, November 5, 1913, in Item 37, folder 1, file 3, YNP Archives.

88. Brett to Secretary of Interior Lane, November 4, 1913, in Item 39, box 20, YNP Archives.

89. Placemat card, Larry Mathews papers, Museum Accession no. 1348, YNP museum collection.

90. L. W. B., "Mountain Coaching" (n.d. [1895]), in Scrapbook 4209, p. 45, YNP Library.

91. Henry Clay Quinby, "Yellowstone Park," pamphlet dated May 1, 1903, in Box YPC-3, file "Historical 2," YNP Archives, p. 4.

92. Carl E. Schmidt, *A Western Trip* (Detroit: Herald Press, 1910), p. 21. An H. C. White photo of "The Boiler," a steam vent that broke out in 1901, is YELL-128391, YNP Archives.

93. A. L. Haines interview with Rexford M. Sheild, August 29, 1962, tape 62-5, side 1, YNP Library. That Sheild was indeed the "official guide" at Norris that summer is confirmed by geologist Arnold Hague who utilized a photograph Sheild took of Steamboat Geyser in eruption. NA, RG 57, Arnold Hague papers, box 13, folder 71, "Norris Geyser Basin," (unpublished ms., n.d., about 1915), p. 24. A 1908 photo has survived of an Association guide standing at Steamboat Geyser, megaphone in hand and wearing the uniform of YPA. Author's collection; copy in YNP museum collection.

94. Sands to Pitcher, July 27, 1905, archive document 6519, YNP Archives.

95. Lispenard Rutgers [Henry Erskine Smith], *On and Off the Saddle* (New York: G. P. Putnam's Sons, the Knickerbocker Press, 1894), p. 7; Mildred Rossini, five audiotapes of her experiences as a Wylie Camping Company employee 1911–1913, recorded 1987, YNP Library.

96. Allen, "Pilgrimage of Mary Commandery," p. 41.

97. Saltus, *A Week in the Yellowstone*, p. 44.

98. Henry T. Finck, "Yellowstone Park in 1897," *The Nation* 65 (October 7, 1897): 276. A photo of an Upper Basin walking guide "at Larry's [Lunch Station], Sunday, August 23, 1903" was taken by an unknown visitor on that date and is number A04-15 in the Bob Berry collection, Cody, Wyoming.

99. Rexford Sheild, two black photo albums marked "Photographs," and assorted ephemera, given to YNP Museum Collection, 1995, accession number YELL-1443.

100. Charles M. Taylor Jr., *Touring Alaska and the Yellowstone* (Philadelphia: George W. Jacobs and Company, 1901), p. 351.

101. Andy Stewart, "Yellowstone Park—Win, Place, Show" (unpublished ms., 1909) (donated to park library February 3, 1958), p. 2, YNP Library.

102. Pardo, "Dorothy in Wonderland," p. 24.

103. Handkerchief Pool at Black Sand Basin was used (at least from 1888 to 1926) to demonstrate how some hot springs could return a handkerchief that might be dropped down into them. Throwing items into springs is prohibited today. Whittlesey, *Wonderland Nomenclature*, pp. 784–85.

104. F. C. Copp to Superintendent, August 1, 1913; A. W. Miles to Superintendent, August 9, 1913; Superintendent to Dr. Ralph T. Knight, August 13, 1913; Knight to Superintendent, August 18, 1913; Copp to Assistant Secretary, August 1, 1913; Assistant Secretary to Superintendent, October 6, 1913; George H. Lamar to Secretary, October 2, 1913; all in Army Records, Item 92B, file 85, YNP Archives. Knight was also remembered and praised by Jack Haynes in A. L. Haines's interview with Haynes, December 9, 1961, audiotape 63-5, YNP Library. Another letter (Haines to Chief Naturalist, May 26, 1961, in vertical files, History-YNP, "Scouts and Former NPS Employees") says Knight was working at the West Yellowstone Wylie camp in 1910. He served as a walking tour guide for at least five years.

105. Robert B. McKnight, "Do You Recall Your Walk in Geyser Basin?" *The Yellowstone News* (Wylie Way newspaper), vol. 1, no. 1 (Spring 1915), pp. 2, 4.

106. A. L. Haines interview with Jack Haynes, Dec. 9, 1963, audiotape 63-5, YNP Library. A discussion of this incident is in Lee H. Whittlesey, *Death in Yellowstone: Accidents and Foolhardiness in the World's First National Park* (Boulder: Roberts Rinehart, 1995), pp. 7–8.

107. That its Upper Basin guides were considered important to the Wylie Camping Company is evident from this blurb that appeared in the 1914 company brochure and that probably referred to guide Ralph Knight: "At the Upper Geyser Basin the Wylie Company employs a special guide, who is an authority on the scenic, historical and scientific matters which pertain to the region. This guide service is intelligent, courteous and painstaking and never fails to please." A. W. Miles, "Yellowstone Park Dictionary, What's What Wylie Way," 1914, in Moorman scrapbook, p. 15, YNP Library. This same blurb appeared in the 1908 pamphlet in an abbreviated form that mentioned only a "special guide while viewing the geysers." Miles in "Wylie Way," 1914 pamphlet, Moorman scrapbook, p. 9, YNP Library.

344 ~~ NOTES TO PAGES 237–41

108. Gillis, *Another Summer*, p. 26.

109. William and C. C. Murphy, "Trip Through Yellowstone in 1893," portion of unpublished journal, donated August 1993, p. 15, YNP Library.

110. J. J. Aubertin, *A Fight With Distances* (London: Kegan Paul, Trench and Company, 1888), p. 94; H. Z. Osborne, *A Midsummer Ramble. Being a Descriptive Sketch of the Yellowstone National Park*, 1888, p. 14; "Yellowstone Park Brief Notes of a Trip," p. 60.

111. Northern Pacific Railroad, *A Romance of Wonderland* (Chicago: Poole Brothers, n.d., probably 1889). Montana State University Special Collections holds a copy of this folding pamphlet.

112. Clifton Johnson, *Highways and Byways of the Rocky Mountains* (New York: The MacMillan Company, 1910), p. 228.

113. L. W. B., "In the Grand Canyon, the Wonder of Wonders in Yellowstone Park, Where Guides Are Dumb" (undated newspaper clipping [1895], unknown newspaper), Scrapbook 4209, pp. 51–52, YNP Library.

114. Haines, *Yellowstone Story* II, pp. 131–33. Haines says Richardson's permit was "revoked" in 1903. If that is so, it was restored for the 1904–1906 seasons, per correspondence in the next footnote. A family descendant, Phyllis Thomason of Bozeman, Montana, conveyed the pinning-of-skirts information to me.

115. H. F. Richardson to Superintendent, May 19, 1904, document 7926; Richardson to Superintendent, October 10, 1904, document 7925; Richardson to Superintendent, February 16, 1905, document 7933; Secretary of Interior to Superintendent, June 21, 1905, document 5754; H. F. Richardson to Superintendent, October 9, 1905, document 7924; W. W. Wylie to H. F. Richardson, October 19, 1905, document 7923; Secretary to Superintendent, May 7, 1906, document 6877; all in YNP Archives.

116. Ed Moorman, "Yellowstone Park Camps History," p. 42. E. W. Hunter to Jack Haynes, March 10, 1954, in Haynes Collection 1504, file 94:45, Montana State University.

117. A copy of Richardson's business card was attached to the diary of a 1906 traveler. While it carried the name "Tom Richardson," his letters to the park all bore the signature "H. F. Richardson." See Fred E. Leonard, "Yellowstone Park—Summer of 1906," handwritten original diary, 1906, at Oberlin College Archives, Oberlin, Ohio, opposite p. 73. Mr. and Mrs. A. L. Noyes, *1906 Our Wedding Journey*, photo album, YNP Library, has a picture of the new stairway at Uncle Tom's.

118. Moses Ezekiel, typescript of diary, July 27–August 8, 1896, p. 23, YNP Library manuscript file.

119. Elbert and Alice Hubbard, *A Little Journey to the Yellowstone*, p. 14; "In the Playground" (n.d. [1895]), in Scrapbook 4209, p. 135, YNP Library. See generally Whittlesey, "Music, Song, and Laughter: Yellowstone National Park's Fountain Hotel, 1891–1916," *Montana: The Magazine of Western History* 53 (Winter 2003): 22–35.

120. W. D. Van Blarcom, "The Yellowstone National Park," *National Magazine* 6 (September 1897): 546; Rube Shuffle, *Yellowstone Letters by Rube Shuffle, Valet, Written from the National Park to His Sweetheart* (New York: Neale Publishing Company, 1906), p. 81. References to West Thumb walking tours are few.

121. Mildred Rossini, audiotape, 1911–1913, recorded 1987, YNP Library.

122. Milton Skinner in "Monthly Report of the Superintendent," August, 1920, p. [44]; Skinner, "Report on Guide Service," June 27, 1921, in box K-11, file 154.3, YNP Archives; *Yellowstone Park Camps Semicentennial Celebration*, 1920 brochure, Moorman scrapbook, p. 19, YNP Library. Skinner was the park's first chief naturalist, who came on board as a ranger on October 1, 1919, with the understanding that the position would be changed to naturalist as soon as possible. This occurred on April 1, 1920. Haines, *Yellowstone Story* II, p. 308.

123. "The Reminiscences of Horace Albright" (oral history transcript [800+ pp.], 1961 microfiche), pp. 379–81, YNP Library.

124. Joyner, "History of Educational Activities," in *Ranger Naturalist's Manual of Yellowstone National Park* (Yellowstone National Park: National Park Service bound monograph, 1929), p. 173; Chester A. Lindsley, *The Chronology of Yellowstone National Park, 1806 to 1939* (unpublished bound document, 1939), p. 260, YNP Library; unauthored handwritten notes (7 pp.) filed under M. A. Bellingham, "Yellowstone Nat'l. Park" (n.d. [early 1920s]), found inside a 1922 NPRR guide to Yellowstone, p. 3, YNP Library vertical files.

125. Wingate, *Through the Yellowstone Park on Horseback*, p. 73.

126. Ibid., pp. 82, 97; Dudley, *The National Park from the Hurricane Deck of a Cayuse*, p. 36.

127. Haines, *Yellowstone Story* II, p. 307; J. A. Heasley, *A Summer Vacation in the Yellowstone National Park* (Grand Rapids, Mich.: n.p., 1910), p. 15.

128. "The Immortal Fifteen," *Livingston Enterprise*, September 22, 1888. "Magic lantern" refers to the presentations of lecturers, whose stories are told in the chapter "Lectures and Lecturers." They often used giant-screen projections of photographs to illustrate lectures that were full of exaggerated flamboyance.

129. Slocum, *23d Annual Conclave*, pp. 33, 40.

130. Townsend, "Quaker Cottages," p. 45; Rev. William H. Myers, *Through Wonderland to Alaska* (Reading, Pa.: Reading Times Print, 1895), p. 233.

131. Morris, *The Yellowstone National Park*, pp. 13, 15; Harrison, *A Summer's Outing*, p. 74.

132. Myers, *Through Wonderland to Alaska*, pp. 233–34. The soldiers' interest in women visitors was understandable—there were not many women in Yellowstone for much of the year. A 1910 visitor reported the following touching incident involving a soldier: "I recall a young lady admiring some wild flowers as she passed. 'Would you like those flowers?' the soldier guard said to her. Of course she would, so he rode back and brought our ladies an armful of wild flowers. Upon [her] thanking him for this act of kindness, he said, 'It is no bother at all to accommodate you. It is only for three months we have you with us and think of what we suffer for the next nine,—not a lady to be seen outside the keeper's [superintendent's] wife and daughters. It's—.' He turned away with tears in his eyes." Heasley, *Summer Vacation*, p. 15.

133. Caroline Paull, "Notes on Yellowstone National Park, June 28–August 4, 1897" (unpublished ms.), YNP Library, July 24 entry.

134. Thula Hardenbrook, "Diary of a trip through Yellowstone National Park in the Summer of 1887" (journal at University of Montana, transcription by Rocco Paperiello), entry for August 25; Acting Superintendent to Secretary of Interior, June 3, 1909, YNP Archives.

135. Lyon, "The Nation's Art Gallery!" clipping from Watertown, South Dakota, newspaper, August 7, 1891, in Scrapbook 4208, p. 19, YNP Library.

136. Carbutt, *Five Months' Fine Weather*, p. 45.

137. Horace Albright to Assistant Superintendent Bob Haraden, March 1, 1973, in possession of author from park archives.

138. W. B. McLaurin, "Park Orders, No. 6," June 1, 1914, in bound volume "Park Orders Y.N.P.," May 1913–Aug. 1917, Record Group 393, Part 5, Fort Yellowstone, Wyoming, entry 18, 19, 21, 24, box 25, National Archives.

139. G. L. Henderson, "Wonderland Caves and Terraces. Excavation, Formation, Erosion. A Gale at the Golden Gate" (unpublished handwritten ms., n.d. [about 1888]), p. 24, YNP Library. Park plant biologist Don Despain read the above passage and commented that he believed Henderson was "half right and half wrong" in his interpretation. "The wind was doing it," says Despain, "but blowing snow and ice were probably also playing a role."

140. Maturin M. Ballou, *The New El Dorado: A Summer Journey to Alaska* (Boston: Houghton Mifflin and Company, 1889), pp. 35–36.

141. Sessions, *From Yellowstone Park to Alaska*, p. 23.

142. Mary C. Ludwig, "Summer in the Rockies," 1895 newspaper clipping in Scrapbook 4209, p. 125, YNP Library; Lee H. Whittlesey, *Mile by Mile Guide to Yellowstone National Park* (Mammoth: Yellowstone Park Company, 1979; T. W. Services, 1985, 1996), p. 27.

143. George Thomas, unpublished "My Recollections of Yellowstone Park," 1883, p. 9; Nicolas Senn, *Our National Recreation Parks* (Chicago: W. B. Conkey, 1904), p. 35; Atwood, *Yellowstone Park in 1898*, p. 15. Calcimining using mud from Fountain Paint Pot is discussed in Lee H. Whittlesey, "'Music, Song, and Laughter': Yellowstone National Park's Fountain Hotel, 1891–1916," *Montana: The Magazine of Western History* 53 (Winter 2003): 22–35. YPA company documents at Minnesota Historical Society also confirm that this happened.

144. Bob Fletcher, *Corral Dust* (Helena: Bob Fletcher, n.d., about 1937), p. 10.

145. William Tod Helmuth, *Yellowstone Park and How It Was Named* (Helena: C. B. Lebkicher, n.d. [1893–1899]), in Rare Box 15, YNP Library.

146. F. T. Thwaites, "Through Yellowstone and the Tetons—1903," *National Parks Magazine* 36 (March 1962): 11. See also Haines, *Yellowstone Story* II, pp. 121–23.

147. "No More Coaches for Yellowstone Tourists," *New York Times*, April 29, 1917. Motorization in Yellowstone, 1915–1917, is discussed in Richard A. Bartlett, "Those Infernal Machines in Yellowstone Park," *Montana: The Magazine of Western History* 20 (1970): 16–29.

148. Albright to Aubrey Haines, July 1, 1963, as quoted in Haines, *Yellowstone Story* II, p. 289. Haines lists the first rangers on p. 412n23 and Smith is among them. More specific information on him is in Charles Jerrod Smith, "Zion and Bryce Canyon National Parks, Utah (Reminiscences of 'White Mountain' Smith)" (unpublished ms., April 1952, YNP Library vertical files), pp. 4–6.

149. Steve Johnson interview with Bessie Haynes Arnold, January 19, 1974, audiotape 74-4, YNP Library.

150. Lucien M. Lewis, "To the Old Stage Driver," *Overland Monthly* 49 (July 1917): 52.

151. Campbell, *Campbell's New Revised Complete Guide* (Chicago: Rogers and Smith Company, 1923), p. 141.

152. Sharpe, "A Yellowstone Story," p. 32.

153. Lee H. Whittlesey, audiotape interview with Ralph Bush Jr., February, 2000, YNP Library. Interestingly, Gary Cooper's first film in Hollywood was "The Thundering Herd" (1925), a motion picture partly filmed in Yellowstone National Park.

154. Fred G. Smith, *Impressions* (Minneapolis: Augsburg Publishing House, 1925), pp. 43–44.

155. Author's conversation with Gerard Pesman, Bozeman, Montana, January 31, 1994. Pesman has elaborated on this period in an oral history audiotape interview on file at YNP Library, and in his unpublished manuscript, "Geysers and Gears" (n.d. [1981]), YNP Library. A fascinating chronology involving Mr. Pesman (1904–2000) can be traced from Yellowstone's stagecoach days to the present in five persons known to have trained concessioner stagecoach drivers, bus drivers, and tour guides. George Wakefield, who established the first in-park stagecoach company in Yellowstone in 1883 and operated it through 1891, no doubt trained his drivers to do the park tour. He trained his son-in-law Dr. S. F. Way, and Way continued in that stead through the end of stagecoach travel in 1916 and then for at least ten years into the park's bus era. Gerard Pesman remembers "Old Doc Way" taking him under his wing in 1926 and teaching him tricks about the park tour, including park facts and storytelling skills. In his late sixties, Pesman returned to the park (1970–1977) as "Commentary Supervisor" to teach park bus drivers to give park tours. He taught author Lee Whittlesey in 1971–1972 and served as Whittlesey's Yellowstone mentor through 1977. In 1978, Whittlesey took over the teaching reins and trained bus drivers and step-on tour guides to "commentate the park" through 1982. Whittlesey trained Leslie J. Quinn in 1980, and Quinn assumed the Information Specialist position in 1994 and occupies it today. Thus a direct, pass-it-down connection in the interpretive training of concessioner drivers and tour guides from the stagecoach days of 1883 through 2006, a period of 124 years, is found in the Wakefield-Way-Pesman-Whittlesey-Quinn lineage. And the training tour is still called a "frolic" today!

156. L. Merlin Norris, "My Yellowstone Days" (unpublished, 1987), pp. 4, 12–14, YNP Library; C. J. Collins, *Yellowstone National Park* (Omaha: Union Pacific System, 1930), p. 6.

157. Author's conversations with Gerard Pesman, Bud Postema, Ollie Harker, and other elderly men who drove buses in Yellowstone from 1926 through 1960. Some of these conversations were taped and are in the YNP Library. This type of interpretation by park concessioner employees (bus drivers) has continued to the present day in Yellowstone. Beginning in the mid-1950s, snowcoach drivers were added to the concessioner interpretive

picture, and they gave park informational tours in winter in the same fashion as bus drivers in summer.

158. Lindsley, *Chronology of Yellowstone*, p. 241.

159. Stephen Mather, *Report of the Director of the National Park Service to the Secretary of the Interior for Fiscal Year That Ended June 30, 1919* (Washington, D.C.: GPO, 1919), pp. 29–31.

160. A park "Information Service" was first mentioned in the Monthly Report of the Superintendent, July 1920. M. P. Skinner's report as chief naturalist was included in the June 1920 Monthly Report for the first time. The history of National Park Service interpretation (post-1920) is outlined in C. Frank Brockman, "Evolution of National Park Service Interpretation" (private research paper, College of Forest Resources, University of Washington, 1976); in William B. Sanborn, "The Educational Program of Yellowstone National Park" (unpublished master's thesis, Claremont University, 1949); and in Denise S. Vick, "Yellowstone National Park and the Education of Adults" (Ph.D. dissertation, University of Wyoming, 1986), esp. pp. 57–58. Dr. Harold C. Bryant was hired as a "Nature Guide" in the summers of 1918 and 1919 at Yosemite National Park, but Horace Albright at Yellowstone established the first "Park Naturalist" position with Milton Skinner. Lindsley, *Chronology of Yellowstone*, pp. 254, 260; *Yosemite Nature Notes* 39 (July 1960): 153–65.

161. Horace Albright, *The Birth of the National Park Service* (Salt Lake City: Howe Brothers, 1985), p. 120.

162. Isabel Bassett Wasson to Peter Bergstrom, 1978 audiotape interview, copy at YNP Library. Albright seemed to have a penchant for women rangers like Isabel Wasson, for he hired several others. He recalled that in 1921, the lecture service "was handled by Miss Mary Rolfe, a fine enthusiastic girl, who tried very hard to please." He placed Margaret Lindsley "in the Information Office with another girl or young college man." Similarly, Margaret Thone and Irene Wisdom both served in 1924, Wisdom and Frieda Nelson in 1925 and 1926, Frances Pound from 1926 to 1929, her sister Virginia Pound in 1927, and Herma Albertson from 1929 through 1933. Lemuel Garrison to Chief of Interpretation, October 25, 1961, in Jack Haynes collection 1504, file 112:3, Montana State University. Isabel Bassett Wasson spent most of her life as a science teacher in the school system of River Forest, Illinois, and died in 1994. Author's interview with Mrs. Theoley Malmer, Seattle, Washington, August 15, 1994, YNP Library.

163. Skinner to Col. L. M. Brett, November 5, 1913, in Item 37, folder 1, file 3, YNP Archives; Newell F. Joyner, "An Outline of the History of Educational

Activities in Yellowstone Park," in *Ranger Naturalists' Manual*, pp. 170, 172, 176. Interestingly, chief naturalist Milton Skinner left the park in 1923 under what were apparently less than agreeable circumstances. A letter dated December 3, 1917, from the park acting superintendent (probably Chester Lindsley) to Horace Albright (then in Washington, D.C.) and marked "personal" outlines how difficult Skinner was to get along with. The letter called him annoying and opinionated and stated that nearly everyone who came into contact with him disliked him. Microfilm reel 49, YNP Library.

164. There is no complete history of NPS interpretation from 1920 to 2004, but a general look at it is in Culpin and Rydell, *Managing the Matchless Wonders*, pp. 152–54. The partnership information was presented in Ron Thoman, "An Overview of the State of Interpretation in Yellowstone," May 31, 1994, speech to new interpreters, Yellowstone National Park, Wyoming.

165. Schullery, *Searching for Yellowstone*, pp. 103, 133; Haines, *Yellowstone Story* II, p. 137.

166. Olin D. Wheeler, "Yellowstone's Semi-Centennial," *Western Magazine* 18 (February 1921): 29.

CHAPTER TWELVE

1. Judith Meyer has correctly pointed out that the word *freak* (as in "freaks of nature") had a different meaning in the nineteenth century. "Freaks of nature" then meant "marvel of nature" or "miracle of nature." Judith Meyer, "Permanence of Place: The Enduring Spirit of Yellowstone National Park" (unpublished PhD. dissertation, University of Wisconsin, 1994), pp. 159–60.

2. The quotation is from John Muir's article "The Yellowstone National Park," *Atlantic Monthly* 81 (April 1898): 522.

APPENDIX ONE

1. In early March of 1994, hot spring expert Michael Keller, with special permission from park authorities following the pointing out of this passage to him by the author, climbed into the well of Turban Geyser in the Grand Group of Upper Geyser Basin following an eruption of that geyser. During the period while the spring was empty, Keller searched its walls for writing. He was rewarded by finding the initials "RBM" on the west wall of the geyser at a location several feet below the surface. Perhaps Ralph Knight was thus not the author of this piece; instead perhaps Robert B. McKnight was a real person. Or perhaps Knight engraved his pseudonym's initials at Turban.

APPENDIX TWO

1. "'Geyser Bill' Keeps Close Tab on Spouts in Yellowstone Park," *Livingston Enterprise*, July 30, 1932.

BIBLIOGRAPHICAL ESSAY

The Most Important Literature
About Yellowstone National Park

Exactly which books constitute Yellowstone's most important ones are a matter of opinion, debate, and personal passion, but after spending more than thirty years researching the place, I can certainly point out the works that seem to stand the tests of time, scholarly critique, and public interest. I have listed many of the earliest park books in chapter five, but my top picks of all time are listed here. I have also mentioned several recent titles that have shown early promise to endure.

Any study of Yellowstone's history must begin with Aubrey L. Haines's book *Yellowstone National Park: Its Exploration and Establishment* (Washington, D.C.: GPO, 1974) and his magnificent two-volume set *The Yellowstone Story* (Boulder: University of Colorado Press, 1977, 1996). Dr. Richard F. Bartlett wrote two volumes on Yellowstone history, and they also are exceptional: *Nature's Yellowstone* (Albuquerque: University of New Mexico Press, 1974) and *Yellowstone: A Wilderness* Besieged (Tucson: University of Arizona Press, 1985). James Pritchard's book *Preserving Yellowstone's Natural Conditions: Science and the Perception of Nature* (Lincoln: University of Nebraska Press, 1999) is the best and only look at the history of science in Yellowstone's management, although the official park administrative history is also now available: Kiki Leigh Rydell and Mary Shivers Culpin, *Managing The Matchless Wonders: A History of Administrative Development in Yellowstone National Park, 1872–1965* (Mammoth: National Park Service, Yellowstone Center for Resources, 2006). Another recent and important addition is Mary Shivers Culpin, *For the Benefit and Enjoyment of the People: A History of Concession Development in Yellowstone National Park, 1872–1966* (Mammoth: National Park Service, Yellowstone Center for Resources, 2003).

Paul Schullery's books are some of the most ground-breaking and thoroughly researched, and I believe that his *Searching for Yellowstone: Ecology and Wonder in the Last Wilderness* (New York: Houghton Mifflin, 1997) is one of the five most important books ever written about the park.

His *Yellowstone Ski Pioneers: Peril and Heroism on the Winter Trail* (Worland: High Plains Publishing, 1995), *The Bears of Yellowstone* (Worland: High Plains Publishing, 1992), and one that I co-authored with him, *Myth and History in the Creation of Yellowstone National Park* (Lincoln: University of Nebraska Press, 2004) are important looks at Yellowstone side issues. Finally his *Mountain Time* (New York: Schocken Books, 1984) has become a classic naturalist's look at Yellowstone.

Older but still one of the most important books ever written on the subject, regardless of his mistake in saying that the name Yellowstone came from the park's canyon and his incorrect use of "Colter's Hell," is Hiram Martin Chittenden's *The Yellowstone National Park Historical and Descriptive* (Cincinnati: Robert Clarke Company, 1895, 1905). There are many editions of this book published through 1964, but the first two are the best because they contain the long appendices, park tour sections, photographs, and bibliography that were omitted from later editions.

There is, unfortunately, still no master treatise on archaeology in the park, but we have three viable works on Yellowstone Indians. Peter Nabokov and Larry Loendorf have written *American Indians and Yellowstone National Park* (Mammoth: National Park Service, Yellowstone Center for Resources, 2002) and *Restoring a Presence: American Indians and Yellowstone National Park* (Norman: University of Oklahoma Press, 2004), which should be used together. Also noteworthy is Joel Janetski's *Indians in Yellowstone National Park* (Salt Lake City: University of Utah Press, 2002).

Yellowstone guidebooks (the first one appeared in 1873) are legion. Janet Chapple's *Yellowstone Treasures* (Providence: Granite Peak Publications, 2002) is my recent favorite in this category. The most important of the earlier ones are *Haynes Guide Handbook to Yellowstone National Park* (written by Jack E. Haynes, F. Jay Haynes, and A. B. Guptill and published under various titles from 1890 through 1966) and Reau Campbell, *Campbell's New Revised Complete Guide and Descriptive Book of the Yellowstone National Park* (Chicago: H. E. Klamer). The Campbell books include a great deal of early history not available elsewhere, and they appeared in four editions: 1909, 1913, 1914, and 1923.

Yellowstone books that contain important general science are as follows: Don Despain et al., *Wildlife in Transition: Man and Nature on Yellowstone's Northern Range* (Boulder: Roberts Rinehart, 1986); Mary Meagher and Douglas B. Houston, *Yellowstone and the Biology of Time* (Norman: University of Oklahoma Press, 1998); Robert B. Smith and Lee J. Siegel,

Windows into the Earth: The Geologic Story of Yellowstone and Grand Teton National Parks (New York: Oxford, 2000); William J. Fritz, *Roadside Geology of the Yellowstone Country* (Missoula: Mountain Press Publishing, 1985); Robert B. Keiter and Mark S. Boyce, *The Greater Yellowstone Ecosystem: Redefining America's Wilderness Heritage* (New Haven: Yale University Press, 1991); and Tim W. Clark, ed., *Carnivores in Ecosystems: The Yellowstone Experience* (New Haven: Yale University Press, 1999). Two crucial recent National Academy of Science publications are Norman F. Cheville, *Brucellosis in the Greater Yellowstone Area* (Washington: National Academy Press, 1998) and National Research Council, *Ecological Dynamics on Yellowstone's Northern Range* (Washington: National Academy Press, 2002).

Perhaps the most important work ever produced in its subsequent influence on Yellowstone's and other parks' management philosophy and policy is A. S. Leopold, S. A. Cain, C. M. Cottam, I. N. Gabrielson, and T. L. Kimball, "Wildlife Management in the National Parks," *Transactions of the North American Wildlife Conference* 42 (1963), pp. 28–45. Known as the Leopold Report, this paper changed everything in national parks.

Animals and vegetation are huge categories in Yellowstone literature. The single most important milestone in Yellowstone wildlife science is Douglas B. Houston, *The Northern Yellowstone Elk: Ecology and Management* (New York: Macmillan, 1982), which is an extremely important book that formalized, rationalized, and fully articulated the "natural regulation" idea and also was an early proponent of reintroducing the wolf to the park. Reinforcing and supplementing Houston is William J. Barmore's *Ecology of Ungulates and Their Winter Range in Northern Yellowstone National Park* (Mammoth: National Park Service, 2003). Likewise Mary Meagher's *The Bison of Yellowstone National Park* (Washington: National Park Service, 1973) was one of the first important book-length studies of any park wildlife species. Her beloved bison have recently been treated by Mary Ann Franke, *To Save the Wild Bison: Life on the Edge in Yellowstone* (Norman: University of Oklahoma Press, 2005). The pioneering park book on a single wildlife species, which was enormously important in shaping policy and practice, is Adolph Murie's *Ecology of the Coyote in the Yellowstone* (Washington: National Park Service, 1940). Yellowstone fish are in John Varley and Paul Schullery, *Yellowstone Fishes: Ecology, History, and Angling in the Park* (Mechanicsburg, Pa.: Stackpole Books, 1998). Schullery's book on Yellowstone bears has been supplemented recently by Alice Wondrak-Biel's *Do (Not) Feed the Bears: The Fitful History of Wildlife and Tourists in Yellowstone* (Lawrence:

University Press of Kansas, 2006), and by John Craighead, *The Grizzly Bears of Yellowstone: Their Ecology in the Yellowstone Ecosystem, 1959–1992* (Washington: Island Press, 1995). Yellowstone wolves are in Doug Smith and Gary Ferguson, *Decade of the Wolf: Returning the Wild to Yellowstone* (Guilford: Lyons Press, 2005), and in Paul Schullery, ed., *The Yellowstone Wolf: A Guide and Sourcebook* (Worland: High Plains Publishing Company, 1996). Birds are in Terry McEneaney, *Birds of Yellowstone* (Boulder: Roberts Rinehart, 1988). A detailed history of animals in the Greater Yellowstone Ecosystem is Paul Schullery and Lee Whittlesey, "Documentary Record of Wolves and Related Wildlife Species in the Yellowstone National Park Area Prior to 1882," in *Wolves for Yellowstone?* vol. 4 (Mammoth: National Park Service, Yellowstone Center for Resources, 1992, pp. 1–73). Bolstered with a great deal of added science and GIS material, this book is slated for publication in 2007 under the general title *The History of Greater Yellowstone Wildlife: An Interdisciplinary Analysis, 1796–1882*. Microorganisms in Yellowstone hot springs are in Thomas D. Brock, *Thermophyllic Microorganisms and Life at High Temperatures* (New York: Springer-Verlag, 1978), and William P. Inskeep et al., *Geothermal Biology and Geochemistry in Yellowstone National Park* (Bozeman: Thermal Biology Institute, 2005). The premier work on plants in my opinion is Don G. Despain's *Yellowstone Vegetation: Consequences of Environment and History in a Natural Setting* (Boulder: Roberts Rinehart, 1990).

The great fires of 1988 in Yellowstone have been treated in many books, but the most important ones in my opinion are: Micah Morrison, *Fire in Paradise: The Yellowstone Fires and the Politics of Environmentalism* (New York: Harper Collins, 1993); Mary Anne Franke, *Yellowstone in the Afterglow: Lessons from the Fires* (Mammoth: Yellowstone Center for Resources, 2000); Linda L. Wallace, ed., *After the Fires: The Ecology of Change in Yellowstone National Park* (New Haven: Yale University Press, 2004); and George Wuerthner, *Yellowstone and the Fires of Change* (Salt Lake City: Haggis House, 1988).

Miscellaneous subjects in Yellowstone have resulted in a vast literature for themselves. Yellowstone art is treated in Peter Hassrick, *Drawn to Yellowstone: Artists in America's First National Park* (Seattle: University of Washington Press, 2002). Yellowstone geysers are in T. Scott Bryan, *The Geysers of Yellowstone* (Niwot: University Press of Colorado, 1995). Yellowstone waterfalls and Yellowstone place-names are in two of my own books: Paul Rubinstein, Mike Stevens, and Lee H. Whittlesey, *A Guide to Yellowstone*

Waterfalls and Their Discovery (Englewood: Westcliffe Publishers, 2000); and Whittlesey, *Yellowstone Place Names* (Bozeman: Wonderland Publishing, second edition, 2006). Place-names are examined in a different way in Aubrey Haines's *Yellowstone Place Names: Mirrors of History* (Niwot: University Press of Colorado, 1996). Yellowstone mountain peaks are in Thomas Turiano, *Select Peaks of the Greater Yellowstone: A Mountaineering History and* Guide (Jackson, Wyo.: Indomitus Books, 2003). Old Faithful Inn is in Karen Wildung Reinhart and Jeff Henry, *Old Faithful Inn: Crown Jewel of National Park Lodges* (Emigrant, Mont.: Roche Jaune, 2004). The history of Yellowstone concessions and their relationship to capitalism are in Mark Barringer, *Selling Yellowstone: Capitalism and the Construction of Nature* (Lawrence: University Press of Kansas, 2002), and Chris Magoc, *Yellowstone: The Creation and Selling of an American Landscape* (Albuquerque: University of New Mexico Press, 1999). The Hayden survey in Yellowstone is in Marlene Merrill, *Yellowstone and the Great West: Journals, Letters, and Images from the 1871 Hayden Expedition* (Lincoln: University of Nebraska Press, 1999). There are at least five different books on Yellowstone backcountry trails, but my favorite is Mark C. Marschall's, *Yellowstone Trails: A Hiking Guide* (Yellowstone National Park: Yellowstone Association for Natural Science, 1999).

I generally do not like books that try to include information on a large number of national parks because the potential for errors is too great, but two are better than usual in this genre: Karl Jacoby's *Crimes Against Nature: Squatters, Poachers, Thieves, and the Hidden History of American Conservation* (Berkeley: University of California Press, 2001) and David Spence's *Dispossessing the Wilderness: Indian Removal and the Making of the National Parks* (New York: Oxford, 1999).

Other older works that I believe are still important are E. T. Allen and A. L. Day's *Hot Springs of the Yellowstone National Park* (Washington: Carnegie Institution, 1935); Louis C. Cramton's *Early History of Yellowstone National Park and Its Relation to National Park Policies* (Washington: National Park Service, 1932); Marie M. Augspurger's *Yellowstone National Park Historical and Descriptive* (for its inclusion of little-known local history) (Middletown, Ohio: Naegele-Auer, 1948); and the Wonderland series of books published annually under different titles by the Northern Pacific Railroad, 1883–1906. Some of these were authored by Olin D. Wheeler.

There are two books that must be acknowledged, but which I cannot recommend in good conscience. These include Alston Chase's *Playing God in Yellowstone* (San Diego: Harcourt Brace, 1987), which, although it stimulated

debate in a disinformational way, is such a combination of errors, adversarial condescension, and intellectual posturing that I believe it should be avoided except as a curiosity. Another is Nathaniel P. Langford's *The Discovery of Yellowstone Park 1870* (St. Paul: J. E. Haynes, 1923, copyright 1905), which remains important for its story of the Washburn party but which unfortunately adds direct quotations of what people allegedly said in a manner that serious historians distrust. And, too, I believe that it fabricates the classic Yellowstone origin story.

Finally, where magazine articles are concerned, readers should look mainly to *Yellowstone Science* (published by the park) and *Montana: The Magazine of Western History*, as these periodicals have the most concentrated groupings of Yellowstone articles.

I continue to be amazed that many corners of Yellowstone history have not been researched and that many Yellowstone books and articles remain to be written.

INDEX